PAINTED IN WORDS

Painted
in Words

A MEMOIR BY
SAMUEL BAK

FOREWORD BY **AMOS OZ**

INDIANA UNIVERSITY PRESS
BLOOMINGTON and INDIANAPOLIS

in conjunction with

PUCKER ART PUBLICATIONS
BOSTON, MASSACHUSETTS

This book is a publication of
Pucker Gallery, Inc.
171 Newbury St., Boston, MA 02116-2897

Distributed by
Indiana University Press
601 North Morton Street, Bloomington, IN 47404-3797
http://iupress.indiana.edu

Telephone orders: 800–842–6796
Fax orders: 812–855–7931
Orders by email: iuporder@indiana.edu

Earlier versions of three chapters of this book have been published previously:
"Samek and Samek" in *Religion and the Arts*, 2000; "Burlap Sacks" in *Boston College Magazine*, 2000; and "Landsberg Revisited" in *Dimensions*, 2000.

Designed and composed by Scott-Martin Kosofsky at The Philidor Company, Cambridge. The text is set in Mr. Kosofsky's Montaigne types; the headlines are set in Berthold Berliner Grotesk.

The paper used in this publication meets the minimum requirements of American National Standard for Information Sciences—Permanence of Paper for Printed Library Materials, ANSI Z39.48-1984.

Cataloging information is available from the Library of Congress.

ISBN: 0-253-34048-0 (cloth)

1 2 3 4 5 05 04 03 02 01

Printed and bound in Canada

For Josée

AMOS OZ

Painted in Words, Narrated in Colors and Light

AT MY FIRST SIGHT of a painting by Samuel Bak, I had the keen sense that he was telling me stories with his brush. Now that at long last he has written this book, I find it no wonder that he has painted with his pen. In both his paintings and in this book, Bak goes beyond erecting a "memorial to the *Shoah* ("annihliation" in Hebrew) and the slaughtered Jewish people"; above all he presents a personal, a unique world. This world is filled with yearning and irony, saturated with nightmare and loneliness, pierced on occasion by a cry of theological protest. It is a world of terror and cosmic bereavement, of twisted time and metaphysical fear.

I regard Samuel Bak as one of the great painters of the twentieth century. There are few artists who have so successfully represented the mad cruelty of our era—its horrors, its desolation, its sadness and vacuity. And fewer still are the artists who have created their own unique personal language. In Bak's world, horror, humor, and dreams all solidify into one radioactive mass.

Painted in Words is not merely another painting, done with a different brush. Among the tens and hundreds of books I have read about the pre-*Shoah* and post-*Shoah* period, including novels, memoirs, documentation, and philosophy, Bak's book is unique. Despite being suffused with a sense of loss, horror, degradation, and death, it is ultimately a sanguine, funny book, full of the love of life, rocking with an almost cathartic joy. At times I found myself bursting out laughing. It is the only time in my life that I have felt sensual pleasure in reading a book seemingly dedicated to the

tragedy of the Jewish people; to the destruction of city, community, and family; to the devastation of childhood and the memory of a murdered world.

But only seemingly is it dedicated to death. Actually it is a marvelous ode, a colorful hymn to the forces of life, love, creation, and the joys of the senses. Bak has written a tragicomic epic about the birth and maturing of an artist who grows from out of the amusing absurdities of childhood into the nightmares of history—the mad cruelty of persecution and ghetto, the strange miracles of surviving, and the arctic loneliness of those who survived.

This book is not only and not principally about "How I managed to remain alive and come through all this without losing my mind." It is above all a "portrait of the artist as a young man," in circumstances that Joyce could never have dreamed of, a nightmare that makes Dante's *Inferno* look like an air-conditioned club.

Like Proust's madeleine, the disappearing and reappearing *Pinkas*—an old book of Jewish records—released in its author a bursting stream of memories. This *Pinkas*, eons ago in a far-off extinguished galaxy, was decorated with the drawings of a sharp-eyed, spoiled only child. Like the Biblical Samuel whose destiny as prophet was assigned him from the womb, this young Samuel was destined by his entire family to grow into a painter. Bak's Lithuanian-Jewish family, with all its bourgeois aspirations, craziness, warmth, secrets, pretensions, and fears, is basically the hero of our epic.

The family, and at its head the titanic mother, was resolved that the child become an artist. Hitler had other plans. Each of the two sides employed all available means. After many reversals of fortune and frightful horrors, it became clear that the means employed by the mother and family were the more refined and efficient.

The book before us was born most probably because that child

returned, *Pinkas* in hand, not once but many times to knock on the painter's window. The child and the *Pinkas* have brought this artist after all those years to recover and revive the child, the mother who survived, and the father who was murdered. An entire community is returned here from the dead: not just the immediate family but a whole tribe of eccentric uncles, grandfathers, grandmothers, and great-grandparents; dramatic, lyrical, and epic characters; almost legendary figures and figures that verge on the grotesque and absurd. And here is the alchemical miracle of this book—the entire community invites us, the readers, not to weep and mourn but to look, listen, touch, smell, find joy in the senses, yearn, laugh, and identify with its members. I entered this book like one who visits a cemetery to be alone with the dead and found myself instead swept up into a warm, lively, and captivating ball.

Painted in words? Of course! But look, here is the wonder. It is also told in colors of varying hues and shades, in visions whose lines are fine and precise—and above all, it is told with the richness and radiance of sunlight.

Arad, Israel, 2001

The stories of this book were written between the years 1996 and 2000. The few I had attempted earlier served as preliminary sketches. Created in no chronological order, they have now grown into a flow of reminiscences and associations. To me the stories are like pictures painted at different times, sometimes over a span of many years, self-contained units enriched by the connections that bind them together. I see them as if they were pictures installed on a gallery's walls.

I hope, paraphrasing Braque's observation on Cubist art, that what in their structure may seem to have fallen apart, their spirit reunites.

—S. B.

CHAPTER ONE

The Pinkas

THE PINKAS: A BOOK OF RECORDS

MARCH 4, 1999. WESTON NEAR BOSTON. A gentle light filters into the room. It is daybreak. Stretching my limbs I try to extricate myself from the lingering remains of a dream. What was it? Crowds of bizarre people, a haunting carnival, multitudes of strange masks. The anguish of exposing my real identity, the need to flee an imminent danger. And now the delight of waking up in the reality of my safe and comfortable home.

It is Purim time, a time of carnival, the most joyous of all Jewish festivities. Purim honors the wise Queen Esther who in the biblical times saved the Persian Jews from Hamman, an ancient Hitler. Purim was also my mother's birthday. As I sank back into sleep, old memories of children's costume parties and Purim parades blended with my thoughts of her. Had she lived, Mother would be eighty-eight today.

NOW AFTER BREAKFAST I am seated in front of my computer's milky screen. Faint vapors rise from my cup of hot coffee. Earlier, on my way downstairs with today's date of March 4 still on my mind, I passed through the gallery that connects our master bedroom to my painting studio. This morning I slowed down, stopped in front of one of my older works, switched on the spotlights, and examined it at length.

The sizable canvas evokes the city of my birth, Vilna. It was painted in the early sixties, while I was living in Rome. I remember that I wanted it to look like an abstraction. But to me it was by no means "abstract": it

contained a quite specific memory. What had been Mother's response to this particular painting when she first saw it? I am unable to recall.

It took me some time this morning to pass through the painting's physical surface of thick color patches and transparent glazes and enter its imaginary space. It may have been a concealed longing that finally transported me there. Under a leaden sky, incinerated buildings surround an open yard. Distant smoke darkens the horizon. A wet ground reflects the entire perspective, and on it, two stains like two small figures seem to be passing. They could be a mother and child; they could be my mother and me.

As I stood there this morning, it felt as if the entire scene were melting, as if its blurry image were on the point of *fading out*, as happens in the magic of cinematography. Yet I could imagine it the other way round, as something I had impatiently captured and fixed on the canvas before the image had fully *faded in* and come into focus.

These were idle speculations for an artist to whom the essential fact about a painting is that it can never be finished. Perhaps I was going too far in my speculations. I had to admit to myself: in those years in Rome I followed the norms of art and this was the way I painted. Abstract art allowed me to keep painful details at a bearable distance.

I shut off the spotlights, left the image of Vilna's destruction to its web of blending brushstrokes, and moved to the stairs. The door of my studio was open. From the other end of the room, unfinished canvases, an empty easel, tubes of colors, and numerous cans of brushes triggered in me a fleeting sense of guilt, which I rapidly discarded: "Let them wait!" I then ran down the stairs, took my coffee to my small study on the ground floor, sat down in front of the computer, and pressed the master button. Green lights began to twinkle. This miraculous receptacle for my verbal accounts and the scanned images of my paintings brings forth the memory of something familiar from childhood. This "something" is an

ancient book of records, my close companion during one critical period of my young life.

Let me explain.

The Old Pinkas

The *Pinkas* is a small and modest object presently safeguarded by the Lithuanian National Museum of Vilna, now called Vilnius. It must be gathering dust in one of the museum's archives that I can't help imagining as murky and damp. When I was nine and ten, the *Pinkas* was in my possession for more than a year's time. Fifty-six years have passed since I last held it in my hands. The moment of our parting was one of the most painful and dramatic of my life.

This old book contains in its unused spaces numbers of my very early drawings. I must admit that I hardly remember them. Nor do I know much about its handwritten Hebrew texts. But the feel of the blemished leather binding and heavy mildewed paper and the smell of its old glue remain vivid in my mind.

Nineteen forty-two was the last tragic year of the Vilna ghetto's existence. Two renowned Yiddish poets, Avrom Sutzkever and Schmerke Kaczerginski, anticipating the ghetto's approaching doom, put the old manuscript book into the hands of this nine-year-old artist and asked me to draw on it whatever arose from my imagination. I was expected to leave my own record on the pages of this ancient book and keep it alive. They thought that it had a better chance of surviving than did the people who might at any given moment have it in their hands.

The *Pinkas* dated from the middle of the nineteenth century and contained a wealth of records of the Vilna Jewish community of that time. I was happy to add my childish drawings to its yellowing pages if for no other reason than that sheets of paper had become very scarce. Thus we became constant companions. Often on my lap for drawing, or next to

me on my bunk when I was asleep, the *Pinkas* became a faithful friend and a guardian of my art.

The ghetto's liquidation in September 1943 brought both me and the *Pinkas* to the HKP (*Herren Kommando Platz*) labor camp. Later, on the terrible day of March 27, 1944, the day of the children's *aktion*, we were brutally separated. We are separated still.

Sometimes in daydream I have imagined the *Pinkas* provided with eyes that would have registered moments of my life and the lives of those dear to me, retaining the crucial events that miraculously saved me from annihilation. How I would love to revisit the *Pinkas* and watch such events "fade in" on its pages. Perhaps that would have spared me what I am about to undertake—a long, arduous, and emotion-laden journey into my past.

Alas, that past must instead be recomposed from fragments of an aching and irksome memory. Like the images I paint, its fragments belong to a complex reality that cannot be contained within the narrow boundaries of any single canvas or even the output of a lifetime. But unlike my painted statements, my written recollections do not call for transformation into metaphors. They are raw, they are real, and they still hurt.

Probably anyone who undertakes to write a memoir faces similar challenges. A text seems to acquire a life of its own, and it takes hold of the entire person. The story writes itself through the one who summons the recollections, and not the other way round. It is a journey into memory that is more than an attempt to save the past from oblivion; it searches for some kind of restoration or mending. Probably aspiring for a *tikkun haolam*, "the repair of a whole world."

I close my eyes and see the *Pinkas*. I see it as if I were holding it in my hands. The book smells of its age. I open it carefully. Whatever was chronicled a century and a half ago, by the well-trained hand of a meticulous clerk, is inscribed in beautiful Hebrew letters. The scholarly texts were

incomprehensible to me as a child, full of wonder and mystery. Now that I could read and understand them, they are gone.

The Glossy Publication

I have not seen the *Pinkas* since 1944, but recently I received unexpected news of it. Open before me is an ambitious publication of the Lithuanian Ministry of Culture, dated 1997. The title page of my *Pinkas*, attractively reproduced on one of the brochure's glossy pages, depicts the elaborate gate of a temple or theater. Various ornaments embellish the gate's heavy architecture, and the whole device is topped by a two-headed eagle. Decorative curtains reveal an oval shape that proudly displays the words: *Ohabey Hessed,* "Lovers of Righteousness."

Unluckily, the image has been printed upside down.

Next to this inverted title page are reproductions of two of my youthful drawings, taken from the *Pinkas's* inner pages. Both are executed in quick decisive lines, evidence of the young artist's naive self-confidence. One of them shows three shtetl Jews seated at a table. They might at first sight be taken for learned men in a fervent discussion about scholarly texts, but further scrutiny reveals that one of them wears an outlandish bowler hat. A bottle and a glass are placed on the long and rather tall table. Do the men taste ceremonial wine? Or is it a jovial company simply enjoying *a glezl bronfn,* some schnapps?

Never had the young artist seen men like this in real life. But his passion for reading books from the ghetto's ample library made him fantasize an unknown world. Thus the Jewish shtetl, unfamiliar to a child of the urban Jewish middle class, was re-created within the limitations of his youthful imagination. The jolly company might be exclaiming *lekhayim,* to life!

Complementing this, the second drawing pictures a boy. It is an imaginary portrait, perhaps a self-portrait, to whose ominous undercurrents I

shall return in due time. The glossy publication gives the young artist's name in bold letters: Samuelis Bakas. Translated from Lithuanian: Samuel Bak. Let me put aside for a moment this recent publication and return to the story of the old *Pinkas*.

The *Pinkas* entered my life in a period that words like "painful," "distressing," or "tragic" fail to describe. Yet to the best of my memory, my child's imagination chose to escape the hardships rather than depict them. If I could see all those drawings again today, would I nonetheless find in them some hidden expression of the boy's actual experience? My self-portrait makes me think so.

While this strange document indeed validated my precociously mature talent, didn't it at the same time attest the child's "childishness"? Mother's repeated warnings resonate in my memory: "The trouble with child prodigies is that the prodigious stuff evaporates with time, and only the child remains." She has been dead for three decades, but her sayings continue to haunt me.

Suddenly the image of my father comes to mind!

German soldiers are dragging Father to the place of his execution. I am far away but I imagine the *Pinkas* witnessing the scene with its non-existent eyes. I have been told that when the first Jewish partisans rushed into the abandoned HKP camp that had been our last place of confinement, they found in the rubble the bodies of shot prisoners, and among these bodies the old *Pinkas*, stained with blood.

Soon the *Pinkas* found its way back to Kaczerginski, himself a partisan. This was in 1944 when Vilna was freshly liberated, though the war with Germany was still going on. In Kaczerginski's hands, the *Pinkas* was immediately designated for a Holocaust museum he was already trying to create in Soviet Vilna. Some time later, certain that it would give me pleasure, he proposed to show me the *Pinkas*. But I vehemently refused. I was not ready to face the kind of witness this object had now become. I asked

for time. But time has passed, and the opportunity has not returned.

Once it came close. The rattle of a thrice-repaired telephone provided the fanfare for the *Pinkas's* prospective return.

The story goes like this.

Ramat Chen, Israel, 1966

Hearing the phone, I dropped my brushes and hurried from the tiny upper room that had been converted into a temporary artist's studio and plunged down the steep stairs. The instrument was immovably fixed near the entrance door, and a very active party line made it so difficult to get through to us that we rushed to catch any call. To avoid breaking my neck I had to hold on to the two walls that enclosed the narrow passage, leaving on them unsightly traces of fresh oil colors.

I was living in a rented semidetached cottage, miserably furnished, with my then wife Anna and our two children, in a space that was less than a fifth of what we had left behind us in Rome. It was our second attempt at returning to live in Israel, which I had left in 1956 for Paris. Israel had always been for me a country of problems.

The first attempt at return failed; that had been in 1964. This time I took a lease for nine months. Would this second chance, to which I allocated the time span of a human pregnancy, result in the birth of a local market for my art? Would I now be able to support my family by painting my kind of paintings? There were hopeful signs. The success of my most recent show was more than promising.

That 1964 experiment had been disappointing. Although I had established a growing reputation as theater designer, my intense work with directors, actors, carpenters, electricians, dressmakers, and other members of the theater crowd had totally alienated me from my painting and made me quite unhappy. Returned to Italy and reimmersed in my art, I transformed my pictorial language in ways that were challenging and

satisfying. But nostalgia for my country and my friends and a feeling of guilt about distancing Mother from her granddaughters led me to try a second return.

And on this morning in Ramat Chen, the telephone was ringing its decrepit, rattling ring.

"Soviet Embassy speaking, please remain on the line. . ."

Soviet Embassy?

What in the world did they want from me? Could it have anything to do with Uncle David, my father's elder brother? All we knew about him was that after many years in the gulag he had returned to Moscow. We had accepted the fact that his fear of the authorities made him refuse any contact with the survivors of his family, now in Israel. Poor Uncle David! What a wasted life! Was this call a sign of life from this sadly betrayed idealist, terrorized by the people he believed in? He must now be more than seventy. Was he having second thoughts about his former refusal to be in touch? Was he trying to reach out to us through official channels so as not to be suspected of dissidence?

The Soviet Embassy in Ramat Gan, near Tel Aviv, was a white Bauhaus-style building, not too far from my then residence. Its walls were peeling, and its rows of small windows, many blocked by permanently buzzing air conditioners, shed tears of dripping water, thus staining the stucco. Its roof had no onionlike domes but was topped instead by a most heterogeneous collection of antennas. People called it the Kremlin and believed it was the center of the Communist bloc's notorious spying in the Middle East.

All these thoughts ran through my mind. At last the voice of a man who spoke good English tinged by a slight German accent introduced himself as director of the Historical Museum of the Socialist Republic of Lithuania. He wanted to know if his current visit, as a participant in an international meeting of museum curators in Tel Aviv, would allow him

to meet with me that afternoon. He was very, very interested but unfortunately his time was severely limited.

The Visit

A noisy Volkswagen stopped at the gate. The director was accompanied by a robust and very silent young man. The young man, a Russian, wore a narrow tie and a semi-transparent nylon shirt that was soaked with sweat. The middle-aged Lithuanian had a bookish and a more cosmopolitan look. Tall and very formal, he wore metal-framed glasses with heavy lenses that magnified his clear eyes and made his narrow nose look like a bird's beak. We spoke in English, a language in which he seemed quite at ease. But he addressed his colleague once or twice in Russian, without ever obtaining from the young man more than a distracted murmur. Very polite and friendly, sipping slowly the iced tea that I had offered to my two guests, he explained the reason for his visit. The state museum possessed a leather-bound book that had served as an official record book for the old Jewish community in Vilna. His words at once accelerated the beatings of my heart. He went on:

"The book had something more to it than just an ancient text. Many empty spaces and a certain number of blank pages were used by a probably quite young artist."

I moved to the edge of my chair. "Yes, yes, I am the artist! You are speaking of the old *Pinkas*! Oh, my God!"

There came a long pause. The director's unexpected news now hampered our conversation. His careful way of choosing words made him seem oddly to belong to some far-off world, far from my Vilna, the glorious center of an ancient Jewish community. The present Vilna was controlled by a strict administration of Communist Lithuanians, and was practically *Judenrein*.

The Lithuanian, a man of the world, attempted to put me at ease. He

spoke of a lucky coincidence. When visiting some of the current gallery exhibitions in this "interesting country," he had come across my name and connected it in his memory to that of the young artist whose drawings appeared in his museum's old leather-bound book. He was happy to learn that I had survived and that I lived in Israel. The gallery had given him my telephone number. "I would like to hear everything about this unusual book. I am sure that you have a lot to tell."

"Well, you know, I was practically a child, nine years old, maybe ten. Paper was scarce. I used every available surface."

My hesitation and the ensuing silence made him again take over the talking. He said that he understood why I had some difficulty speaking on this subject. He well knew what the innocent victims of the Nazi era had had to endure. The struggle against the barbaric invaders of the Soviet Motherland was heroic. He was well aware that there were many Jews among all the Lithuanian and Polish citizens who had paid dearly with their lives. It was comprehensible that I was reluctant to recall a period in my life that must have been so unpleasant. He was sorry if his visit had stirred uncomfortable memories. He thought that I was more than wise to keep them at bay. "Why dwell in the past? Life must go on."

I re-proposed iced tea and we spoke some more. I agreed with him that one need not dwell in the past but suggested that the past gave meaning to the present. Israel was a result of that past. He did not contradict me. Israel was also full of historical sites that reached back into very ancient times. The subject of ancient archeology distanced our conversation from the heavy shadow of the Holocaust. I questioned him about the archeological sites in the Jordanian part of Jerusalem that his diplomatic passport must have permitted him to visit. For Israelis this was off limits.

Finally I dared the question: "Did you know that Jews considered Vilna to be the Jerusalem of Lithuania?"

He winked and corrected me: "It *was* Vilna, Mr. Bak. At present it is

our capital city Vilnius, and it has a population that is three times what it was at the war's end. Yes, yes. Of course, Jerusalem of Lithuania, those old bygone traditions!" Although they were not the field of his special expertise, he was aware of them. "Books and museums must safeguard them from oblivion."

The now-surfaced tension between these different worlds left us little to talk about. The weather was very agreeable. He enjoyed his present visit in Israel. Thanks to the hospitality of the Soviet Embassy everything was easy and accessible. Those devoted comrades had made his visit most pleasurable. He cast a smiling, inquisitive glance at his companion who was looking into the void and slowly sipping his drink.

The visit was over and the two men got up. At the door he stopped for a moment.

"Mr. Bak, I know that the old book does splendidly attest your precocious talent. If ever an important show of your paintings should require it, our museum would be more than happy to lend it for your exhibit. Please do not hesitate to ask the third secretary of the embassy, here present, to contact us." The younger man lightly nodded. "The Soviet Union and Israel are signatories of an important agreement for cultural exchange. Such loans, as long as they go through the friendly channels of the official administration, are simpler than you might think. It was a great pleasure meeting with you. I congratulate you on your beautiful and spacious home. I was able to observe through the window your little girls playing in the garden; they are adorable." I thanked him for the kind words. My younger daughter was pulling the older by her hair, and both were laughing and screaming. "And very vivacious, aren't they? My daughter has a little girl, my first granddaughter."

" I have a little boy," said the Russian in perfect English.

A few words in Russian induced the silent visitor to produce a card and leave it in my hand. "Shalom," they said in unison, and laughed.

I closed the door and leaned on it for a moment trying to recapture a more normal pace of breathing and calm my galloping thoughts. I reached for the telephone to tell Mother about this unexpected visit, about the *Pinkas's* return from the other world, but the telephone line was dead. Other users of our party line were keeping it busy.

The Six-Day War

Several months after this visit, the Soviet Union and its Communist allies broke off diplomatic relations with Israel. Among the swarm of East Bloc diplomats who crowded the Ben-Gurion airport in their attempt to leave the country must have been the third secretary with his wife and son and his semitransparent nylon shirt.

It was one of the outcomes of Israel's surprising victory in the Six-Day War. The possibility of ever reconnecting with the *Pinkas* seemed to have been lost, if not forever, then for many years to come. The war was not unexpected. The feeling that a clash with the Arab neighbors was inevitable had been haunting us for some time. But the spring of 1967 with its sudden mounting of tensions precipitated a crisis. Nasser, the ruler of Egypt, saw himself as leader of the Arab world. Intensifying the rise of Islamic nationalism served his ambition. Thus he tried to mobilize around him the states that surrounded Israel, calling for a Holy War, a *jihadd* against the Jews. Anyone in Israel who dared look at neighboring countries' television programs was covered with cold sweat. Their political leaders and popular figures were calling for a unanimous outcry against Israel, the massive destruction of the Hebrew state, the total annihilation of its people. "Throw the Jews into the sea!"

For the first time since the creation of the Jewish state, the proud Israeli-born "Sabras," largely impervious to stories of the ghettos and camps, felt something akin to the survivors' experience of persecution. Or so it seemed to me. In our tiny and suffocating bedroom, bathed in

sweat, I was plagued by long stretches of insomnia, unable to free myself from haunting images of the Vilna ghetto's last days, days when feverish people were running to and fro in mounting anguish. It seemed to me that all they could say was: "Look at us, our ship is sinking and we are like panicky mice."

My mind resonated with my fear that the Israeli spring of 1967 would be like the tragic month of September 1943 in the ghetto. Then thousands of men, women, and children saw clearly that all hope was lost and that they were about to be sent to their death. I knew I was going too far and tried to be reasonable. Israel had an army, an excellent air force, and a population that was courageously determined to fight for its right to exist. We were not, as in 1939 or 1943, at the eve of our planned liquidation. Though I was aware that my fears were much more anchored in my personal traumas than in objective reality, I was unable to shed my mounting anguish. Looking at my two girls, Daniela and Ilana, six and four, I felt I was experiencing the same helplessness my parents must have known in 1939. What were we to do?

Mother, who was living then in Tel Aviv, insisted that we leave for Italy, the sooner the better.

"And what about you?" I demanded.

"The world shall never allow! The Americans are going to act, they..."

"You don't really believe it! It happened before. Jews were taken to slaughter and no one moved his little finger."

"Therefore it is not going to happen again."

"Then we stay . . ."

"No, don't take chances. Besides, your nervousness is going to drive us crazy. You owe it to your children. They need a calm father. We can make choices, but they are innocent bystanders."

I refrained from voicing an answer that might have led to other words. It was Mother who had brought me to the newly established Israel and

tied my destiny to it. Instead of becoming one of the many struggling foreign painters begging for recognition in the cruel arena of Parisian arts, I was supposed to grow up in a Jewish state, a proud and invincible fighter in khakis. But I was a handicapped Israeli. My past had taken from me the capacity to deal with aggression. Now, I told myself, Mother is devoured by feelings of guilt. Therefore she would like see us gone. My childhood's old tendency to blame her for whatever went wrong had never fully subsided.

There was also an objective reality. My rented lodgings in Israel had to be vacated. The original plan for a prolonged summer stay in Rome, where I was expecting to produce my next exhibition, had long since equipped us with tickets for a departure in mid-May. I profited from this fact and sped my wife Anna and our girls to Italy. Let them take a rest from the tense state of my nerves.

War seemed imminent, and it was important to see how things evolved. I stayed in Tel Aviv with my insomnia, gnawing stomach, and fantasies of catastrophe. I would have loved to be a hero like my father, but cowardly tremors ran through my body. Sending my loved ones to safety should have given me relief but was instead tearing me apart. Was I right to send them away? Where was my solidarity with all the other Israeli families that had no such option? I felt awful.

Having remained in Mother's flat, sleeping on the sofa of her small living room, I expected at any moment to be enrolled for active duty. Thousands were being called up daily. With Markusha, my stepfather, I listened constantly to the radio. The broadcasts spoke of massive mobilizations on the two sides of Israel's tortuous and flimsy state borders. We heard all of general Chayim Herzog's commentaries of strategic analysis. Intended as verbal antidepressant for a population in distress, they were being re-broadcast several times a day. Herzog, using his unmistakably hypnotic voice and erudite Hebrew tinted with an English accent that

made us dream of foreign intervention, did his best to infuse us with some rationality and calm. It had little effect on me.

"How is it that half of the men have been called for active duty and I was left out?" I asked the superior officer of my reserve unit whom I went to see on June 1. He was very close to the chief of the army, and I assumed that he knew what was going on. "I know that I am not much of a fighter, but people with much greater handicaps have been mobilized." The answer was that Zahal, the Israeli army, was demobilizing. Most of the contingent was to be sent home. "Haven't you seen all those men in army fatigues crowding the cafés of Dizengoff?" He advised me to join my family in Italy. "If I were you," he said, "I would leave this very afternoon for Rome. I'll see you in November, when you return. It is absurd to jeopardize your expensive air ticket. And by the way, don't forget to say hello to the pope."

Mother and Markusha accompanied me to the airport. "Thank God that this crisis is over! In this crazy country of ours we shall never know a dull moment," she said. "The Chinese must be right. Whenever they want to curse someone, they wish him interesting times."

The Short Pause

Reunited with Anna and the girls in a comfortable country house north of Rome, I reflected on the frenetic impulse that had made me send them away. I was thinking of my father carrying me on his back in a sack, removing me from the labor camp's deadly terrain. For shame! It was an absurd analogy.

Was I losing all perspective?

I bought a good number of new canvases. Painting was the best cure for my torment. On June 5, in front of my easel, I was happily applying oil colors to a white ground. I have always cherished the sight of immaculate canvases, which I see as the supreme metaphor of unspoiled hope. I

felt reborn! The weather was glorious. The old pine trees around the house gave off a sweet smell of resin, which mixed well with the odor of turpentine that marked the terrain of my studio. Attenuated sounds of Vivaldi poured from the radio. Then came lunch with its odorous *formaggi* and *vino*. The clinking bells of the sheep grazing around the house lulled me into a deep, prolonged siesta.

The next day's music on the radio was interrupted by a special news bulletin.

I gulped, put away my brushes, and sat down. Over the radio, a self-confident specialist in that region's politics was giving the latest news. The Middle East had erupted in war. Tel Aviv was burning. An uncontrollable shivering seized me. My stomach became a huge spasm of pain. Mother, Markusha, all my dear friends in a Tel Aviv in flames! While here was I, unwitting, stupid, in a lovely Italian house sheltered by huge Roman pines, pointlessly transferring dumb colors from idiotic tubes to asinine linen on moronic stretchers.

In reality, Tel Aviv did not burn. Later we were told that the Israeli generals had sought to disorient the enemy by circulating misleading information. Who could have imagined that demobilization was only a stratagem to cover this surprise attack on June 6? History is still studying the lessons of that day and its repercussions.

Israel and I

The unprecedented outcome of the Six-Day War, which brought a temporary resolution and cemented for years a tragic stalemate in the region, appeased me only temporarily. Some people plunged at once into the illusion that a victorious Israel was to enjoy peace and prosperity for the next millennium. Others understood that we were in for trouble. But even to them, this disappointment came much later.

We rushed back from Rome in one of the first planes to land in the

"post-Six-Day War" Israel with the hope of needing never again to depart. The country has experienced "a miracle of survival" and was going through a period of euphoria. The same year my painting career had begun to encounter broad success, and in 1969 I built a house with a large studio. We tried for some years to make Israel our home, but the country's constant tension compromised my work. Israel was plagued by external enmities. Internal enmities exacerbated the external ones. The population was rent over concepts of identity, contradictory and extreme. My very success abroad was exacting a price in the form of professional jealousies and resentment, something I should have anticipated but nonetheless found oppressive. Faced with the signs that everlasting strife was to be the price of living in Israel, I succumbed to a mounting lassitude. The state that was created to assure the Jews that never again would an enemy freely raise his hand against them had plunged me into a new ghetto.

My work was visual and therefore free of geographic and linguistic limitations. It exported well. Major exhibitions in Europe and America had all along taken me for long stretches away from Israel's painful predicament. When I started to envisage the option of leaving altogether, two tragic events helped me to make up my mind: Mother's untimely death and, shortly after that, the passing of Markusha. Their disappearance left me in a state of shock. But mourning brings with it new thoughts and new evaluations. Without the care that I naturally owed them, my situation was much simpler. Now I could search for quieter grounds and give myself this chance to live and work with a far greater sense of outer peace and inner freedom.

And I wanted to give this privilege to my offspring as well. Would they know how to take advantage of it?

The Ghetto's Liquidation

In 1943, when the Vilna ghetto was in the throes of liquidation,

Father, Mother, and I could have been considered a very privileged family.

Father was assigned to a labor unit of the German army's technical services. He had to work with three hundred of the ghetto's most skilled mechanics, welders, and automotive specialists on transforming gasoline-powered motors into engines capable of running on gases from burning wood. It was slave labor executed under dire conditions, but it temporarily delayed the death sentence.

The huge German war machine launched to conquer the world had started to break down. Its attempt to occupy the Soviet Union had encountered in Stalingrad a decisive defeat. The scarcity of necessities like food and gas had reached an alarming point, and every scheme that permitted the creation or saving of such commodities was being exploited. Nevertheless, the Nazi war against the Jews continued to spiral upwards. Nothing could stop its absolute madness. Precious reserves of manpower that could have been used for the benefit of the German war effort were being systematically destroyed by Hitler's suicidal obsession. In some rare pockets of practical rationality, bosses like Schindler managed to convince the Nazi leadership that their units were making important contributions to the war machine. Many such bosses, middle-aged men in semi-military positions, better administrators than soldiers, did this for personal reasons. Not indifferent to the money, gold, or jewels that this strategy allowed them to put aside for an unknown future, they also hoped to remain inland, far from the trenches and killing fronts.

As most of the ghetto's remaining nineteen thousand inhabitants were being transported to the death camps, my parents and I were among the two thousand prisoners retained in two Vilna labor camps, Kailis and HKP. Temporary survivors, we owed our precariously prolonged existence to such practical technocrats. The HKP labor camp, created on the eve of the ghetto's liquidation, was to hold me until March 1944.

Departure to HKP

I see vividly before me the day we left the agonizing ghetto. Drab military trucks are entering the main gate. Their decks, usually covered by heavy canvas, have been left open. Middle-aged soldiers in ill-fitting and worn uniforms guard us with rifles in their hands. As the ghetto's men are already at work, our large group consists mostly of women and children, their immediate families. A tall bespectacled officer is looking through lists of names and comparing them with the passes we are ordered to show. We are being counted, again and again. My outstretched hand, holding firmly my own little card, starts to get numb. Those pieces of paper have the power to give or to prolong human life. Till when?

I lower my eyes. I have been told not to look into the faces of the Germans who hold over us absolute and limitless power. It is wise to be unassuming. With my other hand I press to my chest the old *Pinkas*. I wish it were smaller. Now it is wrapped in a kitchen towel and tucked under my winter coat that has remained unbuttoned. The *Pinkas* contains some of my older drawings as well as recent and unfinished ones, and it is dear to me not so much for what I have already put into it as for the space that it still provides. My shoulders ache from the weight of a small rucksack that contains a shirt or two, a sweater, underwear, shoes that are a couple of sizes too large, and a small box of crayons.

The trucks' engines have not stopped turning, and they fill the air with heavy fumes. Finally an order is given. We must start climbing on the trucks. Their decks are littered with empty burlap sacks on which we sit down and wait. The engines' vibrating tremor runs through our bones. Black exhaust escapes from the vertical pipe of a stovelike cylinder in which wood is constantly ablaze. The fumes have an acrid odor and burn my eyes. Many of us have fits of coughing. Some of our people whisper to each other, but the only audible voices are the dry and cursing orders

given in German. The guards seem irritated by the exhaust smoke. From a distance men and women of the ghetto observe us and gesticulate. I cannot read their faces, but their meaning is not difficult to guess. Soon they shall be transferred elsewhere. Everybody knows that the ghetto must disappear. Some recognize a friend or a relative and their hands try to say goodbye.

One thing is clear. We on the truck are the chosen people.

Crouching down I put the *Pinkas* on my lap. Another boy's filthy shoe treads on my coat where it touches the deck. A fleeting thought reminds me that this coat had once belonged to a boy who is now dead. I look at my neighbor's face. He must be my age. His eyes are crossed, and he looks ugly and terribly sad. I do not say a word. I try to think of something else.

Moses

Our crowd seems a kind of exodus. If Hitler is an evil pharaoh and the ghetto our Egypt, and if leaving the ghetto is transporting us through a desert called HKP to a place that would save us, where is Moses? My thoughts wander to the clay sculpture of Moses I have been working on for months. I do not remember the name of the persons who provided me with the clay, but I recall the name of the sculptor whose work served me as a model. Michelangelo.

I found Michelangelo's horned Moses on an old postcard that originally came from Rome and is now in my rucksack along with its funny postage stamp of a helmeted head called Mussolini. I had discovered the card under the dresser in a tiny apartment where (after our narrow escape from a seized convent and our second arrival in the ghetto) we had spent a few nights packed in with a dozen other people. Most had to leave early for work; so during the day there was peace and quiet, but the crowded nights were distressing. I was suffering from a high fever and could not sleep. Turning on my mat on the floor, I noticed the tiny postcard figure

of Moses. Impressed by his nightmarish stone eyes and the beautiful undulations of his carved beard, I decided to appropriate it and conceal it in the pocket of my pants together with my secret image of Jesus' bleeding heart.

I knew that Moses was the great liberator of enslaved and oppressed Jews. It was he who led them out of Egypt, and therefore I figured that it would be very auspicious to create for the ghetto a sculpture in his honor. I would have liked him to be very large, but our conditions forced me to proceed on a much humbler scale. The enterprise was more difficult than I had anticipated. My parents' friends, who were daily leaving the ghetto for work in one of the German units, brought me clay, smuggled into the ghetto in their large pockets. "Clay for sculpting instead of loaves of bread or some potatoes," said Mother when she handed me the heavy bucket. It was a precious offering and it made the clay seem sacred. This awareness, instead of helping me, rather hampered my ambitious endeavor. In the end I gave my Moses as a gift to Jacob Gens, the Jewish chief of the ghetto. My parents believed that Gens was a decent man and that he merited such a present. Perhaps Father wanted to cultivate an influential and powerful person. Hadn't Michelangelo made gifts to the pope?

What a pity that there was a gap of centuries, of geography, and of language and that there was no possibility for me to meet Mr. Michelangelo. I would have loved to discuss with him these matters! Even more so the problems of sculpting in clay. But Michelangelo must have had it had it easier. He wasn't sculpting in this sticky and brittle clay, he was sculpting in stone! It is also a shame that I have never met the Jewish Michelangelo, Mr. Antokolski. Mr. Antokolski was the pride of Jewish Vilna. He must have showered the Jew-hating czar with priceless gifts to obtain a permit to reside in the capital. I could have learned a lot from his experience about how to survive and how to work in clay. Mother told me that

Antokolski was an expert in clay modeling. My poor clay Moses was constantly cracking. His drying was a far greater problem than I could have anticipated. It seemed to me that all he needed was to be well hidden under a soaking shroud so as to remain damp. Or else to leave our room in the ghetto, the miserable place of his creation, and return to the soil from which his clay had been extracted.

Indeed my Moses wasn't too cooperative. It was only after I scooped the clay from his insides that he had agreed to dry, to become presentable, and to end up, surrounded by walls of a strangely orange color, on Gens's upright piano. Recently I heard a rumor that the Germans have killed Gens. What will now become of my Moses?

Perhaps instead of making a Moses I should have used the same clay to produce a golem? Mother told me a story of the Rabbi of Prague who had breathed the spirit of life into a clay figure of his making. He named it Golem and gave it an order to punish all the enemies of the Jews. Once in a cinema display box I saw among other film stills the Golem's photograph. As much as Moses was handsome (aside from his strange horns), the Golem was hideous. On second thought it is perhaps better I concentrated on Moses.

Moses, golems. Our enemy is too powerful for them! Even Father, who in his happy days would at the slightest provocation beat up heinous anti-Semites and leave them with black eyes, is now powerless. Yet his resourcefulness and talent have permitted the three of us to be now among the chosen: people chosen for the transportation to the HKP camp. Seated on the truck's deck we go on waiting. My neighbor's dirty shoes make a mess of my coat. Waiting in suspended time is now part of our life. The *Pinkas* is well protected in my lap. The truck grows more and more packed. I have been pushed closer and closer to Mother and end up in her lap. She is sitting on a small bag and leaning against the back of another woman. Yet more women and children are told to mount, and

the pressure increases. My eyes are teary. The truck's black smoke has made us look gray and dirty.

Crowded to the maximum, piled up against each other, we look like a compact accumulation of human spare parts. Some children try to guess what foot belongs to what head, find it funny, and giggle. The soldiers count our number and lower a heavy canvas that plunges us into semi-darkness. Only the tail of the vehicle remains open. Two soldiers have climbed in and now sit near the opening. The cloth deprives us of air but protects us from the exhaust. The engine noise mounts. Our collective vibration increases, and the truck lurches forward.

On the Way to the Camp

The whole convoy is on the move. I think of Father in his new welding unit. The unit was moved close to the living quarters of the camp to which we are being taken. Our trip should not last more than twenty minutes. I imagine Father's happy face meeting us at the gate. I try to imagine the new labor camp. Would there be any vegetation? The ghetto has only one tree. Now, who knows, I might see various trees, bushes, and grass and be able to touch them. The idea fills me with anticipation. After having been trapped for a long time in the ghetto's arid and overcrowded streets I am eager to explore any unknown territory. I must have forgotten how much a traveling vehicle shakes. A damaged road makes us absorb sudden unforeseeable jolts. Involuntary kicks are being exchanged between close neighbors. We are quiet. I do not know what passes in the other people's minds, but I can feel tension mounting in us all. Beyond the two guards' dark silhouettes there is a background of escaping images—disappearing roofs and branches of trees.

Suddenly somebody sitting near whispers that this might be the road to Ponar, already famous as a killing ground for Jews. A few attempts at laughter die out quickly. Was it meant as a joke? Indeed, are we so sure

that we are being taken to the HKP camp? There is a hubbub; a woman in a state of panicking apprehension mumbles incoherent sentences. She causes quite a stir.

Mother yells at her: "Shut up."

The soldiers curse and the noise of the motor drowns the voices. I hold the *Pinkas* with both arms and press it to my chest. It is becoming part of me. A thought flashes by. Rokhele, my beloved teacher who introduced me to the two famous poets who gave me the *Pinkas*, told me that we Jews were the people of the book. And as long as we went on respecting books.

Rokhele, who knows what became of her?

The bumps in the road are very rough. I loosen my grip on the *Pinkas* and relinquish the idea of too much physical unification. There is something else that I find remarkable. In the old times, before everything in my world was totally upturned, I used to suffer from travel sickness. Now there is no trace of it. Or is there? The thought of feeling well makes me slightly nauseated. But I remain determined not to throw up. I am not going to speak of it, to complain or to protest, I am not a crybaby. Tears water my eyes.

The Two Poets

I try to follow Mother's advice for such a tricky situation: "Think of something else." I cling to the *Pinkas*.

The *Pinkas* and my recollection of Rokhele generate thoughts about Avrom and Shmerke (the two poets Sutzkever and Kaczerginski), who gave it to me. I have heard that a few weeks ago they escaped from the ghetto. Have they joined the partisans in the surrounding woods? Vilna's forests contain many groups of fighting men. Are Avrom and Shmerke, those warriors of words, now going to kill Germans and become real heroes? All partisans are supposed to fight the Germans, but some fight each other. It is widely known that many Polish partisans hate Jewish

partisans and try to finish off any Jews the Germans may have missed.

I think of Shmerke who has one eye that constantly looks at the corner of his nose. He is much better in profile. The boy with the filthy shoe on my coat reminds me of him. How is Shmerke with his crossed eye going to aim a rifle at a German? Perhaps he will have to use hand grenades! I imagine an explosion: a hand grenade killing the two Germans in our truck. But what if it takes many of us along with it? What a terrible idea! I shall leave Shmerke's hand grenades for later. Another thought. Once I promised Shmerke that as soon as my drawings filled the whole *Pinkas* I would give it back to him. Avrom said that I should keep it for myself, that later when all this is over and I am grown, the book will be a unique and precious document. Who knows when I shall see the two men again? I haven't yet read anything of the two renowned poets' writings. I shall do that when I am a little older. Still, I must have heard some popular songs that are Shmerke's words set to music. Avrom has shown me some of his published books.

Mother, who adores Yiddish poetry and greatly admires both of the poets, once told me that Avrom Sutzkever was famous even beyond Poland's boundaries. Father, who overheard her, added that indeed the poet had conquered many hearts, particularly hearts of women. It had more to do with the poet's looks and vigor than with his poetry. Father received from her a severe look. But later she smiled pointedly and said that Father should be the last person to take the liberty of speaking so disrespectfully about one of the greatest living Jewish poets, given his own disgraceful obsessions that continued even now when the world was going under. In a different tone of voice and with sadness, Father remarked that soon there might be only poetry left, and no readers.

More than a decade after my parents' bickering conversation, Sutzkever wrote a poem dedicated to Mother. He praised her for her courage in saving the life of her "miraculous son" and described how in

the midst of the most difficult circumstances of hiding and despair the boy had created a sculpture of Moses the liberator. "Where did he find for it the clay?" asks the poet-narrator. The Mother answers him: "In the many graves of the Jews." His observation was prophetic. The experience of those years indeed determined the future direction of my art. The poet, aware of the complex paths of creation, guessed right.

The "miraculous son" is the subject of another chapter in Sutzkever's writing. It is part of a devastating book he wrote in Yiddish about the slaughter of Vilna's Jews. Published in Yiddish in Moscow in 1946, it dedicates a chapter to the young artist of the ghetto. Composed with a lot of affection, it allows itself some poetic license. Samek, the diminutive of my name, is changed to Zalmen, which sounds a little more Jewish. But in case the renaming made me too typically Jewish, my greenish-brown eyes turn light blue under the poet's inspired pen. And the poor clay Moses, instead of receiving a simple kick from a heavy military boot, gets a German bullet in his head. Sutzkever mentions a grand prize that a jury of artists grants the ghetto's young prodigy. I have no recollection of such an event. What I well remember is the prize given me by the two poets: the old *Pinkas*. It was their formal recognition of my talent. Avrom had found this ancient book during his forced labor, where he was made to sort out documents and precious books looted by German authorities. He stole it back from the looters and smuggled it into the ghetto, and with Shmerke placed it in my hands.

I was too small to grasp the pathos of their romantic desire: to generate a document that in the midst of the most harrowing circumstances would attest to the indestructible power of human creativity. Pathetic circumstances breed pathetic clichés.

The Exhibition in the Ghetto

An "Exhibition of Art" seems incongruous with the very idea of a

ghetto. A waiting room for the horrors of the death camps seems an unlikely setting for something meant to liberate the spirit and bring it joy. Yet it is not an unusual conjunction, as we know from many books about the Holocaust. Genuine artists tried in the bleakest of times to reassure themselves of their humanity and give value to their existence. In this way art could grant the spirit an escape that the body's imprisonment categorically forbade. "You do not play theater in a cemetery" was the slogan shouted against the ones who in moments of relative calm tried to renew in the ghetto some of the old effervescence of Jewish Vilna.

Such a period of calm started in the ghetto after January 1942. By then the number of its inhabitants had been greatly reduced. Former *aktions* had brought its population to twenty thousand, less than half its former count. On September 23, 1943, the ghetto would be liquidated.

During this interim, performances of theater, music, choral singing, and readings of poetry began to attract large audiences. An exhibition of paintings by the most prominent of the still surviving artists was planned. My two new adult friends, Avrom and Shmerke, were among those involved in its preparation. They decided that my drawings were to be a significant part of its display.

Rokhele Sarovski

The two poets lived in a small room shared with Avrom's wife and two other persons, a room cluttered with beds, crates, and stacks of books. I came to know them through my tutor-teacher, Rokhele Sarovski.

Rokhele was a lovely, warmhearted woman with shining eyes. She had a slight shadow of a moustache and very dark and curly hair. Her dimples sweetened an expression that always looked on the brighter side. Today I can guess that she must have had a crush on the two poets, given the coldness with which Avrom's wife used to treat her. A lucky fate brought her into my life. Rokhele was a renowned teacher, but she was not among the

small number of people caring for the ghetto's children. She had been assigned to a labor unit on the outside. After my parents' and my escape from the occupied convent and our return to the ghetto, Mother asked Rokhele for advice about my education. At once she took it on herself to give me private lessons. Thus I was blessed with an extraordinary privilege, especially considering the dire conditions of our constraint.

The ghetto consisted of a few narrow streets of old and decrepit buildings. They were interconnected in a strangely labyrinthine way, and they crammed within their walls a population ten times their normal number. Five and sometimes six times a week I would climb to the attic of our building on 7 Szpitalna Street, pass from there to another attic, descend two floors and knock on the door of a room that Rokhele shared with others. She gave me her evenings, and I would spend with her an hour or two, sometimes three, never starting before eight in the evening. She taught me Yiddish and Polish spelling, arithmetic, and much else. I especially loved geography because it permitted me to travel beyond the narrow boundaries of the ghetto. She refused any payment for her time and devotion.

To me Rokhele was a gift from heaven. She liberated me from the obligation to attend one of the overcrowded classes of a ghetto school, where children sat on the floor, four or five sharing one book. The search for lice used to take up a good portion of school time, and all had to have shaved heads. "You will never become part of this spectacle," said Mother with her habitual assurance. We stood on the threshold of the school's door, which she closed as quietly as she had opened it. Thereafter my time was dedicated to drawing and to the reading of books that Rokhele advised me to borrow from the ghetto's library. On rare occasions she accompanied me there.

I remember well the Sunday she brought me to the room where the two poets lived. Before we joined them in their quarters, she came to our

cramped lodging, pulled out from under my bed a good number of my sketches and drawings, chose some, and carefully rolled them up. Displaying them with mounting pride to her two friends, she silently awaited their reaction. At first they did not want to believe that these works were really mine. They thought it was a joke that Rokhele was playing on them. But Rokhele's reaction left little room for doubt. They had to believe us. And then they treated me with a lot of respect and admiration, conferring on me their instant friendship and making me feel as safe as I felt with the close members of my family. Now they were convinced that others, too, must be introduced to my art.

They took it on themselves to promote my "debut." A forthcoming exhibition of the ghetto's painters was to provide us with an excellent occasion. Rokhele, they said, had to acquaint me with one of the show's organizers, a young well-established painter, who happened to be a relative of hers. He was the right person to become my tutor, capable of advising me about all I needed to know. But our meeting was not to happen.

The Unknown Artist

He lived in a tiny room accessible directly from a narrow and dark staircase. The staircase's only window, opening to the Christian side, was blocked. Like all the other windows that opened on the forbidden world, it was walled in with old bricks of various colors and sizes. Only windows that looked into the ghetto had a right to exist. The higher we climbed the darker it became. The painter shared a tiny room with an old aunt of his. We wondered if he was there. Two previous attempts to find him had failed. Answering to our insistent knocking, an elderly woman opened the door. Hesitatingly, even after having recognized her visitor, she let us in. A dim light was filtering through a glass pane. It made her hardly visible.

Bent and sobbing she talked to Rokhele. Almost a week before, her nephew had been taken to the Lukiszki prison; it was a place from which

very few ever returned. She reached out to a switch, giving the room a dim yellowish light. I noticed her features, which made me think of Grandmother Rachel. She pointed to a large drawing board leaning against the wall. "The police came and took him while he was working on this." The board displayed a large drawing in black and white, composed on two or more sheets of paper. The surface was held together by thumbtacks.

It was the drawing of a boy sitting at a table. He looked at the viewer with the old aunt's eyes. His hand was trying to touch a crumb of bread or perhaps a little stone that had been deposited near a white cup. The cup was on a saucer. Emerging behind the cup's rim was the erect handle of a teaspoon. The boy wore an oversized cap. It ballooned over his head, as if it would have liked to fly away, possibly taking him along. Its visor cast a shadow that accentuated the white of his eyes. Their sad expression was perplexed and inquisitive. His little coat, a turmoil of black shapes, looked worn and crumpled. The turbulence continued in the wall's peelings and cracks, the only things visible behind the boy's figure. It was a much distressed surface. Only the perfectly immaculate white cup comfortably centered on its saucer and the erect handle of the spoon radiated something of a serene assurance, as if they were the ghostly signs of an impossible dream. With all my being I tried to absorb this mesmerizing image.

"I think we must go," said Rokhele, putting a gentle hand on my back. "Are we ever going to meet the artist?"
"Who knows?"

"Who knows" is a phrase I hear daily repeated dozens of times. Who knows what kind of existence awaits us in the HKP camp? Behind the silhouettes of the soldiers who guard us in the truck, the sky is dark gray. Intermittently faint glimpses of sun illuminate little green fragments of a moving landscape. Sometimes tree branches caress the vehicle's canvas. The houses are becoming lower, and I can see more roofs.

The Boy in the Drawing

Along with the *Pinkas* I take to the camp a myriad of memories. The large drawing of the boy with a white cup is one of them. My crumpled and anguished young self, traveling on the German truck, cannot yet know that in many of my future paintings this boy will hold a prominent position. The boy of the drawing, perhaps that other artist's imaginary self-portrait, will dissolve into the figure of the Warsaw ghetto's little boy, the one with the surrendering arms. In my work this most haunting of all images has absorbed my own small figure to make the three of us resonate as one. And the cup, an unassuming domestic icon, will also appear on many of my canvases. The boy with the questioning eyes was about to touch a crumb of bread that had turned into stone. His arm, frozen in the stillness of the drawing, never reached the cup. Perhaps that is why the cup and spoon, in their serene assurance, seemed to belong to a different dream. My thoughts on the truck bring me back to the ghetto where Rokhele and I descend the dark stairs. She is trying to say something, but I hear only muffled sobs. Something bad must have happened to the young artist.

Today I am unable to recall his name. When I was staring in awe at his unfinished work, he must already have been dead. Was his drawing the kind of art that withstands the test of time? I do not know nor does it really matter. It was an art that managed to save itself from oblivion by generating images in the mind and work of another artist. I am grateful for what he passed on to me, and I regret not remembering his name. The Unknown Jewish Painter has become to me a sort of an Unknown Soldier, whose nonexistent tomb I visit daily, trying to continue a vision that I think of as his.

Were I not afraid of sounding presumptuous, I would say that in my daily toiling with brushes and colors there flickers a small flame in his honor.

Arrival at HKP

The truck slows down and comes to a halt. The air under our cover does not move, but a smell of acrid smoke invades our interior. The two soldiers descend. The noise of engines dies out after a while. All the other trucks seem to have stopped. I hear a loud order to disembark. The first, a boy my age, dashingly jumps down, slides on the slippery ground and is bathed in mud. Cautiously he gets up to his feet. His head is lowered, as if he fears being slapped. People step down with caution. Officers and soldiers laugh and curse. Some of the numerous puddles that cover the wet terrain reflect fleeting patches of light.

We come to a gate that connects two oblong barracks. The workshops, contained in low constructions of wood and tin, are nearby. High fences of barbed wire enclose the entire compound. Two dark brick buildings form its center. Initially they were meant for housing the homeless and poor; now they are going to house us. With their symmetrical rows of small windows, they look like a prison. Between the two buildings is a large open yard.

I try to shake the mud of my neighbor's shoes from my coat. Mother steadies me with her hand on my rucksack. I must protect the *Pinkas* from getting dirty.

"Look what you have done to your coat. How am I going to clean it?"

I do not answer. My eyes move from the boy with the crossed eyes to distant silhouettes of men. Beyond the fence I am searching for Father's figure. I notice a waving hand and can see his smiling face. He is in a group of men who at the first signs of our arrival have started to walk toward the gate. The soldiers give us an order to enter. Before reuniting with the men, we must be counted again and listen to more instructions. Finally the three of us are together and we can embrace. What a happy moment it is!

There is no time for rejoicing. We are ordered to move on and stand in regular formations. A German officer carefully counts us and reads a long list of rules and regulations. Disobedience will be punished severely. The officer barks his text mechanically, without caring how much of it we understand. His language, supposedly similar to Yiddish, sounds so alien that I can hardly follow his words. The grown-ups listen very attentively.

We are given round metal tags to be worn around the neck. Each one bears a hammered number. The number substitutes for our name and must therefore be hammered into our memory. These metal tags as well as the yellow stars on the front and back of our clothing must be visible at all times. Mother leans over, whispering into my ear the translation of the orders. She skips the ones that concern adults, or adolescents assigned to the various workshops. Suddenly I realize that being a child can be a privilege.

The roll call seems endless. A light rain dampens our clothing and chills my body. But it also it accelerates the officer's speech. Finally we are permitted to enter the buildings and find our cells. Father carries a small paper with a number on it. We go toward the building on the right where a crowd blocks the main door. An elderly man responsible for cleanliness asks people to wipe the mud off their shoes. We try to oblige, and the crowd grows. Guards approach, carefully sliding their boots on the wet ground. An order yelled in German provokes a precipitous rush indoors.

Two flights of stairs lead to a long corridor. A faint light filters from windows at each end. Somber walls contain dark brown doors that are marked by numbers in white chalk. I push a few doors to unidentified cells and discover that they open to dingy toilets.

Our "Room"

We find our number and enter the room. It is a small rectangular cell

that holds two double-deck bunks with a narrow passage between them. A small recess in the wall is meant for a few indispensable utensils or some clothing. Close to the window, two rudimentary stools and a small table complete the furnishing. We will have to share our room with three other persons. I look around. I go to the window and cast a glance at the view of the second building. With its many identical windows, it is the mirror of our own. I realize that I was better off in the ghetto, but when I try to say this to Mother it greatly irritates her. "The ghetto is finished. Here we have still the right to exist and must consider ourselves very lucky."

Soon the others arrive. Like us, they are among the happy few to be transferred here from some recently dismantled ghetto. My parents have never met them. The three are a married couple and a single woman. They seem to be very refined, speaking only Polish and insisting they are not familiar with Yiddish, which they call "jargon." The young wife is very pretty, loud, and nervous. The man, tall, skinny and balding, has a sizable nose, a protruding chin, and startlingly pointed ears. Under his moustache glitter two canine teeth of gold. To me he looks older than the compact middle-aged woman with plain features who is presented as his mother-in–law. Mother welcomes them politely, but the exchanged greetings slowly freeze into an unpleasant silence. The three of them look at us with little sympathy and seem especially to mind my presence. Mother whispers to Father in Yiddish that we might be in for trouble. Her remark is overheard and, surprisingly, understood. Our cellmates exchange loaded glances.

So we began. Our future relations improved but never became really warm. Nevertheless, following the initially cold encounter, our partners shed some of their pretended refinements. A few days proved them to be quite fluent in Yiddish after all.

The right side of the room is now ours. My parents install me (with the

Pinkas) on the upper berth and keep the lower for themselves. Father tries to be lighthearted: "These bunks were certainly designed to bring couples back to a greater closeness. To fit into this narrow space we shall have to learn to sleep on our sides. There is a lot one can do on one's side. How considerate of Hitler!"

Father has tried to be cheerful but his faint giggle meets with little approval. Mother is slightly blushing. She is irritated by his familiarity with the strangers and mutters in his direction: "Beware of the pointed ears."

Is Mother speaking of my interest in the conversation or alluding to the man's ears? It could be a most disobliging remark since those ears are really ugly. A slight nod toward me clarifies her intention. I am to be kept away from such conversations. I cannot understand Mother's attitude, but I must keep my thoughts to myself. Father is absolutely right. Certain things are done frontally, others only from the side. Like checking the roll call's line with your head to the side, shooting arrows, walking like ancient Egyptians, or entering narrow places, among others. Father has a point: people can do certain things sidewise a lot better than frontally.

Our new cellmates, called Salomon and Katia, remain indifferent to Father's observation, but the older woman, who is referred to as Maman, casts a disdainful look at him. The couple will occupy the upper bunk that is at an arm's length from mine. The mother, in a sour mood, lies down on the lower one. Salomon's wife says to her: "Maman. You shall sleep on it like a queen."

"Like the queen of Sheba," adds Mother. Father giggles again. But his good humor is not appreciated, and there follows another long silence.

Next day, with my feet hanging from my upper berth and the *Pinkas* well installed on my lap, I pretend to be involved in my work. But I am sketching quite absentmindedly because I try not to lose a word of what Father, profiting from our neighbors' absence, is quickly relating to

Mother. Apparently someone from Father's welding unit comes from the same small ghetto as Salomon. It seems that Katia's mother is actually an old friend of Salomon's wife, and Katia a school friend of Salomon's daughter. Nobody seems to know what happened to the real wife and daughter. They might have been captured and sent to another camp. He might have found them a good hiding place and used their two passes to save these two of their friends. Or perhaps he simply abandoned his family and brought these two women in their place? It is hard to tell. Father thinks that Salomon has to be given the benefit of doubt. People enjoy saying bad things. Why indulge in gossipy suspicions?

"Still, it's a fishy business. Why can't they tell us the truth?" says Mother.

I realize that my parents and in particular Mother are very severe with Salomon and his family. We live in times that constantly decompose and recompose families. Mother's best friend Mania, whose husband was taken away and who has lost her son Samek, lived in the ghetto with Arcadi whom she always presented as her husband. Our neighbors aren't all that bad. He is now friendly to me and is lovingly caring for his daughter's friend or his present wife, whatever she might be. It is fun to pretend to be asleep and so observe their berth from an opening in my cover. Sometimes, in order to assure Katia's sleep, Salomon puts himself above her into untenable positions. I think he must be scratching himself. Such straining positions give his whole body strange spasmlike quivers that risk sending him crashing to the floor. To prevent such a fall he often stretches out his hand and grips the post of my bunk, transferring to us some of his light vibrations. I am sure that he doesn't do it intentionally since it wakes my parents and makes Mother cough quite strongly. Her cough wakes everybody. Father says, "Let him enjoy it in good health," and Salomon and Katia rearrange the cover with which they try to block out the rest of the world.

Soon enough we are all quivering and shaking, and not for short moments alone. Spread on our bunks, we scratch and turn all night long. A massive horde of the most rapacious bedbugs has invaded us.

Maman, Katia's mother, speaks rarely. Most of the time she seems angry with everything and everyone. Unexpectedly she observes: "God has decided that having the Germans on our backs is not enough." Mother answers: "Permit me to quote my mother's wisdom: "Dear God, please don't test us to find out how much we can endure." Mother loves to invoke Grandmother's sagacity. She does not say it but I know that she has given up all hope of ever seeing Shifra again. But she often quotes her, as if the frequent mention of her name might keep her alive.

"Yes," says the older woman. " Suffering knows no limits."

What are the limits of suffering? How does one judge human behavior under the extreme conditions of suffering? Today over a chasm of half a century I hear the women's conversation. I would love to add a word or two, but I remain as devoid of answers as I was then, perhaps even more.

Reflections on the Holocaust Experience

The span between human extremes is huge. It pushes us to view everything in terms of total saintliness and absolute depravity: worlds made up of executioners and victims. Badness, even collective badness, is more easily ascribed to "the other side." The incidents of my life, the memories that shuffle themselves in my mind, are neither black nor white; they belong to what Primo Levi called the gray zone.

It is in this zone that most influential leaders, politicians, and successful individuals operate, men who have understood the requirements for success in a competitive society and are predisposed for moral compromising and a gentle form of civilized corruption. In order to seize power and triumph, they must act as aggressively as possible, take risks, and outsmart the others. They are highly admired. But such persons when

transposed to the painful times of the Holocaust are typically condemned and rejected. A well-meaning public prefers idealized stories of the ghetto. It is troubling to hear of men and women who undertook responsibilities that involved terrible uncertainties and painful choices, where moral action was not an option and inaction merely meaningless. The resulting violation of what is best in us is relegated to dark and repudiated corners. We hate to tarnish the memory of six million victims by recollections of complicity and compromise, however inevitable those may have been.

Most ghetto policemen and executives of the ghetto administration provided themselves and their families and friends with better conditions, better food and employment, and above all with the few "passes" that granted the chance to live a bit longer. I would have thought that the modern public would identify with them, the smart ones, and not with the anonymously mute victims, however decent. Our double standards sadden me. I know that many *kapos* (prisoners who ruled over units of slave labor in the name of the superior authority of the Nazis) were no more vicious than today's men of power, whom society greatly admires. Doesn't the struggle for survival in extreme circumstances merit a more generous understanding? These were neither romantic heroes nor perfect victims. My cellmate with the ugly ears and canine teeth may have been one of the better among them: a man who saved not only his real wife and daughter but two other women as well, whatever the coin in which they repaid his service. Who knows? And who can judge?

Grandmother Shifra's words echo in my mind: "Dear God, please do not test us too much." I would add: "Dear Whoever-you-are, please do not give me proof of the weakness dormant in every decent person; please do not test me."

The Dead Soldier and the Death of a Policeman

On this subject, let me leap forward for a moment to the first day of Vilna's liberation by the Red Army. We are in mid-July 1944.

The battle for every bridge, street, and building has lasted for more than a week. The Wehrmacht, the German army, determined to hold out as long as possible and cause a maximum of destruction, has left more than eight thousand dead soldiers in our city. I once thought that the Germans' departure would draw a curtain on Vilna's immense tragedy. I believed that the former times would return. But this was a child's wish.

Mother and I leave the bombed and partly destroyed premises of our last hiding place in the former convent and venture into freedom. The center of the city is terribly damaged. Wherever my eyes turn I see the wounds inflicted by heavy artillery, shelling, and air-raid bombing. An acrid smell of smoke hangs in the air. People start to emerge from cellars and air-raid shelters. They slowly move amid the rubble, talk to each other, often embrace and form small groups. Mother holds me by my hand. We try to decipher their faces, guess their identity. Perhaps some incredible conjunction of circumstances will let us meet Jews—extraordinarily lucky survivors like us who have just come out from their hiding places. Mother's hand clings to me forcefully. The conditions of the road make our progress slow. Russian soldiers, moving through streets littered with wreckage, warn us with upraised hands. Mother thanks them in Russian. They are telling us to look out for field mines, to step only on paths that have been used before. We walk through a large street that suddenly looks familiar. We pass the building of our prewar apartment. The walls bear hundreds of bullet wounds. Big chunks of mortar have been blown away, but the edifice still stands. I turn away my eyes. Among the things that the Germans forbade and that are again permitted is using the sidewalks. But only the center of the roadway offers a transit free of debris.

We hope to get to Mother's Aunt Janina's home as soon as possible. It is important to find mine-cleared paths that will lead us to her. Is she still alive? And her two sons? We proceed as fast as we can. Above all we hope that Father has survived the camp, and that he will join us there. The big Russian offensive for the recapture of Vilna started on July 7, his birthday. The howl of air-raid sirens announced the onslaught of the Soviet air force. We were hiding under a thick arch of an ancient building. I knew that the attack was for him, his special birthday gift. Following Mother's careful steps I fantasize our imminent reunion. I am thinking of my last glimpse of Father's face. Mother and I do not yet know that only ten days ago, a few days before this birthday on which he would have become thirty-seven, Father was killed by a German machine gun.

Random explosions of detected mines and the rumbling noise of heavy vehicles mix with the roar of tanks and fighter planes. Often the smoke impedes our view. Heavy machinery, soldiers, and civilians forced to "volunteer" are trying to open crucial passages. Intoxicated by the sense of sudden freedom, we pay little attention to the dangers of our advance. We march in a ghost town. The majority of the population must be afraid to venture outdoors. Unexploded bombs, walls ready to crumble, isolated snipers, revenge-thirsty partisans, and the unfamiliar Red Army soldiers frighten the inhabitants and keep the streets empty. Only shadowlike figures, disheveled, creased and covered by dust, thirsty like us for the forgotten taste of freedom, solitary or in very small groups, haunt Vilna's streets. Seeing us mother and son, they instinctively know that we are chosen remains of the chosen people. Hesitatingly, they question us: "*Amkho?*" I know that it is a Hebrew word, which means "thy people." When we stop they inquire, listen, and give information. While Mother speaks to them I observe my surroundings. The intense devastation reveals fascinating forms, shapes, and colors. Desolate window frames look like huge wounds that have leaked their black blood in rising

smears. They tell of recent fire and smoke. We pass a procession of tall chimneys. Ignorant then of what I now know about the death camps, I do not yet read in them the signs that will testify in my future paintings to the horrors of the crematoria. I take them only for what they are, domestic chimneys that formerly sent up the ordinary smoke of fireplaces and cooking stoves. Now they tower over mountains of still-smoldering ashes and black debris. The strangely sweet smell of disintegrating bodies mixes with gases that flow from the many burning buildings. Smoke floats gently into patches of blue sky, adding a layer of gray to its reddish tint. Mother repeats: "Watch where you put your feet and stop walking with your nose pointed to the sky."

I am unable to take my eyes from the intricate images of all those bombed sites. A few buildings that have lost their facades look like huge dollhouses. They make me imagine a monstrous god, a gigantic and unruly brat who has amused himself by tearing them apart. Little is left untouched. Single walls, sole remnants of rooms that used to stage dramas of life stand alone against the sky. They are like huge theater wings, and they too tell me stories. I look at the different layers of torn wallpaper and see in them pages of a book of former lives. On a third floor, a protruding fragment of flooring holds a child's bed. The tiny bed is partly suspended in the void. I imagine a plush teddy bear still asleep under its blankets.

My foot steps on something soft. I startle.

It is the boot of a Russian soldier. At first sight he looks to me intact. His cap, belt, and gun are missing. Impatiently Mother tries to pull me away, but the fascinating presence of the immobile man in uniform is paralyzing. I know that I must observe him attentively. He came for my rescue. He came from far, far away, and he paid with his life. Yet he never knew I existed. His open eyes look straight into the sky. The puffed-up, dark, and shiny face of a Mongol does not seem to care that it is crawling

with dozens of flies. His shaved head is covered with black stubble. The buttoned collar stifles him. The bloating body has filled out and smoothed the stained uniform on which three medals are proudly pinned to the right chest pocket. I notice a large area of dark dry blood that spreads under the medals. It has stained the ground. He rests as calmly as if he were recovering from an exhausting chore, patiently waiting for further orders.

Many more dead soldiers and sometimes civilians make up the macabre guard of honor that on our unforgettable day of liberation salutes me and Mother. Seen in bigger numbers, the dead become less engaging. While a single dead person demands my attention, in bigger numbers they seem to be taking care of each other.

We must cross the river to get to Aunt Janina's house. Arriving to the river's bank we discover a contorted mass of green-painted iron. It had been the bridge. The gigantic hand of a Titan seems to have lifted it up and let it drop. A buoyant stream of greenish water traverses its metallic tentacles. A few of these momentarily retain floating debris, while others cling to dead fish. I think of Rokhele's lessons in the ghetto when we were speaking of the sights that had been taken from me. "A day will come when you will walk again along the banks of the Viliya," she said. "Observe the stream." Today I know that the river's water will end up in the Baltic Sea. It will evaporate, form heavy clouds, travel, and return in to the waste regions of Lithuania's beautiful forests and lakes where it will come down as pouring rain. And so on again, with the same haughty indifference to man's struggles and pains.

The river flows steadily, unhurried. Mother must be touched by the bridge's destruction; she tightens her grip on my hand. Thousands of dead fish floating on the river's surface are sickeningly smelly. Close to where we stand the current gently caresses bodies of dead soldiers in Wehrmacht uniforms. They must have been dumped from a large vehicle.

Thrown pell-mell, one on top of another, some are on the bank but many have landed half in the water. To me they look like discarded marionettes. It is impossible to imagine that a short time ago they could have been alive, that their lives had menaced mine. The arm of one of the partly submerged soldiers is moving with the stream. Although his body remains stuck in place he seems to wave a sign of goodbye. An impulse of sweet revenge makes me stick out my tongue.

Yes, I hate their guts! I despise them! I loathe them!

An old man takes us into his dinghy and deposits us on the other shore. With a toothless mouth he thanks Mother for the few coins of Russian money that have survived in one of her jacket's pockets and have miraculously appeared in the palm of her hand. We climb a steep slope that brings us to a clearing that was once a public park. Now many of its beautiful trees have been cut down to serve the neighborhood's stoves. This was common practice in times of great shortage.

A blond peasant woman is crouching against the remains of a small wall. A girl my age who vaguely reminds me of somebody I remember from the ghetto tries to caress the woman's hair. The woman hangs her arms on the girl's neck and pulls her close to her face. We approach them.

"Nadia?"

"Mitzia?"

The woman's white face and her swollen eyes look familiar. When I realize that her blond hair was black in the ghetto, I know who she is. Her daughter used to scare away boys who tried to pull her pigtails by yelling at them that they would pay for it dearly, that her father was a policeman. I well remember her father, a very amiable man. He helped us in the ghetto. His good word obtained for us our lodgings at Szpitalna 7, a small storeroom that once served a grocery shop. The policeman was always full of "dirty" jokes, most of which I could not understand. People liked

him. Maybe some did not: after all, he represented the ghetto's authorities. To us he was a devoted friend. I heard that a short time before the ghetto's liquidation the three of them had disappeared. On such occasions people preferred not ask questions. But I could not help overhearing my parents' talk. The privileged conditions of the policeman's job had permitted our friend to circulate with a special pass. Thus he could create a hiding place to shelter his family during the crucial final months of the occupation. Did they have Christian friends from before the war? Few hid Jews for free. Most did it for money. "It is a tricky business," Father would say, "because the suspicion of money in a Jew's possession could turn potential saviors into rapacious hunters."

Seeing these two, I recall that our friend's ability to move in and out of the ghetto would have allowed him to indulge in some black marketeering. Money convinces people to help. This must account for their survival. But where is he? Utterly surprised by the happy encounter with Nadia and her daughter, Mother pulls me toward them. The woman's arms are locked around her child. Both seem to be in great distress.

"What has happened"?

Tears flow down Nadia's cheeks. She swallows her saliva but is unable to utter a sound. Mother, who has been smiling, suddenly looks worried. Hardly able to speak, Nadia tells us that a couple of hours ago on the road from a village to Vilna's center, her husband was gunned down. Gunned down at close range and in cold blood. Mother is thunderstruck: "The murderers, the rapacious beasts, even when it is clear that they have lost the war . . ."

"Not Germans," whispers Nadia. "Jews . . . our own brothers . . ."

Nadia's sobs try to make us understand what Mother refuses to believe. "The killing wasn't done by Germans. I wish it had been." Mother's exclamations of incredulity accompany Nadia's wailing story. They had left the farmer's basement and taken the road to town. A small

truck carrying a few Jewish partisans was passing by. It stopped and the men ordered the family to halt. One of the partisans had identified her husband as a former ghetto policeman and gunned him down.

"Without any warning?"

Without any sign. In front of his wife and daughter. In one fateful moment. The partisans threw his body on the truck and departed, leaving Nadia and her daughter in a state of shock.

"Why, why didn't they kill us as well? At least we would have gone together. . ."

Our meeting with Nadia near the destroyed gate of a place that was once a beautiful park must now recede into the gallery of my past's images and make place for a less disordered narrative. One cannot compare the atrocities of a state machine focused on the destruction of an entire people with a tragic story of an impulsive and hasty execution delivered on the spur of a particular moment. The unprecedented circumstances of those times had allowed a man, who in his opinion had the right to take the law into his own hands, to kill with full impunity. It was a juncture of two gray zones such as fill all the wars of all times with similar stories. Perhaps it unpleasantly tarnishes the heroic status of some Jewish partisans and serves as an unnecessary reminder that some profiteering policemen were also good friends, loving husbands, and devoted fathers.

It is a sad story and a sad fable.

The Fight Against Bedbugs

These reflections have taken me away from our camp, from Mother and Maman, Salomon's mother-in-law, where several months earlier, still under the rule of the Nazis, the two are having their conversation about measures of suffering. They do it while carrying our straw mattresses and

blankets to be aired and de-bugged. At the same time Father and Salomon toil diligently in our cell with a small burner. Actually it is Father who does most of the work, with Salomon assisting him obligingly. This fact makes me feel very proud. It is a matter of eradicating the bloodsucking hordes of an invading enemy. The men do it, so they say, with the indispensable help of my newly discovered talent for bedbug reconnaissance. It almost tops my talent for painting. I am sure that they are joking. In a strange way the bedbugs contribute to the shaky relationship with our cellmates.

The nauseating smell of incinerated bugs is accompanied by an odor of smoldering oil from the paint on the walls. Such odor is permanently floating in the air as a reminder of a never ending war. The overzealous burner has covered our walls with multiple eruptions and layers of interesting peelings. Those stains create imaginary continents. Landscapes and spaces of different colors into which I project my desire for escape. These suggestive landscapes make me think of those I used to see in the fake "marble" painted onto my grandparents' staircase.

In addition to the job of bug reconnaissance I am also chief of our cell's fire brigade. On steady alert with a bucket of water, ready to control the damage of an overenthusiastic burning of bugs. Setting fires, and thus damaging the living quarters, is a matter so seriously punishable that one prefers not to think of its consequences. The war between Jews and bedbugs is one thing and the war of Germans against Jews another. Both are constant features of the camp's life. There may be brief lulls, but these never last long.

I show Father the skin of my arms and my belly that bears fresh signs of the enemy's counterattack: "So soon after our thorough job?" He lifts his shoulders and looks at me with a sad smile. "It was to be expected. These are the relatives of the bugs we killed. They came for the funeral and counted on having a party."

Workshops

I liked to visit the workshop where Father and many other men with blackened faces and dirty hands, clad in old oil-stained and patched coveralls, toiled incessantly. They were cutting sheets of metal, bending them, welding them together, and turning them into wood burners. They also manufactured containers for the gas that such burners produce. The men installed them and an array of interconnecting pipes on trucks that came from a depot of seized goods. Thus the recycled and readapted trucks, repainted and equipped with various items that the Wehrmacht exacted, became vehicles for military use. The military trucks left the HKP compound looking trim and utterly reliable.

The best time for visiting the workshop was at noon when the German supervisors were away for lunch. Since the incident in which one of them "unintentionally" pushed me against a glowing cast iron stove and made me burn my hand, I carefully avoided visiting at any other time of day. The dim, noisy space was always ablaze with welding sparks and flames, to me a jubilant display of fireworks.

Noon was the hour in which the frenzy of work was at its peak. With one of the Jewish laborers on guard lest the first of the German supervisors return, the others cut, dismantled, and unscrewed certain parts of the complex mechanisms and immediately reattached them by a very superficial welding. The work had to pass the scrutiny of a rigorous control, and at the same time break down a few days after the truck's new assignment to an army unit. It was a very dangerous game. Had it been discovered, the cost to the camp's population would have been unimaginable. I am not sure that these activities influenced or modified the ultimate outcome of the war, but though modest, this contribution of the HKP men to the allied war effort was immensely courageous. I wonder whether historians have taken account of it. That Father trusted me with such an

important secret, despite my mere ten years of age, was for me like a rite of passage to the world of the adults.

Father's work as a first-class welder was being gradually downsized in order to make him available as an assistant to the camp's doctor and as a dental practitioner to aid inmates plagued by toothache. At first he extracted teeth with a pair of regular workshop pliers. But after persuading the workshop's boss that a laboratory equipped with even minimal dental tools could boost productivity, he got what he needed. The new tools were of a rudimentary kind, but they changed his life. I saw him once, at night, in the corner of his laboratory. He was working under a tiny lamp, with the window well blocked to prevent telltale light from filtering out. He used the utensils to melt metal and make plausible imitations of gold coins. According to Father, it was good to have such rubles hidden in one's garments, especially for situations of great peril. At times a coin that looked like gold, extracted at the right moment from one's pocket, could create a miracle. How right he was! A golden ruble coin could provide food, open doors that would otherwise have remained closed, and close inquiring eyes. Whatever looked like gold could increase some people's willingness to take risks. Gold could transform ordinary Gentiles into saviors. In short, even fake golden coins, said Father, could buy life. He strongly believed in man's timeless attraction to riches. I was fascinated listening to him while his clever hands fabricated the imitation rubles. His alloys looked authentic and withstood the rudimentary test of a bite. Did it matter that the shining coins were a worthless sham? They saved lives.

On the top floor of our building was a huge sewing workshop. That is where Mother toiled with most of the camp's women. They were refurbishing damaged military gear, underwear, socks, and uniforms. Garments that arrived torn, stained, filled with bullet-holes, and encrusted

with the blood of "discarded soldiers" were given a second life. While Jewish women's hands sorted out recyclable items from heaps of dirty rags—the "second skins" of recent war casualties—their former wearers were either badly injured, mutilated, or had departed to a better world. The fragments of garments were taken apart, washed, sterilized, and later recomposed into perfectly suitable uniforms. The war was galloping toward Germany's defeat, and these uniforms would clothe confused adolescents and frightened elderly men who were being sacrificed on the bloodthirsty front. The Jewish women, forced to do this unpleasant work, did it with malicious pleasure, hoping the uniforms would soon return with fresh holes and new bloodstains.

The Führer's desperate bloodletting was visible on the workshop's tables. It became clear that the end was near. What we could not know was whose end would come first.

Cutting Wood Behind the Gallows

At the rear of the compound was a third workshop. It was the section for cutting wood and consisted of an old stone construction and a shed where mechanical saws rumbled like thunder from early morning till late at night. Rough logs of wood were being transformed into small wooden cubes to be used for automobile fuel. The workshop was located behind a gallows whose menacing presence was intended to act as a steady reminder of our condition. It was a platform surmounted by an inverted U of wood and metal. Anyone who might have nurtured a plan for escape had to think twice. When the camp was first established, the inmates were forced to witness the hanging of three prisoners—father, mother, and teenaged son. It was a lesson not soon forgotten.

The three had managed to escape and find a hiding place in town, where they were later discovered. Returned to the camp's guardroom, interrogated, beaten and severely tortured, they were condemned to

death by hanging. In a special roll call in which every one of us had to participate, several prisoners whose identity tag numbers were close to those of the fugitives were selected and immediately taken to be shot. The execution of the fugitives occurred a few hours after the roll call. Only small children were permitted to remain in their cells and not watch. I was glad that my parents had declared me "small."

I shall never forget the inmates' oppressive silence over the long afternoon of that execution. The first to die was the son, later the mother, and last the father. The rope on the father's neck broke twice and he fell down. Invoking an ancient custom he begged to be spared. The impatient officer in charge, irritated by the slowness of the proceedings, put his gun to the imploring man's temple and silenced him forever. The bodies of his son and his wife dangled for hours over his inanimate corpse and mangled head.

Alone in our cell I was crouching on my parents' bunk, pushing my nose into the poor *Pinkas* and pressing my ears with the palms of my hands. By breathing its ancient odors of glue, leather, and decaying paper, I hoped to transport myself elsewhere. All I wanted was to efface the awareness of what was happening behind the wall. The putting to death of three people so close to where I lay. I wanted to block out the ominous silence that preceded the condemned prisoner's howls, block out the shots that shook the panes of the small window, and block out the fact that all this was a part of my world.

The *Pinkas* was of little help. I threw it on the floor.

After that, every inmate of the camp watched every other inmate. It was obvious that anyone who dared to flee automatically condemned to death those with identity numbers close to his. Very few would have taken it on themselves to buy their freedom with other peoples' lives. Similarly no prisoner wanted to sacrifice his life for someone else's attempt to escape. The constant mutual scrutiny did not make for solidarity. Suspi-

cion and reciprocal mistrust were the rule. Rarely were new friendships forged, and only a few ties of ancient companionship managed to survive. Those that did became very precious. We lived in a state of terror, yet life went on.

On a small hill in the rear right corner of the compound behind the ominous platform, a few small trees stretched out their fragile branches. When the late autumn started to announce the approaching change of season their last leaves flew over the fence and fell on a huge heap of rusting rolls of barbed wire, discarded bed frames, and a menacing jungle of iron rods used for building fences. The oncoming winter would cover everything with the white that blankets in egalitarian beauty whatever it shrouds and conceals. The free portion of the small hill would become a playground for the younger children. A place for experimenting with all sorts of improvised devices for a very short stretch of downhill sliding.

Children's Games

This playground was partly closed off by heaps of burlap sacks filled with processed wood waiting to be carried to the gate. The deafening rumble of motorized saws and other squeaking noises kept away the guards and their dogs. Among piles of abandoned junk and the remains of dilapidated and abandoned huts, children played at cops and robbers, but they called it partisans and Germans.

The partisans were the courageous heroes who ultimately had to win. The mean, vicious and cruel Germans were destined to a death of the most horrendous kind. The taking of prisoners, restraining them, pretending to interrogate, torture, and execute them transformed these games into tough experiences. Although the roles were supposed to be distributed at random, the predictable return of certain players to particular roles made it clear that while some loved to pretend being hunted, others insisted on being the hunters.

What scared me most was the loss of control over cruel instincts. The game's momentum could obliterate established rules. Anything could happen. Therefore, more than playing I liked to watch. The role of impartial observer or judge was more in tune with my nature. An artist's predicament. I realized that some boys could go on chasing each other for hours, but their prolonged games ceased to fascinate me. Inconspicuously I would leave the playground to return to the old *Pinkas* on my bunk and take up my pencils.

I would take the trail that passed by our block's entrance and continued to the main gate. Countless steps had imprinted into the arid soil a muddy path. It swarmed at all times with men carrying heavy sacks of wood. The sacks were breaking their backs, and the men muttered and swore. I felt proud that my father, in his privileged position, was exonerated from such a chore. He would never have to carry a sack on that footpath. Little did I know!

On my bunk, with my bent head close to the cell's ceiling, I would pick up a pencil, open the *Pinkas*, and daydream. I wished to get away from its yellowing pages. Sketch on sheets of some other paper. This desire would be fulfilled sooner than I thought.

The Camp's Sign Painter

Once, trying to explore a steep staircase that led to an unused upper attic, I found myself in front of a door that had been left slightly open. It displayed signs forbidding access. Curiosity overpowered obedience, and I peered inside. The cold attic smelled of dust, raw wood, and smoke that was coming from a distant stove. A long chimney of round metal pipes that emerged from the stove was inserted into the attic's ceiling of roof tiles. A window cast a pleasant light, and near it a busy man was tracing signs on plywood. The iron stove must have been radiating very little warmth, because he worked quite close to it. I recognized in him the man

who made the signs that regulated our lives in the camp. I pushed the door, which responded with a light twitter. Having remarked me, he signaled to me with his hand. I entered.

"I know who you are—Samek the genius, Jonas's boy! Come on over. Get closer, I won't swallow you. It is warmer here. I remember you from the exhibition in the ghetto, and now I have the honor of seeing you here."

Genius! I hated it when they spoke of me like this. Was the man making fun of me? Mother had a Russian saying to the effect that every Jewish child is a true commonplace genius; her humor emptied the word of all substance. I well understood that to say the word correctly one had to inflect it with a good deal of irony.

I realized that the man at the stove was working on paintings. They were portraits in different grays, a few in very brash colors, and several landscapes that all looked pretty much alike: one mountain, a water mill with a cascade, and a single pine tree. After a quick glance at the art, I had a better look at the artist. He was a small man. Bundled up to keep warm in a space that was not made for conserving heat, he wore a color-stained apron over a long coat, a scarf wrapped tightly around his neck, and a cap that covered his ears and descended to his eyebrows. He had the look of a small bear. His tiny deep-set eyes conveyed a friendly smile.

"Dear colleague," he said, "the jury of the ghetto show refused my one painting but consecrated you with a whole wall. A whole wall covered with your paintings! How many were there, one hundred?"

The word "colleague" was said in Polish and sounded funny. A large number of missing teeth gave his speech a whistling sound.

"Maybe twenty at most. They were small drawings."

His words evoked an unpleasant memory. Several established artists among the ghetto's surviving inhabitants had been angry with the jury for admitting me to the show. Furious about "sensationalism," as they called

my participation, and even more about the large space allocated to my work, they got hold of my drawings and pasted them up edge to edge against each other, making of them one big patchwork. This way my art would take up less wall space, leaving more room for theirs. Shmerke and Avrom, my two devoted poet-patrons, discovered the scheme and were enraged. They toiled a whole night with the help of another two friends to undo the work of my "aggressive competitors." The carefully separated drawings were re-pasted on independent sheets of Bristol paper and shown that way.

My patrons decided I should never learn about this mean behavior. I was too young to lose my innocent belief in the human heart. One silly outbreak of jealousy should not undermine my trust in friendly and collegial relations between artists. But the petty intrigues and bad feelings that collective art affairs seem doomed to generate, even in times as tragic as these, quickly brought the whole matter to light. Samek Bak the child-painter had to add this unpleasant event to an inevitable list of disenchanting "learning experiences." They are part of every artistic career.

The sign painter continued: "Only twenty? I thought there were many more. Anyway, to tell you the truth, my own painting isn't worth much. I can produce good signs that will last for years, even in very bad weather, but I lack your natural talent. To be an artist you must be born with it. I am a craftsman. I know how to hold a brush." As he talked I was looking at his work. "What are these heads?"

"The chief of the camp ordered me to enlarge for him a portrait of his wife and children. It wasn't difficult. I know how to do simple commercial stuff. Before the war I was an assistant to a painter of large billboards for Vilna's cinemas. You must have seen them. We also worked for the authorities. The Russians made us paint ten large portraits of Marx and a lot of Lenins. My boss painted the essential features and I did the beards and hair. He told me I had a genuine gift for moustaches." He laughed.

"Who are all these smiling people? They seem happy."

"Germans, Germans, Germans. *Imokh Shemam* (May their names be eradicated)! My immediate boss, the chief of the guards, makes me paint them from tiny and sometimes crumpled photographs. They are for the soldiers. They sometimes keep them for themselves and sometimes send them home. They pay him good money, but I never see any of it. Still, I get extra food, the use of this place, and some peace of mind. It was much better before it became so cold. Here, have a biscuit. It is what the Germans get in their war rations. I bet you haven't tasted anything like this."

"Do you like doing these portraits?"

"Who speaks of liking, disliking? Excuse me for saying it: you may be a great genius but you are still a child. The camp doesn't need additional signs. You see, instead of carrying heavy sacks and cleaning floors or working in the garage, here I have my own corner. I spend my time painting families that I can curse as much as I like. When the oil dries, I can even spit in their faces and wipe it off." His tone and manner were confidential and friendly. Suddenly I realized that he was treating me like an adult. When a man says to another that he speaks like a child it means they are equal and on friendly terms. I listened to him with growing attention.

"Sometimes I look into these faces and wonder where my own family is today. These cursed heads must well know what type of work their darlings are doing so far from home."

"Mother's uncle who lives in Berlin wrote us that some of his best friends . . ."

"Leave me alone. In other times, maybe! Before they invited Hitler, may his name be cursed, to rule their land. Sometimes I feel I would like to pierce the very eyes my own hands have painted. I hate them! Oh, how I hate them! It is not simple to paint faces that you hate."

"Then why don't you paint them more landscapes, like these?"

"Nobody's interested in landscapes. They long for their bastards and their whores. Excuse me. I shouldn't use such a language with a young person. Let's hope that before these portraits reach them, good Russian bombers will find their addresses. This is the price I have to pay for my comfort. Well, my friend, you asked me if I liked doing what I do. You asked me a short question and you got a long answer."

"But it's terribly cold. Don't your fingers freeze?"

"It's okay when you're close to the stove. Come get closer."

"Thanks. Do you see my bandaged hand? I burned it on a stove like this and now it refuses to heal."

"Don't worry. Before you marry it will be healed. Come and visit me sometimes. It is lonely over here, with only these ugly faces around. Let me tell you in all sincerity, I really liked very much what I saw of your art in the ghetto. Honestly. I'm sure that you will go far. Wait a moment before you go; here are some usable sheets of paper and a few pieces of cardboard. Take these pencils with you too. They will give me others. Then one day you will show me what you made with them."

"Thank you very . . . How did you know I needed them?"

"I saw the way you looked at them. Use them in good health."

My Exhibition in the Ghetto

Loaded with the unexpected gifts, I slowly descended the stairs and walked back to our room. The visit had vividly brought back the memory of the exhibition and my artistic "debut."

At that time the ghetto's population had been reduced by half. The massive "transports" were temporarily suspended. An old theater building that happened to be in the ghetto area had been brought back to life. Today I can hardly fathom why the Nazi authorities permitted such a project, when it gave so much pleasure to the population imprisoned in those few narrow streets. It allowed for non-punishable escapes from

dreary reality into imaginary realms of amusement and drama. This release explained why the theater, the choir, the cabaret became so popular.

The art exhibition was held in the foyer of the ghetto's theater. On opening day all the artists were expected to be present, each in front of his or her own work. Rokhele was terribly excited. Avrom was to meet us at the entrance, which was accessible from the courtyard of the Judenrat, the center of the ghetto administration. Father had permission to leave his work place briefly, and Mother, who was employed by the accounting department inside the ghetto, was also allowed a free moment. Both proudly accompanied me.

The ghetto might make plans, but the Nazi machine dictated our realities. For several days something new had begun to disrupt our lives. Small ghettos outside of Vilna were now being liquidated. On the eve of the show's opening, several German trucks unloaded hundreds of people from a nearby defunct ghetto and dumped them on the raw paving-stones of the Judenrat's large courtyard.

In order to reach the theater's door we had to force our way through a crowd of men and women of all ages, including youngsters and toddlers. The evacuees, many burdened by heavy backpacks, some with kitchen utensils or other strange objects tied to their belts, were crouching over their poor belongings. Suitcases and opened bags of rudimentary food supplies that had become rancid and smelly lay all about. In their weathered rags, buttonless coats belted by rope, and bundles of clothing wrapped in bedcovers or old curtains, they emitted the odor of many days on the road. A myriad of yellow stars sewn on their clothing helped to distinguish living matter from inanimate objects. In the midst of all this pile of humanity, tragically reduced to garbage, a skinny woman was trying to breast-feed a crying baby. I lowered my eyes and slowed down. My struggle to get to the door made little sense. The scene was too ominous,

and I felt ashamed of our purpose in cutting so energetically through the courtyard crowd. But my parents' hands pulled me in the direction of the theater. I tried to close my eyes, to wipe from my mind the haunting expressions of despair on the crowd's faces. They all looked alike.

Did they know that in a day or two they would depart for another destination? Later we learned that they got no further than Vilna's notorious suburb Ponar, where they were met with machine guns. They rest there to this day. But their poor belongings, stained with blood and torn by bullets, were sent back to the ghetto for further use. Shouldn't I have asked the sign painter what he thought about all that? Perhaps not; he had enough worries.

* * *

I was eager to try out the new sheets of drawing paper, even if it kept me from my sacred commitment to the *Pinkas*. I was sure Mother would not approve, but I told myself that a little infidelity of this kind was harmless. After all the *Pinkas* was an inanimate object; it had no feelings and it could not suffer. I remembered what Father told me: every artist must aspire to be free. I decided to draw illustrations to some of my most beloved readings. My favorite story was the tale of the boy-king, Matthew the First. Matthew knew how to become invisible. He was capable of observing others totally undisturbed and of escaping from the most dangerous predicaments. To paint the invisible was quite a challenge.

I was told that the writer who invented Matthew wrote under the assumed name of Janusz Korczak and that in reality he was Jewish.

My Dream of Revenge
I am invisible. Aimlessly I walk around in the compound. I come close to the heavily guarded gate, pass it, and stop to look at the low shed that is filled with the sacks of wood cubes. A

group of prisoners is hoisting them on trucks.

On the nearby road, a slight distance beyond the camp's fence, there pass cars, horse-drawn carriages, and some people on foot. They cannot see me because I am invisible, but to their comfortable consciences the barbed wire fences, the prisoners, the guards and gallows might as well be invisible too.

Protected by my state of invisibility I approach an army truck that has just arrived at the gate. Its engine is running and the sleepy driver waits to be escorted into the camp. I mount the vehicle, which is loaded with the kind of bloodstained uniforms that fill Mother's workshop. Four Germans in long coats, wearing heavy helmets that hide their eyes, unknowingly follow me and mount the truck. I stick out my tongue at them, touch my nose with my thumb and wave my fingers, but they do not react. They cannot see me.

I spit into their faces.

"I think it's starting to rain," says one of them, and he gives the driver a sign to pass in through the gate.

We proceed through the compound and arrive at the women's workshop. While the soldiers start to get down I give a forceful kick into the fat ass in front of me. The man jumps up and screams:

"Are you crazy?"

Startled, the soldier smashes the stock of his rifle on the head of his companion. A terrible brawl ensues. Shots are being fired. Four Germans lie dead on the ground.

I wake up on my bunk. My face is glued to the Pinkas. I move, and I discover on its perfectly clear page a stain of dripping saliva, the only testimony to my superb act of heroism.

Involuntary Invisibility

To be voluntarily invisible can be great fun. Involuntarily, it is another matter! Several days before this I had been in the second of the two housing blocks, searching for a friend. I was looking along a row of doors to find his cell's number. It was late afternoon, and the empty place seemed almost haunted. People were still at work. A little ray of orange sun was still suspended on the dusty panes of a window at the end of a long corridor. The stain of light was designing a few oblique forms on a nearby wall and gave a murky illumination to the long perspective.

Near the stain of light a couple was kissing. A man's hand rested on the back of the woman's overcoat. Her curls hid his face. Embarrassed to have violated their intimacy, I remained frozen behind the thick frame of a door. I was also amused by my invisibility and intrigued by the nature of the scene. My face was warming rapidly. The undulations of the woman's back fascinated me. It moved with the light rhythm of the arm that caressed her.

Suddenly she moved away, turned in my direction, walked along the wall of the corridor and disappeared into one of the rooms. I knew who she was, the mother of the little blond boy from Warsaw, the one whose father was supposed to be a genuine Frenchman. The boy was a real crybaby and nobody liked him. His mother had once been a dancer in Paris. She got stuck on a visit in occupied Poland and took refuge in Vilna. For some unspecified reason, Mother disliked her.

The man moved toward the window that was close to the infirmary's door. His short gray jacket, cap, and entire silhouette looked more than familiar. In the instant in which he passed by the glowing panes of glass, I clearly recognized Father's profile.

My warming face became burning hot. The corridor was empty. My heart was pounding. I was alone in the world. I pulled off my cap to wipe

my sweating hands. Why was I so troubled? There was nothing new in what I had unwillingly witnessed. But there was a world between supposing, imagining, presuming, and being confronted with an actual demonstration of what I would have preferred not to know.

I had no doubt that Father loved and admired Mother and that she accepted him the way he was. I knew that for some reason, other women were attracted to him and that he simply tried, so I told myself, to be nice to them. But I felt miserable. I quickly took the stairs. My friend and other boys were mounting them with a lot of noise and laughter. Descending with a lowered head I pretended to be in a great hurry. I waved my hand but did not stop. The smallest of them, distanced from the others, puffing and panting, inhaling and exhaling through a congested nose, was the blond boy from Warsaw. My hand flew out and wrenched the boy's ear with a force that totally surprised me. A harrowing howl came from his throat. It all happened in a flash. He started to sob, and I hurried away as if running for my life.

Our small room was empty. When Mother returned I was on my bunk pretending to sleep. I was drenched in sweat, my ears were ringing, and I felt ashamed, terribly ashamed.

"Wake up! If you sleep now what will you do at night? Come, come down from the bunk. Look out, careful, do not drop the *Pinkas*. I have brought you some food." Her hand touched my forehead.

"My God. Aren't you running a fever! That's all we need!"

For a Lakhoudreh? A Whore?

Five or six months later, several days after Vilna's liberation and our reunion with Mother's converted Aunt Janina, I was resting on my folding bed in the little room that Mother and I occupied in her aunt's home. The house had miraculously survived the heavy bombings. A few smashed windows and minor bullet holes marked the walls, but the roof

was practically intact, and it sheltered us under its expanse of domestic warmth and love. Collected rainwater and a small well allowed us to clean ourselves and to quench our thirst. We managed to calm our hunger with the only food available—dried beans cooked over a fire of garden twigs. There was no electricity, and we lived by the light of fuming candles, using them sparingly, one at a time. The day of our liberation is forever marked for me by the memory of devastated panoramas, floating smoke, the grieving Nadia, and Aunt Janina's overwhelming emotion.

I can see us approaching Janina's home. In the modest park of tall birches and pine trees across the street was a huge bomb crater into which a truck had carelessly tossed a heap of corpses in German uniforms. They would remain there for days. Among muddy coats, boots, and helmets popped up human hands and hairy heads. I tried to disregard the foul odor, hurried along to the gate of Janina's garden. When Janina saw us in her doorway, a little shriek burst from her throat, but then there was no further sound and her mouth remained open. Her eyes told us that she could hardly believe what she saw. She stretched out her arms. She had to hold on to us to convince herself that we were real.

"Where is Janek?" She meant my father.

Her question gave my stomach a stab.

"God knows."

"Have patience. God provides."

We were installed in a small guest room, pampered and coddled. It was difficult to grasp that our nightmare was over. Excited, worried, bewildered, we hardly felt our fatigue. Outside, the Red Army went on de-mining for days, and the incessant sound of distant explosions seemed to lull me into a semiconscious state of somnolence. In my head I went over and over again the film of the recent events. Mother was determined to get information about Father's fate. She soon went back to the area of the defunct ghetto, trying to meet other surviving Jews. At such

times a walk to town was a perilous adventure. Aunt Janina strongly advised against it. But Mother felt that whatever the dangers, it was a mission she had to undertake. A streak of formidable courage and a bizarre sense of optimism drove her; she would leave early and return late in the afternoon.

After a few days she brought back the tragic news.

I am on the folding bed. All of a sudden I hear the sound of steps coming from the garden. It is Mother. Her wooden soles click unmistakably. I have been waiting with anxiety for her return. The entrance door opens and shuts. Janina speaks in a low voice. I get up and put my ear to the door. She tells Mother that I was very worried but am now fast asleep. Mother seems to be crying. She says that bad news travels fast. Janina says only one loud word:

"No!"

Yes, there is no doubt. Mother spoke with a man who had seen his body. Father's hands had been tied behind his back.

"When?"

"On the third or the fourth of July. . ."

Both women speak at the same time, but Janina's voice is so low that I can hear only what Mother is saying. She knew it from the beginning. She never had hopes, no, she only pretended. Had it not been for this *lakhoudreh* he might have found a way to escape. Oh, yes, yes, yes. How well she knows that it was difficult. But, but, but he might have, he should have. Janina tries to say something appeasing. She speaks of God's will. Mother's voice becomes angry. She is really mad at Father. How could she ever forgive him for letting himself be killed? Be killed for this *lakhoudreh*? What does this word mean? I think she must be speaking of the blond boy's mother. A bitter wave rises in my throat. I try to swallow it.

Later Mother enters my room. There is no need for words. She puts her arms around me and holds me in a tight embrace.

"I have only you left. You are my man."

I am being swept by waves of powerful emotions. I know that I would give my life for her. My duty now is to repair all the damage, sooth all the pain. I am angry that Father has brought this anger on her. All this for a few kisses of one Parisian, or perhaps of a few other *lakhoudrehs*. I suspect that this is an ugly word—perhaps whore. And I know that I shall never ever pronounce it, never. Her tears mingle with mine. I breathe the smell of her sweat that has been absorbed into her dress. Walking in Vilna's desolate streets for long hours has exhausted her. I am sure that we will take care of each other as no other people ever did.

At this moment I do not realize the magnitude of the enterprise. Nor can I imagine its cost.

* * *

In the Middle of My Writing, a Dream.

March 25, 1999. The 6 A.M. radio news begins with Kosovo. The allies' spokesman declares that the united military command is determined not to repeat the mistakes that half a century ago permitted Hitler to engulf all Europe in the bloodiest war of human memory. I stretch out my arm to light the bedside lamp. I am eager to return to my writing, but I cannot free myself from the emotion of the dream from which I have just wakened. It has called up so many of the circling motifs of my life that I feel dizzied. I turn off the radio's intruding voice, let the dream pass again before my eyes, and think.

The dream reminds me that I have been a perpetual wanderer and have lived over the years in Tel Aviv, Paris, Rome, New York, Lausanne, and now Boston. Although I have managed to hold on to individual friendships and have cultivated several languages and cultures, I am everywhere and nowhere at home. I have no geography of my own and am always afraid of losing my identity and those transportable roots that

I keep neatly folded in a suitcase. The struggle to take off, to spread my wings, is a familiar motif in my life. It brings to my mind my long-dead mother and the conflicts in my desire to pull away from her, the turmoil all this has generated in my soul. But the surprise of the dream is what it suggests about my feelings for Israel, a country that has given me many happy years and a satisfying material success. I had been brought there, willy-nilly, by Mother's Zionist determination. Is my disenchantment with Israel so great? I have blamed its political tensions for destroying the calm I needed for my work. Should Israel be blamed for these tensions? I have spoken of collegial jealousies, yet I had encountered these as a child in the ghetto.

Yet deep in me lingers an anger, justified or not, with the whole Israeli cultural establishment. Unlike the public, it never accepted my art. Could this be the reason for my rage? Perhaps there is more to it. Perhaps a remaining anger with Mother still taints my feelings about her chosen land? I promise myself to have a good talk with my subconscious. But first I need some coffee. I shall then start the computer, annotate the dream, and ask readers who are impatient with such self-indulgent soul searching to skip it altogether.

I am in a distant continent, perhaps Latin America, though everything bears a familiar middle-European appearance. The hotel where I am staying is beleaguered by noisy tourists queued up at the reception desk and at the checkout counter. Old-fashioned panels of sadly glimmering brown wood cover the walls and ceilings. Plushy and worn red carpets smell of something repugnant and aged. Hundreds of look-alike suitcases clutter the lobby. I leave mine in the same hall, slightly distanced from the others. I have to look for a doorman, any doorman. I am eager to leave. I must get my rental car from the

hotel's garage and return it at the airport. Yet for now all the doormen seem to be extremely busy.

An exhibition of my paintings was the cause of my brief sojourn. I try to remember the show and the names of the people who set it up. I should have thanked them. But memory is completely blank. Who are they, what are their names? I tell myself that since they have abandoned me at this last stage of my visit, they do not deserve thanks.

Suddenly I realize that I do not even remember what city I'm in. My car materializes at the hotel entrance, blocking the traffic. Now I am told that I must leave at once. I rush to get my suitcase, but I cannot find it. It contains all my tickets, passport, and important papers. I start to panic. A doorman tells me it may have been sent with other passengers who left in a large bus for the airport.

With the faint hope of finding it still in the hotel, I rush frantically through various reception rooms. Unexpected miracles do happen, and indeed I suddenly discover it partly hidden behind an old chair. The suitcase is intact and still contains all the things I need. I am relieved. But not for long.

The way to the airport becomes an exercise in anguish and frustration. No road signs indicate anywhere its direction. I try taking various exits, knowing that I am losing precious time and risking the loss of my flight. I stop at a large shopping mall to question some local people about the way to the airport. I speak to them in English and they answer in perfect English that they have difficulty understanding my strange language. I strongly doubt their sincerity and fume with anger at their unwillingness to help. I must find a map.

Totally dismayed, I look into the windows of parked cars

until I find one with a whole bundle of maps visible through its rear window. Luckily the car door has been left unlocked. I grab the maps, but at the very same instant two heavyset men with curly dark hair and prominent moustaches emerge in front of me. To all appearances they are the legitimate owners of the car. Loudly cursing me in their language, Arabic, they forcefully tear from my hands the packet of roadmaps, slam the doors of their car, and leave with a screeching of acceleration.

One of the roadmaps, though, remains in my hands. I feel saved. Now I will find my way to the airport, and even if I have missed my flight I should be able to book another. I must get out of this nightmarish place. I unfold the map. It is a city plan on which the road to the airport is clearly marked. At the top it reads: City of Hong Kong. Desperate, I let it fall to the ground. I look around. Among the various commercial enterprises, one catches my attention. Silvery letters on a pink marble spell in Hebrew the name of Israel's national bank. It says in Hebrew and other languages that the offices offer specially individualized services for Jewish tourists. What a relief! I feel suddenly consoled and enter.

The bank's lobby is a large pink hall with a high ceiling. Panels of expensive marble cover the immense walls on which thousands of shiny metal letters form sentences in various languages. The letters must have been poorly glued to the stony surface, as a good number of them have fallen to the floor. Many of the phrases are almost unreadable. I look around. No living soul is visiting these premises. I discover that the whole agency is a shrine to the memory of the victims of the Holocaust. I realize that the promises of banking and tourist services were a trap to attract a naïve public. It is a shocking revelation.

Should I protest?

Something tells me that I must keep my distaste to myself. My present objective is to board a plane and take off as quickly as possible. This need is so imperative that I would be ready for any compromise, even to swallow my principles, my beliefs, my pride. I walk toward a bulletproof door behind which I hope to find the agency's employees. I want to ask them, in as friendly a manner as possible, about the road to the airport. The door is fully automated and mechanically checks that no dangerous weapon is being carried inside. In this hall, too, there is no living soul. Only automated machines surround me. I realize that they serve uniquely for the acceptance of money. Donations to the beleaguered State of Israel.

An uncontrollable anger overtakes me, and I wake to the sound of the radio.

I let my mind recover some calm. Yesterday, when I shut down the computer in the middle of my narrative, my bereaved mother was holding me in her arms.

The dream's reluctance to let me spread my wings and take off brings to my mind an old Yiddish poem by Izaak Manger, which speaks of a little bird that is ready to receive from its mother a first lesson in flight. The little bird complains bitterly. It cannot spread its wings. They are being restrained by the little pullover that the loving mother has knitted to keep her darling from catching cold.

This very early morning, with a cup of steaming coffee in my hand, I scroll yesterday's pages on the processor's screen. Rereading these recollections brings me back to my last weeks with Father. I don't think my parents guessed what I was feeling. Indeed I hardly knew myself. I remember that I preferred being with both of them to being alone with either

one; this protected me from the possibility of asking questions. I knew that I knew what I was not supposed to know. But uncertain of exactly what that was, I felt ill at ease.

Today I smile sadly at all this discomfort. Mother had knowingly married a loving man who was very lovable. Didn't she realize that no reality, not even the most calamitous, could block in him a drive that totally controlled him? He had a nature that went beyond the "normal and reasonable." What she and society expected of him was beside the point. She was very proud to be his wife and in later years his widow. A feeling of deep nostalgia for their special kind of love haunted her till the last days of her life. In fact, she never stopped mourning him. Her marriage to Markusha, whom she greatly admired and respected, never altered her almost adolescent longing for this man over whom she shed many, many tears. She must have known and shared with Father innumerable happy times, and I had the impression that over the years she recalled only these, letting the memory of their difficulties recede from her mind.

Father demonstrated his love by continuously showering her with gifts. That these might also have been guilt offerings did not diminish their magic. She became convinced of the sincerity of his remorse, if not when he was alive, then years after his death. This is how he eventually succeeded in disarming her completely. How real was this remorse of his is another question. Sometimes when we spoke of the prewar years in Vilna, it seemed to me that she was trying to cleanse her mind of painful details that I myself remembered so vividly. One of these details was the sunglasses she wore to hide her response to his infidelities. As if she had never cried silently behind the closed bedroom door. As if her friends' careless gossip had never dealt hurtful blows. And what about the searching glances that she cast at her little son, when she was wondering how much of the parental strife his childish eyes took in? These too had to be expunged from memory.

Jonas was the man who knew how to make her life eventful, comfortable, and playful. His ambition for material success accorded well with her heightened sense of self-respect. Very focused on being considered one of the most elegant men in town, Father needed her at his side, matching his level of performance. It was a symbiosis in which their two different vanities both flourished. Even the way he solicited languorous looks from her many female friends added an ambivalent glow to her strange pride. Whenever faced with her husband's not-so-secret indiscretions she would repeat a phrase that she had coined: "It is better to be a partner in a flourishing business than the sole owner of a failing one." Later she would cry behind a locked door, while her little son, his ear laid against it, would search his childish mind for things he might have done that were responsible for her unhappiness.

Misha and Slava

A dashing "modern" couple of close friends served Mother as a mirror in which to examine her own conjugal scene. Misha, a medical doctor, had good looks and a nature very much like Father's. His wife Slava, an exceptionally smart, pretty, and sexy woman, shared with her husband a perfect affinity of character. Their very free style of life seemed never to pose a problem. But Mother was very far from Slava's easygoing charm, her nonchalance, and inner freedom; she was quite unable to play the game and pay her husband back in his own coin. It was a mirror that offered little help.

Misha, Slava, and their daughter were with us in HKP. They survived the liquidation of the camp, passed through the DP camps in Bavaria, and in 1948 settled in Israel, as we did. Three or four years after we all arrived in Israel, Mother and I visited them in their new lodgings. Misha was set up in a residential part of Tel Aviv, had a flourishing practice, and owned a large American car. We, on the other hand, were living in one of the

poorer suburbs that were cluttered by survivors and refugees freshly arrived from Europe and North Africa. Markusha's modest salary hardly promised a quick improvement in our standard of living. To help pay for my studies I had to start looking for various sources of income.

Mother and I were at a bus station close to Misha's building. "If only your Father were with us. Ah, if only your Father was alive, by now we could have been their neighbors."

"In the penthouse," I added. "Let's not begrudge them their success." She did not like my irony: "Stupid boy, do you think I have forgotten what we owe them? Without Slava and Misha we wouldn't be waiting for this damned bus. We wouldn't be waiting at all. We wouldn't even be."

Misha had been the labor camp's doctor. Father shared a corner of his very rudimentary medical premises, supplying what there was in the way of dental care. He also acted as a doctor's aid. Misha and Slava lived on the ground floor of our building, off a secluded corridor cluttered with huge piles of junk. Recyclable building material, plywood, old beams, dismounted panels, and pieces of timber along with broken chairs, old mattresses, bed frames, discarded drawers, and cupboard doors, served all current needs for various repairs. It was a hazardous place to pass.

It was at the foot of the big staircase leading outdoors that Mother and I saw Slava on March 27, 1944. She was next to her corridor's door, holding its handle as if determined to prevent anyone from entering. Her body was leaning forward and her face, turned to the courtyard, was frozen in an expression of strange intensity. The courtyard, encircled by armed Gestapo, was filling with women and children.

The Children Aktion

I must return to the eve of the *aktion*.

Winter seems to be over. The melting snow has left a layer of slush and sticky mud. It clings to our flimsy felt boots and fits them out with heavy

soles of dirt. A man and a woman, carrying their damp boots in their hands enter our cell. Strange wrappings made of old newspapers and patched up socks cover their feet. The feeble yellowish light that dangles from the ceiling casts deep shadows on their thin faces. They talk with foreboding about a new rumor. On the parking grounds near the camp there are many trucks. What does it mean? What are the Germans preparing?

* * *

I have just realized that today, as I write, is the anniversary of the event that I am about to describe. Exactly fifty-six years have passed since March 27, 1943. An odd and troubling coincidence in time.

* * *

Early, with the arrival of the morning's faint daylight, after a tense and sleepless night, Father leaves for the workshop. Also our cell partners leave. Mother, who works on a later shift, stays with me. The room is filled with the heavy air of sleep. She slightly opens the window to let in some fresh and cool air. A cracking sound of approaching trucks bursts from outside. It is mixed with the shrill and penetrating sound of whistles. Loud voices of the Gestapo command our attention.

"The children! The children!"

We try to listen carefully. "All the children out into the courtyard! Vaccinations! They must go for vaccinations! Hurry up! Hurry up! No dawdling." Mother looks at me. Her face is expressionless. Her head and her shoulders seem frozen. An inner jolt makes me realize that this could be an end. An end? The end? What kind of end, I do not know. Voices in German shout through the corridor. "Get out! Quickly, you *schweine*!"

Mother takes my hand. "I am staying with you. Don't worry, nobody can separate us. We are going to stay together." We reach the crowded staircase on which many women and children, bewildered and panicking, move downstairs. The noise of whistles and shouted orders is more and

more interspersed with the growing sound of lamenting. Mother firmly holds my hand. By clinging to the rail we move more slowly than the others. But the crowd pushes us toward the large doors that open to the square. The courtyard is filled with officers and soldiers as well as with women with children expelled by the pressure on the stairs. Though it is still difficult to see what is happening, the running soldiers, gesticulating officers, and piercing screams freeze my blood.

Suddenly I see Slava at her corridor's door. I pull Mother's arm.

"Slava!"

Slava, who has remarked us, moves quickly in our direction, blocks our exit to the yard, grabs Mother's sleeve, and pulls us away: "What are you doing? Are you insane?"

"I can't go on; I just want to get it all over with. . ."

"There's always time for that!"

Slava seizes Mother by her arm and quickly draws the two of us into her corridor, whose door she then immediately closes. "Follow me." With her hand she indicates her distant door. Suddenly Mother is transformed. The little injection of Slava's courage is bringing her back to her old self. We run and burst into a small room whose window has been blocked by several burlap sacks. The women grab me, push me under the bed, and cover me with tattered cloths. I feel the presence of two more children. One of them is Slava's daughter. I recognize her from her subdued nasal voice with which she lets everyone know how very uncomfortable she feels. Someone whispers, "Please keep quiet." Noises from the corridor suggest that our door is being barricaded by the stuff that is scattered nearby. Two or more men who are quickly arranging some heavy objects call out to each other. Among their voices I recognize Father's. The noise that penetrates from the yard through the ground-floor window swells to a wail of sobs and cries that are drowned by the rattle of machine guns and pistol shots.

A piercing woman's voice shrieks "Murderer! Murderer!" It is quickly silenced by the sound of a shot.

I crawl into myself. I know that the children with whom I played only yesterday will not be there any more.

The sobs of the children fade with the rattle of departing trucks, and the sound of retreating army boots leaves behind a silence of death. But the pause is short-lived. A mounting sound of moaning grows in crescendo and turns to a fortissimo of wailing cries, a chorale of hundreds of bereaved parents.

A strange shivering descends along my spine. I am the last to crawl out from under the bed. Slava's daughter is stretching. Another boy, smaller than I with watery eyes and a runny nose, jumps into his mother's lap. No one is capable of uttering a word. Time passes. A light knocking on the door is a sign that we should not worry. Our men are back. Heavy objects are pushed away from our door. Father, Misha, and a third man enter. Their faces are ashen, and they look curbed and small. Whispering so as not to arouse suspicion of our presence, Father tells us about the *aktion* that has torn most of the camp's children away from their parents. He tries to be practical and speak in a matter-of-fact way, but his voice cracks with emotion. We have questions and he tries to answer. Were other children saved? How many? He is unsure, "Perhaps a dozen or so. . . All have remained hidden."

There is a rumor that the Gestapo is going to return to the buildings for an additional search. Nobody can tell how long it will be possible to hold out in hiding. Even parents of the saved children must at present pretend that they are bereaved. I am told that that from now on I shall have to be very careful. Not only am I in danger of being detected by the guards, I risk even more being discovered and denounced by our own people. Men and women, driven into insanity, wander now in the empty corridors, on the former playgrounds, and in the deserted workshops

where they call their children's names. They might be capable of tearing apart any living child who is not theirs. One has to beware. They know the camp's places fit for hiding.

The story of two mothers, a dead baby and a living one, and King Solomon with his sword flashes through my mind. Can I show myself in our cell to our Salomon with his Katia and Maman?

The other boy and I have to remain under the bunks at least until midnight. Slava's daughter, since she is thirteen, must be made to appear older. They will try to integrate her into a group of women at work, without arousing suspicion.

Now it is Misha who gives us additional details. Several mothers who clung to their children were taken away on the first of the trucks. Others, who opposed the soldiers, were gunned down. They were immediately buried, on the orders of the Gestapo. He and Father tried to help dig the common grave, but the men who recognized the bodies of their wives insisted on doing it with their own hands. How many were gunned down? Nobody seems to know. At present the total number of women prisoners in the camp is unclear.

Father thinks that it is a rare chance for Mother to escape and prepare a hiding place for both of us in town. We must seize the opportunity. Mother's eyes widen: "How?"

"Leave it to me."

I crawl back under the bunk and so does the other boy. I wait patiently for midnight to arrive. There are proofs in all our familiar tales that midnight's secret powers carry in them miraculous and unexpected solutions. After a while I push away the rag that hides my face and observe Misha's daughter. She is being metamorphosed into a grown woman. While Mother works on the hairdo, Slava fits her into a pair of shoes with thick wooden soles and very high heels. Since the shoes are too large, extra filling is put into her socks. A wool muffler is placed under her pullover to

give her a developed bosom. Her lips are painted dark red. While Slava toils on the girl's transformation tears run alongside her frozen smile. The girl is perplexed. To me it seems as if she were being dressed for a Purim play. How absurd! I want to say something but a giggle tries to escape my throat and I focus on keeping it inside. When the work is completed they prepare to leave. "Doesn't she look like a bride!" says Mother.

"Let it be with blessings and good luck," adds the little boy's mother.

Night descends. The boy's father returns sooner than we expected. He pulls him from under the bunk and covers him with a blanket. Holding the boy in his arms, while his wife walks in front of them, they disappear into the corridor's blackness.

Mother's Departure

Later in the evening, Father brings some bread and a bottle of water. In his hands he carries Mother's coat and her white and red checkered headscarf. The scarf is a souvenir from her last skiing trip to Zakopany. To me it evokes a scene at Vilna's railway station—a scene that is celebrative and lighthearted—and today, strangely incongruous.

Father and I stand on one of the platforms, awaiting Mother's return. I am filled with joyous anticipation. I see my hands holding flowers and feel the touch of his hand on my shoulder. There is a long whistle. This very scarf is being waved from an open window of the slowing train. Mother's smiling, suntanned face lightens the slightly undone curls of her hair. The train comes to a halt and she jumps off the steps. What a happy reunion!

Now Mother's face is sharpened in attentive listening to Father's account of the "miracle" of our present survival: "The Germans who came to check this corridor were of the local unit. Luckily they vaguely knew me. They first inspected the rooms that were left open. When one of them came near the stuff piled up against the door it was clear that he was

going to find you. I pulled from my coat's lining one of the gilded rubles and pushed it quickly into his hand. He closed his fingers, let it drop into his pocket, called out to his companion that everything was all right, and suddenly both were gone.

"And what will happen if they find that the coin is a fake?"

"I can't tell. The common test of biting should not reveal it. I made them of hard metal. The same coins have been used to pay for your departure. You will leave tonight, when the number of guards is at its lowest. I'll let you out through a door in the shed. Don't forget to undo the yellow stars. You must reach Janina. She has to find someone to send for Samek. Let that person walk at some distance from the shed and give us a sign with the checkered scarf. I'll do the rest. You'll remain here for a couple of hours or so. Meanwhile I'll take Samek to a temporary hiding place. Wait for me here. Don't move."

Father takes me quickly by the hand. My rapid goodbye to Mother is a faint brush against her arm, which seems as frozen as the closed lids of her eyes.

I whisper, "See you tomorrow. . ."

In Hiding

We walk fast. The corridor is pitch dark, and I cling strongly to Father's hand. He seems to be familiar with all the obstacles that are strewn on the dirty floor. A very faint light falls on the steps that lead to our level. One of Father's coworkers waits for us on the corridor landing. He quickly turns his head in opposite directions, checks that there is no undesired presence, and gives us a sign that the way is free.

Across from our cell I am made to climb quickly into a niche above a closet for pails and rags, a clandestine place that was used for illegal food. I lie down on my side. An old cover that Father has spread on the shelf softens the surface. The ceiling above my head touches my shoulder, and

my knees must remain bent. Father hands me a small empty bottle in case I have the urge. The niche smells strongly of chlorine and green soap. When I mention this, Father says that the advantage of this odor is priceless, since a control with sniffing dogs is not to be excluded. I place a kiss on my hand and touch with it Father's cap. He whispers: "Try to sleep. I'll be back as soon as Mother is on the outside." A board closes on me.

Worrisome ideas start to circle in my mind. What if, what if. What if Mother is caught, and Father with her. Both are brought to the gallows. I gulp down a lump that forms in my throat. Impossible. Everything will be all right. I listen to whatever sounds come from the outside, distant trains, barking dogs, passing cars. More than anything else it is the moaning of the bereaved parents, the prolonged cries of lamenting voices filtering through the cracks that penetrate my brain. While I listen I try to imagine that I am in a book of adventures that some imaginary reader, a person totally unknown to me, holds in his hands.

My parents are constantly on my mind. Their ability to pass undamaged through the most difficult situations has been well and often demonstrated. It is not to be doubted that Father will succeed. It is not to be doubted that Mother . . . Not to be doubted! I manage to invoke thoughts that deny my situation. The sound of faraway noises lulls me into sleep.

An unusual noise wakes me. Something is chewing the wood of my hiding place. Is it some other child's clandestine digging? I realize that the board that hides and entraps me is being dismantled. In the faint light, Father's face is all smiles. Everything went well. His hands reach out and he lifts me down. It is still very early and the daylight offers only a dim glow. Soon the siren that signals the beginning of the workday will make itself heard. The corridor is empty. When I am put down on the floor I can hardly stand straight. Cramps in all my limbs prevent me from moving. I do not utter a word. Father lifts me into his arms, carries me quickly to

our cell and puts me down on the lower bunk. The place is empty. Our cellmates are gone.

"Where are they?"

He speaks in a hushed tone: "If ever Mother was discovered. Or you . . . They were afraid to remain. They wanted no part of it. You cannot blame them. They are gone."

"Better so."

"Much better."

Father has realized that to put me back in the former hiding place is impossible. It is small and confining, and a prolonged stay would be torture. "You'll stay in the room." He hands me a metal can. "Relieve yourself here." He spreads a thick cover on the floor, makes me lie down and wraps me in it. I am a neat packet. He whispers, "You are my Eskimo child, I wish I could tie you to my back," and slides me under the bunk. For the time being this is how I must remain. I dread an unexpected emergency that could force me back into my former tomb.

Again I hear his subdued voice: "Don't worry. I am sure that your mother has already reached her aunt's home. Janina will find a way to help us with your escape."

The checkered scarf. I know that the two of us must patiently wait for Mother's sign. A little more waiting, and I'll be able to regain my freedom of movement. According to Father it is only a matter of a day or two. I stretch comfortably on the cell's floor. It is really not too bad. My thick wrapping gives adequate padding and keeps away the chill of the concrete floor. Had the cover been a little less itchy and my hands more free to scratch the old bugbites, I would have been able to endure it for weeks. My face is turned toward the wall. It has been left uncovered and I am able to breathe freely. Under my very low metal ceiling of the bunk's frame, pungent odors invade my nostrils. The bed frame stinks faintly of scorched paint. The straw mattress emanates familiar smells of cowshed mixed

with delousing disinfectant. Recent drops of mice feces are deposited on little lumps of dust. There is a row of them in the angle between the wall and the floor. The idea of mice bothers me. I can observe two bedbugs, a big one and a much smaller that crawl out from a crack and move toward my face. The pair progresses very slowly, as if convinced of their invisibility. They repel me. I pull my hand out from under the cover, hold my breath, and crush them with the nail of my thumb. Although I have done it before, a shiver of disgust runs down my chest and my spine.

Later I feel sorry for them. The hunted is hunting. It makes me smile!

My side starts to ache. I manage to turn over and lie on my other side. The new vista of the cell's floor is more interesting. I fix my gaze on Father's felt boots. Then I see his real feet. He is wearing socks that Mother had stolen from her workshop and had mended numerous times. A German soldier might have died wearing the same socks. I hope so!

Usually Father wears the felt boots when it snows. They must have again lost their soles, making him leave them with the cobbler for whom he had fabricated a small aluminum dental bridge. As long as he is in the room I feel safe. The door opens and Salomon's hesitating voice announces itself. He says that he and his women have found a better accommodation. His shoes, of which he takes great care, move around nervously. He is picking up some of his family's meager effects. "A much larger bed," he explains with a little uncomfortable chuckle. Some of their rudimentary cooking utensils that he must be collecting rattle in his hands. I can hear his whispering voice:

"Is he here?"

Father doesn't answer.

"You are right, I shouldn't ask such questions. We hope that you forgive us for having moved out. God knows. Extensive searches could start at any moment. We know that Mitzia is missing. We would prefer not to be involved. Best luck from the three of us."

I can see his feet getting close to Father's. He must be giving him a silent hug.

A whole day passes under the bunk. There have been no searches. The wailing and the moaning of the bereaved parents continues, a little abated. For the night I am placed on the bunk, and I sleep like a stone. The coming day I remain hidden more comfortably. I am on Father's bunk, installed in the slot between the wall and the mattress. Clothing has been strewn about to hide me even better. Father has left me a small opening for breathing and observation. Twice somebody bangs on the door and calls Father's name. The third time the door is opened, and it remains so. I fear that anyone passing in the corridor can easily perceive me. I try to freeze in my position. People hurry by and nobody looks in. The door stays open for hours. I pretend being a tied-up Eskimo baby. Ants run through my motionless limbs. I must keep myself from falling asleep. Sleep would take away the control over immobility. Immobility is indispensable.

But in my head thoughts run wild.

Again an unknown fear takes hold of me. The distant sound of crying does not end. When one voice stops another takes over. I am so scared of being discovered by the parents of my friends who were torn away that I fear the Jews more than I fear the Germans. Father said that many parents were driven to insanity. I know insane people are unpredictable; they do not know what they do. The horror that can be expected from the Germans does not come as a surprise, but what about my own people, the people I am supposed to trust?

I feel guilty for having escaped the fate of those other children. The bereaved parents may justly think that their kids died in my place. They will not hesitate to deliver me into the hands of the Gestapo. King Solomon's trial bears proof that a bereaved mother is capable of cutting up another woman's living baby. Having some ruling authority perform the execution makes it all the easier.

The Sack

Nightmarish scenarios whirl in my head. The afternoon light starts to fade. Father's energetic steps approach. He closes the door behind him. An empty sack that he was carrying falls to the floor. He delivers me from my state of mummification.

While I stretch and shake my legs he speaks into my ear. "Finally! Good news! A woman has come with your mother's scarf. It is clearly the person sent to pick you up. My friends who deliver the sacks of cut wood at the gate saw her. She is on the main road, walking back and forth, keeping a distance from the fence. We gave her a sign that we saw her and that you are on your way."

He seizes the yellow star that is sewn to the back of my pullover and starts to tear it off. "Take off the one in the front." My hands try to take hold of the threads that hold it, but my fingers are numb. The harder I try the more I am unable to execute the order. Father's decisive gesture takes care of the matter. Automatically I try to close up the pullover's woolen threads that he had pulled apart.

"Stop messing around. Listen to me well."

I stare at his face and quickly lower my gaze. "Don't forget to show Aunt Janina that you remember the prayers." Father's blackened hands hold the patched-up burlap sack that he has brought with him. The sack smells strongly of freshly cut wood. It carries the rotten smells of the workshop near the playground. The playground must be empty. Father's face is very tense. I know that he whispers into my ear important matters but I can hardly hear his voice. My heart is pounding. Something that sounds like a waterfall is resounding in my ears. My gaze tries to be focused on his moving lips. Will I ever see him again?

His hands open the sack. "Get in and make yourself as small as you can." I climb inside.

He gathers the two ends of a rope hidden in a seam of the sack, and as he tightens it I see his figure disappear as if behind a closing burlap curtain. He secures the rope and hoists me on his shoulders. Hanging on his back I absorb the rhythm of his steps. He descends the staircase that leads outdoors. His felt boots pleasantly muffle his jolting steps. Such boots would normally have been too hot for a thawing weather like today's, but I am grateful for them. Bent in the form of a fetus I absorb the warmth that radiates from his back and with it a feeling of security. A little hole in the burlap lets me look outside. We are in a line of men who are carrying identical sacks. Do any of the sacks contain children? An old childhood nightmare in which I am carried off by robbers flashes through my mind and disappears. A recurring dream, it used to plague me. I know too well that this, now, is not a dream.

In my mind I try to visualize Father's face. I would like to choose a more handsome face than his present one with its black bristles and dark shadows around the red eyes. Not one face, but many, emerge from a multitude of past events and whirl in my head. They pass by too fast. Finally I keep hold of one that is as motionless as the image on one of his pre-war photographs. Shining pomaded black hair and a hearty snow-white smile.

The sound of running engines, orders shouted in German, and the sight of prisoners who pile up mounds of oncoming sacks tell me that we have arrived. Father, following in the steps of the other men enters the barracks, moves aside, and his strong hands set me down on the floor. The rope on my sack is being slackened. A voice whispers: "Don't move." Was it Father's voice? I cannot tell. It was almost lost in the general hubbub. Where is he now? My immobility has made me lose the sack's little peephole and I am in the dark.

I wait and wait and wait.

Time has either stopped or else it is flying by with incredible speed. A

noise erupts, prisoners must be quarreling. A furious burst of orders in German tries to silence them.

Was it prearranged? It seems that something of this kind had been explained to me. Why didn't I listen more attentively to Father's instructions? Why am I so confused?

Suddenly somebody grabs me, brings me quickly to the window and opens the sack, letting me slide from the window to a ground that is covered by soft vegetation. A voice is saying something but I am unable to understand. My inner waterfall is pounding.

Yet I hear the word: "Run!"

Is it "Run, run" or "Do not run, walk slowly"? I cannot tell.

Was it Father's voice? I am not sure.

Galloping with the Saints to Janina's Home

Something makes me get up, shake off the dust, and start walking away. I notice the silhouette of a woman quickly stepping in my direction. She takes my hand.

"Obey," she says softly. "Do not hurry. We are taking a leisurely stroll. Follow my pace."

I can hardly breathe. I expect the sound of machine guns, but nothing happens. A pistol-like shot startles me, but the woman's hand holds me firmly and stops my instinct to bolt and run. I realize it must have been a backfiring from one of the trucks that the prisoners are loading.

Against a narrow strip of light hanging above a line of somber trees there appears a horse-drawn carriage. We move toward it as if this were a banal evening promenade. We mount it, and the driver gives a nervous sign for departure. There is a tilt, a slow acceleration, and then it seems that my feeling of being hunted is now transferred to the horse that is speeding with all its might. The woman crosses herself innumerable times and bursts into frenetic prayer.

God Almighty, Mary, Jesus, and all the saints gallop with us to Janina's home.

Jesus, whose presence had gradually faded in the camp, suddenly revives in my thoughts. I feel that I would have liked to join the woman in her prayer, but I risk being misunderstood. She will probably think that the ungrateful boy for whom she might have been risking her life is now making fun of all that is holy to her. I look at her rough hands. They are clenched in a fervent gesture of imploring. Her lips move. I try to check whether I still remember "God our Father who is in Heaven." I move my lips too, but she doesn't look at me. She doesn't seem to care. Her hands are rearranging the folds of her coat. She is starting to relax. I wonder if money was her motive. Her eyes are searching the heavy clouds that hang over our head. Light drops of rain start to tick on the carriage's hood. The horse keeps a steady speed.

We are leaving behind us the sight of the camp's distant buildings. My last glance had perceived them glowing with a dim and very red light. There Father must also be thanking his fate for the propitious outcome of today's undertaking. I think of him and my longing has no limits. Will I ever be able to be his worthy son? Suddenly I realize that the *Pinkas* has remained in the camp! Abandoned in our cell, alone on the upper berth of my bunk. How stupid of me! What would Shmerke and Avrom say?

For hours, when I was crammed next to the bunk's mattress and letting my thoughts come and go, I had imagined endless ways to rescue the *Pinkas*. I had contemplated stowing it under my shirt. But it was stiff and heavy. I might have taken it along in the sack, clinging to it in my folded arms. Would have Father permitted that?

I tell myself, let it be a sacrifice, a *kapporeh*. "*A kapporeh!*" is Grandfather Khone's magical exclamation that seems to go with every occasion of material loss. Let the *Pinkas* be an offering to God, let it enhance our chances of survival. Grandfather's nasal voice resounds in my ears. Where

are you now, Grandfather? I am on my way to the house of your beloved sister. Soon I shall see her again. I look at the leaden sky and imagine that somebody behind these heavy clouds will accept my offering and provide me in return with an indispensable protection.

The driver says it is important to reach our destination before the curfew. After that all traffic must stop. The darkness increases. No domestic light filters into the empty streets. Air-raid regulations strictly impose the blackening of all windows. The buildings are turning into dark silhouettes. A few passing cars have headlights that are covered by thick blue paint. We come to a halt. In spite of the darkness I can see Janina's figure standing near her garden's gate. I climb down from the carriage. The prepaid driver whistles and, with my rescuer, hurriedly drives off. Janina catches my arm and guides me to the house. Mother is behind the door; she grabs me, wraps me in her arms, and lets herself go, overcome by uncontainable sobs.

My short-lived grief about the *Pinkas* evaporates.

Search for the Pinkas

Between this reunion with Mother in Janina's home and the day of our liberation three months later, which brought us again to this same place, a lot will happen. But that is material for a later chapter.

Meanwhile the *Pinkas* has never fully disappeared from my life. I have already told how in 1944, in a Vilna controlled by the Soviets, I had an opportunity to look at it but refused. My wounds were still too raw. Many years later, in 1990, I happened to retell the story of the *Pinkas*. I was in a Madison Avenue art gallery that was showing my works. A film team was gathering my testimony about Vilna. The producer, the film's director, and several technicians behind a heavy camera listened for hours to my recollections. Among other things I told about the loss of the *Pinkas*, its recovery by the partisans, and its installation in a temporary

Holocaust museum in 1944. I also mentioned the visit in Israel of the Lithuanian curator in 1967 and his generous offer to lend it out. The film crew was supposed to visit the newly established Jewish Museum of Vilna/Vilnius, now the capital of independent Lithuania. A small Jewish community that had reestablished itself in this ancient town dreamed about a cultural institution of its own that would safeguard the relics of Vilna's glorious past. I assumed the community would feel that the *Pinkas* was part of its patrimony and advised the producer to look it up. In 1993 a search for the *Pinkas* in a number of city museums unearthed in the Jewish Museum of Vilna a forgotten bunch of other early childhood drawings of mine, but no *Pinkas*. The earth must have swallowed it.

I sadly accepted this as proof that the *Pinkas* was lost. But the story did not end there! The Lileikis scandal erupted in the mid-nineties. Alexandras Lileikis, former head of Vilna's Lithuanian police, was a Nazi collaborator. In the early postwar period, hiding his true identity, he fled to the United States and later became an American citizen. In spite of the fact that Lileikis's hands were stained with Jewish blood, he lived quietly and undisturbed not too far from my home in Weston, in the suburban community of Norwood. But scholars of the Holocaust had known his name for decades, and it was they who managed slowly to awaken the federal authorities to his case. The old man, feeling haunted, fled with the help of the Lithuanian authorities from the United States to his country of origin. According to international law the Lithuanians were supposed to try him for crimes against humanity, but they found ways to drag his case through endless procedural delays.

This affair brought the name of Vilnius into the headlines and news-reels. So many times was I personally interviewed about this unfortunate business that when a young female voice introduced itself on the phone as speaking from Vilnius, I answered that I had no interest in pursuing the subject of Lileikis. But this was not the purpose of her call. On the line

was a curator of the National Historical Museum of Lithuania, wondering if I could offer some information about a strange document that had recently been brought into their collection from the dismantled archives of the former Museum of the Soviet Revolution. The document was an ancient, Jewish, leather-bound manuscript, and it contained modern drawings. She knew that I was their author.

<p align="center">* * *</p>

Our conversation generated that small article in the Lithuanian Cultural Magazine that I spoke of at the outset of this story, in which two of my drawings from the *Pinkas* had been nicely reproduced. In the first, three Jews seated at a table were raising their glasses and saying *"Lekhayim!"* To life! In the second was the figure of a boy of nine or ten, seemingly at play in a tree. But the image does not at all suggest "To life!" Rather it offers a painful image of insecurity, or worse. At first sight the boy seems to be letting his body swing from a branch that he grips with clenched hands. His suspended weight stretches out his arms. The very thin branch is so flimsy that it may break at any moment. His lowered head is bent far forward, as if his down-turned eyes were refusing to look at the world. The knees are gathered close to his chest, as if he sought to regain the shape of a fetus. But the vertically outstretched arms could belong to a surrendering prisoner or to a figure that had been crucified. Had I intended it as a self-portrait? I can't tell. I do not remember.

The third reproduction, printed next to my two drawings, is the title page of the *Pinkas*, the one printed upside down. It brings to the knowledgeable observer a thought that evokes a uncomfortable smile. Among the keepers of the ancient remains of a Jewish world that was destroyed, keepers who are entrusted with safeguarding such relics, is there no one capable of recognizing the shape of a Hebrew letter and preventing such a careless accident?

Or has some strangely mischievous spirit willfully let this happen to

symbolize a world that was turned upside down, a world that can never be restored? My poor, sad Jerusalem of Lithuania.

* * *

This Jerusalem of Lithuania—this Vilna that I painted so "abstractly" in the sixties in Rome, with its leaden sky, its incinerated buildings, and its two small stains that move across the smoke-darkened landscape—this Vilna is embedded with chronicles. In me they are the tales of my people, stories of forefathers, captivating figures of my close family, and haunting accounts of struggle and survival. Vilna was a magical place for hundreds of thousands of Jews. It has generated an endless flow of memories and reflections, mountains of books, and pages of sacred and secular texts as innumerable as the stars in the sky.

It is the open spaces of these texts that, in my life as a painter, I have tried visually to fill with images, inventing a nonexistent "ancient" Jewish art, linking past and present. Countering the stern traditions of our ancient religion, I have made paintings that evoke the concerns of our time and invite observers to invest them with their own reflections. A representative of the people of the book, I sometimes see myself as a book, my mind an amalgam of stories and images, a mortal *Pinkas*. As a boy I added my images to old texts. Today I am adding new texts to my old images.

My "abstract" painting of wartime Vilna hangs from a sturdy oak beam that bridges the space of our upper floor. Back to back with this painting, so as to be visible from the other side of the gallery, I have suspended another semiabstract painting created in the same period. For me this second image represents a fragment of a landscape devastated by some universal flood. Now the water has receded, and many vertical strokes, like marking poles, suggest plans for reconstruction. They speak of human resilience and hint at a possibility of renewal.

Beneath these two images I have placed a simple iron table that per-

manently holds a classical competition-size chess set made of wood. Its board conceals a computer, which allows me to play, losing regularly, yet keeping my honor intact. Playing chess with a computer (in effect, with one's self) is akin to working on paintings. Since I am not a very good chess player, I prefer to dedicate my time to the art of painting, which is also a perpetual struggle with one's self. But in my eyes, the time dedicated to painting has the advantage of leaving tangible results. In my case results that have provided me with a livelihood. But this practical reflection is not meant to diminish the admiration I feel for the greatly creative minds of chess masters. As it happens, one of these masters was my stepfather Markusha.

CHAPTER TWO

How All This Writing Began

I was in my early teens.

My stepfather, Markusha, a survivor from Dachau, presented me to the chess king and queen, their entourage of bishops, knights, castles, and their pawns. He tried zealously to instruct me how to deal with the problems they raised. Chess was a game he played very well, perhaps better than the game of life.

The contrast between chess and life, and the way life's uncertainties invade the realm of chess, have always interested me more than the abstractions of Markusha's rational strategies. As a teenager I imagined a future in which I would face the anguishing need to make grave decisions. I saw myself carefully taking one step after another, reflecting on every move, reevaluating, changing conclusions, in short, acting like an adult. It scared me. I knew that one was never alone on the ground, that opposing forces would always challenge me. I understood that one must devise long-range plans in spite of living in a world that brutally disrespects all the rules. Being an artist, I tried to depict my own mental images, metaphorical visions of a terrain transformed by the *Shoah*.

This train of thought, together with other reflections about my stepfather's sad passing, inspired in the early 1970s and then again in the middle 1980s two series of paintings that employ the imagery of chess. These paintings were the subject of a book published in 1991.

After I moved to the United States in 1993, I painted yet another

group of chess-related works that were reproduced and discussed in the book: *The Game Continues*. Having been asked to write an introductory note for this publication, I came up with the brief piece that follows.

FOR MARKUSHA

NOVEMBER 1998. BOSTON. I would never have landed in these strange landscapes, populated by all those relics of ancient battles, had it not been for my encounter with Nathan Markovsky—or " Markusha," as my mother renamed him after their relationship became intimate.

Markusha was the first person of the Jewish administration in the displaced persons camp in Landsberg, Bavaria, whom Mother had approached upon our arrival. It was late in 1945, and the two of us were worn out after weeks of exhausting and perilous wanderings through postwar Germany. We found ourselves among scores of people who flocked to the gate, trying to speak to one of the local employees. When Mother's turn came, she met with a rather soft-spoken man who kindly explained to her that we had to move on. He advised us to go to Feldafing, some sixty kilometers away, because Landsberg was over-crowded and the American authorities had issued strict orders to stop all admission of new refugees. He then took a long second look at this rather attractive woman and her twelve-year-old boy who was clutching with both hands the folds of her overcoat, gave us a timid smile, and told to wait for him in the corner of the administration barracks. We realized that he had decided to try harder, even at the price of disobeying the order. Weren't we lucky!

Only later, when I came to know the nature of his compulsive sense of responsibility, his stoic acceptance of rules, and his legendary honesty,

did I realize the measure of his unease. After all, the Americans had liberated him from the concentration camp of Dachau, and he owed them his life.

After a couple of hours he returned with various papers in his hand and told us to follow him. Once we were installed on two bunks in an overcrowded dormitory of the camp, fed and taken care of by UNRRA, the United Nations Relief and Rehabilitation Administration, personnel, we became legitimate refugees. The conditions for Mother's future meetings with Nathan were now very favorable.

After a few months Markusha became my stepfather.

I believe that Mother must have chosen him from among a large number of suitors because she thought he would be good for me. In fact, he had shown great concern for my well-being and often sided with me in my interminable arguments with Mother. This might have been his way of gaining Mother's affection. The physical conditions of our life in the camp improved dramatically. I had a room of my own, lots of space for painting, and the means to go regularly to Munich for tutoring in an art school. Soon I started to add his name, Markowsky, to my own name, in official documents and as a signature on my works. I did this for a couple of years, although it made me feel uncomfortable. Later when I started art school in Jerusalem I decided to return to the simple "Bak" signature. Mine was a Hebrew name, and I decided to liberate it from the Slavic-sounding appendage. What a typical thought for the times of Israel's freshly experienced statehood. I knew that this change could not pass unnoticed. I believed that it might hurt him, and I lacked the courage to talk it over with him. Markusha never spoke about it, but deep in myself I felt that I had acted wrongly.

Did I love him? Did I love him in the way that one expects a son to love his father?

I don't think so. The wound of the loss of my own father, who had

been shot by the Germans in July of 1944, only a few days before our liberation in Vilna, was refusing to heal. Many years had to pass to let it develop an acceptably hard scar tissue. For a very long time I lived with the feeling that it would have been some sort of an abominable treason to let anyone take his place. But I greatly admired my stepfather.

Markusha was a handsome man. He was cultivated, fluent in several languages, and at home with the world of Tolstoy as well as the traditional studies of Judaism. He had an extraordinary talent for mathematical calculations, the capacity for total recall of visual information, a lively sense of humor, and an incredible ability to write in very funny rhymes about anything he chose. He did it in his beautiful Yiddish. He was a man of the world, with an elegance that befitted grand hotels. Before World War II he had represented Lithuania in many international bridge competitions and was involved in the world of chess. Mythical names of chess champions like Botvinik, Lasker, and Capablanca were on his lips whenever he tried, with very poor results, to turn me into a chess master. He loved to invent and solve chess problems and to play chess with himself. I was amazed to see that he did not need the physical presence of a board or chess pieces. He would sit still in an armchair, his eyes half closed, and play his game in a different dimension. Everything happened in his mind.

He was a man of great integrity. Many of his friends among the survivors, in political activity or in public service, requested his advice. He never identified with any one of the existing parties nor did he ever accept any of the material advantages that came with being considered a member of the elite. He dedicated his time to the needs of the community. He served as a judge of an inner tribunal that investigated allegations of collaboration with the Nazis. It was a difficult task. Those were years of great distress, and the traumatized survivors walked around with open wounds. Too often, when one heard people yell at each other *"Kapo,"* pandemonium would follow.

Markusha's public person inspired trust and respect. His private person was very different. He was torn inside, intrinsically depressed and devitalized. He was a sad man. He never got over the tragic death of his first daughter in the ghetto of Kovno and the subsequent loss of his wife and second child. He was plagued by horrible dreams that brought him back to the terror of the camps. I remember being startled by the screams that came from my parents' bedroom. These became the familiar sounds that invaded many nights of my adolescent years. Markusha's nightmares woke him, and he often found himself in a sweat and with his heart pounding. Then followed the reassuring sound of Mother's voice. She was trying to dissipate the fear, to dispel the shadows of the past, and to guide him back to the present.

When we arrived in Israel in 1948, Markusha became a modest employee of a bank where his mathematical talents and prodigious memory were put to some use. Luckily for him these were the pre-computer years and he found employment. As time passed it became clear that the energy he had displayed in the immediate postwar milieu of Landsberg was all spent. My parents settled down to a quiet life in which Mother was the driving force. Markusha loved her, accepted her overpowering personality, and was most accommodating. Mother was totally dedicated to his needs and to the facade of their life, but she kept on nurturing, deep in herself, the feeling that tying herself to him might have been a mistake. There was a gap of seventeen years between their ages. This difference became more and more obvious with the passage of time. Shortly before her death Mother confessed these feelings to me. I had always suspected them. Who knows if she had ever admitted them to herself before? These two had been considered an exemplary, loving couple and only I felt the claustrophobic effect of the life between their four walls.

My dream was to get away from them as soon as I finished my service in the Israeli army and had made enough money to go to Paris. I wanted

to be on my own, to exploit my talents, to nourish my hopes, to conquer the world, to become "a name." I knew that I needed another father, or several other fathers, to serve me as role models. I was an ambitious young man, and I had to look for them elsewhere.

In the late 1960s, Markusha started to die. More exactly, the part of him that did not die in the ghetto and in the camp, the part that somehow kept him with us, started to wane. Today we would speak of an Alzheimer-like haze. But in those years a clear diagnosis was difficult. Between the travels that mother forced him to undertake, her dinners that were supposed to cheer him up, my successful career and my children who were meant to give him pleasure floated his unobtrusive presence— Markusha with his gentle smile, his dignified composure. It took me some time to grasp how excruciating the effort to hide his failing health must have been for this cultured man. The remains of his extraordinary intelligence disoriented even the doctors, from whom he tried to hide his humiliating condition. This situation did not continue for long. At a certain point Markusha lost control over the last remains of reality. He took me for the accountant of his glass factory in prewar Lithuania and started to speak to me in Russian. He never realized that Mother died suddenly of a galloping cancer at age sixty and that he was a widower for a second time. The fog of his mind protected him from an awareness that might have been too much to bear.

It was Markusha's drifting away that led me to my "Chess-land" paintings. I tried to imagine the inner spaces of his structured world, which was governed by rational rules that had become in his youth the underlying source of his certitudes. I then thought about the cataclysmic forces that swept through him in the black years of the Holocaust and all the havoc and destruction that came with them. I translated these forces into images of a world of chess after the universal flood, when hardly anything remained intact.

Markusha lingered for another year in a "home" where every patient looked to him as a potential bridge partner, and he called every nurse Mizia, my mother's name. He survived her by an entire year.

The chess paintings, done in the early seventies, were a clear tribute to Markusha's memory and to the tragic death of his mind. The ones included in this book are a continuation of that very journey into the old, familiar spaces of the former paintings, spaces that continue to surprise me with their diversity of possibilities. It is fascinating, for me, to explore their hidden riches. I keep examining a world where things disintegrate, with the intent of seizing the moment before it is too late and all proof is lost. I think of Markusha and of his departure.

I wish I could have told him, or maybe it is my way of telling him now, how sorry I am that I never opened for him the space of my lost father. Nor have I ever dared to invade the space of his lost children, since the wound that they left in him was sacred territory. We were, after all, a typical family of survivors, living with our much too present ghosts, in an arrangement of civilized tolerance. There was a lot of love among us, but we were at pains to deal with it properly.

I guess that my being today of an age close to Markusha's at the time when he started to drift away helps me finally to talk to him, man to man, and to tell him how dearly he is enshrined in my memory.

WHY DID I WAIT SO LONG?

The writing of these former few pages affected me greatly.

Suddenly I became projected into a faraway time. Ancient, seemingly forgotten recollections started to emerge and linger, refusing to recede. Floating on the surface of my consciousness they began hampering the regular flow of my daily life, disrupting my well-organized daily routine of long hours in the studio, painting and drawing. I realized that something in me had moved in an unexpected direction. The obsessive need for an ever expanding production of my art, which over the years had transformed a self-imposed discipline into a pleasurable second nature, was losing its unchallenged grip. I became less and less sensitive to the magnetic attraction of my canvases, my brushes, and my colors. The beloved and dependable "tools of my trade" ceased to gratify me with their familiar, always reliable and almost physical connection to the world of my daily reality.

At present these old friends, partners of my imaginary journeys, wonderfully dependable instruments of a healing discipline, seem to have lost their attraction and their charm. I find it very troubling! Particularly after so many years of a daily work routine that always kept my inner pressures ventilated and my entire psyche under control. What could now replace the structuring effect of my old practice?

On the more practical side, painting daily for a steady number of hours has always made it possible to predict the rate of my artistic output.

In the past I never hesitated to set a date for a future show. The maintenance of a good and reliable routine, based on a discipline of intense work and free from a romantic search for "inspiration," has always been one of my most valuable assets.

All this has changed. Now, when I place myself in front of my easel I feel as if I were forcing my person, as if a part of me were stranded elsewhere in a some other space and time. I know I have to focus on the canvas, to decipher the needs of its composition, to balance its color tones and to stretch its illusory depth inward toward a far horizon. But the painting that I physically touch with my brush remains remote.

I find myself again in the Vilna of my early childhood. Segments of ancient memories emerge like shards asking to be recomposed. I pick them up, examine them, try to remember where they fit. Inevitably they bring me back to a world that has long since acquired the status of a lost paradise or an unspeakable hell, or both together. Why have I brought this on myself?

My short memoir spoke about my stepfather Markusha's love of chess, about his masterful knowledge of the game's complexities and how he tried to pass this on to me. Alas his patient effort only revealed the limits of my interest and aptitude. I must have disappointed him. Yet, without his presence in my life I would have never have had the incentive to explore the "Chess-land's" imaginary territories, much less the drive to revisit them regularly, decade after decade. The game's traditional heroes, detached from their familiar set of rules and inserted into the confines of my paintings, were now telling a different story. Chessboard and figures were painted as metaphors of life's human struggle. That brief memoir's additional purpose was emotional. I felt the need to tell Markusha, so many years after his death, how important he had been to me, something I had been embarrassed to do while he was alive. I wanted to tell him that I loved him. The expression of these particular emotions must have bro-

ken in me an inner dam. I was flooded, immersed, indeed almost drowned in an uncontrollable flow of ancient memories.

Extracting one or two stories from my memory was not new to me. I have done it before. But until now I have somehow managed to preserve the pace of my daily existence. For that purpose I would penetrate the "archives" of the mind as if I were on tiptoes. I would draw out only what I had promised to deliver. Not too many items at one time! I would do it with special care, leaving the more risky and painful layers of remembrance as untouched as possible. The dam was never permitted to overflow. But this time it has been different. This time the need is urgent in me to deal with this invading surge of recollections, to unload their burden. And there is another reason for my recent feeling of pressure. In telling the story of my stepfather's gradual departure from life I am reminded that memory can be even briefer than life: I must gather my memories while I still have them.

Mother was the great repository of our family's story. She was a living encyclopedia of names, dates, and places, and a most extraordinary storyteller. The last time we spoke of my great hope that one day she would write down the riches of her memory was a few days before her final hospitalization. The ensuing surgery revealed cancer of the ovaries. Six weeks later we stood at her grave.

Whenever I spoke to her about the importance of creating such a record I could feel her reluctance to relive the tragic times that were so much a part of our story. Knowing this, I thought that the more distant saga of our family's forebears would be a good way to begin. I tried to encourage her. I thought she might find it great fun, that she should do it for my children, and for theirs, her future great-grandchildren. She lifted her shoulders. Her face was sad and she looked tired. I respected her reserve. I did not speak of other thoughts that were on my mind. I did not dare speak of the dead who had been so brutally torn from us and in

whose shadow we had been living for years. I was convinced that she carried in her a talent that could "restore" them and give them a life beyond the limitations of one mortal person's memory. Something prevented me from insisting. How well she would have recounted their stories, recounted in her uniquely elegant Yiddish, beautifully handwritten in her steady and energetic lines! She knew so much about all the "heroes" of our family. She would have been able to restore to them their richly detailed identities, their loves, their dreams, their desires and successes as well as their failures and shortcomings.

But on that occasion, in what was to be one of our last conversations, I was reluctant to speak of the dead. The "something" that was restraining me from touching the subject was not obscure. Markusha, in his clinic, was slowly dying. I looked at her: in the last two years of her life Mother had aged noticeably. She was sixty but looked older. It was better to avoid speaking about the passing of time, to avoid touching the subject of death.

In this period her days had become a repetition of one single routine. She spent hours, every day of the week, in the "home" in which her husband Markusha was lodged. The clinic was very depressing, but it was the best place we could find. It was badly understaffed, not very clean, and smelled of urine. But we had no choice. It was the only place that in spite of his fugues would agree to keep him.

He always used to welcome her with a beaming face. After one of the nurses lost his dentures, his smile looked like an open wound. With Markusha's memory gradually dying, he barely recognized anyone or anything. Such a state protected him from comprehending the horror of his situation. But it did not protect Mother. In order to agree to put him in the institution, she had had to overcome a strong reluctance. She reached this breaking point only after a number of times in which he left home, got lost, and was subsequently recovered by the police. Sometimes

we found him, after a prolonged and agonizing search, in some hospital to which he had been admitted as an unknown male suffering from total amnesia. Better to keep him in a closed clinic.

Mother would arrive at the clinic daily, exhausted and covered with sweat from her long ride in a hot and sticky Israeli bus, carrying bags full of food she had cooked on the previous evening. Once she saw that the meals served in the "home" were of a very poor quality, there was no way of dissuading her from such an exhausting undertaking. The food, which she used to bring in various pots and pans, was intended not only for Markusha. The clinic provided a home for a number of younger, severely handicapped patients struck by multiple sclerosis, and Mother became increasingly interested in these tragically afflicted and often abandoned persons. In them the body was dying but the mind remained alive, and it broke her heart to see them condemned to their tragic condition. She tried to help them preserve some glimmer of human dignity. After having cared for her husband she would talk to them, wheel them around, dry their sweaty faces, and feed them her domestic cuisine by the spoonful.

Mother felt that she was indispensable. Whenever I tried to suggest to her that she was jeopardizing her own health by her limitless, almost mad devotion, she wouldn't listen. Was she repenting for not having loved her second husband as much as she felt she should have? Was she expiating an "infidelity," having remained eternally in love with the memory of my father?

At Mother's grave, on the last day of 1971, devastated by my immense loss, I felt I was saying goodbye to more than her unique and irreplaceable person. I knew that the better part of the lives of many members of our family, who had perished in the tragic years of the Holocaust but gone on living in her memory, was to be buried a second time. Departing from the small cemetery where she now rested, I was overcome by the conviction that the numerous stories that she so loved to tell and retell had relegated

to me something of their struggling presence on this earth. Her stories had charged me with a grave responsibility. I was the last link. I had promised myself not to wait too long and, by writing about what was still retained in my memory, to save these dead from oblivion. But the times were busy and other priorities took the upper hand. The project remained largely dormant. The immense pressure that I am feeling at present tells me that this is the right time to begin. So let me begin with my Aunt Yetta, my second mother, herself the writer of a valuable memoir now long out of print.

CHAPTER THREE

Aunt Yetta's Magic

YETTA LOVED TO PLAY cards and to read magazines. She loved to hear and to tell stories of ghosts and of magic. Although she would never have admitted to it, somewhere deep in herself she believed she possessed uncanny powers. Mother saw through her thoughts. "Rubbish," she would say. "This is the typical gibberish of my sister."

Yetta, Mother's three years' younger sister, was my "magical" aunt. They looked unmistakably similar, but in everything else they differed.

Yetta loved Mother unconditionally. She revered her intelligence and wisdom but feared her elder sister's constantly present scrutiny and her high standards. In return she was monitored with a patronizing sense of responsibility, showered with unsolicited motherly advice, and above all, very deeply loved.

"Your mother could be a pain in the ass. Now let me tell you about the time I decided to kill her."

I sat on an uncomfortable metal chair next to Yetta's hospital bed and listened to her tale of childhood nostalgia: "She profited from your grandmother's frequent absence and ruled me and your uncle Rakhmila like a real despot. One day we decided to show her the force of our resolve. I took Rakhmila by his hand, and armed with the heavy iron tools of the living-room fireplace we courageously confronted her. You should have seen us! Picture your uncle Rakhmila, a chubby boy of five with unruly hair and a constantly running nose, may he rest in peace. My brother had never been of much help, not even to himself. Look how he decided to die the year he retired. I'll never forgive him his cancer. You

were lucky you did not see him in the end, thin and yellow. But let me go on."

I must have heard the story of their rebellion a hundred times, but because of the sad circumstances of this encounter, I pretended it was all new to me. I did not know that although Yetta would live for three more years, this would be our last meeting. Geographical distance, professional commitments, and other demands limited us thereafter to long conversations on the phone. I offered her a sip from a glass of lukewarm water that was standing on her bedside table, and remarked: "I am glad after all that the two of you did not kill her."

She smiled. This was in 1985. Mother had died in 1971 and her brother ten years later. I was now on a short visit to Israel, sitting next to an ailing Yetta in a hot hospital room. A desert wind was blowing through a narrow window that I had just opened, and it was covering everything with a thin sand dust. Next to my chair a greenish over-bleached room-dividing curtain undulated as if waving goodbye. Behind it someone was breathing with difficulty.

Yetta moved slightly and tried to readjust the position of her arm, to which an intravenous needle had been strapped. She sighed: " I am such a mess." I helped her with another sip of water. After a moment she went on: "I was almost seven and your dear mother must have been ten. Samek, I am sure that with your talent as a painter you can picture the scene.

"Imagine us, Rakhmila and me, equipped with our heavy iron tools. Imagine us standing in the middle of the dining room in front of your mother, our constant terror! I am telling her that she is going to receive from us an unforgettable lesson, that she is going to die, once and for good.

"And that it will be a lesson she'll never forget.

"And she looks up at us from her homework, saying in a very quiet

voice: 'Who gave you permission to touch those tools, and what are all these ashes you are spreading on the floor?' Rakhmila looks at me, and I can see that he shits in his pants, and we retreat at once, and she calls after us to say that we should immediately clean up the floor. This was my only rebellion against your mother, the only rebellion I ever dared to attempt. I hope she rests in peace. You cannot imagine how I miss her."

There followed a stifled sob. I took a damp towel and tried to sponge her face.

"Yetele, I am glad you did not kill her. Imagine the loss! I would have never been born and you and I could have never met. Moreover, I would never have been able to yell at the nurse for not hurrying to clean you up. Besides, who is going to phone to Germany and speak with Tamara? You must have ordered Zygmunt not to let your daughter know that you are in the hospital again, and he, silly man, obeys you like a dummy. But I'll call her, as soon as I reach my telephone. She has no inkling of your painful situation. Yetele, enough being heroic. Don't protest! Tamara must come at once and take care of you and Zygmunt. Don't worry, she will find a temporary arrangement for her kids. The two of you are very ill, and you need help."

The more I talked, the more her tears silently flowed.

"Stop crying and let me also tell you a secret that will make you feel happy. You spoke of your overpowering sister. Well, you know that I loved her as much as you did. And like you, I still miss her very, very much. But I too felt at times a homicidal urge to rebel. Luckily I had no fireplace and no tools, and therefore she was permitted to live."

Yetta's old familiar giggle made itself heard through her tears. Her thinning blond hair, white at its roots, was glued to her perspiring head. I tried to wipe her damp forehead and cheeks. The tears that were slowly flowing from her eyes had buried themselves in the sweating folds of her neck. In spite of the hot breeze, an unpleasant smell still hung in the air.

A pregnant nurse resolutely entered the room, pierced me with a scornful look, and closed the window. "This is not a day for open windows," she snapped. "Are you determined to kill us? You are worse than an Arab!" It was her turn to get even and show who was boss.

I ignored the irritated nurse and helped Yetta to sip a little more water, as her swollen arms could not bring the glass to her lips. "And how are you?" she asked. What was I going to tell her about myself? This short visit to Israel was happening in a difficult moment of my life. My marriage of more than twenty-five years had been disintegrating and was now on the verge of collapse. Concerns other than Yetta's and Zygmunt's welfare were on my mind.

A few hours before this visit, when I telephoned Yetta's home, hoping to arrange to drop by, it was her ailing husband who picked up the receiver. He reluctantly told me that Yetta had again been hospitalized. He, on the other hand, was immobilized at home, with an inflamed bladder and an ailing prostate. Because visiting her himself was out of the question, he was relieved to give me her ward and room number so I could go straight to the hospital. It was a place I had very much tried to avoid in the past.

It was there that Mother died.

The gray and massive hospital compound had changed little in the past fourteen years. It was still a site of perpetual building, adjusting, and transforming, where people were born, being repaired, or dying surrounded by crates of building material and sheets of transparent plastic. When I arrived, the road to the main gate was cluttered with ambulances and the vehicles of contractors, police, and army. Cars were parked in the shadows of haphazardly planted trees and shrubs, all looking aged and shabby as they moved in the dry wind. A yellowing lawn was strewn with snakelike garden hoses. Intended to save the young plants from dehydration, they must have been doing a poor job; the plants looked half dead.

I passed three men who seemed to care little for their gardening tools and were engaged in a noisy argument. Bits of litter blew to and fro in the capricious wind. It was then that I remarked the absence of garbage cans; most likely they had been removed by the anti- bomb squad. Yes, many years had gone by since my last visit. The parking lot was unchanged except that now one had to pay. A strong smell of disinfectant met me in the lobby. An aggressive and noisy group of visitors crowded the information desk. Should I queue up? My time seemed very precious to me; time was life.

Following some taped-up signs, I ventured into a confusion of corridors and elevators where patients, visitors, and hospital personnel, all clad in attires of the most dispiriting kind, moved among a clutter of oxygen tanks, metal trolleys, and gurneys. I realized that I was starting to lose my way. A flow of painful recollections had overtaken me, returning me to the day when I brought Mother there for the last time. Those were agonizing days. Mother had initially been installed in a room of my house. Struck by terrible pains but unaware of her terminal cancer, she was being given a chemotherapy that was disguised by a veil of invented diagnoses and names. But the medication gave no relief, and her situation was rapidly deteriorating.

The day I brought Mother to the hospital was a special day in the family. In a room filled with children's joyful voices, Mother, half bent by pain, tried to show her granddaughter Ilana how much she was enjoying her ninth birthday party, and in particular the clever tricks of the young magician. But Mother's face was ashen. Meanwhile I was on the phone desperately trying to reach various well-placed acquaintances in order to get her into the hospital. Israel was in the midst of a general strike of all medical personnel. Each urgent case had to be vetted by the appropriate union committees. Finally the good connections worked, and we received the miracle of permission.

A couple of surgeons agreed to act swiftly, but they needed new X-rays. A technician volunteered to meet me in the only X-ray laboratory that was permitted to function. I had to bring Mother there and help him with the task. The lab was two buildings away from her ward.

Mother was stretched out on a gurney, heavily sedated by the medications dripping into her swollen veins. The rebellious wheels of the old gurney constantly pivoted in wrong directions, and I had to push Mother with one hand while the other held an encumbering pole of intravenous equipment. I navigated cluttered corridors, squeezed into overcrowded elevators, and steered on the uneven surfaces of temporary passages, both indoors and out. This kept my mind from focusing on the hopelessness of the situation. Whenever I passed between two buildings, it was good to see the sky. The cool air and a light winter drizzle freed me for a few moments from the hospital's oppressive atmosphere.

By the time I reached the lab, Mother had fallen into total unconsciousness. Under the worn white sheet and the now rain-dampened hospital blanket, she was naked. The technician, a kind and qualified man, helped me to position her on the X-ray table. She looked small, shrunken, diminished. The intravenous devices attached to her body seemed to be sucking from her the last remnants of her vitality. Seeing the expressionless mask of her face, her floppy breasts, and the area of her womb that was marred by an ugly scar from a previous surgery, I felt crushed and humiliated. Perhaps it was my inability to accept the presence of death.

The second surgery that followed on the same day as the X-ray proved to be a matter of opening and closing. The surgeons threw up their arms in a gesture of surrender. Mother's heart went on beating for another fortnight, but she never regained consciousness. The last image that she took with her must have been of little Ilana's joyous bewilderment at the magician's fabulous hocus-pocus.

This was the image I clung to when I entered Yetta's room. I had tried

but failed to chase away the invading memory of Mother's death by recalling her happiness the year before it, when my third daughter Mikhal was born in the same hospital. Now a day of hot desert wind, against which all windows were closed, had replaced the rainy day of fourteen years ago. A heavy stench hung over the room's three beds. Someone's throat was rattling behind a drawn curtain. One bed was empty. In the middle, attached to various pipes, an old person, in whom it took me a moment to recognize my own aunt, was silently crying.

"Yetele?"

She turned her face, her mouth opened in disbelief, and her glittering eyes shot a look of unexpected joy: "Am I dreaming? Are you for real?"

I carefully placed a hand on her shoulder. It shook her: "Please do not touch me. I am one big piece of a hurting wound. I cannot move, I pee and I shit in my bed, and right now I have dirtied myself, and the damned nurse is ignoring my bell. I don't know for how many hours I have been calling her. Do you call this life?"

An impulse of sudden anger took hold of me. I first rushed to open the window and then quickly left the room in search of help. The first nurse that received the outburst of my rage happened to be from a different ward. Unconcerned, she looked at me with contempt and told me to behave. The second and third nurses informed me that I was yelling at the wrong persons. Finally, when I reached a young woman with an enormous belly perched on her very thin legs, I was rewarded with a tirade of complaints. Did I know how bad she herself was feeling? Yes it was a hot day, but my aunt was a difficult patient, especially for a nurse who was on the point of delivering a baby. Why wouldn't I take this old lady home?

Shortly after this, Tamara arrived from Germany and took her mother and stepfather to live with her in a small town near Cologne. There, with the financial help of German authorities, who had acknowledged their responsibility for the care of Nazi victims, she turned one of her home's

rooms into a real hospital facility. Yetta had all the necessary equipment, twenty-four-hour professional assistance, and the constant presence of her beloved daughter, son-in-law, and grandchildren. A telephone at the reach of her hand and magazines galore!

How could this woman, who since the end of World War II had filled her head with the trivia of cheap gossip magazines, produce a prize-winning book of her survivor's memoirs? Perhaps the ludicrous stories of royalty, movie stars, and jet-setters helped her build mental dams to protect herself from a daily flood of undesired and hurtful memories. Or perhaps, captivating storyteller that she was, she simply loved any re-source that could add to her repertoire of enchantments.

Yetta's book is full of the most extraordinary stories of rescue and escape, and even these are only a part of the many she loved to tell. She and her little daughter Tamara were the only survivors of a trainload of thousands of women, children, and elderly people who were sent off to the extermination camps when the Vilna ghetto was liquidated. At the train's first stop, in a transit facility in Lithuania, an order was given to hurry to the showers. Yetta grabbed her small bundle of clothes and rushed there with her daughter. Despairing and disheartened she tried to be among the first to die. To her great surprise, the shower was only a shower. Clean and "refreshed" she found herself walking with Tamara along a lengthy stretch of a barbed wire fence when suddenly a small gate, operated from a distance by an electric command, opened itself, letting her walk away from what would otherwise have been her fate. Who opened the gate, and why, remains a mystery. But the event cemented in Yetta the certainty that it was at least partly the result of some magic of her own.

Indeed she was saved by a chain of miracles. Her husband Yasha was not so lucky. Separated from his wife and daughter, he was sent to another camp where he labored under the grimmest conditions. Later, as

the Red Army was approaching, he was among a large group of prisoners whom the Nazis killed by putting them in boats and drowning them in the Baltic Sea.

Shortly after our liberation, the resurrected Yetta appeared one day, with five-year-old Tamara at her side, at Janina's gate. I shall never forget the wild embrace, the animal-like howling, and the tears of the two sisters. Later we all left for Poland.

In Lodz, my future uncle fell in love with Yetta and undertook an assiduous courtship. He had survived the ghetto of Czenstochow, where his wife and children had perished. Mother considered him to be the silliest man who had ever walked the earth. Yetta unwillingly and hesitatingly acceded to Mother's absolute determination to keep Zygmunt at bay. It was important to leave Lodz, but we had to wait for false papers that would take us, the two sisters, Tamara, and me, to the American zone in Germany. The day we were to leave, Tamara came down with mumps. Mother and I left on our memorable adventure to Berlin (told in a separate chapter), and Yetta was supposed to follow us after two weeks. Instead, there arrived a message announcing Yetta's marriage to Uncle Zygmunt. Mother seemed to be amused. Zygmunt was not very bright, nor was he well educated, but he was a very decent man, a devoted and helpful husband, and a warm and loving father to little Tamara. Mother's judgment of him proved to be totally wrong.

A small flower shop in one of Tel Aviv's modest suburbs permitted Yetta and Zygmunt to earn a small living. I can still see Yetta there, with the eternal cigarette in her mouth, surrounded by dozens of buckets of blue carnations that she had been dyeing with a powder imported from Germany. She insisted that such magical transformation, conceived and executed by her own hands, was her major pleasure in working with flowers.

Yetta's harrowing life in the war years had badly damaged her health.

Heart failures (which of course her heavy smoking did not help) and crippling arthritis were recognized as resulting from her past suffering, and they condemned her to ever longer hospitalizations. Massive doses of cortisone provoked additional health problems. By the time she reached Germany with her daughter, she was a total invalid. Although I used to call her regularly from my home in Switzerland, something kept me from going to Koln to visit her. It wasn't only the heavy schedule of my work, exhibitions, and necessary travel. Nor was it my lack of energy due to a nightmarish divorce. I guess that I preferred the sound of her cheerful voice on the phone to the sight of her incapacitated body, held in a pivoting frame on a special bed. Then, too, my image of Yetta was shadowed by my memory of Mother's body on the X-ray table, so battered by her illness and so vivid an image of human mortality.

Yetta's and my phone conversations often brought us back to the times of my childhood. One of the last talks we had concerned the time Yetta took me to see Disney's *Snow White and the Seven Dwarfs*.

I was so impressed by the witchcraft and the evil manipulations of the princess's horrible stepmother and so profoundly scared by the magical undulations of the black trees against the forest's frightening night sky, that suddenly from my throat there burst an uncontrollable wild scream. The theater stopped the screening of the film, and a very scornful gentleman asked the "irresponsible" lady and the "hysteric" child to stop disturbing the public peace and leave at once. When Yetta returned me to my parents I was running a high fever. The pediatrician was unable to explain the reason. He advised some cold compresses. But grandmother Shifra had a better idea. She told me that she would take me to see some other films, harmless films with real people who speak Yiddish. Scary cartoons were not for sensitive children. Mother forbade Yetta to take me to the cinema and feed me with junky ideas of magic.

In the fall of 1987 I set a date with Yetta for a long overdue reunion.

Since I had to travel to Boston and New York, I would stop in Germany on my way back. She told me how overjoyed she was; she was counting the days.

Toward the end of my American sojourn, Tamara reached me by phone with bad news. Her mother was in an intensive care unit with serious heart trouble. Should I cancel all my commitments and rush to her bedside? It was a delicate situation. I was traveling with a person who had become very important in my life, Josée, who is today my wife. Should I hurry back? No, my cousin thought there was time. The doctors had seen some promising improvement. Yetta was expecting me in three or four days, at the date we had previously set.

Among the various endeavors that I had planned for the last days of my New York stay was a visit to the old YIVO building on Fifth Avenue. It housed the Institute for Yiddish Culture. I knew that in its collection were a few of my very early works, watercolors done in 1944 that were brought from Vilna and donated by the poet Avrom Sutskever. Which of my paintings had he chosen, and what were they about?

In the mid-seventies I had lived only a few blocks from the institute. I must have passed countless times in front of its massive door, but it had never crossed my mind to inquire about my childhood paintings. Surprisingly, while planning this 1987 visit, I was filled with a strange curiosity to examine them. Calling from Boston I spoke with a very amiable employee, who in heavily accented English promised me to look for the works. We set a day and hour for me to appear. The institute had been located for many years in this once impressive patrician townhouse, but it was preparing to relocate. I thus found it in a real mess. The sumptuous staircase was crowded with all sorts of crates, ugly office furniture, and numberless bookshelves. A tiny lady of a respectable age with sandy hair, thick glasses, and badly applied lipstick came carrying a large but very thin folder. It contained only three paintings. The first was an imaginary

portrait of the Polish King Zygmunt the First, a hero of beloved childhood reading; the second, a landscape with trees. The third watercolor was a real surprise: it was a portrait of Yetta.

I returned the folder to the lady, thanked her for the institute's kind service, and bade her farewell. Her magnified eyes looked at me with bewilderment. With a beating heart, I left the premises and headed straight for the Jewish Museum where Josée was to join me to visit a current exhibition. Absentmindedly, overly troubled by my unexpected discovery of Yetta's image, I could hardly focus on the paintings and artifacts of the museum's show. An hour later we were back in the hotel.

A new telephone message had been waiting for me. It came from Tamara, and it had been delivered a few moments before our return. It stated that an hour earlier, at the moment I was being handed the thin folder, her mother had succumbed to a final stroke. Tamara was expecting me for Yetta's funeral.

On Father's Side: The Baks

Arriving

My Aunt Yetta loved to delve into the circumstances of my birth. An excellent swimmer, she spoke with her arms as much as with her mouth. She always implied that her "almost more than motherly feelings" for me were anchored in the upheaval of those very first instants of my life, in which her presence and help were very instrumental. I had to acknowledge that such a sentiment was extremely powerful and gave her special rights. She insinuated that her chief competitor for a preferred place in my heart, Father's sister Tsilla, could not pretend to have done so much. On that very important day Aunt Tsilla, according to Yetta, kept a strangely cool distance. "Like a cold fish," declared Yetta, her hands on her hips. But I knew that it was not true. I adored them both, and loved their struggle for my affection.

Aunt Tsilla's version was very similar, but reversed. It was she who welcomed me while the carefree Yetta must have been dancing somewhere with one of her numerous beaux. "Really? Does she say that she was there?" Tsilla insisted that she remembered every detail of that memorable day. She arrived just as Mother had lost her water and everything was pointing in the direction of a mess. She took Mother to the clinic, where soon the four grandparents also arrived. The situation dragged on. Father was chain smoking and tapping his foot. They were all in one big room getting on each other's nerves, listening to alarming disagreements between two gynecologists who whispered louder and louder while my poor mother was screaming at the top of her lungs. Luckily I was tiny and

the specialists finally succeeded in making me give up the stubborn urge to come out with my behind, and changed my uncomfortable and rude position to something more presentable. "Who ever heard of such an impolite way of being born?" Tsilla was keen on teasing me.

Later, during the war, when we knew dangers and overcame hardships in which metaphorically Mother gave me life again and again, she did not scream. Then the pain was of loss and of mourning. She cried silently.

Vilna would become one of the tragic places of modern Jewish history, but I obediently accepted it as my birthplace. And I accepted the year, month, and day of my first sight of the beautifully filtered light of the long Baltic summer days. Obediently I took possession of the names my parents gave me, or more rightly handed over to me. "Bak" was the family name that Father received from his parents and "Samuel" the name of Mother's grandfather who died a few days before I was born. I soon learned that Samuel was the name of an ancient prophet. But the hidden meaning of my family name was unknown to me until my fifteenth year.

Had they asked my opinion concerning the date and place of my birth, I would have made a different choice. Why here? And why at such a dreadful time in history? These questions came to me much later, in moments of particular hardship. But I was a child, and children had to keep quiet. Even a protected, pampered, and spoiled only child had to cope with great difficulties. Receiving inadequate answers to important questions was one of them. Later I made some more disappointing discoveries. I could not foresee the future and that bothered me, though it had the great advantage of allowing for hope. Anything could happen! Even the most desperate situation might be saved by a miracle.

"And what if the miracle did not arrive?" It mattered little because one wouldn't be alive to be disappointed. I learned this last truth when we were in the Vilna ghetto surrounded by German guards, and everything

depended on chance. Life was precious, but came with no guarantees. Even today, whenever I imagine that I can control the course of my life an inner alarm starts to sound.

That I am here at all surprises me. Born in Vilna, in the year that Germany brought Hitler to power, my odds of remaining alive were almost nil. I owe my survival to a series of miracles that never failed to arrive. They allowed me to accomplish whatever I have accomplished in life and now to search for the words to tell my story.

My narrative will not be chronological. In spite of the many times I have been asked to tell about the tragic years I witnessed as a child, and my sincere willingness to do so, the sensitive material remains under guard. I think I must begin by circling around it, edging only very carefully toward its painful core.

The Strange Case of a Name or, the Case of a Strange Name

What is in a name? This question started to intrigue me when I was nearing thirteen. We were living in the limbo of Landsberg's DP camp, awaiting major international decisions that would affect our individual lives. To what were we destined? An avid reader, I saw that the fates of many of my biblical and literary heroes were suggested in their names. Might this be the case also with me?

Many names are easy to decode. They indicate the profession of some distant progenitor, his nickname, or his appearance. Or they are links to a geographical region or town. But where did Bak come from and what did it mean? At this early age I still believed that most facts could be explained, and it bothered me that my family name should remain an enigma. Even Mother, who seemed to know so much about so many things, had no answer.

"Bak" in Yiddish could mean "cheek." A Hebrew teacher in the

improvised Landsberg School, a tense woman whose dentures used to slip whenever she spoke, assured me that in a Jewish state my name would become *Lekhi*, which is "cheek" in Hebrew. I did not like the idea of being called Mr. Cheek. Then there was another possibility. In Yiddish *bak* was the imperative form of the verb "to bake." Impossible!

Finally, at fifteen, after my immigration to Israel, a passionate historian of Jewish family names gave me surprising information. It was at a time when many newcomers, heady at the creation of our new state and succumbing to nationalistic fever, began changing their names into Hebrew, their freshly recovered ancient language. My erudite expert insisted that I keep the name of my forefathers. I was lucky, he said. My name was authentically Hebrew! He then revealed to me its history.

His explanation stunned me, and filled me with sadness and pride. BAK is an acronym of Beney-Kedoshim, Children of Martyrs. The term's origin dated—according to my learned instructor, but there he might have been wrong—from the times of the infamous Chmielnicki. Horrendous pogroms perpetrated by his Ukrainian Cossacks in 1648 decimated entire Jewish villages. Some of the children remained miraculously alive in the rubble of their burned families and houses. Since then these salvaged children and their descendants have been called Beney-Kedoshim, in its abbreviated form: Bak.

So that was it. I was born into a family that had carried from one generation to the next the sign of an ancient wound inflicted by centuries-old anti-Semitism. We, the Baks, were the bearers, across the chasm of generations, of a darkly ominous memento conferred by the nameless victims of Ukranian pogroms to the millions who perished in the Nazi ghettos and camps. What a powerful revelation!

Could I, one of the "surviving children found in the rubble," a member of a family decimated in the Holocaust, have found a more fitting name? Could I have invented a more appropriate sign to leave on each of

my paintings? Wasn't my signature a variant of those small stones that every Jew deposits on the tombs he visits, a memorial to the dead?

I shall never know to what extent this discovery trapped me in a sense of predestination that later influenced my painting. At age fifteen I had no idea what direction my art would take. Of course my traumatic experiences of loss and survival had eventually to find some appropriate outlet, but the search proved arduous. It took years to detach myself from the stifling fashions of contemporary painting and to understand where my own art was taking me.

With time my art language gained transparency and I began to perceive certain reasons for the choices I was making. Yet after almost four decades I still start my morning in front of the easel, thinking that I understand what I am doing and arrive at evening's pleasurable feeling of closure having learned again that I can never work from a pre-established plan. I have no doubt about my larger intention. My paintings are meant to bear personal testimony to the trauma of surviving. They depict troubling images of a world shadowed by the dissipating clouds of yet another universal flood. Is it presumptuous to claim that such paintings could bear no better sign than the name Bak?

As the children of Chmelnicki's martyrs overcame the traumas of his pogroms and joined in the life of their communities, the name Bak grew rarer, perhaps from a desire to avoid painful memory. But such memories apparently ran deeper than they supposed. It seems that a family of printers, known as the sons of Rabbi Gershon Bak, was active in Venice and Prague in the 1500s, predating even Chmelnicki and his pogroms. When were there not already Jewish children of martyrs?

Other Baks, coming from the Ukraine, moved south in the eighteenth century to Palestine, then part of the Ottoman Empire. They settled in Saffed, a small town in northern Galilee. In this ancient center of learning, Rabbi Israel Bak, printer and publisher of holy books and in particular of

the Talmud, pursued his craft. In 1759 the town was destroyed by a severe earthquake, killing more than two thousand people.

But the family survived and moved to Jerusalem, where they prospered. Some became respected community leaders. Jerusalem took pride in the synagogue of Nissan Bak, built at the turn of the twentieth century for the glory of God and the reputation of the sponsoring family. It was destroyed in 1948, during Israel's war of independence.

Vilna

I was born in a faraway and very different Jerusalem.

"The Jerusalem of Lithuania" was the name given to Vilna, an important Jewish center in eastern Russia, northern Poland, or central Lithuania, depending on which period one chooses of Eastern Europe's agitated history. The Jewish community made up more than a third of the general population. The Christians were very proud of Vilna's ancient and renowned university. Under quite restrictive conditions it sometimes admitted Jewish students, exposing them to a different world of ideas.

On the map of Jewish culture, generations of spiritual leaders and renowned institutions of religious learning had long given Vilna a leading position. With the turn of the twentieth century, the larger part of the town's Jews were rather poor, but a growing middle class of craftsmen and professionals, together with some rising well-to-do merchant families, started to enrich its social and economic life.

The city had always been known for its learned rabbis and its yeshives, the numerous theological centers, but in the nineteenth century there began to emerge a number of secular leaders. Some advocated assimilation. Others were Zionists, dreaming of a return to the ancient homeland in Palestine and a rebirth of Hebrew. Their antagonists were the Yiddishists, who believed in social progress and the future evolution of the Yiddish language and culture. Whether religious, Zionist, or socialist

they found in Vilna a fertile ground. In an epoch of an oppressive czarist regime some of these associations pushed their members, like my Grandfather Chayim, toward subversive theories and clandestine activism.

Chayim Bak

Books on Jewish history are filled with vintage black and white photographs of men condemned to remain forever unidentified. They pose in proudly frozen postures next to their admired leaders. All look alike, as if fate had made them interchangeable. Whether their jaws are clean-shaven or fully bearded, they display impressive moustaches, wear dark clothes and black hats. One of them, probably one with a dashing moustache, is Chayim Bak.

Chayim was born in the 1870s, a son of a family of forest merchants. Early in life he married Grandmother Rachel and fathered two sons and a daughter, David and much later my father and Aunt Tsilla. David was to become the uncle I would never meet.

Though Chayim participated little in his family's business, he enjoyed the easy life it offered. With free time on his hands, he dedicated himself to secular studies. Thus were born his thoughts about changing the world through new theories of government and improved social justice. He nonchalantly rejected the comfort of his privileged milieu and joined the semi-clandestine Bund, a Jewish Socialist movement. I dare to suppose that he must have lacked the passionate determination that made talented men who had suffered real hardships become more driven and ambitious. Although he never reached the status of a leader, political activism became the center of his young life.

Chayim's distraught parents judged him a totally irresponsible black sheep. They pitied his wife and young son and felt that their own principles were not being respected. Doing profitable business in an anti-Semitic regime left no place for liberal tolerance. Since the devoted

socialist had never acquired a breadwinning profession, he was unable to assure his small family a decent livelihood, and they soon found themselves in a penniless situation. In spite of Rachel's growing reproaches, Chayim made it clear that renouncing his principles and joining his parent's trade was out of question. Luckily, his wife's ability to maintain a contact with her in-laws helped the young family survive. These were hard times. The first Revolution of 1905 against the czar had been brutally suppressed and was followed by a wave of massive arrests and deportations. When officers of the police, carrying a warrant for Chayim's arrest and imprisonment, entered his gate and started climbing the stairs, he grabbed his wallet and coat and ran quickly to a door that opened on a small balcony. The need to prepare for such an escape had been vaguely anticipated but not carefully planned.

I can well imagine the adventurous socialist fleeing from the police. So many films depict similar scenes. I see it in black and white, or even better in a sepia-colored light with piano music in the background. This might be an irreverent observation, since Chayim's escape was a matter of life or death that could compromise everything, his future, my own father's conception, and my being here. But I find it hard to imagine my beloved and always dashing grandfather in the role of a criminal fugitive. Chayim—escaping immediate arrest, a probable deportation to Siberia, and the prospect of a miserable death in one of its frozen prisons—ran across balconies and roofs, courtyards and inner alleys, side streets and city gardens. In the end he made his way to the central train station. Improperly dressed, with little money and no documents, he boarded the first departing train. He had to disappear.

Rachel, holding eight-year-old David by the hand, opened the door to the police. With a drumming heart and a face as straight as she could produce she told them that she hadn't seen her husband since, since . . . a very long time. She accompanied them through the empty rooms of their

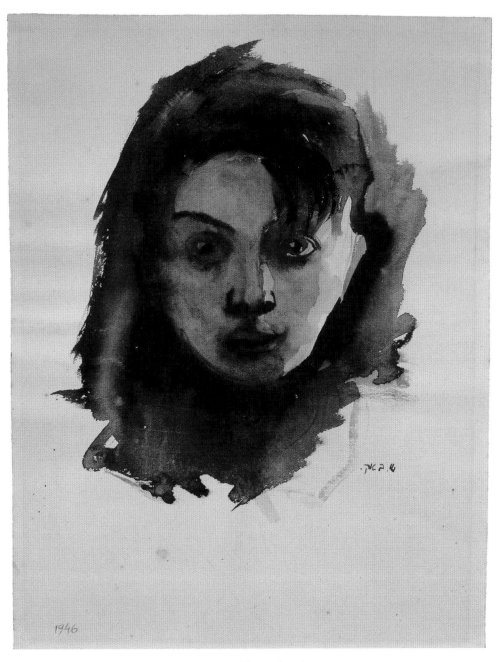

1946

A self-portrait in watercolor, painted in Landsberg, shortly
before my repudiation of the Bar Mitzvah ceremony.

NEXT TWO PAGES: *The Family*, 1974, is probably one of my
most complex and ambitious paintings, the subject of a doc-
umentary produced by German television. In it I attempted
to reconstruct a family portrait from fragments of memory.

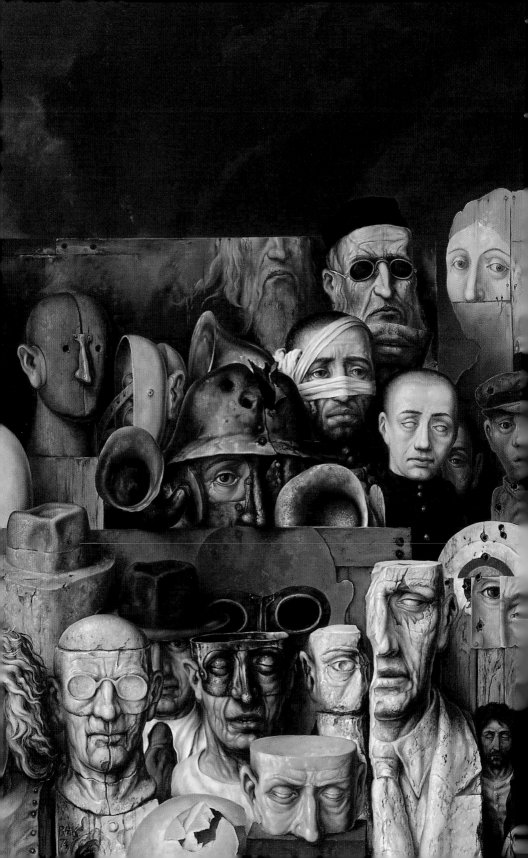

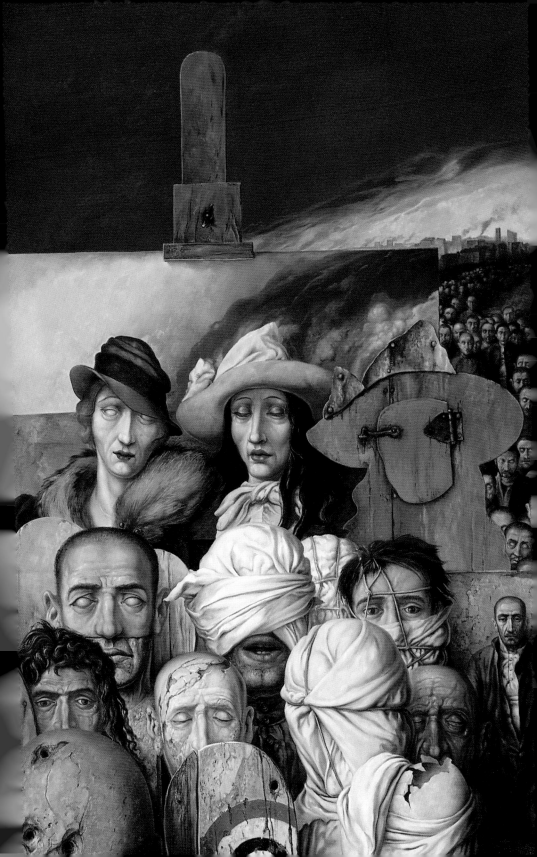

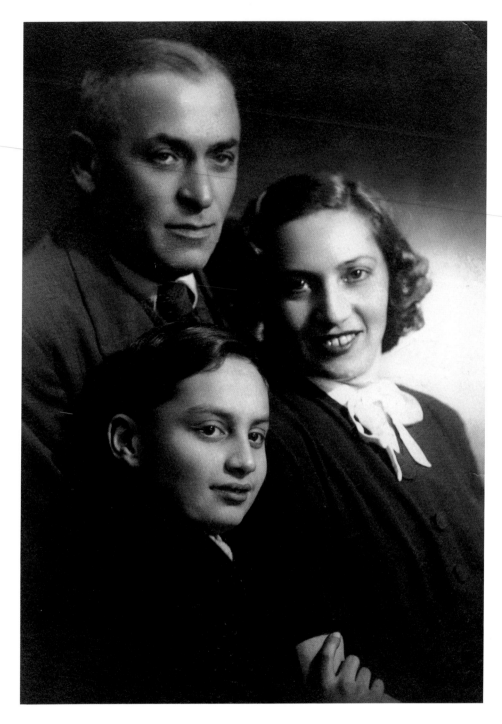

In Landsberg am Lech, Germany, with Mother and my stepfather Markusha (Nathan Markovsky, a Dachau survivor), around the time of their wedding in 1947. The camera of a German photographer produced an unexpected *tikkun* giving three displaced persons an aura of middle-class respectability.

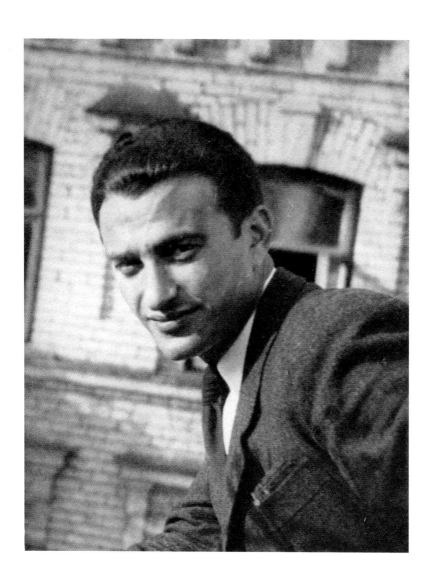

My father, Jonas Bak, in 1933, the year I was born. He must be leaning on the "treacherous" balustrade of my grandparents' balcony.

TOP LEFT: Strolling with Grandfather Khone in one of Vilna's parks. 1940.

TOP RIGHT: Grandmother Shifra behind a plant that hides her uncomfortable shoes. 1935.

BOTTOM: In a photographers studio at the end of the twenties, Grandmother Rachel, Father, and Aunt Tsilla with my forever dashing Grandfather Hayim.

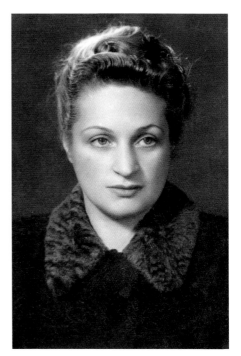

TOP LEFT: Janina Rushkevich, Grandfather Khone's sister who had converted to Catholicism, and to whose devotion and courage I greatly owe my life, in a picture made years before her unexpected return to Vilna.

TOP RIGHT: Mother's younger sister, my "magical" Aunt Yetta in 1946.

BOTTOM: On Avrom Sutskever's lap. 1944.

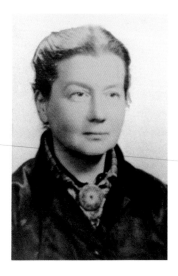

LEFT: Sister Maria Mikulska in the early '50s, after she had left the Benedictine order and emigrated to Poland.

BELOW RIGHT: The rooftop of the Benedictine Convent in which we hid.

BELOW LEFT: The courtyard of the Benedictine convent.

BOTTOM: The HKP work camp. In the center is a memorial to those who were imprisoned and persihed there.

RIGHT: Vilna, 10 Wilenska street, our once gray building from which we had been sent to the Ghetto, under a recent coat of cheerful colors.

BELOW: *Vilna*, a semi-abstract work painted in Rome (1961) that evokes a bombed city's inciner-ated facades, and some passersby.

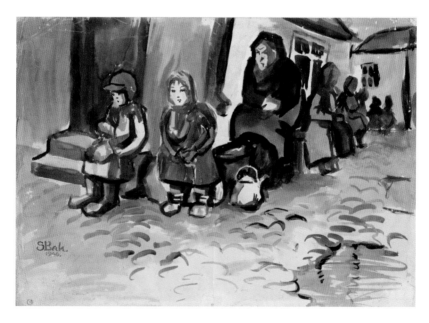

TOP: Myself in the documentary film footage I discovered on a video screen in the Holocaust Memorial Museum, Washington D.C.

ABOVE: The same watercolor, hanging today in my home in Boston.

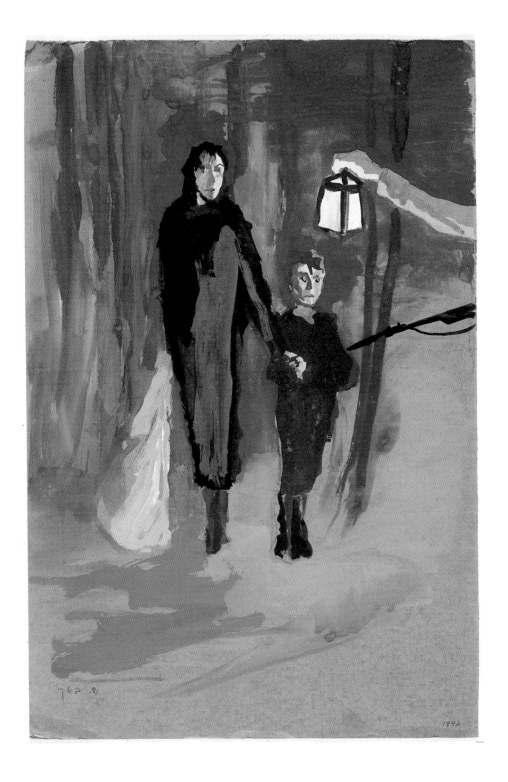

Landsberg, 1947. A mother and son. Painful memories do not fade away.

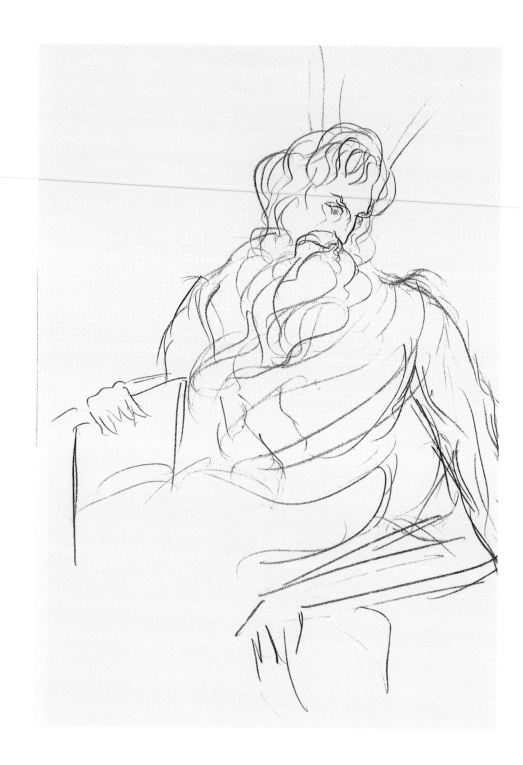

1942, from the *Pinkas*: a sketch of my horned Moses, a clay sculpture
I presented to Jacob Gens, the head of Vilna's Ghetto.

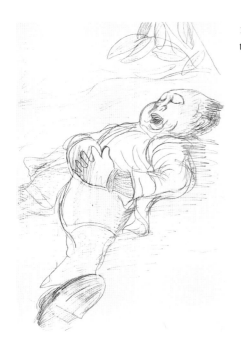

1942, the *Pinkas*: from the land of the sleepers

1942, the *Pinkas*: Scorn and Laughter

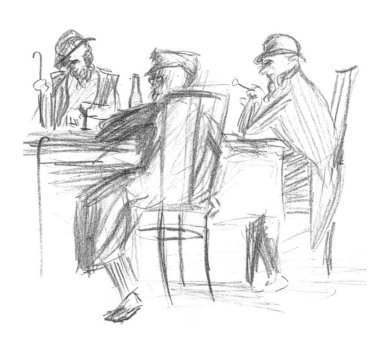

1942, the *Pinkas*: "Lechayim!"

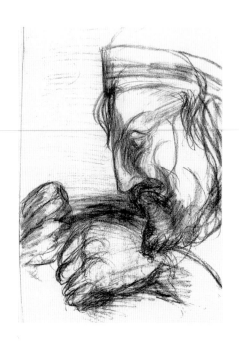

1942, from the *Pinkas*:
A profile of Odysseus.

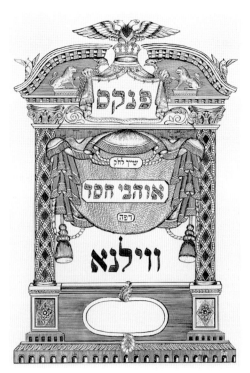

The original frontispiece of the *Pinkas* and a sketch of a boy clinging to a flimsy branch.

RIGHT: Me, in 1944 or 1945 after our liberation by the Red Army.

BELOW: Two works of the same period. While I had been taught to draw in the classical manner, my preference was for a more expressionistic approach as seen in my watercolor portrait of Aunt Yetta. Both drawings are part of the collection of YIVO in New York City.

TOP: 1949, our modest lodgings in a Tel Aviv suburb. I rarely painted then since most of my time had been dedicated to studies.

ABOVE: Uncle Rachmila, who had a fantasy of dedicating his years of retirement to fishing, did not see his dream come true, an untreatable cancer truncated his life at age 65.

flat. Fortunately they found no incriminating clues and left. Days and months went by. Finally, a trusted messenger arranged to meet her in a secret place, bringing news of Chayim. The messenger gave Rachel a package of railway tickets: her husband was in Paris, waiting for his wife and son.

The meeting threw Rachel into a state of apprehension and anguish. How could she leave Vilna? What was she going to do in an alien country? Nevertheless she decided to leave. Her husband's reluctant family, dreading the loss of their grandson as well as their son, helped her obtain the necessary travel papers.

Paris

When Rachel's train pulled into the Garc du Nord, it took her a moment to recognize Chayim. The man waving his hand was shabby and much thinner. Recognizing how eagerly he had been waiting for them, she fell into his arms. She was confused and tried to be as cheerful as she could, and so did he; but the months of incertitude and anguish had taken their toll, and in her relief she burst into sobs.

It is not simple to reconstruct a single version from the three different sources that have come down to me. The differences are a matter of nuance. Grandmother's version, centered on her own suffering, stressed her irreproachable dignity throughout that difficult time. Grandfather might have biased his version with his sense of personal renunciation. Mother, who knew the story from hearsay, and had a high sense of her own intellectual integrity, doubtless added a hostile ingredient that came from her subtle ongoing battle with her mother-in-law. The only demonstrably sure fact about what I am telling here is that I was not there. Like an archeologist, I must construct a narrative from shards of evidence that do not always neatly fit.

The three of them remained clinging to each other for a long time. Crowds of busy travelers brushed against their clothes and against their heap of bags and suitcases. Rachel poured out her heart. She spoke of her anxiety in Vilna, her suspicion that all her arriving mail was being controlled and the outgoing letters censored. She had been plagued by a constant sense of being followed. Her husband's persecuted friends had had no way of giving her news about him. Did he have any inkling of what he had brought on her? They collected their luggage and hailed a carriage. She lent an ear to Chayim's flow of words, but her eyes were checking out the unfamiliar busy streets, the traffic, the shops, and the imposing boulevards. Chayim told about the blind chance that had sent him to Paris, the incredible journey on the train. Rachel and David learned that in Vilna's central station, before a group of policemen that was combing the crowd could get to him, he jumped on the first train he saw moving, destination unknown. The rest followed from that hasty decision. He began his journey by hiding in the lavatories of passenger cars. Later he looked for shelter between crates of merchandise and luggage. Sometimes he managed to find refuge in the kitchen of the restaurant car. The little money he had with him served to bribe various attendants and controllers. They helped him to travel with no ticket and to pass the borders without a passport. That he had arrived to Paris a free man was to be considered a miracle!

Chayim's story went on. Emerging from the train station after his exhausting and perilous journey, hardly able to stand, he found himself in a square swarming with people. He looked around. A comforting feeling came over him. He was surrounded by familiar faces. The passers-by had dark eyes and dark hair, mostly Semitic traits. For a short moment he felt encouraged by what he took to be a huge Jewish presence, but he quickly discovered that these people were French, and that nobody understood his Yiddish. Luckily one man answered him in his language. Having lis-

tened attentively to Chayim's story, he advised him to go to the Pletzl, the Jewish quarter of the rue des Rosiers.

There he knocked on endless doors of Jewish merchants, only to be sent away, but finally found a tailor who agreed to give him food and shelter in exchange for work. He had to clean the shop, deliver merchandise, sew buttons, and learn how to iron. His employer assured him that he would gradually acquire a number of more demanding skills. This could become his trade and secure his future. After several weeks, moved by Chayim's devotion and diligence, the kind tailor started to pay him a small salary with which he rented lodging and secured a loan to cover Rachel's and David's expensive journey from Vilna.

Rachel listened. But when she saw the narrow street, the murky courtyard, the dark staircase smelling of boiled cabbage, the dilapidated corridor leading to their bare and poor lodgings, she could hardly hide her distress. Clearly they were far poorer than they had ever been before. How would she learn to manage with so very little money?

It was hard to conceal from Chayim the depth of her disappointment. Her coming to Paris might have been a terrible mistake. Her husband had to take on a terrible burden of debt, and for what? Hadn't she been better off in Vilna, close to her own grumbling family and to Chayim's embittered parents? At least she knew how to deal with them. But here he was exposing his wife and son to the humiliations of ugly attic rooms, soot-covered courtyards, and the stench of black streets. In Vilna such a place would have housed the poorest of the poor. Was she ready to share the miserable life of an exiled, ill-prepared, and impractical revolutionary? This was by no means the life she had imagined for herself. By agreeing to marry the handsome and elegant son of a "good family," a promising dealer in important commercial transactions of forests, she had chosen a man who seemed capable of assuring her the pleasures of comfort and stability.

I remember my two grandparents when they used to discuss half jokingly their overlapping yet so very different memories of those days. Paris came up often, especially when they were discussing my future life as an artist. They had no doubt that I was to become one of the most universally acknowledged artists of all time. Another Antokolski, or another Repin. Or, perhaps like one of those lesser-known Italians, Leonardo or Michelangelo, who were not among the peaks of their Olympus.

They seemed to agree about Paris on one single issue. It was a must for a painter's career. About all the rest their views diverged diametrically. For Chayim Paris was a mythical ground. The sound of the name alone would make him half close his eyes, form under his gray moustache a mysterious smile, and emit a deep sigh. Obviously, between his hostile wife and ignorant grandson he lacked the proper public to share his sense of the glory of his enchanted city. But he implanted in me a seed of desire that would grow with time. Over the years, it became obvious to me that Paris would one day be my destination. And that I would fulfill Grandfather's lost dream of living there.

"I shall live in Paris!" I insisted to myself. "No force in the world will ever tear me away from it, as it tore Grandfather. That he should so love a city in which he knew such hardship must be proof of its extraordinary nature."

For Rachel, Paris was a different matter. The mere name evoked a list of all the elementary things a person like herself needed and that Paris so maliciously refused to grant. Sometimes, hesitatingly, she acknowledged the dreamlike quality of the city's beauty "for certain people." But she could declare with authority that "there was in the courtyard only one single stinking hole that served the whole building, with a door that would not shut." Life without so much as a decent lavatory was no life for Rachel. And as if this weren't enough, "It was a city where people ate horses."

Did I hear well? They ate horses? How could I believe such fabrications?

Grandfather admitted she was right. Her irrefutable proof was the butcher at the end of her street displaying the abominable sight of a huge gilded head of a horse that advertised his merchandise! Rachel would pronounce the word "merchandise" with a very funny expression of disgust. She always tried to avoid passing near the shop, since the mere thought of eating horsemeat made her throw up. I loved the idea of Grandmother throwing up in the street. " Delicious" was Grandfather's verdict on horsemeat. At this point I would feel reinforced in my secret desire to go to that very same street in Paris, determined to search for a golden head of a horse and anxious to find out the facts for myself. But first I had to become adult.

When I arrived in Paris in 1956, I roamed the Marais, whose knot of narrow intertwining streets had once been the stronghold of a Jewish population, from which many were sent to the camps. The odors, the decrepit facades, and the blackness of it all corresponded to Rachel's stories. Whenever I saw a woman with a boy I tried to picture Grandmother with David. The few peeling heads of gilded horses that hung over the barred windowpanes of horsemeat butchers were much smaller than I had imagined.

Who can deny the power of reality? After Rachel overcame her first wave of indignation over the life they were to lead in Paris, she made an effort to adapt. But she had to find a way to escape the dreariness and save her sanity. Daily, as soon as she fulfilled her domestic duties, she left her depressing neighborhood and, with David at her side, walked along the banks of the Seine. She ventured into those affluent parts of the city that flourished during this era of the belle epoque.

Thousands of vintage postcards survive from that time. Museums of history have them on display. Passionate collectors find them in special-

ized markets or shops. Some of the postcards show famous monuments or lavish department stores, others are dedicated to the boulevards swarming with antlike figures that seem to be made up of tiny dots. I can easily see Grandmother Rachel and David among them. Decently dressed, in what she had brought from her better days in Vilna and rearranged according to the current mode for which she had an excellent eye, she explored undisturbed the world of ladies' fashions. The huge, newly erected department stores were a treasure house for such an endeavor. Rachel didn't yet know how wisely she was investing her time. She didn't imagine that one day all the information she was absorbing would bring great benefits. How could she, given the humble reality of the thrifty rue des Rosiers?

With David's presence, assuring her an unequivocal respectability, she would plunge into a dreamlike world. She spent hours looking at fabrics, ribbons, embroideries, lace, multi-colored feathers, hats, and furs. The department stores looked like real palaces. Paris was the center of the fashionable world, and this was the period of its greatest flourishing. Carefully and methodically she studied the magic paraphernalia displayed with such panache. David, in the early days of her window-shopping, was as obedient as one would expect a well-brought-up boy of nine to be. But he soon became bored and increasingly impatient with what today we would call her "therapeutic" explorations. This may have been when he first put down the roots of his hatred for all that was, in his eyes, the vain varnish of a wealthy society. For David these palaces of merchandise defined the sharp difference between those who had too much, and those others, like himself, who had nothing. His father's philosophy reinforced these beliefs. Reluctantly, Rachel left him more and more often in the tailor's modest shop where Chayim sewed buttons and talked to his son about socialism, justice, and fraternity among nations.

In later years David rejected his parents because Chayim renounced

his high ideals and returned to Vilna. David had something to prove to this father who had let himself be led by a wife's bourgeois choices: he joined the clandestine Communist party of Poland, was put in prison, and managed to escape to Soviet Russia. There he saw his idols betray him, was arrested, accused of Trotskyism, and exiled to Siberia. As if that were not punishment enough, because of an administrative error he was deported in company with his first wife, from whom he had long been divorced.

David experienced very much the fate that his father had barely managed to avoid. The shadow of his absence never lifted from his parents' home. I had a very vague notion of Uncle David and had to learn not to mention him. His name evoked hidden pains. When in the sixties Mother's extensive search for her lost brother-in-law turned up the Moscow address to which he had returned after his long odyssey in various gulags, she sent him a message. The sick and prematurely old man was too terrorized to acknowledge the existence of a family in the West and begged Mother's emissaries to leave him in peace.

I wonder what his thoughts were when more than half a century earlier his parents told him that a little sister or brother was on the way. This imminent event triggered the family's return to Vilna. In 1907, Rachel, several months pregnant with my father, found it unacceptable to give birth to a child in the harsh conditions of their Parisian poverty. Chayim was forced to admit that she made a good point but was troubled by the prospect of return. Rachel made it clear that she would return to Vilna, not only to have the baby surrounded by people who possessed the means to help out but also to check out some ideas that she wanted to explore.

A series of letters from Rachel to her in-laws, carefully written so as to evade the censor, prepared the terrain for their return. She claimed success in reeducating her husband, this childishly stubborn man. In return she expected his parents to change their attitude to her little family and to provide practical help. They responded positively. An employee of the

police was secretly paid, and the "careless" official inadvertently obliter-ated all the incriminating material in Chayim Bak's file.

Thus Paris received the hoped-for signal that it was safe to come home. The perplexed Chayim could not free himself from the fear that he would be framed by the czar's secret police, though he knew they had a limited interest in his person; he had never been a "big fish." Moreover, his parents would never expose him to a trap. After many discussions, after much hesitation, having listened at length to Rachel's insistent plea and become tired of it, he finally made up his mind, packed their few belongings, and brought his family to the train station.

The Return

All went well. In July my father, Jonas, was born, and after a couple of years, my beloved and unique Aunt Tsilla. Both would be protected by Chayim and Rachel's great love, attention, and care. In Vilna Chayim rented a space in a central street. With financial support from his parents, he opened a store for men's wear, naming it proudly "The Tailor of Paris." The arrival of a new baby, and Rachel's smart diplomacy, improved relations with the older generation. His parents' eagerness to launch their son in a respectable business was understandable, given their desire to avoid any danger of being associated with a subversive element. They had had enough troubles with him already. Chayim must have been aware that their generous help was first of all purchasing their own peace of mind. Never have I heard Grandfather speak about his own parents. I shall never know the nature of his real feelings for that part of his family. Outwardly, they all lived in polite harmony.

In spite of their very different characters, Chayim loved Rachel dearly, and she had a way with him. She made him realize that life could be much more agreeable if he subscribed to her ideas, and not the other way round. With time he became wise enough to understand that she was too pretty,

too feminine, too vain, and too much in love with herself to accept the kind of life that he had unsuccessfully tried to force on her. The obligatory grayness of a revolutionary's clandestine life was not for her. It was clear that their happiness required a certain degree of luxury.

Chayim took upon himself the role of a generous provider. He genuinely enjoyed delighting his well-dressed wife. Also he reclaimed in himself those qualities that had charmed Rachel when she was his lovely fiancée. He had a certain natural flair and elegance that his new trade reinforced, and it seemed that his old ideas of changing the world made way for a commitment to changing the dress needs and habits of well-paying clients. With the help of a couple of good tailors and a few diligent assistants, he set out to conquer Vilna. The great spiritual center had remained in many domains a merely provincial city of northern Europe. A good portion of its "better" population had always lived in awe of the great foreign capitals, and he took advantage of this unconditional admiration. As the store prospered, Rachel decided to launch a department for ladies. A couple of local seamstresses were carefully chosen and engaged. The women, fascinated by her elegance and curious about her ideas, were ready to offer their competence to one who knew so much about the world of fashion.

About this time there was one late evening a knock on Rachel's door. It was a story she loved to tell, her eyes glimmering with mischief. At first, fearing an uninvited comrade of her husband's past, she was reluctant to open and pretended that her husband was away. The voice of an old man insisted that he was there for her, not for her husband. He wanted to sell her a unique machine. He knew she had inaugurated a fancy "salon de couture" and was sure he must cede his fabulous invention to her and her only. She opened the door to a strong odor of alcohol. A poorly clad man staggered in and presented her with two boards of wood covered by shining metal. The sides held small rings to which ropes were attached.

"Is this the whole machine?"

"Yes it is, and it transforms fabrics in an extraordinary way!" He was sure that in all her life she had never seen anything like it. With a drunkard's slurring voice he explained how to proceed with the help of a few hot irons, which must be left overnight in order to create a very novel type of pleats on fabrics of her choice, silks, velvets, or woolens. The drunkard stretched out his begging hand, and Rachel paid him the few rubles he demanded, more out of pity than from any interest in his strange object. She never saw him again. However, the machine worked better than she could ever have imagined. It created interesting surfaces that she learned to control and vary. She incorporated them into her already sophisticated designs, making her dresses altogether unique. The *froissé* became her local trademark. People believed that she had it sent directly from Paris. They were sure that all the Parisian ladies wore what Rachel secretly produced at night, in her kitchen.

Her success was assured. The better-informed ones, her seamstresses and assistants, knew that she transformed her fabrics at home but never discovered the secret of how she did it. Nobody ever saw the machine or Rachel working on it. In later years I knew by heart the story of the drunk old man and would correct, as children often do, the smallest inaccuracies in Rachel's narration. Once I asked her to show me the magical device. She said that she had put it away in the attic so safely, and so far, that it had become virtually unreachable. Anyway, I had to understand how much she now hated the sight of it, since it represented thousands of hours of work that she had grown to detest.

It was one of the very few requests that my loving Grandmother Rachel ever refused me.

David, Tsilla, and Jonas

My grandparents' enterprise ended its golden period with the out-

break of World War I. Then the eruption of the Russian Revolution made things even worse. These two milestones marked the end of an epoch.

Dramatic changes in individual lives and a reversal in the fortunes of entire nations left everything disrupted. Millions perished in the war, and then other millions died in a sweeping epidemic. A Polish general's private army occupied Vilna, the capital of the newly established Lithuanian Republic, and made it an integral part of Poland. Most European cities were shaken by economic crises, and Vilna was no exception. Chayim's flourishing business collapsed, and his beloved Rachel suffered a severe fever, perhaps the "Spanish flu." She recovered very slowly and was left with no sense of smell or taste.

Chayim, who had to reduce the size of his affairs, converted a part of his private apartment into a tailor's shop and kept only two of his best workers. Everything was scaled down. But this was not the worst. The worst was David's political activism. Obsessed by feelings of guilt, they spent sleepless nights trying to figure out what they had done wrong. Grandmother never spoke to me about David's arrest or about her painful visits to him in prison. These events happened before my time, and I heard about them mostly from Mother. I wonder if it was Chayim's money that facilitated David's escape from prison and his flight to the Soviet Union. One thing was clear. My grandparents were left with an open wound. The very sporadic news they obtained from clandestine sources brought little comfort. Luckily they never learned that the ideology to which he devoted his life got him sent for many years to the gulag.

Given their failure with David, Chayim and Rachel sought a "redemption" in the upbringing of their two younger children, my father and Aunt Tsilla. Both prospered. Aunt Tsialla owned a small boutique in which she sold custom-made corsets, brassieres, garter belts, and all sorts of finery for ladies. I can see her longish face, slightly blurred in my memory, emerging from a perfectly well-remembered background of fabulous

laces, satins, silks, and chiffons, in pale pinks, lavenders, and shades of white that are mixed, from time to time, with viciously shining blacks. She loved me dearly and dedicated much of her time to my care.

Tsilla was an artist of form. She shaped her clients. Amorphous matrons came to her place to be remodeled. They never questioned the presence of the cute little boy, her nephew, who observed them with a growing fascination. They undressed, revealing mountains of falling flesh. With the help of zippers, ribbons, whalebones, elastics hooks, and strings hefted into the right places by Tsilla's expert hands, the obedient clients submitted themselves to her firm restraining devices, the magical corsets that transformed them into statuesque goddesses who left her shop in states of glowing bliss. All this did not happen without a struggle in which they had often to hold their breath while my sighing aunt toiled on them with great competence and concentration. Then it was they who sighed abundantly. I admired Tsilla. She was an incredible sculptor in the clay of her clients' flesh.

Aunt Tsilla loved joking and giggling with me. Like Father she had a talent for imitating the voices and speech of others. We maintained an ongoing conspiracy; her last customer was always the designated victim of her mimicry. She made me laugh to tears.

My tears gave us no hint of what lay ahead. We had no idea that in a few years she and her husband and their baby, fleeing to Kiev to escape the German occupation of Vilna, would meet their death, riddled by the bullets of a Nazi machine gun, most probably on the precipice of the mass grave at Babi-Yar. It was well, perhaps, that we could not after all foresee the future.

Jonas, my father, became, as so often happens, the exact opposite of his brother David. Ambitious, energetic, and good-looking, he profited from every advantage his parents offered. He studied well, specialized in orthodontics and technical dentistry, and had a successful career. He

engaged passionately in several sports, especially gymnastics. Exercises on parallel bars and on rings gave him a beautifully agile and athletic body, of which he was very proud. No lesser pride resulted from his owning the most powerful BMW motorcycle in town. When he used it in due time to try to boost my macho instincts, it gave me some terrifying moments. He dressed so well that he became a real arbiter of masculine elegance. He also loved drinking in company and playing cards. An expert in ballroom dancing he was surrounded by a horde of mistresses who kept on fighting, even after his marriage, for his exclusive attention. He was a most genuine, charmingly irresponsible, and somewhat shallow playboy, and the fact that he and my mother ever got together and produced me, for which I shall always remain grateful to them, is a mystery that will forever baffle me.

Whenever I think of them as a couple, I cannot decide if theirs would be more likely as a story invented by a writer of bad novels or a tale contrived by an absolute genius for the purpose of illustrating the complexities of life. How shall I ever do justice to Father's multiple qualities of courage and resourcefulness, his obvious defects, and his always endearing personality?

He died when I was only ten. I hardly knew him. Today, years after his death, I think I know him a little better. For that to happen, I had to grow up, become an adult, and dig into my earliest recollections. Several of Father's stories will unfold in the chapters that follow.

Saving My Parents

Many times in my young life did my parents, together and individually, save my life. But once only did I have the good fortune to be able to save theirs. This occurred when I was not older than three, at most four, but each detail of the event is vivid in my mind. It happened in the middle of a winter night. I managed to extract myself from a haunting dream and

woke up suffocating under the heat of several blankets. Feeling quite bad I pushed them away and got up on my knees. My head was spinning, and it was difficult to hold myself upright. Leaning on the rails of my bed, I threw up everything that was in my stomach. It landed on my nightshirt, my bedcover, and on the precious carpet of my parents' bedroom. A strange fume was floating in the air. It was not the odor of my vomit.

In the aftermath, Father, Mother, all our family and friends celebrated me for days on end. I was a miracle child. The savior of my parents' lives!

Before all this upheaval I was only a spoiled first child born after a previous pregnancy that did not reach term, and an only grandchild to four very permissive and adoring grandparents. A hyper-sensitive boy, in psyche as well as digestive apparatus, I was by all the rules of modern psychology on track to become a real mess. The great love that was showered on me must have helped save me from such a fate.

I had a faint heart murmur. My worried family saw to it that many cardiologists of Vilna earned good money for repeating to them the comforting diagnosis: I would be okay. However, instead of letting me walk on my own two feet, I was too often carried in my family's arms, metaphorically as well as physically.

One of the things I used to hate most was the feeling of being excluded from my parents' activities. They had busy lives full of social commitments. Whenever they went out in the evening, leaving me with the nanny and the housekeeper, I raged with fury. The women to whom I was entrusted would try to console me. They would read to me from my books, make my electric trains run, and even allow me to turn the radio's huge knob, normally off limits. In extreme circumstances they let me help them feed the heating stoves with egg-shaped chunks of compressed coal. This task jeopardized my pristine nightshirt. The women, aware of my obsession with cleanliness, believed that by letting me do a dirtying chore they could take my mind off my devastating feeling of abandonment.

Wintertime kept the apartment's stoves burning uninterruptedly. In spite of Vilna's bitterly cold winters they made one feel secure and protected. They were benevolent armoirelike constructions, of imaginative forms and rich ornamentation, covered by shining porcelain tiles. Beautiful domestic skyscrapers reaching to our home's high ceilings, they radiated warmth. But they had to be fed their coal daily.

On the particular evening of what later became known as my "life-saving exploit," I had remained inconsolable. Feeling abandoned, I did not give a damn about the stoves. When all other efforts to appease me failed, the young nanny and Xenia, the housekeeper, gave me a piece of that evening's dessert, a cake that Mother had strictly forbidden because it contained a strawberry preserve that gave me a rash. The two women did not believe in allergies. The cake, like all forbidden things, tasted great! Finally, reconciled with life, I went to bed and fell asleep. The squeak of the front door in the middle of the night woke me. My parents' giggling voices and suppressed laughter were proof of the wonderful occasion from which I had been unjustly, unfairly, brutally excluded. The feelings of abandonment that I had experienced before falling asleep returned now with intensified force. My parents must reach out and ask forgiveness! I knew that I wanted to see them at my bedside. They had to repent!

The most efficient way of calling them was to emit a low, steady sound of crying. At that age it was easy to produce. I knew that boys were not supposed to cry and that Father hated my doing it, but obvious reasons made me disregard his irritation. Fits of coughing were more productive than mere sobs, and I knew how to bring myself to prolonged chokinglike spasms that on other occasions came to me naturally. Aware of the power of my chronic bronchitis, I used it when I urgently needed their presence, and it always worked. Soon their loving, worried, and sleepy heads were hovering above my tear-drenched face, and the intermixed odor of sweat,

tobacco, alcohol, and male and female perfumes enveloped me in a capsule of protection and safety. I could insist now on my most daring demand: to be transported in my bed to their bedroom. They tried to negotiate, to put it off for another night, but I was relentless. Finally they picked up the bed and carried me to my desired destination. Straining with its weight they reassured me that I was the center of the world. Lying on my back I could observe a sequence of parading ceiling lamps and doorframes that gravitated around my small person. I knew these parades from similar occasions in the past, and I cherished my power.

As soon as I was installed in the proper place, under my parents' two large pastel portraits, which indicated that I had landed in the correct corner of their bedroom, next to my beloved old crib, I fell asleep.

I fell asleep and woke to the scene in which I was standing on my knees, covered by vomit, gasping for air, and emitting dreadful sounds. It was dark. The heavy bedroom curtains were not drawn, but the wintry sky let in very little light. Mother reached out for the switch of her bedside lamp. I saw her get out of the bed, make in the golden circle of the electric bulb a step or two in my direction, and fall with a heavy thud to the floor. Her nightgown landed in my vomit but she remained motionless.

The sound of her fall woke Father. Now it was his turn. His arm rose slowly into the air and quickly dropped. He seemed to be having great difficulty finding his usual agility. With visible effort he pushed away the bedcover, heaved himself to an upright position, seized a chair, and threw it at the window. An incredible blast pulverized the glass panes. Instantly icy air swept into the stifling room. Shimmering pieces of glass covered everything.

The housekeeper Xenia, in her flannel nightgown, disheveled hair, and bewildered face was at the door loudly invoking her God. "*Boje Moi!* What happened?"

Perhaps she believed He might suddenly appear. Dropping her hands quickly from their gesture of prayer, she reached for my father's pajamas and, covering her eyes with one hand, held them out to him with the other. Later, after I had been washed, put into a clean nightshirt, and permitted into my parents' bed, it was explained to me that apparently a collapse of the chimney's ashes had caused the bedroom stove to emit a very dangerous gas that had almost killed us. If it hadn't been for my throwing up the forbidden cake, all three of us might well have been found sleeping forever, forever.

"Sleeping forever?"

"Yes," Father told me, "the eternal sleep of people who try to liberate themselves from life's haunting problems." "Haunting problems? What are haunting problems?" My parents immediately reassured me, who did not understand their humor, that like everyone else they had their problems, but theirs weren't haunting and they had no desire to solve them this way.

I drank a lot of milk that made me vomit again. Mother and Father spent two days in bed, taking pills and recuperating. Time and again they told each other how very beautiful life was. And I was nicely tucked in where I felt that I definitely belonged: between the two of them. My pillow lay under the wooden headboard that vaguely depicted two stylized storks. I knew that those large birds pretended to the supernatural task of distributing newborns, but I was instructed to disbelieve such stories! Placed at the center of the bed's domain, under covers which, I had been told, had witnessed nine months before my birth the miracle of my conception (whatever this word meant), I experienced real bliss. If I was not the center of the universe, at least I was the center of our domestic world. The house was deluged with well-wishing friends. Grandmother Shifra donated a lot of money to the local synagogue to have some poor Jews say prayers and study the holy scriptures on our behalf. And life returned to normal.

Over the years I reflected often on this episode, trying to gather from it some lesson beyond the child's natural cherishing of unmerited praise. Years later when I recalled that distant night's events with Mother, she looked at me dumbfounded. She refused to believe that I so vividly remembered all these details. The subject had come up because we were discussing the behavior of one of my daughters who was going through an unusually obstinate stage. What was the moral of my own story? A spoiled brat had had his way because his parents were exhausted, too sleepy to impose reasonable limits. They finally gave in to a babyish caprice.

Had I then behaved obediently, the way I now expected my own children to behave, that is, to be good and remain quietly in their own rooms, my Mother and I would not be alive to have this present conversation. Mother lifted her shoulders. "It is troubling to think so, but maybe there is no moral to this story. Chance plays a role in our lives; but since we cannot control chance, let us do what our head, or maybe heart, indicates as the right thing." She looked at me with her clear eyes surrounded by lines that revealed how much sorrow she had seen in her relatively short life. "Loving you, feeling the depth of your childish distress, and carrying you in your heavy bed to our bedroom must have been the right thing to do. The rest came as a wonderful gift."

Sailing on Rachel's Wet Floor

Almost a Ritual

The sweet afternoons in my paternal grandparents' home were a well-established ritual. A simple walk led from our house to theirs.

It is a different matter getting there today, revisiting the place and recovering that period in time. But a magic wand from the kingdom of words dissolves ceilings, pushes away walls, turns the ground on which we walk into a sea of undulating waves. It carries us to far countries and reveals horizons that had seemed forever lost.

A man sits in a patched-up boat. His mast is the trunk of a tree that is firmly rooted in the soil. The sail, a discarded shroud. But his eyes, riveted to a page of a book, transport him on a never ending journey. This is the subject of a painting that I have entitled *Reader*. I was carefully applying its final varnish with a spray can, laying it on as lightly as possible so as not to risk smoothing away all the signs of my past struggle with the painting itself. A painting's process of maturation, its "past," is part of what the varnish must preserve. Applying varnish is an almost mechanical procedure that invites the mind to wander. An unexpected thought flashed through my mind.

Not totally unexpected! My entire being has for the past several months been plunged into the creation of this memoir, this fragmented collection of recollections, reflections, and confessions. Unable to respect chronological order, since feelings rather than a need for documentation have guided this unusual journey, I spend more hours of my day in the late thirties and forties of Vilna than in my present Weston home at the turn

of the twenty-first century. Thoughts are fast travelers. The painted boat has annulled in one second a gap of sixty years. Projected into one of my childhood's dearest playgrounds, I have landed in Grandmother Rachel's living room.

Now the painting is ready to go to the framer and I can return to the absorbing world of my past. The pungent smell of varnish is still in my nostrils. Little dry coughs try to expel its lingering particles from my throat. I quickly wash my hands and hurry to my downstairs study, to my word processor.

Once Every Week

This chapter is dedicated to the one afternoon of every week that I used to spend in Grandmother Rachel's domain. I said Grandmother, and I did not mention Grandfather Chayim, because I had always the feeling that in both lines of my close forebears, women and not men were the ultimate rulers.

Our housekeeper Xenia brought me regularly to Grandmother's home, which was in walking distance from ours. When it was very cold or when it rained we used a "droshki," a black carriage similar to the ones that cater to today's tourists. Sometimes, when a thick layer of snow covered Vilna's roundheaded cobblestones, sledges replaced the carriages' wheels, and every trip was accompanied by a festive sound of tiny bells that I loved. But even in wintertime I hoped for a pleasant stroll on foot, and I had my reasons.

There were three entrances to the cinemas that were located on our way to Grandmother Rachel's house. The movie theaters promoted current and forthcoming films with a rich display of black and white stills. My eyes used to devour them; I loved to enter their images and travel in their vistas. Warriors in various attires, captive beauties in bonds, magi-

cians and monsters, aristocrats in powdered wigs or bizarre top hats suggested awesome adventures. Luckily the presence of Xenia, the reassuring reality of the street, and the thick glass between the photographs and myself protected me from getting lost in their luring worlds. This ritual became an unchallenged custom. The movie stills nourished my imagination and populated my dreams. They also stimulated my conversations with Xenia.

Traces of her peculiar piety and the outlandish nature of her ideas could be detected in my innocent reports about our walks. Mother had warned me that the housekeeper's explanations were to be taken with the utmost reserve. But I was only five. Perhaps even today some of the housekeeper's popular beliefs, prejudices, and certitudes remain deposited under layers of old varnish in some forgotten place in my soul.

Our absorbing talks would make me lose the notion of time. My feet automatically zigzagged among uneven sidewalk stones. Eventually, like a welcome apparition, my grandparents' house would appear before us. The day presently on my mind was a Catholic holiday. It coincided with an event of the Russian Orthodox Church, and even the Jewish workmen had a day off. A great many bells were ringing. We approached the house's dull, light brown façade, now cracked, with many details of its brittle stucco ornaments long gone. The ornaments represented angels that by this period were badly injured, lacking parts of their wings, hands, or even heads. The upper three floors of the building had narrow balconies whose elaborate wrought iron balustrades were shaped in the form of menacingly entangled branches. Everything cried out for a thorough restoration, or at least a new coat of paint. The place had obviously known better times.

A sound of joyous children's voices resonated in the air, but the narrow street disappeared into a distant, foreboding emptiness. The tall bell tower of an adjacent church had gracefully shifted its shadow to let a sliver

of sunlight bathe the third-floor balustrade on which grandmother Rachel was leaning. She had seen us coming and signaled to us with her arm.

Until quite recently I had liked spending time on their balcony. It was a good place for the launching of soap bubbles. It also gave me a prospect of a busy street corner, a constantly changing view of horses, cars, and a multitude of hurrying passers-by. Unfortunately, an unexpected occurrence had ended my trust in the balcony's friendliness, teaching me to avoid the treacherous tentacles of the iron balustrade. More about that later.

Now Xenia's quick steps lead us to the gate, a dark tunnel-like passage made to accommodate a horse-drawn carriage. A massive door on the right opens to the vestibule of the master staircase. Xenia pulls me in by the hand, but despite her impatience I linger to look into the darkness of the familiar courtyard. A few upper windows, set between narrow walls, glow with the color of a darkening sky. Down below, in a far corner, is a small door to a much narrower staircase intended for "deliveries, domestic personnel, dissident politicians, or masters trying to escape their creditors," in the words of Grandfather Chayim.

Grandfather often accompanies such explanations with a faint smile that makes me wonder whether they are supposed to be taken seriously. The service stairs lead directly to all the kitchens on the various floors. It is also a place where the maids hold many important discussions. The courtyard, a rather elongated and shabby quadrant of cobblestones, strewn with old pails and discarded crates, often serves as a playground for children whose joyful voices, screams, shouts, or heartbreaking cries reverberate from its peeling walls.

On this day the courtyard's open gates have let some of this tumult escape into the narrow street. At times I think I would like to play with the building's unknown children, but I also know that for me this territory is forbidden. Do I regret it very much? The courtyard's life stirs up a faint curiosity, but I know that I feel much safer within the protecting

walls of Grandmother's apartment, or my own home, where I can share my play with the clean and well-behaved children of my parents' friends.

"I am in a hurry," says Xenia, pulling me by the hand. I anchor my feet in the ground and try to resist her. Whenever I am about to mount the staircase I cast a glance in the direction of the prohibited courtyard. I want to see the basement's two heavy trapdoors that rise from the ground in a mounting angle and lean against the building's wall. They serve for the unloading of coals for heating.

My Father the Hero

For my family these two trapdoors have a mythical dimension. It was there that Father, when he was twelve or thirteen, locked up two Christian boys his own age after having beaten them up and given them both a bloody nose. They had dared to call him " dirty Jew" and he had dared to teach them a lesson. They must have spent several hours locked in the pitch-dark coal cellar, moaning and crying. When Father finally liberated them—in the presence of his own father, the boys' distraught mothers, and a local policeman—their blood and their tears were mixed with the coal dust that covered them from head to foot. They looked like two miserable devils. At the sight of my father, and in spite of the policeman's protecting presence, they fled.

This is one of Grandfather Chayim's favorite stories. "Your father was a real *enfant terrible*," he always says, not hiding his pride. "We were lucky that a small bundle of cash, intended to compensate the families but gone astray in the official's pocket, settled the affair. The policeman was very kind and understanding."

A twinge in my heart tells me that I will never be a hero like my father. Can I ever be the "real man" that Father expects me to become? Perhaps I should find some alternative venue and strive for an excellence of my own.

The Welcome

At last Xenia's pulling hand overpowers me. We mount the stairs to the third floor. A dim light reveals walls painted to look like large squares of marble. My artistic judgment is awed by what must have been a passably executed job. I find entire worlds in those panels. Mountains spitting smoke, stormy seas, tempestuous skies, flying monsters, and vaporous angels intertwine with unsolicited cracks and some disrespectful deposits of flies. A smiling Rachel, whom we first saw on the balcony, is now standing on the landing. She stretches out her arms, lifts me up with a visible effort, presses me to her bosom, and rubs her cheek against my ear. I am invaded by the smell of a familiar perfume that comes from a dark blue bottle whose name resonates with the magical words of "Paris" and "soir." Grandmother, having lost the sense of smell, wears the perfume to give pleasure to others. Xenia is in a hurry to give pleasure to herself and wants to be in time for a special church service where she is to meet some friends. She promises to take me back before evening, mumbles a quick goodbye, and leaves.

Grandfather jumps out from the entrance hall with a growl. His eyes bulge and his fingers bend to make claws of his outstretched hands. I know his trick. He is a monster who is going to devour me.

To please him I feign being terrified.

His face undergoes a metamorphosis into his old handsome self. He recomposes and adjusts the buttons of his dark-red velvet jacket. Having pulled back with both hands his beautifully undulating white hair, he brushes his prickly moustache against the tip of my nose. He slowly lifts me up, breathing heavily, carries me to the hall of the apartment, and tries to throw and catch me as he used to when I was smaller. The effort shows in his face, and he quickly lowers me to the floor.

"How heavy you have become. My little demolisher, my sweet

wrecker, my appetizing provider of universal devastation, I am going to swallow you alive before you totally destroy this house!" He laughs louder than necessary. "What is on your mind today?"

Why does he ask me? I have nothing on my mind. He picks me up again and feigns biting my neck. It tickles me and I am shaken by convulsions of laughter, but my thoughts carefully assess the situation. Luckily, my past involuntary damages to their property have been tolerated and forgiven. It is encouraging! I promise myself to be particularly prudent today. It is a promise I gave Mother before leaving home for this visit. Now the laughter has subsided. I know for sure that I have a talent to amuse them.

"Stop it Chayml, please stop. This is not your son Joyne. You know well that the child is delicate and fragile."

A few more ups and downs of decreasing force, and some more heavy breathing, do not make me fly off into the air. Grandfather is totally exhausted, and I wonder if his effort to fatigue me doesn't tire him a lot more than it does me. Does he hope to make me less enterprising by wearing me down early in my visit? I have enjoyed Grandfather's forceful outpouring of love, but I am happy when it is over.

"Leave Samounia alone and go finish reading all those newspapers that litter my bedroom. Or, at least fold them up properly. They are going to spoil your health and give you ulcers. You and your many papers, as if any one of them weren't enough to make us sick with worries."

How Long Is Short?

Once Rachel closes the door we go to an adjacent guestroom. Automatically I take off my short pants and hand them over to her. She needs them for the regular alteration that she will execute quickly, as on all my other visits. I crawl into a small bed and she closes the door. Surrounded by a horde of horses, and an army of good-looking French cavalrymen, I

am listening to the ticking of the sewing machine and imagine it to be the sound of their hoofs. A whole battle scene is contained in a gilded frame of considerable thickness and is hanging over the bed. The soldiers, their uniforms, and the stains of their blood are as gray as the sky over their heads. Bulging gray clouds, which look more like a heavy smoke that has escaped from invisible stacks, float above a darkening horizon. The scene is made out of a myriad of tiny black lines. The beautiful horses, the dying men's faces, their uniforms as well as all the other details of the picture, are made of fine, tiny stripes. They are engravings, though I do not yet understand the process. I hope one day to be able to produce such art. For that I must grow up.

Strangers with smooth and brownish faces look at me through the glass of dark pictures framed in black wood. They are my grandparents' family, a collection of heads whose owners I have never encountered, nor ever will. While I crawl under the blanket, they acknowledge with the wise gaze of immobile eyes their awareness of this established ritual. Generally it is improper to walk around in underpants, but to show myself in this state to such serious and important people is very impolite. As soon as Grandmother will have finished her job of sewing, I'll get my pants back and put them on. They will have been lengthened by the addition of a fabric noticeably different from the rest. This addition shall make it clear that a boy's pants must descend to his knees.

A wordless discussion concerning the desired length of a small boy's pants has been going on between Mother and Grandmother Rachel. Wordless because expressed exclusively through sewing on these additions and removing them. In other respects their relationship is quite civil. It seems that no external law establishes rules in this particular matter. Unlike the length of ladies' skirts, which is decreed every year in the important capitals of fashion, and which every woman of sound mind (says Mother) accepts without questioning, a Vilna boy's pants, in the

year 1938, existed in a limbo of lawlessness. Rachel and Mother, after a failed verbal effort to come to some compromise, gave up any possibility of accord in this matter. Their disagreement was too extreme. Like weathered diplomats they agreed to disagree.

Mother liked the pants to be cut at the length of one finger below the crotch, because a little boy's naked thighs were very "appetizing," while Grandmother Rachel protested its "indecency." Acknowledging that personal modesty is a function of *Weltanschaung*, she stressed the practical argument that my chronic bronchitis was poorly served by excessively bare legs. Her additions to the length of my pants began rather timidly and in full harmony with the color and type of their fabric. Grandfather's business provided her with a limitless choice of samples. Mother saw in these additions an invasion of her territorial rights. Her diligent hands regularly unstitched Grandmother's work and Rachel, well aware of the disrespect to her opinion, passed to an offensive mode by making my pants increasingly longer and with totally incongruous textures, colors, and prints.

The two women must have seen in me a neutral ground for pursuing their ongoing battle. I was supposed to be as detached and as indifferent as my soulless and tongue-less pants, but my returns home, exposed to the amused stares of passers-by, were quite unpleasant. I felt I was an object of ridicule. Often Xenia made me mount the service stairs and enter our apartment through the kitchen, to prevent Father's patients from seeing me in my grotesque attire, and Mother saw to it that upon my return home from the afternoons with Rachel, I would always find a pair of ultrashort pants waiting for me.

"Jonas, your mother is too much used to having everything her way. I don't know what to say. With your poor father never daring to contradict her, this whole craze about Samek's pants has become totally insane." Father would not react. At most he would reply "You know my mother,"

which meant nothing, or maybe everything. Thus I felt torn between contradictory feelings: the unease of being an object of public derision, and the great pleasure of seeing myself so prominently at the center of a serious and important family struggle for power.

A Boat on a Domestic River

In Grandmother's house I pretend not to mind the elongated pants. By implicitly accepting her position, I gain greater leverage in my desire to be indulged, to be granted the unreserved fulfillment of all my whims. Grandmother is my only playmate in today's game of sailing on the river. She will sit on a chair behind the object representing my boat; her aching back will not permit her to join me on the living room floor. The room is slightly dark and a little claustrophobic. Heavy drapes of a thick and velvety fabric, secured to large metal rings riding on long poles of brass, block most of the daylight. The poles are fastened to the wall by elaborate brackets. A gap in the drapery reveals a fading afternoon sun. The light filters through an inner voile-like curtain and is reflected in the highly polished parquet. The whole picture reappears reversed in a mirror on the opposite wall.

The mirror is set in an elaborate structure of black wood, with shelves that look like small balconies. A good number of tiny porcelain aristocrats crowd the upper balconies, leaving the lower ones empty. I could certainly have arranged the figures better, but they are out of my reach. I wonder if they remember the time that they barely survived an ill-fated adventure on a merry-go-round.

The statuettes gleam with tiny luminous highlights on those extremities that remained unbroken. The same light is caught by the huge lacquered horn that surmounts a gramophone, once a dangerous merry-go-round. This horn tops a sturdy cabinet, whose little hanging padlock has condemned a world of famous singers' voices to life imprisonment. The

light finally fades into the ferocious eyes of a lion's head that sticks out from the end of a fat black leather sausage, the arm of a very heavy sofa. The lion's mouth tightly clasps a huge bronze ring. The rest of his body is concealed inside the padded leather arm, or perhaps there is no body at all, since I cannot find it by squeezing and probing. The sofa's other arm has an identical lion, which looks even more ferocious because he is partly hidden by the branch of a large palm like houseplant. A less visible danger is always more scary. I know well that the lions are not real. They are my friends. Their fearsomeness is needed for my game.

Grandmother and I pull on the sofa's arm, which as usual slips right out. I declare that this object is now my boat. We place the boat on the floor. "I know what you need," says Grandmother and she leaves the room.

I sit astride my boat and think. The image of Father comes to mind. Sitting in his small kayak on the Vilyia, he glides with a single oar locked in his muscular hands. Darkly suntanned, athletic, wet and glimmering in the sun, he is the most handsome of all fathers in the whole world. He smiles to me displaying his perfectly resplendent white teeth. The image is from a photograph in a shiny silver frame on Mother's night table.

No! For me a kayak is too small! I need something bigger, something more imposing. I must have a mast and a sail.

Grandmother arrives with a kitchen broom and tries to make me accept it as an oar for my boat. She doesn't see how ridiculous I would look with this object in my hand. I always use the broom as a hobbyhorse. They may employ my hobbyhorse for whatever purpose they want, but I know intimately its secret nature. She does not realize that it is impossible to ask a devoted horse to become an oar.

"And anyway I am not interested in a small boat," I try to explain. "It must have a mast and a huge sail. What I need is something like this." I take the broom from her hands and gesture at the long brass drapery rod. She takes the broom back with visible apprehension.

"Impossible. The drapery is fixed very tightly, so tightly that there is no way of taking it apart"

"Grandmother Shifra would have done it in a jiffy."

"Don't be too smart. Look how strongly the rod is attached. There is no way of removing it, believe me." Rachel points with the broom towards the corner where the rod is held up by a bracket.

"You see?" And to reinforce her words she pushes lightly against the bracket's delicate point of attachment. The heavy rod slides from its place, hangs at an angle, and sends the entire drapery slipping down to the floor. Like a sail lowered in panic, it lies crumpled in a heap. To add to our shock, the other bracket releases the dangling rod and it comes down with a blast, jumping and rolling across the floor. Surprisingly the room is flooded by a light that only a moment ago seemed to have been fading. I look intensely at Grandmother Rachel and try to understand whether I am permitted to let the huge pressure of my retained laughter escape, or if on the contrary such a situation demands sorrow and tears. She is bent in two, her hand holding her mouth and her body shaking.

Have I provoked something really bad? Is Grandmother totally devastated? Will they ever take me again for a whole afternoon? Something in my heart tells me not to worry. Their love does not permit such doubts.

Rachel collapses in laughter, tears rolling from her eyes; I join her, greatly relieved. Grandfather, who comes running, is observing us with a restrained expression, but his eyes betray his amusement. "How nice that you have finally decided to take down the drapes and let some light into the room."

"I haven't laughed like this for ages," says Rachel when she can speak. "I swear to you, it is not his fault." That is nice of her! She acknowledges her fault.

"Why don't you ask your grandmother to pour a few buckets of water on the floor? It will give you an excellent river, now that you have the mast

and, if I understand, the sails as well." I realize that Grandfather has been listening to our discussion. Even though Grandmother has tried to protect me, responsibility is returning to my shoulders. Grandfather's alludes to an earlier incident that had irritated him and had made him protest against Rachel's weakness in giving in to what he termed my "incredible whims."

Once, yielding to my insistence, Grandmother poured some water on the floor. Not more than a quarter, maybe half, hardly a full bucket. And as soon as the flood enabled me to extricate myself from a very delicate situation, it was quickly mopped up. I even helped her with this task. The delicate situation had been caused by a chain of events over which I had no control. The arm of the sofa, my transatlantic vessel, was stuck on an overturned chair that represented dangerous rocks. Only a rising tide could save us from the fast-approaching boat of cruel pirates (the other leather arm) whose vicious chief (another I) had ordered the seizure of all the first boat's occupants, my entire army of toy soldiers. Grandmother's water brought the tide that saved us from disaster. In that well-remembered incident Grandfather had left the room in anger. He had been very unfair to both of us! I am sorry he brought it up. It is a bad omen.

Perhaps it was partly to appease his memory that I painted the picture I had just varnished, in which a reader travels on dry land in an imaginary boat whose rooted mast reminds us that for journeys of the mind, one need not move in space.

Back in Rachel's living room my grandparents appear to have forgotten my most recent boating project. "Chayml, come, help me to fold the curtains. It is time to bring them to the cleaners. And you, Samounia, go at once to pee. Never forget to pee after a great commotion. It is indispensable for your health."

The Light Comes In

I know that whenever Grandmother has to tell her husband important

secrets, things that I am not supposed to hear, I must pee. Since I have started to go to a Yiddish-speaking kindergarten and my understanding of the new language has progressed, I am sent to the bathroom more and more often. Before reentering the living room, in which I shall discover Grandfather standing with the soles of his shoes on an upholstered chair, which I am told never to do, I can overhear them talking. I get closer to the door's frame but remain in the corridor. They remove and fold the curtains from the other windows. They speak of me. I hear that Grandmother's solemn voice scolds Grandfather. She is telling him that he should be much more careful. I am an exceptionally sensitive and highly imaginative child. He knows well that on top of my constant coughing I have a slight murmur in my heart, as if either one of these were not enough to worry everyone to death. He must always remember that emotional vexation can cause the murmur to worsen. Doesn't he realize how carefully I watch their expressions? It is inconceivable to let me imagine that they disapprove of me. He should try to dedicate more of his time and attention to me, man to man. He must profit from every occasion, and today offers a good one.

My entrance instantly changes the subject. Grandfather smiles at me. "Isn't it beautiful to have all this sun? Even the church, which robs us constantly of light, cannot prevent the sun from reaching these rooms." He looks at Grandmother: "Are you sure you need these heavy drapes at all? Look what a nice view they block."

This is further than she is ready to go. "Precisely, it is a view that I do not want to see. The church, the tower, all those bells, they make me sick."

An Important Date

Yesterday, March 4 (1998), was Mother's birthday, and it was also the birthday of Josée's father. Both have been dead for very many years. It was also the seventh anniversary of our wedding, which we had celebrated in

Vevey, at that time our residence, surrounded by my girls, Josée's family, and a group of close friends. We had chosen this particular date for our ceremony in order to mark by it fate's strange arrangement of coincidences.

At the end of the day I asked Josée to read the above pages, the result of my last two days of intense toil. I had stopped writing because it was late in the day, and I felt worn out. I was still with my grandparents, and they were folding their heavy drapes. They had to be left in the middle of performing their task and wait patiently for my return to the word processor. I told Josée that I wanted to have her reaction. Was I over-extending the story? Would it hold a reader's attention? What I really desired was to share with her some of my time in a beloved world that had been torn from me. I had often told her about Chayim and Rachel, given her other texts to read, and talked to her about my "lost Paradise." My grandparents had lived in a world far distant from hers. In the year she was born, they were murdered. Yesterday I wanted to take her with me to visit the apartment in which they had lived for more than twenty years of joys as well as pain. I know they did their utmost to hide their worries from me and that they pretended to joys they never had. But they turned that space into one of my dearest playgrounds.

After Josée had finished reading, she joined me in our open kitchen area. Her hand caressed my bald and peeling head (too much sun on our vacation in Martinique) and she told me that I hadn't changed much. I have remained the same "self-consciously scheming" Samounia. She well recognized the little boy who was discovering in his weak points a mighty force. "Luckily for me," said Josée "I have never let myself be drawn into such maneuvers." Her healthy attitude and mature scrutiny of our relationship guarantees a loving and durable alliance. "Remember. You must abandon any attempt to manipulate *me!*" Such discourse, often repeated, has become wholly familiar. We laughed. Weren't we fortunate to have each other? Yes, we were.

We had dinner, watched a disappointing film on television, and went to bed. The very early light of today was preceded by a crisp rectangle of moonshine in whose glimmer I opened my eyes. With the help of a small lamp, I tried to read a book. But my thoughts immediately departed to faraway Vilna. I switched off the lamp, closed my eyes, and there I was in my grandparents' living room. Chayim, with his shoes on the chair, was still holding the heavy drapes, while his free hand was trying to free the last of the dismounted brass rods from its metal bracket. The buttons of his dark-red velvet jacket, inserted into elaborately entangled ornaments of a crimson silk cord, were all undone. He was perspiring.

"Can't we take a break?" he pleaded.

"Why now, when we have almost finished?"

The drapery in his arms falls in soft and shiny folds and makes a huge heap on the floor. I approach him, and my hand delicately caresses the fabric. Of all the curtains that have embellished and sheltered my life, these were the most voluptuous. Their soft velvety fabric used to give to my touch a pleasure that made me almost shiver. It was a sensation more reassuring even than the touch of my irreplaceable companion of sleep, my beloved and balding teddy bear. Often, when alone in Rachel's living room, I would rub my cheek against the curtains' folds, and rub it again and again, repeatedly.

"Careful, careful. Don't step on the drapes. Your shoes will do irreparable damage to the delicate fabric."

"Yes, Grandfather. You are right! It was you who told me that we must learn to take good care of the things we love." Did I say it to myself or did I speak it out loud? I sense an inner pressure.

"Are you sure you don't have to pee?" I am not at all sure.

Did I dream it? I get out of bed. The luminous numbers on the dial of the radio that will soon wake Josée indicate that we are nearing 6 A.M. It is time to shed water. I ascertain with satisfaction and relief that I hadn't

had to get up in the middle of the night. My capricious prostate has behaved well. Have I substituted the possibility of a mysteriously invading cancer with the worry about an ancient heart murmur that has so far left me in relative peace? In spite of mounting PSA readings and a few biopsies, it has remained undetected. There is a good chance that it is nonexistent.

After all, Josée was right. I haven't changed that much.

I return from the bathroom, crawl back into our bed, and in a few minutes a bursting female voice, accompanied by a vigorous jazz band, tells us that a new day is born. So long as I am not asleep I accept being shaken by noisy alarm devices, though I dislike depending on them rather than on my own will power. My need for control prefers to remain unchallenged.

Processions of clocks of various shapes, sizes, and kinds, all constructed to stop one type of time in favor of another, revolve in my memory. Clocks have punctuated my life and made it fit the patterns of duty, though mostly by reaffirming (fortunately for me) choices I had already freely made. How many times have I awakened an hour or even two before the burst of their aggravating call, in order to outsmart the damned noisemaker and prevent it from tearing me away from my most interesting dreams? While my thoughts whirl, Josée starts to stretch. I cling to her with all the parts of my body. Her arm folds across my back. We remain immobile for a long stretch of time. The pleasure of touch has no age.

"Stop touching the fabric and come with me. I have something for you," says Grandfather Chayim, and he lets the curtain fall to the floor.

My fingers touch my word processor.

God in Chayim's Study

Leaving Rachel with her drapes, Grandfather and I pass to his study. It is a small room, littered with books, magazines, and old newspapers.

His messy desk displays at its center a heavy book that he must have pre-
pared for my visit.

"Wait for me. I have something for you," says Grandfather at the door.

I remain alone in the room and open a heavy leather-bound volume. It
had been published many years ago and is a history of Grandfather's old
enemies, the Russian royalty. The paper that smells of stale fish is very
smooth, almost shiny, and has a yellowish tint and many tiny dark stains.
It is filled with dozens of engraved images. Bearded moujiks with crowns
on their heads populate the first part of the book. The middle is filled with
elegant gentlemen in powdered wigs and others with prominent side-
burns. Faces with beards of all sorts decorate the final pages. The men's
wise eyes look confidently into a distant and stable future. I love to study
their portraits. Many of these royal persons should have suffocated in
their very high and stiff collars or collapsed under the sheer weight of the
medals that cover their tight-fitting uniforms, but their breasts are crossed
by especially large ribbons that seem to sustain them. What I most admire
are the epaulettes. They look like ping-pong rackets that have been gar-
nished with fringes of little cords. I quickly give up any effort to guess
their purpose.

Gracious ladies in skirts that look like Grandmother's lampshades add
a feminine touch to the book. But none of them is as important as Kather-
ine the Great, whose portrait takes up an entire page. She is the only
queen I can identify by name. From various sources of information,
mostly Xenia, I deduced that she did not like to fall asleep alone and that
she had a special trap in her bedroom through which those who loved her
were sent to torture and execution. This, of course, contradicts Grandfa-
ther's warning that we have to take good care of people we love and who
love us, and explains why he hated Russian royalty.

The most fascinating image, to which I love to return whenever I han-
dle the pages of this book, is a painting by Repin that depicts Czar Ivan

the Terrible. I wonder what the czar must have thought when he heard people call him this name. Being notoriously cruel, he doubtless sent them to the executioner. In Repin's picture the czar has collapsed to the floor. He is in a palace room that is strewn with heaps of carpets and precious fabrics, like our dining-room drapes that must go to the cleaners. Ivan is clutching in his arms the dead body of his only son, the czarevitch, whom he has just killed with his own hands. The czar's crazy eyes bulge and seem to be popping out from his terrifying face.

Grandfather Khone, my other grandfather, often speaks to me about this painting. On one of his unfortunate military adventures, while everyone was praying for his safe return, instead of taking the first train back to Vilna he went to St. Petersburg to visit one of the world's most famous museums, the Hermitage. He had a good look at Repin's original painting on which was based the engraving in Chayim's book and he assured me that the print does not convey the power of the immensely large canvas. Trying to understand the mystery of the artist's skill, Grandfather Khone went back and forth, back and forth, looking up close at the artist's handling of the paint, and then from a distance, where the illusion of reality seemed more real than life. From very near all he saw was what the working artist saw, canvas and blotches of oil paint applied one over another and looking like a mess. From a distance he was in another time and place, witness to a terrible event.

" I have never figured out how it works. How is it that distance makes us understand what nearness does not. Samounia, you will have to study these secrets when you grow up."

What most remained with him, of all the hundreds of paintings that were hanging in that museum, was the crazy gaze of Ivan's devastated eyes. Of all the painted surfaces of all the canvases he had ever seen, this tiny tangle of brush strokes contained the greatest mystery.

As I study the engraving I think to myself: if an artist's greatness

depends on his ability to recreate in its finest details a scene from hundreds of years before his birth, I shall have to go further than Repin. To overtake him and not disappoint my family, I shall have to paint scenes that happened thousands of years before my birth.

Perhaps one day I shall paint Abraham, gone completely mad with grief, holding in his arms the dead body of his bound son Isaac. A slight delay in the angel's arrival has changed the whole story. It is a great subject for an impressive painting. The story of the bound child haunts me. Whatever its outcome, even when the angel prevents the killing, the tale raises many questions. I wouldn't wish on anyone an irresponsible father like Abraham, capable of planning to kill his offspring. Even if he was trying to appease a cruel god, this wasn't a thing to inflict on a child.

I am absolutely sure that my own father would never let himself be trapped into such a situation. For no reason in the universe would he envisage the possibility of exposing me to a scare like the one Abraham gave Isaac. Fear alone could have killed the poor boy. I imagine him, tied up like a roast, his heart pounding so wildly that he can hardly even beg for his life. Mother, who is my main provider of tales from the Bible, tells me that the stories are more complicated than they seem. They are full of hidden meanings. One has to grow up and study them. But I think studies are one thing, and dying of fear is quite another. I am really sorry for Isaac.

Occasionally our Jewish God becomes a subject of conversation between my two pairs of grandparents. Shifra does not like to hear what the others have to say. In her relationship with Him she is forgiving, tolerant, and accepting. But these conversations are rare, and usually provoked by my questions. Most of the time the four of them share jokes and laugh. Every child knows that in order to retain pleasant relationships one must avoid certain subjects or raise them only when some shouting and yelling would make everyone feel better.

All these reflections run through my mind when Grandfather Chayim

appears holding the alarm clock that usually stands at his bedside.

"Look what I have for you!" He knows I have a passion for taking apart clocks.

"But Grandfather, this is your clock. You always use it."

"Who needs a clock? It ticks with a lot a noise that doesn't let me sleep. When it rings, it does it mostly at wrong hours. Sometimes it makes me jump up from the deepest sleep and my pounding heart seems to burst. You will do me a mitzvah if you take it from me. Take it home and work on it. From now on I shall have every right to expect that your grandmother will take it upon herself to wake me whenever I have to get up at a given time. Maybe she will do it more softly than the mechanical device. Yes, yes, no, no. At my age I have the right to be late. It is good to be late. In particular, when the *Malakhamoves* is waiting."

Grandfather doesn't know that I understand the meaning of this strange word. He believes that I think it is the name of one of his clients. But I know that in Hebrew it means the Angel of Death.

Something touches me and I feel sad, as if the angel's dark wings were casting a passing shadow over the two of us. I have little capacity to grasp the meaning of the words dying and death, yet they affect me. These are words that belong to games or stories, not to my person or to those dear to me. I am unable to imagine my loved ones' not existing. My sadness comes from the expression on Grandfather's face.

"I can easily repair it for you. I can make it go very slow or very fast, as you wish."

My face becomes red. I have greatly exaggerated my skills. Of all the various clocks that I have taken apart and then tried to put together, only one has ever ticked again. It ticked very fast for a whole minute and then it died. The others were forsaken victims of my clockmaking practice, now deposited with their tangled inner parts in a cardboard box under my bed.

"I shall take it home and bring it back to you on my next visit. It will tick much more softly and ring only when you are awake, so that it doesn't scare you."

Grandfather puts his fingers into my unruly hair and combs it with a slow and caressing movement. He gently pinches my cheek between his thumb and forefinger, catches the tip of my nose, pretends that he has put it into his pocket, and proclaims with a practical seriousness: "You will have your nose back after you take a nap." I accept the rules of the game.

"I cannot nap without my nose. My mouth is stuck and I must breathe through my nose."

"Smart boy! Will you take a nap if I give you back your nose now?"

"Yes," I say with little conviction. A quick gesture gives me back my nose.

"Let's go."

"But I hate to nap. I cannot sleep in the middle of the afternoon."

"Try."

"I never nap at home"

"Try"

"Not more than ten minutes . . . No, nine, no eight . . ."

He laughs, takes me by my hand, and tries to move in the direction of the guestroom.

"No, no, no, no. . ."

"But we have a deal."

"Not in the room with all those faces and horses. They scare me."

This is not true. Since I have become a big boy they scare me very little and only at night, when the light is dim. But I profit from recalling the time I awoke from my nap to find myself in that room filled with all those unfamiliar faces. I was totally disoriented. I screamed and screamed, and they had to take down all the pictures, turn them on their backs, and lean them against the wall.

"It is all right if I sleep in your big bed?"

"It's a deal!" Their bedroom is a territory that merits exploration. We pass to a corridor that leads us there.

Chayim's Business

To the left are doors to Grandfather's business, all that has remained of his "Tailor of Paris, Fine Clothier for Vilna's Discerning Gentlemen."

A small room contains shelves that are loaded with rolls of cloth in black and in various shades of gray and brown with textures and stripes of all kinds. Boxes of lining fabrics and other accessories are piled up on the floor. The room is guarded by three dummies, two male and one female, tailor's mannequins. Those amputated beings could have profited from having heads and members to give them a more animated air. Turned into giant marionettes they would better display Grandfather's art. As they are, they are kin to the imperfect ornaments on the building's facade. Condemned to an idle existence, they pivot aimlessly on the wooden lances on which they are impaled. Each upright lance stands on three feet. Three and not two, which is an insult to the dummies' longing for something of their human origin. Being reduced to a mere torso is a horrendous misfortune that commands respect. I have learned to treat them with consideration. Because of the risk of making them fall to the floor, it is inadvisable to spin them around. They are heavy and particularly dangerous for children. A year ago I barely avoided a very bad experience with the female dummy. Though she had lost her head, a visceral instinct of maternal origin made her crash to the side opposite where I was standing, saving me from bad injury.

The second room serves for fittings. It is here that an imposing Grandfather, impeccably dressed, performs his most dangerous work. He is equipped with a tape measure that hangs around his neck and a piece of white chalk in his right hand. The danger does not come from the dan-

gling tape, but from the multitude of pins that he holds in his tightly clenched lips. The chalk leaves on his immobile clients all kinds of mysterious signs. The pins are inserted into the clients, but they rarely cry out. The new garments that have been diligently prepared by his two tailors, covered by huge stitches of white thread, are often ripped apart again, paf! paf! to be reassembled in a slightly different fashion. The clients often look as if they would like to converse, but they must keep quiet because any attempt to make him talk might cause Grandfather Chayim to swallow the pins. This could result in a lot of suffering and a horrible death. But my grandfather is not afraid. He is as courageous now as he was in the times he fought the czar and escaped the police.

All this ceremony of fitting and refitting happens in front of the most magical arrangement of mirrors. Made of three wings, of which two are movable, it permits me, whenever they are not in use, to shut myself in a dark triangular space. Inside I am instantly transported to a huge field that is covered by thousands of boys, all of whom look exactly like me. When I open the flaps, I am observed by elegant gentlemen in evening garb, business attire, or smart sport clothes smoking pipes, cigars, or cigarettes. They hang in various groups, properly framed, on the room's walls, and look with total indifference at my patched-up pants. Two men in knickerbockers hint to me that in time I will be relieved of my short pants and promoted to the intermediary stage of knickerbockers, a stage that does not require full adulthood. They seem to empathize with me.

The third, much bigger, room of Grandfather's domain is the place where the real sewing is done. The work is often accompanied by singing, talking, quarreling, and joking. But today it is quiet because of the holiday. This is the room where I am usually supposed to say hello to Grandfather's two tailors.

Alter, Berl, and the Third Man

Alter, a youngish man with pale, thin orange hair, a pale face plagued by pimples, and a smiling mouth with sparse teeth, is always jovial. *Alter* in Yiddish means old. I was amazed that a young man would be called that. Grandfather explained that several years ago Alter was fighting a terrible infection and seemed to be on his deathbed. His desperate parents decided to rename him in order to increase his chances of survival. What the most expensive medications could not achieve was accomplished by a simple renaming. This may explain why Mr. Cahanowitch, the accountant from downstairs, recently changed his name to Krakowski.

The second tailor, Berl, is much shorter and older. He is proud of his three golden teeth that must have cost him months of work. His small piercing eyes are set in a head of curly black hair, and his pants are kept in place by sturdy suspenders stretched over a protruding belly. "Do you know, Samek, why all American men wear suspenders?" I have heard it before, but I let him tell me since he loves laughing at his own jokes. "Because the world as you know is round, and since they walk upside down, the suspenders keep them from falling out of their pants."

He laughs, showing his gums as well as his teeth. I am not sure I like him. He loves to pinch my ear till it hurts. He thinks this is funny and that we are playing a game in which I am provoking him. If I hold my ear with my hand and make a very sad face, Berl takes me on his knees and, slowly turning the wheel of the machine, lets me punch out lines of tiny holes on sheets of discarded paper patterns and suffuses me with his sour breath.

Both tailors are skilled workers. Sitting at the sewing machines with their feet firmly placed on the balancing platforms of cast iron, they speed and slow down the wheels as if their feet had minds of their own. They are cheerful and proud of their craft, but in the presence of clients, when-

ever they are called to assist Grandfather in the fittings, they become timid and self-effacing.

A third tailor, a thin man who never takes off his cap, with a narrow face whose cheeks and chin are covered by a permanent shadow, is the specialist of pants. He comes in to get measurements and cloth and sews the pants at home where he cares for his sick wife. They say he likes to linger for endless hours, engaging everybody in idle discussion, as if to postpone the moment of return to his depressing lodgings. I see him rarely, and I have never had the chance to ask him about the appropriate length for a boy's pants. This conversation would not have been idle. I do not remember his name.

The trouser-man treats the two tailors, who hold steady jobs, with a lot of respect. Alter and Berl are obsequious toward Grandfather, who in turn is very polite with his clients. His refinement attracts clients, and it keeps him in business. After his clients leave, Grandfather often calls them "morons." But he does not mimic them the way Aunt Tsilla does her patrons. Each group seems to know its place. The world's globe, on which every man seems contented with his fate, spins smoothly on. It makes me think of a tailor's dummy impaled on its invisible lance.

Little Samek walks down a poorly lit corridor. Chayim's hand lays gently on his shoulder. They pass the room where Alter and Berl have spent innumerable hours of their lives. In three or four years, they, as well as their children, spouses, relatives, neighbors, employers, and tens of thousands of other men, women, and children, will be taken by force to Ponar and turned into dead bodies dumped in a pile. The sheer weight of cadavers will flatten them into an anonymous similarity. The Nazis will call them *figuren* and will force Jewish prisoners, in leg-irons, to dig them out and burn them, transforming their remains into smoke and ashes. The dead will achieve a degree of equality that does not exist in the most egalitarian of societies.

Berl's golden teeth, deposited in a safe place, will become an uncomfortable item for the case of the prosecution. Was Berl called Berl? Wasn't it Motl or maybe Yankel?

In the Bedroom

We reach the end of the corridor. Grandfather opens the door of the bedroom, and we are bathed in an orange light. It filters through the gold-colored satin curtain covering a window overlooking the courtyard. To permit the flow of fresh air, a glass pane has been left slightly open, giving the curtain a life of its own. Animated voices rise from below. There is no school and many children play outdoors. Hesitatingly I sit on the bed. "You can go now, I'm fine."

"Good boy."

Grandfather collects the newspapers that are on the bed and on the floor. He softly closes the door. It squeaks. Air that filters through the pane continues slowly to move the curtain. The swellings and the contractions of the silky fabric hypnotize me. The moving folds stir in me a suspicion that someone might be hiding there. Too small to be the size of an adult person, it could be a dwarf. My heart beats faster. Time passes. Finally I get up, and with trepidation verify that my fear was unfounded. The cool air brings with it a good share of outdoor noises. A small handle that seems to be stuck holds the pane open. I try in vain to close it. The courtyard, seen from above, reveals to me a group of boys in strong foreshortening, who appear and disappear from my sight. They must be playing cops and robbers. Prisoners are being mishandled or shot. My courtyard also swarms with noisy boys. A familiar feeling of contradictory desires returns to me. I would like to be with them, and at the same time I am glad to be far away.

"Is this your nap?" Grandmother is at the door.

"I couldn't close the window. The noise won't let me fall asleep."

"Chayiml, Chayiml," mutters Grandmother quietly to herself" How can I trust you with the child?" She closes the window, draws the curtain, helps me to take off my shoes, spreads a blanket on the bed and makes me lie down. She covers me, tucks me in, and places a wet kiss on my forehead, which as soon as she is gone I will have to dry with the back of my hand. She wishes me a good sleep and goes out the door. I cry out "Remember to wake me in six minutes," but she doesn't answer. She pretends not to hear me.

For a moment I remain immobilized by the blanket's binding folds and enjoy being a prisoner. The helplessness exonerates me from any responsibility and gives me a strange feeling of freedom. I turn to the right and to the left, let the blanket loosen its grip, fall to the floor. I am not going to close my eyes. I am afraid to sleep. Last night I had one of those frightening visions that have lately tormented me. Mother who rushed to my bed in the middle of the night told me that it was a bad dream. Had I known at the time that I was dreaming, that it wasn't real and that only a horrible nightmare was afflicting me, I would never have let myself reach such a state of despair.

BEING KIDNAPPED

I was in my bed and my room was dark.

One of its two doors had been left partly open, disclosing in its luminous gap a section of our dining-room wall. On the heavily decorated wallpaper shadows were dancing. I could hear the voices of noisy guests as well as the clatter of cutlery and glasses. The soft laughter of my parents, who were the hosts, stood out in the hubbub. Loud music was being played. They must have forgotten about me! It was impossible to sleep with all that noise, and I felt angry. How very, very unfair it was to send me to my bed, to tell me to sleep in the midst of this incredible hullabaloo.

A squeak of the other door startled me and made me jump up and look in that direction. Two rugged men of incredible size, carrying a thick blanket in their huge hands, came over to my bed. They told me to get up. Moving slowly, as if they did not care to be discovered, they started to wrap me up. I fought to have my head free, to be able to keep on breathing. Fear paralyzed me. One of them lifted and moved me to the door from which they came. It opened directly to the service staircase. Suddenly I realized how odd it was. Never before had I noticed this strange exit.

My heart was pounding with a force that seemed to tear it out of my chest. I wanted to shout.

I wanted to call for help, but no sound came.

I knew that I had to alert my parents, whose party was going full steam.

My soundless screaming continued, as if I were a fish in a water tank. I was being carried down the staircase. The men were gypsies, or some other strangers. Delinquents specialized in the kidnapping of children. I was lost. At the last moment, having mobilized the last bit of my energy, my extreme effort produced a result.

A shrieking howl burst from my throat.

Its force projected me from the pillow straight into Mother's comforting arms. I sobbed so heavily that I couldn't breathe. It took me a long while to calm down. Later, locked in Mother's warm embrace, listening to the appeasing sound of her slow breathing accompanied by a light and tender snoring, other experiences of the same dream rose to my memory. I promised myself never to fall asleep again.

Now I am determined not to have this nap in my grandparents' bed! Definitely not!

The window's double panes of glass that Grandmother has so thor-

oughly closed protect my peace, and the motionless curtain immerses me in a world of orange quietude. Thoughts keep sweeping through my mind. Grandfather's subdued voice carries through the wall. It is steady and monotonous. He must be reading something aloud to Rachel from a paper spread on the kitchen table. It is the place where he is allowed to read to her while she works. I don't know what her tasks are. Their maid, who comes every day except holidays (like today), does most of the cooking. Since Grandmother lost the senses of taste and of smell after the terrible illness that had almost killed her, she does not trust herself to prepare food. Her appetite is small. Rachel is rather slender. One of Shifra's dresses could make two dresses for Rachel. I might be slightly exaggerating.

There were times when Shifra was thinner. A brown picture of her with Khone, Rachel and Chayim, and their children, hangs on the wall. In another photograph I recognize Father in the uniform of a Polish soldier with Mother at his side; they are holding hands. My eyes move to Father on one of his motorcycles. He holds the handgrips with powerful arms that display his iron muscles. In the background are several horses with sacks on their noses. He smiles. Luckily the horses don't know that one of their kind was killed by Father's deadly motorcycle. Apparently a hole in the ground threw him into the air and onto a haystack. A horse that had been pulling a heavy cart absorbed the machine's impact and paid for it with his life. Luckily Father was unharmed. He only ended up with a lot of hay in his hair. The driver, a dumbfounded peasant, received from Father a vigorous beating "as a precaution against any complaint to the police." Later, several banknotes covered the cost of a new horse and put everything back into good order. Another motorcycle replaced the badly damaged one. Father said that it was much safer because it had more horsepower.

There is nothing I hate more than riding on the back of Father's

vicious machine. The noise, the bumps of the road, the speed with which everything flashes by my eyes, and above all the mounting nausea turn it into a dreaded ordeal. When he makes me sit behind him with my arms clutching his jacket and all my being praying for the nightmare to end, I close my eyes and try to hold back all the stuff that my stomach wants to expel. Luckily since the time I threw up all over his leather jacket and pants, he has never again asked me to come for a ride. I know I have badly disappointed him. He wants me to be like him. Strong, manly, and courageous!

A much better photograph shows Father in his office with Dr. F., his associate. The associate is a dental surgeon. Father's specialty has to do with the reconstruction of teeth and the creation of special dentures but doesn't allow him to blazon himself with the title of "Doctor." The fact that he is now much solicited in his profession and earns good money must partly console his regret. Sometimes Father mentions the "numerus clausus," the law that limits the number of Jews admitted to Polish medical schools. He claims that this is what prevented him from putting the beautiful two letters "Dr." before Jonas Bak. Whenever he says it, Mother tells him not to make her laugh; this is a story he can tell to anybody, but not to her. She has a different explanation. His sleeping late and his passions for cards, drinking, dancing, and above all for hunting and pursuing women have taken from him what no Polish law could have denied a totally determined person, serious, devoted, and armed with ambition and willpower. I was never supposed to eavesdrop on such conversations.

I leave the photographs and climb on the bed. Its footboard is made of an intricate structure of metal rods. Large spheres of polished brass top the bed's four posts. Each one of them makes me think of Grandfather Khone's recent gift, a terrestrial globe with all its continents. Since a mechanically moving toy tank had pushed it with its cannon to the brink of a table where it fell and got terribly damaged, our planet stands now

on the top of my room's cupboard, showing to the public its miraculously undamaged hemisphere, America.

The brass spheres mirror a distorted image of the room. It resembles images that are reflected on the ephemeral skin of soap bubbles. Like the world, each brass sphere turns on an axis. I give it a light spin; it turns joyfully, comes off from the screwlike attachment, rolls to the floor, and disappears under Grandmother's armoire.

I try to reach the fallen sphere with my hand but it is too far. I try to hit it with Grandfather's slippers, but also they remain stuck under the armoire. How could I reach them? I open the armoire's doors and make a discovery. What I see between the mirrors of the open doors is a space that I thought existed only in Grandfather's fitting room. Here it shows me a procession of Sameks. We are in the thousands. I can make faces, and all of us repeat them after me, but I can also stand like an obedient soldier at roll call, and all of us are obediently ready to receive orders. I stretch out my arm and point my finger at the boy in front of me. I shoot him: Boom, boom, and boom. It is too late. He has made the identical gesture at the very same instant and has produced an analogous sound with the same result, as he must have hoped he would do. What a dangerous game!

Grandfather's voice comes from afar. My grandparents must be still in the kitchen. The field of action is free. I push the door to the corridor and it opens without the least squeak. My shoeless feet make no noise. Now I am a young gypsy looking to kidnap elderly persons. Reentering the salon I see on the very bottom of the large mirror my head, as if it were floating, separated from my body. I become a lion. I try imagining how I would look with a metal ring in my mouth.

The French porcelain aristocrats crowding the upper shelves are turned in my direction. They recognize me without displeasure, and their attitude reassures me. Father, who took it on himself to glue them back

together, must have done a good job. They have accepted their few missing details and faint cracks with pride and no hint of annoyance.

Music and Revolution

I hope the aristocrats are grateful for the good time I gave them. It all started with Grandfather's decision to make me listen to what he called "some incredible voices." He kept them under his gramophone, in a special cabinet. The voices were inserted into black discs of a very breakable material, totally forbidden to a child's touch.

An endless number of deep grooves, methodically arranged in a single spiral, contain music that can only be extracted by scratching it out with a little needle. Since this would be difficult to do by hand, a round head like a yo-yo attached to a movable arm keeps the needle firmly in place. An appropriate mechanism turns the disk, while the needle travels slowly from the outside toward the center of the record and produces a sound of music, singing and scratching. Passing through a huge horn it pours out and reverberates through the room. The people who sing for Grandfather are forever unhappy and complaining.

In order to listen to all that one had to turn a handle identical to the one Xenia used for mincing meat. While the meat mincing would become increasingly easier as the pieces of what had once been a living animal metamorphosed into thick brown noodles, the gramophone's effect was the reverse. Its handle grew stiffer as one turned, and finally stopped when the "home concert" was ready to begin. One had only to release a small lever that regulated the speed of the turntable, and living music would pour out. I was permitted to touch this small lever, which was the only thing that guaranteed real fun. Pushing it from left to right turned male voices into female ones, and vice versa. By making the mechanism go slowly, the voice of a famous soprano would become very grave and spooky.

Once, while Grandfather was playing for me one of his favorite recordings and was trying to explain why I should like it, the doorbell announced the arrival of an unexpected client. He had to leave me, and I promised to be a very good boy. Rachel was away on one of her errands. All by myself I listened in the semidark salon to an ever mutating voice. It was spooky!

When the turntable stopped, a brilliant idea popped into my mind. I took off a safety pin that invisibly substituted for a missing button on my shirt (a secret between a hurrying Xenia and myself) and opened it up. Firmly clenching its head and holding its point between my thumb and the index finger, I introduced it into the record's groove. My attempt to produce with it the familiar sounds encountered an unexpected difficulty. I scratched and I scratched. I followed the grooves with even greater care and intensified the needle's pressure, but nothing came of it. After having tried it on four or five records, of which only one broke apart, I gave up. I was particularly sorry for the one broken record. I told myself that it was not my fault. I had been as careful as possible. The record must have had an ancient crack. When Grandmother returned from town, we mourned its loss. Grandfather was busy with his client. I was happy that Xenia arrived sooner than expected. I left before Grandfather discovered the damage. Next week's visit revealed a small lock that was hanging on the cabinet's door. It was a troubling sign. Trying to test Grandfather I asked him, offhand, if I could listen to some music.

"Immediately," he said " Let me find the key." He moved to the door. "Why is it locked?"

"Haven't you heard? Gypsies are burglarizing homes in search of precious collections of records." Gypsies? A shudder went through my body. If disappointed with the collections of records, the gypsies might take the children and leave.

He left for the key and returned looking very disappointed. I offered

my help. But we were unable to find it, even after searching every corner of the house. Grandfather lifted his finger and scratched his temple. It was a sign that he was thinking. "It is possible that my 'pants-maker' inadvertently put it in his pocket. Let me ask him when he comes next month." Luckily our joint search for the lost key produced many forgotten objects that were re-proposed as challenging material for new games.

The locked cabinet now confines what remains of the voices of Smidt, Kiepura, Caruso, Galli-Curci, and Chaliapine in Grandfather's records. He is very proud of me that I am able to memorize such complicated names. But what are names without their voices? The unemployed gramophone looks abandoned and sad. The two collections, the one of porcelain figurines and the other of records, had been ignoring each other for years, as my grandparents and their Christian neighbors often did. It was my well-meaning intention to introduce the one group to the experience of the other that caused an unforeseeable disaster and resulted in the figurines' all being crowded onto those unreachable high shelves.

It began with my discovery that by fully releasing the little lever I could rotate the turntable at a remarkable speed. A few weeks earlier, I had thrown up while riding a wooden horse on a merry-go-round. The other children had no problem with this type of motion and seemed to enjoy the treat. But the merry-go-round and I were not meant for each other. Now the turntable was rotating. I had my own merry-go-round; there was no need to accept in person its unpleasant consequences, and all that was missing was an appropriate clientele.

Suddenly all the porcelain figurines looked at me with imploring eyes. Well aware of how delicate they were, I knew I had to handle them with great care. First I blocked the turning surface. Then I mounted a chair, got the figurines down, and placed them in a nice circle on the turntable's outer rim. Later I filled its center. A country boy with his little dog stood next to a huge-skirted lady who hid her face with a fan. Very

refined, she did not want to see why the dog's leg was lifted. A ballerina standing on one toe was firmly anchored to the ground by a cloud-like protuberance. Two elderly gentlemen with glasses in their hands, absorbed in sipping their wine, were ignoring all the others. Two white horses were the most appropriate elements of the arrangement. I was sorry to have only two of them. Other figurines resembled the elegant princes and princesses in Grandfather's book of Russian history. This whole joyous company was going to experience something unusual. They were going to have the time of their lives.

I gave a slight push on the lever and they began circling. It was very slow and uninteresting. I pushed the lever harder and the merry-go-round sped up. I wondered what happens to porcelain figurines when they feel bad? Do they throw up? Before I was able to find out, the turning table, possibly angry at being exploited for a purpose not its own, began ejecting the poor figurines. They flew in every possible direction, with the greatest hurt to those who soared farthest.

Dumbfounded I looked at the bits and pieces littering the floor and started to cry. There was a slam of the entrance door. Grandmother was standing in the living room, still in her coat and hat, and with a more than surprised expression. Grandfather too rushed to the room. He remained in the doorway for a second or two before being pushed away by Grandmother's nervous hands. I knew that to cry loudly was in my vital interest.

She rushed to embrace me. "*A kapore, a kapore. Tfu, tfu, tfu!*" Al my grandparents think that material offerings, what they called *kapores*, guarantee reparation.

"My grandson has brought the French Revolution to our home. Look at all the aristocrats who have lost their heads. You, my boy, must have inherited something from somebody I know in this family."

"Chayim, stop your irony. Stop it immediately. Can't you see how shaken the poor child is?"

Later the reparation was produced by Father's clever fingers and not by a superior force. With the special tools and materials that were used in dentistry he put together, as well as possible, all the bits and pieces of the unlucky figurines. From a distance they looked the same. Relegated to the highest shelves, to a place that no chair would allow me to reach, they now live in the most cramped conditions. Their life after the revolution is not as ostentatious as it used to be. I make a sign to my porcelain friends and leave the salon. I am not a gypsy nor am I a lion. My steps are very silent. I am Samek who will pretend that he has just woken up.

In the frame of the kitchen's door I can see Grandmother. Her face is troubled. Grandfather is folding the papers, and his voice sounds angry. "The wild beast! Destroying his own country does not suffice, he must move to the West and to the South and to the East. It might be the right time to sell everything and pack our cases."

"And where would we go? At our age . . ." Grandmother sees me in the door." Here you are! You must feel all rested. Do you see how wonderful it is when you are invigorated by a healthy nap? Chayml, please bring me Samek's shoes, he shouldn't walk around in his socks."

Grandfather returns with my shoes in his hand. "Rachel my love, have you seen my slippers? I wonder where I could have left them . . ." I have completely forgotten my intention of picking up my hobby horse and putting everything back in place.

The Art of Bubbles

We sit on the chairs that surround the dining table. Intricately sculpted, they do not like it when people lean against their backs. I sit on my legs, in a tailor's position. It adds to my height and makes me feel older. I sip a glass of milk and chew the little squares of cut up sandwiches I adore—Grandmother's little canapés, made of pumpernickel, butter, and very stiff honey.

The door to the balcony is open, and I observe its balustrade of wrought iron. Black branches of an imaginary tree, bearing mysterious fruit, spread in every direction. I vividly remember the scare it gave me not long ago. It was a beautifully sunny day, and I was leaning against a metal branch with one of my feet inserted into the balustrade, while my hand dipped a straw in a small bowl filled with soapy water. I was sending out soap bubbles. A gentle wind carried them great distances. I refused to consider the ones that exploded in flight. I hoped that others would go on floating forever.

Each balloon was a small planet. Each one reflected the image of our world. It also contained my breath, perhaps a particle of my soul. (The soul, one of Xenia's big concerns.) In my imagination I was as light as they were, and I was floating above the roofs of Vilna. In this dreamlike state I released the bowl with the soapy water. It fell from my hand, and with a big splash landed on the balcony's floor. A lot of the soapy liquid fell into the street.

A shrill female voice started to yell.

It belonged to a tiny woman whose hand vigorously shook out her hat. Was this innocuous liquid doing her harm? With a lifted fist she menaced me. I wanted to escape indoors, but a wrong movement of my foot had embedded my shoe in a net of iron tentacles. The more I pulled the more it seemed to be caught. The balustrade's grip was unyielding. My heart pounded. I started to sob. I badly needed Grandmother. Why was she not there when I needed her so much? Grandmother arrived with Aunt Tsilla. The two women tried to release my foot, but the balustrade seemed to have reinforced its grip. I was yelling.

"First calm down. Please calm down."

It was necessary for them to push my leg into the opposite direction and take off my shoe from the outside. It was not an easy thing to do, but the only way to liberate me from the vicious trap. They toiled for a good

while and made considerable progress, but my desperation kept growing and I was unable to stop crying. All this noise caught the attention of many passers-by, who stopped and pointed at me with their fingers. Many of them seemed to be laughing. I was dying of shame, and worse, of ridicule. After that I refused to step out onto the balcony's treacherous territory.

What comes to my adult mind, when at a distance of many decades I recall this grotesque episode, is little Samek's obsessive fear of ridicule. His constant need to please and to entertain is a shield that protects him from exposure. His mother's motto, "Don't make an ass of yourself," which also meant "Do not injure my own pride, since I am being judged by your behavior," must have been one of the burdens of his heritage.

An afterthought to all this.

There is another reason why a scene as ludicrous as the soap-bubble episode still lives so vividly in my memory. It has become one of the metaphors of my life as an artist. Sending out my bubbles, which to my belief reflect the world, and hoping that their fragile substance will persist through time, I remain forever trapped in a condition that only the care of loving persons alleviates. I have had to learn to ignore those who feel that my kind of art is a joke or an offence, and who point their fingers at me. Some people may object to my equating art with soap bubbles, and I hope they will. There is nothing I welcome more. The sound of friendly voices speaking seriously about my work is a music I treasure.

Xenia Comes for Me

Xenia's return brings this visit to an end. "What a beautiful light!"

"I have been planning for a long time to send these drapes to the cleaners," says Rachel. "How was the service?"

"Extraordinary! There is this young good-looking priest who has a voice to die for, a second Chaliapine." Xenia looks at my pants with a

telltale stare but doesn't say a word. She must be savoring the idea of Mother's coming annoyance. Luckily, my little coat will hide most of the absurd addition.

"Tell Mrs. Bak that he has slept well and that today he can go to bed a little later than usual." I kiss Grandmother and embrace her with all my force, hoping that some of her perfume will linger on me. "Good-bye, Grandfather!" Another visit to my private paradise has come to its conclusion. Rachel and Chayim's house recedes into the distance. Its facade was of a light brown color, but the missing parts of its decorative stucco revealed many gray stones. A multitude of gray stones that have found their way into several of my paintings, stones that hover, that float like weightless bubbles in search of hospitable grounds.

CHAPTER SIX

Another Realm: Her Highness Xenia

AN ONLY CHILD, I fancied myself an all-powerful crown prince of my parents' household. But unlike my position with my adoring and very permissive grandparents, my own home imposed many rules and regulations, and I had to obey them. Even the "king" and the "queen" had learned how to adapt themselves. The real ruler of our kingdom, the one who brought rain and occasionally allowed some sun to shine, was our Russian housekeeper and cook, Xenia.

I still can see her clear eyes and high cheekbones, the smallish flat nose on her round heavy face, and her stocky, well-padded body. Her graying blond hair, which she displayed on festive occasions, was usually hidden, together with the better part of her forehead, by a lightly colored kerchief. She wore it as peasants do, tied firmly at the back of her neck. It made her look like one of the Lithuanian villagers who used to bring their chickens and vegetables to the city market. There must have been a deeper need behind her humbly rural attire, as if it were meant to display a self-chosen form of subtle humiliation. Xenia always considered her servant status as inferior and tragically undeserved.

A cruel fate had obliged her to accept it, but she believed that it was temporary. In rare moments of emotional closeness , which we shared whenever our walks took us to her Russian Orthodox Church with its onionlike domes and exotic smells of pungent incense, its aroma of burnt wax and damp walls with images of legions of dimly lit saints — she tried to confide in me, and I would listen attentively. There was something semi-clandestine about it. My parents had insisted: the church was not

supposed to be part of our promenades. But it always chanced to be on the track of our strolls, ready to receive from Xenia her hurried but intense prayers, and I had no heart to prevent her from this practice. I gave Xenia my word not to talk about it. I knew it gave me the right to be rewarded by her.

The holy semidarkness of the place and the vulnerability of the fascinated little Jewish boy pushed her toward a conspiratorial openness. In spite of my promise I found it difficult to keep the secret of our "forbidden" escapades to myself. Did she really care? I wonder how much of her confidentiality was for the little boy I was and what part of her message was consciously intended to reach my parents. It is possible that Xenia tried to make us see, in a way that was beyond my childish capacity of understanding, that she had to pray a lot for her final day of reckoning: God was to avenge her for all the wrongs done to her. Could I have conveyed that message to them? Did they see, in whatever reached them through my childish articulation, anything more than the predictable bitterness of a bigoted Russian woman?

We knew that Xenia was very religious and never lost an occasion for prayer. Her calendar contained many days of saints that obliged visits to the church. In her little room a small light flickered permanently, illuminating a dark icon to which she prayed daily. But for a long time it had seemed to me that all this had little bearing on our life and that her day of reckoning was far from coming. On the other hand, I had to admit that she was quite powerful. She had her ways to provoke crises in our household and seriously affect its established order.

A chronically recurrent problem was the manner in which she dealt with my part-time governesses. They were young students who used to live with us while following courses at the university. Most of them originated from central Poland (possibly Kracow) and their task was to teach me the perfect Polish accent, clean of the northern inflections of Vilna. I

hardly remember their faces. Quite a few of them passed through our home, and Xenia saw to it that they never lasted long. She had a way of making the lives of those young students miserable. Independently of what they did and who they were, Xenia disliked them intrinsically and made no secret of it. She regularly provoked them into altercations. Some of the *panienkas* lasted a couple of months; many left after a few weeks. During their absence, Mother had to take over the task of leaving me in the morning at the kindergarten and picking me up at noon as she returned home from work for lunch. I owed those leisurely walks, hand in hand with Mother, to Xenia's intrigue. I cherished those moments and prayed for them in my heart. On many afternoons I would accompany Xenia on her errands and practice my Russian.

At a certain point it had become clear to me that Mother was secretly afraid of Xenia. She would confide in me that Xenia had the most unbearable character of anybody she had ever encountered and that she would have since long fired her, had it not been for her extraordinary qualities. I am still wondering, sixty years after the fact, why Mother endured all that. Is it possible that she wanted to demonstrate to her own mother, the legendary Grandmother Shifra, that she too knew how to be in command, how to select a perfect employee and make her run a fault-less household? Mother had to be a "working woman" and be able to undertake a serious job on the outside. It was part of her modern ideology. Plagued by an uneasy pride, she knew that her friends admired her for the force of her character. Her own weakness, in the rapport with her maid, had to remain hidden. She had an important facade to protect and was ready to pay a price.

Xenia, well aware of this, played her hand smartly by provoking one crisis after another in which everyone would get involved. The rules of outward politeness were never broken. There would only be more ener-getic closing of doors, more intense whispering behind them, and more

sternly loaded glances. It was a gentle screaming, within the silence that bon ton required. Those "storms in a glass of water" (as Father called them when tired of Mother's complaints) continuously reinforced Xenia's domineering role.

With the eyes of a child whose innocence was still barely eroded, I must have been quite intrigued by all this and doubtless took it quite seriously. Obviously other and deeper distresses complicated those moments when tensions rose, and I could see dark clouds under the high ceilings of our apartment. Mother's hurt and anger over Father's many infidelities must often have been redirected toward the kitchen, toward lesser domestic problems, the cat, the dog, and above all Xenia, helping to save some appearances. My parents, by pretending to hide trivial things from others, hid more important ones mostly from themselves.

Still there was no question that Xenia was our household's sacred institution. She had an array of tricks that established and cemented her status as prima donna. At least three times she dramatically packed her cases and left. My parents, trying to avoid any form of disturbance, would capitulate and accept her new rules. They would beg her to return, promising a better salary—exactly as she had expected.

After wonderful days of sweet reconciliation, there was always a gradual return to the established routine and a new gathering of clouds for the next storm. These domestic upheavals rarely affected Xenia's attitude toward me. She used to show me a lot of affection, and I shall never know, in view of the events that ultimately shook up our lives, what was the real nature of her sentiment. She had always been respectful to my father. She would open the door to his patients, when it was not being done by one of Father's assistants, with a lot of dignity. She used to flirt with our visiting friends, her admirers, for whom she prepared the most delicious meals, with a sweet air of lordly forgiveness. However, she treated her help harshly and condescendingly. Rather cold and distant even with her

own children who visited her from time to time, she had only one true passion and that was for our tomcat Mourka. For Mother, this I remember well, she reserved a special attitude of disdaining obsequiousness that was a subtle exercise in intimidation.

Mother, for whom her own work in the accounting department of Grandmother Shifra's company represented a moral and spiritual necessity, was ready for great sacrifice. With time she had found herself totally dependent on Xenia, who knew well how to deal efficiently with all the material needs of our lives. Mother accepted the whole setup smilingly, with an indispensable dose of ironic resignation. She was quite aware that the price demanded for the decorum and comfort of her existence had become very high.

Xenia, too, had her reasons. Born in the region of Odessa, she had married a noble officer of the Imperial Army (so she said), borne him a son and a daughter, and taken care of their mansion—properties, servants, and peasants included. Mother used to listen politely to Xenia's descriptions of her past riches and kept her doubts to herself. After all, Xenia was the only source of this information about her past. Nevertheless, the language in which all this was related, as I was later told, suggested a certain education and refinement. Mother admitted: Xenia had class.

Xenia told us that at the outbreak of the revolution and the cruel civil war, her husband had became one of the leaders of the local White Guards who fought the Bolsheviks. In those horrendous times, slaughters of entire populations were commonplace. Did he also participate in pogroms against the Jews? He might have. There was no way of asking her about it, and the facts remained hidden in the fog of the past. The outcome of the war forced them to escape from Russia. The couple and their two children undertook a perilous and long journey. In Vilna, at the start of a planned voyage to America, the broke and totally exhausted

foursome came down with the Spanish flu and were hospitalized in an overcrowded convent among hundreds of other sufferers from the epidemic. Xenia's husband died. The children barely survived and were in need of a long convalescence, and she, feeble and spent, left her bed, and started work as a charwoman in the convent, now a hospital.

She had decided to pay back the family's debt to the nuns, who at that desperate moment had been the only ones to provide them with shelter and food. The children were later placed in two separate orphanages of the Russian community in Vilna.

I remember them as the young visitors who occasionally, after having come up via the service staircase, sat and chatted with her at the kitchen table. After their departure she would confide in me, with some sadness, that they came to see her because of her money. Her daughter, a good-looking but poorly educated girl, was to start working as a domestic for a local family. Xenia could hardly expect better for her child. It might cast some light on her enmity toward the refined students who tried to live with us and take care of me. The son was a tall lean fellow in his early twenties, with sandy hair and a rueful smile. He would ask me for paper and pencils, of which I had an ample reserve, in order, as he said, to draw for me. He usually drew monsters with deformed faces or scenes of cruel punishments, images I felt he produced mostly for himself. But I never suspected him of calculating to exploit his mother financially. On the contrary, I found him nice and rather outreaching, while Xenia's cold attitude seemed to me reprehensible.

We were the first Jewish family for whom Xenia had worked. She, an observant Russian Orthodox, must have found serving in a secular Jewish household more bearable than being given orders by Catholic Poles, who, she was convinced, never thought of forgiving the Russians for occupying Poland. I wonder if she ever suspected what her presence meant to my parents. A representative of the old anti-Semitic czarist

regime, this "ex-Barynia," this "deep in her heart Jew-hater," relegated to the kitchen, must have brought to them, together with her remarkable competence and efficiency, the sweet taste of a barely admitted revenge.

Xenia's kitchen was her exclusive domain and became more and more so. After one of her melodramatic departures, Mother agreed to honor the exclusivity of Xenia's space. Sometimes when Xenia was away on errands, Mother sheepishly revisited the forbidden kitchen territory, and I was amused and thrilled to share with her this secret infringement.

If Xenia was the unstated ruler of the house, the recognized empress of the kitchen, Mourrka, our gray tomcat, was the czar. For him she used to change the tone of her voice and modify the expression of her face. She would shower him with declarations of love, caress him and cover him with kisses that infallibly ignited his mysteriously loud purring motor. Whenever he went out for his nocturnal escapades—he had not been altered and often came back badly torn and bleeding—Xenia became tense and more irritable than usual. When he lingered longer than she expected, she would open the kitchen window, expose herself to the coldest of nights, entreat him with the sweetest promises, and call for his return. If this did not work, and she still found no sign of Mourrka, she would change her human voice to the meowing of a cat in heat, for which she possessed an extraordinary repertory of sounds, and let this reverberate in the silence of the nocturnal courtyard. Invariably, after some time he would respond with his husky voice and appear at the door.

To keep him happy, she often dropped a special liquid from a small green bottle, a medicine she used for herself whenever her "nerves were in shambles"(often). She would let it be absorbed in a piece of sugar and make Mourka inhale the vapors. The behavior of the cat was instantly transformed into a lascivious moaning and stretching of a most erotic kind. She always called me to witness this fascinating "séance." Every approaching event of this kind filled me with wonder and anticipation. I

was highly perplexed at the cat's transformation as well as Xenia's own reaction to it. She used to emit strange sounds intended, most probably, to encourage Mourka on his "trip." All this spoke of something beyond my comprehension.

I will never forget those amazing shows. Unfortunately, I reported them inadvertently to my bewildered Mother who seemed very troubled, and Xenia stopped inviting me. Nevertheless, I used to spend a lot of time in the fascinating territory of her kitchen. At the huge table Xenia had *her* chair, a chair that no one else dared use. It was similar to my Father's "sanctified" place in the dining room. She would sit there and bestow her graces upon those who did not question her superiority—the seamstress, the woman who came to do the laundry, the help for the cleaning of the house, various people who delivered goods, and particularly the wife of the janitor, her source of local gossip.

Whenever Xenia baked her cakes, cooked large dinners, or planned receptions for many guests, whenever she created her unique and exclusive preserves and jams, that kitchen table would become a theater of magic events I was permitted to witness. An expression of special glee accompanied her labor on my favorite multilayered chocolate torte, the one that assured her unsurpassed reputation. The cake gave its name, so she told me, to a "famous French emperor, who had dared, the devil, to attack Holy Mother Russia and the Little Father of us all, the 'Batiushka,' the czar. However that Napoleon, the wretch who stole the cake's name, paid for it dearly."

Dinners prepared by Xenia became my parents' pride. Her talents for the improvement of traditional dishes and her culinary inventions were surprising. The telephone rang often for Xenia with friends' requests for her secrets. She always gave out intentionally wrong recipes, which she dictated diligently with a mean smile and the sweetest of voices. The friends assured Mother that in spite of having followed Xenia's instruc-

tions with the greatest attention, they never obtained comparable results. How they envied Mother. They had to admit: they lacked Xenia's magic fingers.

Xenia was considered a rare jewel. The friends, ignorant of her subtle reign of terror and Mother's silent acceptance, assumed that the great cook was guided by the inspiring mistress of the house. Little did they know that only in moments of particular benevolence did Xenia even inform mother of her plans for a given reception or the details of a menu. All Xenia ever needed to know was the exact number of guests. Thus together they maintained a facade that brought some comfort to Mother's pride.

When the real thunders of an approaching war shook us to our roots, when our home became inundated by refugees and men in uniform, when the real problems of survival surfaced and we all underwent deep change, Xenia started to mellow. Was it because she felt closer to the day of her revenge? She knew the changing circumstances only accentuated our need for her services. On the other hand Mother, who had never really trusted her, was reconsidering her own scale of values and changing her attitude toward Xenia into one of greater detachment and resigned acceptance. Unexpectedly, they obtained a much better rapport. The news of Nazi expansion that was sweeping all corners of Europe, and of the anti-Jewish laws under German rule, altered Mother's perspective on Xenia's reign of terror. Suddenly it looked futile, and all its former importance was gone.

When last I saw Xenia she stood next to the janitor's wife, her arms folded on her bosom, barely visible in the dim light of the staircase that led from our apartment to the courtyard in which all of the Jewish inhabitants were being corralled. She looked at me and Mother being led away to the ghetto by Lithuanian police. No words were uttered. In spite of the darkness and drifting rain, I saw her face distinctly. It showed no emo-

tion. I tried to read in it something. I smiled to her. But the moment was short, the light was scarce, and the face remained blank.

I never knew what became of her.

When after our liberation Mother ventured into our building, which had miraculously survived the bombings, the apartment was a military infirmary. On none of the floors were there traces of the former occupants. Of those now present, no one seemed to have heard of Xenia. Mother tried other ways to find her, but she seemed to have disappeared. Maybe she simply did her best to avoid us. Following our forced departure she must have worked very hard to save for herself a portion of what we had left behind. The looting of Jewish belongings was common. I am sure that she was joined in this by the janitor and by some of the neighbors who had been waiting patiently for their share. Compared to the loss of the lives of our dear ones, the dispossession and the dispersion of material belongings seemed to us trivial.

I wonder sometimes. Was the day of our expulsion the day of Xenia's reckoning? Were her prayers directed toward this revenge? Did we harbor a snake in our midst? Or was she simply the victim of a notoriously anti-Semitic environment? Maybe she liked us, after all. Is it possible that she was so shocked at the sight of our plight that no sound or expression could form themselves to indicate to us what her soul wished to say?

Xenia. I remember her well. But I still ask myself if I knew her then or if I shall ever discover who she really was.

CHAPTER SEVEN

Three Stories in
Search of My Father

FATHER'S GAMES

Father died three weeks before reaching age thirty-seven.

"Died" is an inappropriate euphemism. He was murdered in 1944, on the eve of the Red Army's recapture of Vilna, shot on the precipice of one of Ponar's huge mass graves. Like Father's parents, in-laws, many close friends and relatives, he was executed in cold blood, his beautiful body, shaped by the relentless exercises of a dedicated gymnast and now riddled by a German machine gun, was left on a pile of bloodstained corpses.

I was not old enough to know him well. Were he alive and thirty-seven today, he could be my son. Would I then know him any better? I doubt it. Somehow Father's nature still eludes me. Like my three adult daughters whom I have known for so many years, he remains familiar and at the same time enigmatic. The memory I carry, a direct recollection from living with him for the first ten years of my life, is only the sum of observations that a child can collect, observations stored in the mind of an inquisitive boy, an overly sensitive only child who lived in a reality that was predominantly the world of adults and later on became a horrible world at war.

The remainder of what I know about him comes from Mother's numerous stories, stories I used to listen to with a slight reserve, all the more when they concerned my deceased father. She was a person of an extraordinary honesty, but her hidden nostalgia for the past and her

desire to make repairs while restoring it, which I well understood, made me sometimes question the reliability of her accounts.

Today I know that reading too much between the lines can also lead to error, replacing one distortion with another even greater. I shall do my best both to nourish my own recollections with her tales and to check her stories against what I myself remember.

What do I remember about Father?

He loved playing games. All sorts of games! And I never knew where his fun ended and the seriousness began. He used to utter the most outlandish stuff with the coolest of expressions, and he often baffled me. I think I used to observe him more than he knew. Often when the phone rang I would pop by, as if by chance, to eavesdrop on his conversation. Sheltered by the invisibility that the telephone provided, he sometimes pretended to be somebody else. Father knew how to speak with various voices. He could use the high-pitched voice of Liova, his stammering assistant, the one who fought his afflicting handicap by taking lessons in opera singing; or Xenia's deep hoarse speech with her heavy Russian accent: "No, Gaspadin Bak is not at home." I knew that his behavior was far from irreproachable. Utterly unfit for an adult professional, it did not correspond to the canons to which the adults held me accountable.

But his smiling eyes would send a little wink in my direction, trying to make me understand that this sort of game was but an innocent joke. Were such jokes permitted? His winks also told me that we shared complicity, complicity that my inner tribunal of rectitude scornfully rejected.

Father was playing his games, and my cheeks were burning with shame.

Card games were another of his passions, especially games in which pretense was key and adversaries were forced to make guesses based on scrutinizing each others' faces. Father maintained that in poker parties he was king. But such parties were never held in our home. Mother disap-

proved. She had therefore to accept that on certain evenings he would join his buddies "somewhere in town." His rationale was that he badly needed relaxation and that no other thrill came close to this one. His "need" for such games must have sometimes masked a different kind of nocturnal adventure, escapades that inevitably generated between my parents a tension that was heightened by Mother's tough pride.

I felt something was wrong.

Once I became an adult I understood that he was like a beautiful butterfly thoroughly dedicated to a flower he adored. The proud flower was firmly planted in the ground and it assured his stability. His fidelity or his particular concept of it was not to be questioned! But he also needed motion. All he asked from his adored one was the acceptance of his desire to check out other flowers. This metaphor might be a terrible cliché, but whenever I think of my parents it is the first thing that comes to my mind

Flower and butterfly, that was his game with Mother. Naturally at the time of his return from such adventures I was fast asleep. But the mornings presented a black cloud hanging under the apartment's ceiling. A high-strung and hardly speaking mother, a father with heavy eyelids, dark circles under his eyes, unruly hair, and in the background a housekeeper on her tiptoes, thriving on her employers' misery. Mother would leave for her work in Grandmother's company without a goodbye. Looking elsewhere she would lovingly ruffle my hair with one of her hands while the other lowered her hat's brim as low as it could go. She would then close the door after her with excessive force. And Father would walk over to the dental laboratory and quietly immerse himself in his work. The first patients arrived much later.

On my return from kindergarten he would silently join me for a lunch prepared by Xenia. Seated quietly at the table, we were observed by her from a proper distance, as also by Mourka the cat. The demanding housekeeper was checking our appreciation of her cuisine, and we knew it.

Father's uninterrupted yawning signaled to Xenia that she was invited to make some conversation. She would tactfully point out that by going to bed late, some people lost precious sleep and jeopardized their health. Father approved her wise observation. Consequently he would take a prolonged nap while his bored patients, unaware of the fact that he was not attending to urgent dental work, patiently continued to wait. To kill their time they used to immerse themselves in various newspapers or fashion magazines to which Father subscribed. The crawling time filled ashtrays with innumerable cigarette butts, and the small waiting room's air became saturated with heavy vapors of burned tobacco.

The work that went on in the dental laboratory sheltered Father's siesta. From time to time, a poorly sung fragment of an aria from an Italian opera reverberated in the space accompanied by sounds of various mechanical tools. Xenia, at work in her kitchen, immersed herself in a soliloquy about the unfairness of life. Such monologues, vaguely directed at a drowsy Mourka, tended to be very repetitive, and the exhausted cat barely acknowledged them with lazy movements of his tail. This scene was habitually part of the preparations for the evening's dinner. The baking and simmering that went on for hours flooded Xenia's kingdom with delicious smells. There was an absolute schism between the dismal message in her mouth and the vivifying production of her clever hands.

These were the different playgrounds that coexisted on our floor, and I circulated among them freely. Sometimes when Father took his siesta I furtively entered the bedroom. On a chair, prepared ahead, were his hat and overcoat. When the sky looked rainy, an umbrella and galoshes were added to the lot. I used to find him deeply asleep, as immobile as the consumed Mourka after a night's wild roaming. The sounds of hammering, drilling, and singing that came from the laboratory never bothered him. I assumed that his snoring protected him from being wakened.

Having taken his restorative nap, he would jump out of bed, dress, put

on the overcoat, hat, and, if the view from the window told him that it was raining, slip his custom-made shoes into rubber galoshes. He would also seize his ivory and silk umbrella. Thus fully equipped he would emerge in Xenia's kitchen, lift the lid of one of the simmering casseroles, inhale the steam, and grace her with an approving smile. The amused housekeeper was used to the master's unconventional habits. Sleeping while his patients were waiting was only one of them. She loved tacitly to cooperate with him, especially in situations that were irritating to Mother. When it was raining she would give Father's umbrella a generous sprinkle of water and quickly open for him the service door that led to the back stairs. It took him no time to run down the three floors, re-climb the main stairs, and reenter from the main entrance.

Rested and relaxed he would carefully fold the umbrella, take off his coat, and cordially salute everybody. Sometimes he exchanged a few jovial words with those patients who seemed the most nervous. "Called for an important consultation" was the usual excuse for his prolonged absence. Donning his white coat, Father would absentmindedly make some remarks to one of his assistants, just to show that he was master of the situation, display his perfect teeth in a generous smile, and invite one of the patients to sit down in the cabinet's hydraulic chair.

I, who had no part in this whole operation, was left with a mixed sense of pride, amusement, and shame. Such ambiguity was perplexing. Why did my admiration for Father's playfulness trouble me with a sense of guilt? Years had to pass before I understood that Mother's disapproval of "certain" of Father's games was unsettling me for reasons I could not then comprehend. In my child's mind a myriad of perceptions amalgamated into one confusion and thrust my young self into bitter embarrassment.

While I was in pain with shame and with guilt, life would quickly return to normal. By next evening my parents, in what seemed to be the

best of moods, would be joking, laughing, and lightheartedly preparing themselves for one of their many parties. How much of it was a show intended to dispel my tensions, I cannot tell. Soon I would feel much better and quickly return to the old pattern of being furious about their outings and their cruel banishment of me from their fun. Not only were the dancing parties, theater, invitations for dinners, balls, and gala events an opportunity to promote the young couple socially, they were also an occasion for Father's display of his exquisite wardrobe. Masculine elegance took up a lot of his attention and was just short of an obsession. The perfect body needed perfect packaging. His sources of inspiration were French, American, and Polish films that displayed to an underprivileged film-viewing public a dream world of young men of moral integrity, singing heroines, and good-hearted millionaires. All were dressed to kill.

Father was fully integrated in Vilna's prewar Jewish middle class, and to some extent he shared its provincial mentality. He was convinced that his professional success depended equally on his technical expertise and on the net of his personal relationships. But he so loved to stand out from the crowd and be admired that the rest may well have been mere utilitarian rationalization. Worthy son of his father, he had to show his friends how "men of the world" dressed. Equipped with a pencil and small notebook he sketched in the semidarkness of movie theaters the stars' jackets, lapels and notches, pockets and flaps, center back vents or side vents, buttonholes, and other details that were later discussed with the two tailors of his father's workshop. The two men were entrusted with the garments' final production. Mother loved to tell me about the particular jacket with a gathered back and huge patch pockets that he had copied from a Clark Gable film. He had to refrain from showing it off before his return from a trip to Warsaw in order to make his "entourage" believe that had ordered it in one of the most exclusive boutiques of the Polish capital. His vanity, as Mother told it, must have been limitless.

Once, inspired by a fashion drawing that hung in Grandfather Chayim's workshop, he returned from a journey to Warsaw with a large basket containing two whimpering puppies, progeny of an international award-winning pair of beige Great Danes. Grandfather's drawing represented a tall man standing out against a mundane crowd gathered on the lawn of an English estate. He was wearing a cap, impeccable beige knickerbockers, and a somewhat darker tweed jacket. His expressionless mouth nonchalantly blew a pipe's smoke into the languid eyes of a slender lady, while his outstretched arm firmly held the leash of a handsome greyhound.

Father's fantasy supplied him with an even better image of himself on Vilna's main promenade, collecting looks of admiration for the perfect combination of his two spectacular dogs and the fine English fabrics of a stunning attire that was gradually taking shape in his imagination.

The sight of the two puppies gave Mother a shock. Immediately she anticipated all the trouble to come and made her apprehension fully known. Only after a good deal of arguing did she succeed in making Father sell one of the puppies. The one who stayed with us, "Father's toy" as she referred to him, was named Douglas. The bearer of the famous American general's name, Douglas started to grow as we watched. Quickly he was taller than I. He became a clumsy animal that weighed more than a human adult. His sheer force, of which he seemed to be unaware, was such that his passage through a room would overturn chairs and displace heavy furniture.

I dreaded Douglas and liked him at the same time. His playful gentleness and the respect he bore for my small person or for the even smaller one of his good friend Mourka was very endearing. Breathing heavily while salivating incessantly, he left wet signs wherever he went. Sometimes he lifted a leg and peed on the heavy carpet that lay under the dining table, and other times he left lakes of urine on my parent's bed. With all

the havoc he brought to our household he seemed to retain a jovial disposition, seemingly disregarding the dismal effect his arrival had on our lives. Never before had my parents quarreled so much. Mother demanded that Douglas be trained. He had to obey orders, learn to walk on a leash without pulling, and be prevented from jumping with his exuberant joy at defenseless people whom he scared to death. But Father had no time for such tasks. This was not any more his game. He readily postponed his planned promenades of masculine elegance for a later date. He believed that time takes care of problems. The unruly dog had to be given a chance to calm down. Wisdom came with aging.

Also Xenia, in spite of bragging (while Douglas was still small) about her foolproof technique of dog control, soon gave up the idea of taking him with her into the city's busy streets. Time passed, and instead of calming down, the dog became increasingly ungovernable. Father's assistants agreed to walk him only if two of them were sent out, and even then there was no guarantee of keeping him under control. Often they clung to lampposts in order to avoid being dragged by his powerful muscles. Douglas's physical force gave the measure of his appetite. And it was the limitless enthusiasm with which he devoured anything he considered comestible, including patients' hats and custom-made shoes, that brought the final resolution to the crisis.

This is how Father's by now postponed project of stunning Vilna with his Great Dane suddenly came to a sad end. A big fish, baked whole, was peacefully resting on a decorated platter awaiting the guests of a reception. Suddenly Douglas, escaping from his temporary confinement, arrived in the very best of spirits, and before the surprised and widely staring eyes of Mother and Xenia opened his huge mouth and swallowed it down in one swift gulp. An hour later he had to be put to sleep in order to spare him the excruciating pain of a perforated stomach. He was not terribly missed.

I used to think with fondness of his quieter moments, mainly the ones in which he was lying on his side fast asleep while his paws moved. I was told that it disclosed the presence of an ongoing dream. What dreams might Douglas have dreamed? Did they concern his parents who allowed him to be sold for good money? Or perhaps my Father, the master who lost all interest in him? The dog was buried in the small wood near our summer dacha. Douglas was my first encounter with death. Later came movements of armies, air raid alarms, bombs, and persecutions. Death became much more common.

The last years of war and occupation, and the terrible hardships that followed made me discover in Father a person of great vitality, resourcefulness, courage, and wit. There was always something playful in the way he used to deal with life, continuing to charm men as well as women. His weakness for the feminine sex was, according to him, his particular strength. And the familiar games of the good old times were partly transferred to a different reality but never totally rescinded. Even my parting from him had something of a game in which the stakes were of the highest order.

In my eyes he was "playing" with the camp's German guards. For them he turned me into a heap of wooden blocks thrust into a burlap sack and carried on his shoulders to the camp's gate and to freedom. Father's final game, which he and I played together against the Germans, gave me life, a "delivery" that succeeded against all odds. Alas, this second birth of mine did not grant him survival. Whatever success I have been able to make of my life will always be the great prize that he won for me and lovingly placed in my arms.

BURLAP SACKS

It was in the late summer of 1941. Previously, in June, the German army had occupied Vilna. Mother, our Russian housekeeper Xenia, and I were left in the large apartment that suddenly looked empty and haunted. The celebration of my eighth birthday in August was postponed for an indefinite date. Our reserves of food were exhausted. It was dangerous for Jews to go out into the streets. Luckily Xenia was able to be of help. She had her resources, and although finding comestibles had become increasingly difficult, we managed. Getting news was another problem. Radios were forbidden. A few Jewish neighbors in our building were the only people we saw. They went on spreading various rumors in which they hardly believed. We were on the receiving end. We did not know what the others did. The telephones of all Jewish households had been disconnected and Xenia was our only go-between. It was difficult to have complete trust in her, given the complex history of our relations with her. Often she was absent for long stretches of time and this made us question her reliability. But we had no choice. We could not protest; we were totally dependent on her goodwill.

Not many days had remained until our transfer to the ghetto.

One morning Xenia left early and came back after a few hours accompanied by a rugged man who was carrying a heavy sack of patched-up burlap. The man smelled of straw and well-fertilized soil. Stiff flaxen hair partly covered his weather-beaten face. A worn jacket, heavy boots, and

the sack were all shedding a sawdustlike dirt. With an awakening feeling of joy I realized that the sack might contain potatoes and that soon we would be able to appease our gnawing hunger. Xenia gave Mother a quick sign with her eyes and with a signal of her hand directed the farmer to the dining room door.

"Please take a seat," said the housekeeper with an unusually polite voice, of a sort that she had never used for addressing persons of his kind. With a quick and agile movement he let the sack fall to the floor, and it landed on the large Persian carpet, that had been placed in the center of the room. The sack came to a quick halt and remained standing there, slightly leaning to one side as if it was about to burst and send the potatoes rolling under the table. A halo of thin soil surrounded it. More of the dirt was being shed with each one of the man's steps. With an unusual gesture of self-confidence he grabbed the back of Father's chair and sat down.

A tremor like a quickly passing wave of some mysterious explosion passed through my body. Never before had I seen anybody but Father sit in that chair. Why didn't they warn him that this was the master's chair, and no other living person in the whole world had the right to sit on it? Few objects had in my eyes such unquestionable sanctity. I tried to interrogate Mother with a staring look. All I got back from her was a light shaking of her head that told me to shut up.

The maid murmured something into Mother's ears. These must have been the pre-agreed conditions of exchange, which would give us the right to the potatoes. Early on that day Xenia had taken it on herself to go to one of the roads that led to the central market with the intention of stopping one of the few carts that were carrying comestible goods from the neighboring villages. The adventuresome peasants, who preferred to leave their horses well hidden from the German authorities, pushed or dragged the carts into the city with the sheer force of their muscles and

offered a limited choice of precious products. Vilna was hungry, and those providers who passed the various military roadblocks with their merchandise and managed to save them from confiscation expected a very lucrative barter.

When mother reentered the room, she carried a well-upholstered hanger from which dangled Father's tuxedo, in all its glory of days bygone. If the satin lapels had had tongues that could speak they would have told many stories, some of them quite unfit for a child's ear. However, I knew that they had a life of their own. On certain evenings, being carefully hung with the rest of the garment on the back of one of my parents' bedroom chairs and turned in my direction, the elegant lapels gave me the feeling that they observed me. I used to admire their delicate shine. There was a buttonhole that fascinated me because it had no corresponding button and served uniquely for the purpose of displaying a white carnation. I loved to prolong the evening hours before going to bed by assisting my parents' preparations for their festive outings. True, I felt proud of being able to contribute to the various stages of their dressing up, but the main reason for my desire to be with them in those moments was the sheer pleasure of admiring their starlike glory. Crawling on all fours I used to search for the special buttons that had to be inserted by Father's expert hands into his white shirt's over-starched plastron. They had the bad habit of popping out and getting lost under the bed. I loved to watch him struggle and get angry. My small hands returned to him the innocent objects, and their final insertion into the stiff material had the power of calming his rage. Father's Russian words of magic, very similar to the exclamations of the janitor who used to clean our staircase, helped him. Mother would tell him that he had a dirty mouth and that the little one was around. But I knew that she was wrong. Father looked resplendent and absolutely clean, with no trace of dirt on his lips. His curly dark hair that had been pomaded and pulled for an hour with a special brush

was perfectly smooth and shone as if it had been lacquered. His face, freshly shaved and sprinkled with a special powder had an opaque marble beauty. The last move before putting on the jacket was the removal of any excess of the perfumed dust in order to save the marvelous lapels from invasion by the soothing after-shave powder.

Those glamorous days seemed far away. At present I couldn't take my eyes from the dirty burlap sack, from all the mess on the precious carpet, and my thoughts were elsewhere: "How does my Father look now?" I knew that he was in a labor camp cutting turf. I saw him once for a few minutes when an extraordinary chance permitted him to visit us for a whole quarter of an hour. Father looked gray, he smelled of earth, his clothes were encrusted with brown clay and huge chunks of it seemed to be glued to his shoes. He appeared unshaved, as rough and as rugged as the peasant who now was claiming his throne. Yet my parents, in that fleeting moment of reunion, were overjoyed. To me they seemed much happier with each other than they had on those magical evenings when they often used to complain and to grumble while transforming themselves little by little from ordinary parents into royalty.

The scene of the potatoes' acquisition continued as if it were a silent film. The peasant gave a faint smile to the black garment. His dirty fingers grabbed the satin lapels, which did not react with the contempt I had expected from them. With another hand he reached for a large piece of burlap that hung from one of his jacket's pockets, quickly wrapped it around the crumpled tuxedo, and turned the whole into a miserable bundle. He tucked it under his arm and was gone. I couldn't help myself. Tears were rolling down my cheeks.

I should have known better. I had already listened to many frightening stories. More than once had I been cautioned about the ways times were changing. I was also told that in spite of the troubling nature of events, I was to be informed of everything as if I were a young adult. It was dan-

gerous to remain a child. I had to grow up quickly. I tried my best, but the mind of a boy of eight had its limitations.

Perhaps it was the potato-man's passage through our home that finally made these things clear to me. It was the first time I fully understood that nothing was going to be the way it had been. When I reflect about it today, I realize that it must have been the moment in which I started to say goodbye to Father.

Two years later it was again a burlap sack that entered Father's and my lives and severed them forever. My last memory of Father is the image of his hands, once perfectly manicured but now rough from labor, holding open a large patched-up sack full of sawdust so I could step into it and be smuggled on his strong and loving back out of the labor camp from which there was to be no escape for him. This was indeed our final farewell. But I did not cry. I was ten years old, and I was an adult.

FATHER'S GOLD

I love picture frames that are manufactured with real gold. I love to move my eyes from the brushed-on colors of the painting to the refined workmanship of gold-leafed surfaces. I love to detect in the sunlike shimmering glow of their highlights a luminosity that might well date from the dawn of creation. Such frames protect, enhance, and add value to whatever they contain.

The noble metal needs no words to describe its easy superiority. An almost mystical shine is supposed to emanate from mountains of golden coins, a radiance that time can not alter. Mountains of coins, coins emblazoned by multiheaded eagles, coins with profiles of great sovereigns, ingots piled glittering in the dark: what else could exude such an air of riches and power? What better symbol could there be for the established order?

So why is it that when I close my eyes and think of gold, what I see is not a noble yellow shimmer but the whiteness of plaster? White teeth, white gums, white palates with no tongues and no lips.

Here the story begins. It is about teeth. But not about the millions of Jewish gold teeth, the harrowing circumstances of their extractions, their melting and transformation into ingots and the subsequent deposit of colossal fortunes in obscure bank vaults. The period is the same general period of war and persecutions, but my story's moment ends slightly earlier.

What gold actually brings to my mind is the lifelike plaster cast of a dental patient's mouth, the kind used for the manufacture of artificial teeth. Its two parts, the mouth's upper and lower imprints, are fastened by a hinged steel structure that assures easy mobility. The principal aim of this model is to render a perfect reproduction of the patient's bite.

Conceived as functional objects, such models possess in my eyes a visual presence that transcends their original purpose. While Father used them to make dentures, bridges, and gold crowns, to me they were something else. Ghostly images of death, evil spirits, perhaps some otherworldly creatures. Brought to life with the onset of darkness, to my mind they were famished, ready to jump on unsuspecting prey, sinking their plaster teeth into tender flesh, and tearing substantial morsels of pulp from the terrorized victims.

At times when I indulged in games of scaring myself, I had a feeling that thousands of such monsters populated our flat. Although I knew that they were relegated to their special cabinet, and that their special cabinet remained locked in Father's laboratory, and that Father's laboratory was separated from our apartment's private section by a heavy door, I feared the possibility of their nocturnal wandering. My childish imagination delighted in exaggerating things ominous or dangerous, or that appeared to be invested with a life of their own.

My rational mind well knew there were actually fewer than a hundred such casts, certainly not thousands of them. Also that these casts were as peaceful as the hands that handled them. But my darker side was, and still is, sensitive to their threatening magic. Decades have passed. I hardly gave them a thought until recently, when my dentist presented me with the model of my own mouth.

Each of Father's patients was allocated a personal space in the huge cabinet of drawers to which an entire wall was dedicated. The drawers— provided with little nametags, numbers, and dates—looked to me like

small extractable coffins. And the dangerous white mouths that nested in them like little golems seemed to possess spirits of their own, capable of spreading real havoc and destruction. I do not remember when they started to appear in my nightmares. I believe it was after Father's hands had once moved the two parts of the plaster model, making the teeth go click click. Eyeing me standing at his side, he added to the clicks a spooky howling. The joke, at least for a short moment, was supposed to make me behave as if I were convinced that the creepy dental model possessed a life, a will, and a dismal language of its own. Father's eyes were half smiling and half observing me with worry. I knew what he expected from me. A real man would not be afraid and would not retreat! I had to show him that I was strong and courageous! This game had to do with his relentless desire to increase my hardiness. He must have felt that my being constantly pampered by mother, grandmothers, aunts, and nannies jeopardized my manliness and demanded from him an ever present infusion of ruggedness.

Father's young and fearless assistants did most of their technical work close to that cabinet of coffinlike drawers but did not seem to mind it. They handled the models with temerity, competence, and care. I watched them at their task with mixed feelings, listened to their stories, laughed with them at jokes I was unable to understand, and gradually let my apprehension of the spooky teeth be expelled by the young men's reassuring presence.

In the fifties when I was a student in Paris, I roamed the city on foot, north to south and east to west. It was the city in which my father was conceived. Now I wanted to absorb its special aura, as if to make up for all those years when Paris had been beyond my reach. On those walks I visited many of the city's most beautiful cemeteries. Impressive family chapels, ornate statuary, and sumptuous gravestones made claims for social superiority even in death. Meanwhile the ashes of the poor were

located in huge walls made up of tiny cubicles that instantly brought to my mind Father's huge cabinet. The identities of the deceased were carved into small taglike squares of stone listing names, numbers, and dates. How familiar it all looked!

In spite of the overcrowded conditions of the impoverished dead, piled layer upon layer forming tall walls, there was a dignity of timelessness in the place of their repose. I thought for a while that unlike Father's collection of "golems," the real dead had terminated their obligations toward life. Nobody was ever going to disturb their peace. However, this belief was later demystified. The Parisian cemeteries rented out specific spaces for determined periods of time. Families that were unable to sustain the city's onerous fees saw their loved ones' remains thrown into the anonymous *égalité* of graves in which the *fraternité* of good company and *liberté* from worldly worries brought them rest at last.

What was the logic of it? Peaceful times tend to spoil the wealthy dead. Abundance of material means allows beautiful and well-cared-for cemeteries, where, on very valuable city real estate, their bones take up more space than necessary. Surrounded by the hubbub of a noisy urban presence, these dead seemed to whisper the only pertinent message left to them: "Slow down and think." When in front of languid marble statues of weeping women, or of lovely stone children with flowers in their hands, or of dreaming bronze angels, I slowed down and thought. What came to my mind were wars, explosions, the sound of machine guns, and the tragic sight of mass graves. Father's dental plaster models still surreptitiously nourished my imagination.

When Germany invaded Poland, Vilna, then part of the Soviet Union, became inundated with hordes of refugees. Many were Jews who were trying by means of special visas and semiofficial permits—in which there was a real commerce—to travel the network of contorted and dangerous routes that led to Shanghai, to Palestine, or to the United States. The

refugees tried to obtain visas distributed by the Japanese consul in Kaunas, a man who in time became a real legend. Our home turned into a center for the coming and going of such persons. Several of them had a particular interest in getting in touch with Father, for a reason that I shall have to explain. They formed a picturesque gallery of characters. Elderly men, or men who then looked elderly to me, with sad smiles revealing golden teeth, were accompanied by plump and delicate ladies. Sometimes they moved around like sleepwalkers. Most refused to believe what was happening to them. All were desirous of a quick awakening from this ongoing nightmare. Most were from Warsaw—Father's acquaintances, patients, colleagues, business associates, or others sent by them.

They came from affluent homes. Now all that was left of their wealth were the precious stones and some large bills of foreign currency sewn into the linings of their clothes. They knew that Father had a way of creating dental prostheses that contained double bottoms or hollow crowns capable of hiding diamonds. By such means they might hope to carry their valuables past border controls. Patiently they had to wait for the manufacture of their special dentures. Often their old golden teeth, fashionable in former times, had to be changed for porcelain ones so as to give their bearers a more humble look. Father was incessantly at work. His assistants had fled. The partner who usually took care of extractions was gone, and everything had to be done by his own hands. He toiled from very early to late at night.

Surprisingly, our housekeeper Xenia, a person normally of sour mood, did not seem to mind the upheaval. Managing to extract from our unfortunate guests generous tips that more than doubled her monthly salary, she was preparing a thick personal bundle for the hard times to come.

In all that I lost the use of my room. But I did not regret it, since my bed was permanently moved to my parents' bedroom: what had been in

the past a special reward now became my daily condition. In our home every bed, sofa, and empty space that could hold a mattress was offered as temporary lodging to the unlucky refugees, or rather those lucky individuals who had so far succeeded in escaping the Nazi boot. Shaken, disoriented, and distressed, they showered us with stories of their perilous experiences. Tales that together with a lot of cigarette smoke remained suspended over the round dining table, floating under the domelike lampshade in the shaft of yellowing light, evoking empathy, admiration, and frequent disbelief.

I realized that my life was becoming more and more exciting. Now I was party to all that was going on. I listened to the most interesting tales of escapes, of disguises, of stories about false documents, of unorthodox techniques for border crossings, of possible plans for traveling in impossible countries, and a myriad of designs for salvation: practical, cautious, often illusory. Complex attempts to analyze the geopolitical scene of the moment, which my young self had no possibility of understanding, often ended with everybody shouting, with insults, reconciliation, embraces, jokes—and a lot, a lot of laughter and then some tears.

These scenes puzzled and reassured me. With time I developed a suspicion that the grown-ups had their limitations, even when they were trying to do their best. Witnessing the uninterrupted exchange of money and valuables in an epoch when paper money was devalued and banks were confiscated, I was made to believe, like them, that only diamonds and gold maintained a steady and unchallenged worth. At that time I saw Father dispose of most of his assets in order to convert them into little heaps of golden coins and ingots. He kept his precious treasure in a sturdy metal box provided with a very heavy lid and lock that only added to its amazing weight.

The box was constantly transferred from one hiding place to another, none sufficiently secure. Meanwhile terrible rumors nourished our fears.

Since the police outlawed the private possession of gold, muscular agents equipped with an array of special tools and trained dogs began combing suspected apartments, breaking teeth and arms, and savaging whomever they interrogated.

After a relatively quiet hiatus generated by the accord between Russia and Germany, war suddenly erupted; again armies were on the move, sirens began to howl and bombs to fall. We had to seek shelter under the ground, but our cellar was so overfilled by the reserves of food of all kinds "for the hard times to come" that there was no space left for saving our skin.

This was why we had to join the building's other inhabitants in the lower basement that had been turned into a collective air-raid shelter. The place reeked of mildew, sewage, candle smoke, and badly digested cabbage. Stretched out on damp blankets on the soggy ground, we spoke in whispers and listened to the sounds that reached our underground hiding place. Intermittent tremors conveyed a notion of the massive devastation that was going on above us. A rain of mortar particles kept falling from the ceiling, covering us with greenish dust. Next to our group sat an elderly lady who was a neighbor from one of the floors below our flat. Her gray hair that she always wore collected in a strict bun was now completely disheveled. This woman, who in other times had hardly ever acknowledged us, was now all smiles, sad and shy, embarrassingly grinning at everyone in the tense promiscuity of our shelter. Locked in her arms was a heavy log of wood that she pressed to herself as if it were her baby.

I whispered into Father's ear: "She must have gone mad."

"I don't think so! She is filthy rich but not so very smart! Showing around the log was a mistake. Now everyone can tell where she keeps her valuables."

On our return to our apartment Father took out the heavy box from

its most recent hiding place and started the complicated venture of hiding his gold in the old plaster casts of his former patients' teeth. The project had to remain very secret, known only to Mother and me. The most important thing was to keep it secret from our housekeeper Xenia, whose increasingly familiar attitude toward her employers and their involuntary guests had become dubious and disturbing. We started to suspect that she must have figured out the various hiding places in which Father was clandestinely shifting around his illegal gold. Did Xenia have an eye on our belongings?

Father decided to distribute the weight of the precious metal among a large number of plaster casts in order not to arouse suspicion by any extraordinary heaviness. Proper cavities had to be carved out. Fresh plaster was reincorporated to conceal the small ingots and the various coins that the old casts were made to carry. It was a delicate job, and it took him several nights to complete. Suddenly I forgot my childhood apprehensions. I was fascinated by it all and started to smile in my heart. Now we possessed the wealthiest spooks in town, charged with the responsibility of protecting our riches. And Father's trusting me with a secret of such magnitude dispelled many of the concerns I had about his sneaky way of questioning my manliness.

Time passed by. Father was sent to cut turf in a labor camp. Mother and I were expelled from our home and corralled in the ghetto. Later when the two of us became reunited with Father in the hiding of the Benedictine convent I learned the conclusion of this story. It was after a difficult and complex investigation, clandestinely conducted by Father when still in the camp, that he got some idea of what happened to his gold. As a general rule Jewish property was supposed to pass to the hands of the German authority. The men who drove us into the ghetto sealed our flat as well as Father's cabinet and laboratory. But the seal was broken, the apartment looted, and it was never known who took what. What

did the Germans select if they were the first to reenter it? What was taken by the Lithuanian police, who had the right of second choice? Which objects passed to Xenia, to the building's janitor or to other anonymous despoilers who delighted in grabbing "free" Jewish possessions?

One thing was clear: the flat was totally emptied. Whatever remained was thrown on the heap of the rubble of the nearby building that a recent bombing had partly demolished. According to the report of several neighbors, some of Father's laboratory furniture, dental instruments, and discarded plaster casts lingered for several days on a mound of stuff that the city authorities one day took to a general dumping site. Who knows if anyone ever checked the contents of those "white mouths"? I hope they did not. I prefer to imagine the plaster casts reaching their final destination intact, lying in the fraternal mass grave of discards and debris with all their multiheaded eagles and gold ingots safely hidden inside.

In the beginning these casts served as a material base on which Father's diligent hands crafted the devices that gave him "fame and riches," and in the end they carried the treasure of his riches concealed in their plaster back to the original dust of creation.

How well I imagine the picture: a mound of dental casts on the discarded rubble of a bombed building. I think such a picture would deserve an expensive gold frame.

On Mother's Side:
the Yochels and the Nadels

SHMUEL YOCHEL
AND HIS DAUGHTER JANINA

When I was a boy of eight or nine haunting the library on Straszun street in the Vilna ghetto, the old shtetl of Sholom Aleichem was my favorite place of escape. Populated by colorful characters, it gave me access to a universe from which I knew my family must have come. My urban Jewish middle-class environment and my secular parents had made the shtetl life into something alien and exotic. It was in Sholom Aleichem's nineteenth-century world that I rediscovered the landscapes of my own origins.

The books spoke to me of the lives of Eastern Jewish families, families that were identical to the thousands that had lived in the villages around the ancient town of Vilna. The Yochels, my forebears on Mother's side, were one of those families, and Mother was full of stories about them. They would have occupied some small house on a muddy terrain. Adjoining it would have been a shack for a cow. Further on would have been a well, a horse, perhaps a couple of goats, a small vegetable garden. All at the edge of a typical Jewish village with its modest synagogue, a rabbi who was the ritual slaughterer and the instructor of the children, and a few shops to provide the villagers with the necessities they couldn't produce by themselves.

Like most of the Jewish population, Mother's people toiled for a meager livelihood. They raised many children and tried to distinguish

themselves from the Gentiles by doing all they could to give their offspring a minimal education and some qualifications for employment. It was meant to assure their livelihood and, perhaps, a bettering of their lot. They labored in a world of strong racial, religious, and social bias and were consumed by constant apprehensions about the hardships of days to come. One among the Yochels' many concerns was their son Shmuel, my mother's grandfather, a bright and vigorous boy who was nearing his Bar Mitzvah. Barely thirteen, he looked like a young adult. Precociously tall, with traces of facial hair, he was the perfect prey for recruiters of the Russian army.

At this time Lithuania and its capital Vilna were part of the Russian Empire. Although serfdom had been abolished, a large portion of the population lived in a state of semi-slavery. The czar ruled absolutely. Severe laws restricted the life of the Jews and confined them to limited areas of residence. One of the most cruel decrees was a ukase that permitted the authorities to tear a boy from the home of his parents, from his language, his culture, and his religion and send him thousands of miles away to serve the czar. Such army service was expected to last twenty or twenty-five years. For Jewish families it meant the loss of a child. The only way to save a boy from such a fate was to marry him off. The law exempted married men from the draft.

By Jewish religious law, boys are vested with adult responsibilities at their Bar Mitzvah and are thus ripe to assume the charges of marriage. Marriages were therefore arranged, and mere children became legitimate couples. The Russian authorities accepted the legality of the *ketubah*, the marriage certificate issued by a rabbi. Shmuel was married at his Bar Mitzvah to a girl slightly older than he. The agreement between the parents assumed that as usual after the ceremony each of the children would return to its respective parental home. But at the end of this wedding ritual, the Bar Mitzvah husband spoke out. Shmuel had his own idea

about where he should go and what he should do. He believed that the family had to respect the newly wed spouse's legitimate rights. He quoted from the Bible. Well aware that his attitude was very different from that of his parents, he asked for the weighty opinion of the rabbi. The boy's temerity slightly embarrassed the old man, but he saw the justice of his claim. Indeed what the Bar Mitzvah boy had studied in the Bible was binding. The law-abiding families gaped at each other in bewilderment.

That is how Shmuel left the synagogue with his bride for her parent's home.

I shall forever regret having missed Shmuel Yochel's Bar Mitzvah. I have been to many events of this kind, except my own which I refused to celebrate. My refusal might have had its roots in Shmuel's determined nature, but its immediate cause was very different, as will later be clear. This sadly humorous event provided one of the lighter moments in my great-grandfathers' life, which was otherwise one continuous struggle against a long flow of hardships.

Shortly before his next birthday Shmuel became a father. With the passing of time he had many, many children. Their total number was not clear to us, his proud descendants. He lived till his early nineties and his procreative powers gave him a reputation that lasted well after his passing. The aura was so great that whenever his offspring spoke of him, always lovingly but with the inevitably insinuating smile, they were inclined to go overboard. Was he some mythical Jewish rabbit?

According to Mother's calculations, which took into consideration the high infant mortality of those times, the number of his children reached twenty-five. Many of them emigrated to America, changed their names, and lost all contact with their father. But they bred and multiplied and have contributed, under the various names improvised by the officials of Ellis Island, to the Jewish population of the United States.

Shmuel was widowed three times, and his last daughter was conceived

when he was seventy-two. My grandmother Shifra, who married Shmuel's son Khone, took care of this baby sister-in-law who was younger than Shifra's own children and who had the good fortune to survive the Holocaust and in later years marry a high-ranking Polish politician. I later met this thickset matron, Mother's youngest aunt, in Rome. She and her Polish husband, an important Communist leader, were on a state visit to Italy in 1962. The aunt phoned, spoke to me very excitedly about our forthcoming meeting, and rushed to my house to meet and embrace me. Two members of the Italian Communist Party, which was officially hosting the visiting couple, accompanied her.

My art in those years had met with relative approval. My shows were successful. I lived in a large and elegant apartment. My visitor entered, threw a glance at the furniture and carpets, and her face changed. Her excitement about our getting together was quickly restrained. We did not speak of all those things she had alluded to over the phone. The Yiddish that we spoke together was a further obstacle in that her comrades did not understand it, and this made them cast inquisitive glances at us. But we had no alternative: my Polish and Russian had become too rusty. She remained cool and distant and left without a promise to keep in touch. I never heard of her again.

The idea of having had a great-grandfather who diligently procreated for sixty uninterrupted years has always fascinated me. He believed that husbands and fathers had obligations as well as rights. He was a good husband and a religious man who with aging became so pious that his piety brought his long life to an end.

Actually his death was due to two independently coexisting factors. First, the great piety that made him mark the destruction of Jerusalem's temple by a day of rigorous fasting, and second, the housekeeper's concern for the health of the family dog, a little schnauzer whom I remember old and grouchy. When Shmuel returned from the synagogue to Shifra's

home, it was earlier than expected. The members of the family were away, and the kitchen still unattended. Thus the forgotten leftovers of a *cholnt* (a heavy Sabbath meal), which had been initially intended for the beloved animal but not given to him lest they harm his digestion, were retrieved by the hungry (and careless) Shmuel, warmed up, and eaten to break his fast. The *cholnt* did him in.

Although Shmuel was in his nineties, his passing took everyone by surprise. He was a man who seemed to have been forgotten by his genetic clock. Walking erect, with a hasty gait, he never let his cane touch the ground because it could damage its tip. His hearing and sight were perfect. He was amiable, loved children and dogs, and above all, his long days in the synagogue, where besides prayers and learning he delighted in the intense human exchange. His only eccentricity, tolerated as a matter of course in a man his age, were the empty golden spectacle frames he wore with the conviction that they added to his respectability.

As the father of three daughters I can hardly fathom the work and the energies needed for the care of such a multitude of babies and toddlers as young Shmuel was blessed with. I guess that caring for the physical needs of the newborns had not been his domain in those times of clearly defined gender roles. Besides, he was often away from home, and all this work must have been done by his three consecutive wives and the babies' older siblings. But I know that the children growing up in his household had in him a caring and a loving father. He was profoundly concerned about their future. The small farm he leased and labored on did not suffice to sustain the endlessly growing family. The relentless toiling of his exhausted and ever pregnant wives, assisted by the multitude of children, barely made ends meet.

How did Shmuel make a living? Being a friendly man with a charismatic and outgoing nature, he enjoyed excellent relations with his Christian neighbors as well as with the Jewish villagers. He would travel

across the fields on his horse-drawn carriage filled with bundles and pack-
ages, to try some trading, a minor negotiation, the sale of a horse or
acquisition of a goat. Wearing a coat of a creased and hardened lambskin,
covered by damp and snow-encrusted shawls, he would circulate among
the villages of his county. I can well imagine his energetic silhouette
outlined against the leaden sky of a Baltic winter, or see him sweating on
a torrid summer day in a large sun-bleached linen peasant shirt.

Eventually he succeeded in a quite different venture: he became a trav-
eling healer of animals. He would listen to the peasants' problems and try
to figure out in what way he could render remunerative services. He must
have been a good psychologist and a man of great inventiveness and
imagination, as he soon became known for his "special powers."

Shmuel lived in a world that was suspended between a heavy pagan
heritage and a myriad of primitive Christian superstitions. He spoke
Russian like a born peasant, dressed like a serf, and displayed a whole
baggage of esoteric knowledge that was partly rooted in readings of the
cabala and partly collected from local beliefs. He knew how to fascinate
and bewitch his audience. For all I know, he did his hocus-pocus as much
for the pleasure it gave him as for its material reward. I do not know
whether he invented his special benedictions for chickens that did not lay
sufficient eggs. But I do know that he provided these, along with Hebrew
amulets for cows with milk problems, and much more. Feeble horses were
made to swallow inscriptions on bits of paper. Mules, dogs, and goats had
their special treatments. Baffled villagers watched him writing with his
own hands the magical charms that he later administered in well-
established rituals. He seemed to have something for everything, the
crops, the vegetables, the dry spells of summer.

His meager earnings, the fruit of his strange labor, consisted of
cheeses, a few sacks of potatoes, some flour, a chicken or two. They
barely enabled his family to survive. Inevitably, the perpetual growth of

the Yochel household made life increasing difficult. Looking for a way to deal with the increasing number of mouths to feed, Shmuel decided to establish a rule: as soon as each of his children reached the "grown-up" age of nine, ten, or eleven, he or she had to leave home, learn a trade, and become independent. Since the farms that surrounded their village provided employment for very simple tasks, children who were intelligent and mature for their age would be brought directly to Vilna, the capital of the gubernatorial district, which offered a greater array of possibilities. Shmuel would go to the ancient part of town where most Jews lived, spend time in the synagogue, inquire about the various Jewish craftsmen, and explore all the positions open for apprenticeship. A prudent man, he also checked the reputation of the potential employers. He would then offer his child for an extended period of learning, from which the young boy or girl was expected gradually to become self-sufficient.

Most of his offspring did relatively well, at a price that can hardly be measured by today's criteria. Pursuing happiness would have been for most children of such poor families a strange concept, and surely not one they could afford. That is how, before the turn of the century, my grandfather Khone and his younger sister Hanna, two of Shmuel's smartest children who were also very devoted to each other, were brought to Vilna to start new lives.

Khone was placed with the family of Isaac Nadel, a fine mechanic. Isaac, who had lost his eyesight in a work-related accident, needed constant assistance. In spite of his handicap he was considered an excellent professional, and there was great demand for his care and servicing of bank vaults and sewing machines. His assistants were his eyes and he was their brain, and often their hands. Khone admired the old man's vast expertise, learned his trade, and loved him dearly. Besides, Khone was fascinated by the elder man's exceptional musical talents, and most of all by his endless flow of stories, real or imagined. With time Khone became a

sweet, cultivated, and yet somehow impractical person. Nevertheless his new life with the Nadel family, who almost adopted him, turned out for the best. He married Isaac's bright and resourceful daughter, Shifrah, the love of Khone's life who with the passing of years became the pillar of his family's existence. When at Isaac's passing Khone inherited the old man's business, he gradually managed to bring it to the point of bankruptcy. But theirs is a story that merits a separate chapter.

The life of his sister Hanna evolved in a much more unpredictable way. The girl was placed with the family of an ambitious and successful Jewish baker. Her employer worked for one of the finest palaces in the city, where an ancient family, bearing a name that related it to the old dynasty of Polish kings, held court. Hanna and others of the baker's helpers were often sent to the palace kitchen with fresh merchandise. The girl loved these assignments. Strikingly beautiful, Hanna became popular with the personnel, the cooks, and the kitchen assistants. She also conquered the heart of the palace's governess. The governess and her husband, a childless couple of an impoverished branch of the master's family, were greatly admired by Hanna. Soon the good looks, natural poise, and intelligence of the Jewish child enchanted also the husband, and the pair started to make secret plans for this endearing child's future.

Meanwhile Hanna's life at the baker's was rapidly growing intolerable. The wife's continuous pregnancies and numerous children took the girl away from her apprenticeship and transformed her into a fulltime nanny, spending nights with ailing babies, carrying water from the well, stacking wood in the stove, washing mountains of soiled diapers and clothing, preparing food, and spoon-feeding the children. Hardly an adult herself, she was somehow capable of accomplishing these exhausting tasks. But her mistress never granted her a kind word. Hanna's good looks and the baker's oblique glances may have provoked this hostility.

When Mother used to tell me the story of her Aunt Janina, it sounded

like a page from one of my beloved tales of the Grimm brothers. I looked at the ancient illustration of Cinderella, trying to recognize in her features Janina's face. It was difficult to think that all this had actually happened to a close member of our family. Her story, suspended between the world of fairy tales and the harrowing reality of cruel times, was one of our family's outstanding legends, a real myth.

This may be why, when an unexpected occasion brought Hanna's wonderful story to my lips, I opted instead for silence. In the early sixties, in an elegant Roman restaurant, I was seated across from one of this century's great French artists whose work I greatly admired. The famous painter, lean and tall, was displaying the offhand arrogance too often characteristic of his Parisian milieu. Instead of learning what he might have had to say about the great issues of contemporary art, I was forced to hear lists of princely families to which he claimed to be related. Suddenly he named the family of the palace with which Hanna was connected. Had I known then what I now know, that this pretentious person was not Polish aristocracy but simply Jewish like me, I would have stuttered something about the strange tie that connected my aunt to that family. But I was intimidated and kept my mouth shut.

In the Jewish bakery, a shortage of helping hands sometimes made the boss violate his wife's rule that Hanna remain under her own close scrutiny and send the girl with his products to the palace kitchen. For Hanna these were moments of anxious pleasure. The palace seemed to her a terrestrial Garden of Eden with its spice-perfumed kitchen and its welcoming human kindness. The governess, noticing the confusion and mounting distress of the Jewish girl, persistently questioned her, and Hanna must have opened her heart. The governess gently offered Hanna the possibility of a different arrangement, something other than slavery in the baker's home. But she made Hanna understand that it meant a hard choice. The governess promised the sheltering walls of an opulent man-

sion. The sacrifice was that Hanna would have to relinquish her family and her Jewish heritage. Hanna's conviction and commitment would be indispensable. Hanna understood. She was offered a way out from her nightmare.

Leaving the baker's house, Hanna closed the door on her past. When she arrived at the palace and made her decision known, she was in tears, well aware of the weight of her choice. But it was not a time to vacillate. The Polish couple, too, acted swiftly. The girl was baptized and subsequently given the ancient family name of the adopting parents. They also changed Hanna into Janina. Presenting her as their own daughter, they hid Janina in an exclusive college for girls. The college was in an ancient Benedictine convent that would later play a major role in my survival. It was situated adjacent to the Church of Saint Katherine, opposite the apartment building at 10 Wilenska Street, the childhood home from which I was to be driven to the ghetto. But that will come two generations later.

When Janina chose her new life in the remote Vilna of the time of the czars, it generated in her both pain and an unexpected flourishing of hope. Hidden behind the high and thick walls of the convent, she felt safe. She discovered a world of refinement and knowledge with which her former world could never have provided her. Deep and affectionate ties developed between her and her educators. The convent's Benedictine sisters became her new family.

Hanna's sudden departure threw the baker into a state of panic. The girl's traces led to the palace, where power and authority could hardly be challenged by a Jewish plaintiff. Yet the baker bore a heavy responsibility to the girl's family, and moreover his reputation among the Jews of the city was at stake. He had to send for Hanna's father, notify him of the disaster, and try to plead for exoneration. Presented with the fact of his daughter's flight and renunciation, the devastated Shmuel left for Vilna. He arrived there a broken man. Hannele, the light of his eyes, how could

she? But what could a poor Jew from a small village in Eastern Europe do against such high-ranking persons as those who had opened their arms to his unhappy child? Whatever happened happened within the law. And the law gave him no way to reclaim a child who had left the faith of her fathers voluntarily and without coercion. Poor Shmuel was at a loss.

True, there had been some past cases of parents who in similar circumstances battled in courts, engaged lawyers, alerted journalists and foreign representatives, but the results had always been disappointing.

The heartbroken Shmuel, a simple villager and a pauper, decided to do the only thing that his narrow world expected from him. Since Hanna had done the most abominable deed that a Jewish child could do to her God-fearing parents, it was his duty to repudiate her. All his life he had obeyed laws that prescribed for every circumstance the appropriate behavior. Now it was his duty to mourn her as if she were dead. He sat shivah for seven days and cried. Later he attempted to put her out of his mind, as if she had never existed. He almost brought himself to believe that he had succeeded. But there always remained a narrow gap of hope for her return.

* * *

Years went by. Behind the tall walls of the Benedictine college, Janina, a devout Catholic, completed her studies. She was a lovely and refined young lady, ready to be presented to society and to be married. Her adoptive parents arranged a union with a son of an excellent Polish family. The family originated from the Prussian Junkers, and the young man, noticeably older than his bride, had an excellent pedigree. Well educated and well connected, he was the nephew of the archbishop of Warsaw. They formed a dashing couple and in time became quite affectionate. Janina's husband, a chemical engineer, had a good position with the Imperial Petroleum Company of Baku, on the Caspian Sea, where he and Janina lived a very respectable and comfortable life. She bore him three sons.

The events of World War I totally disrupted their beautiful life. After many hardships and wanderings, moving through a war-torn Russia, in trains and on foot, after an escape from a Bolshevik prison, in the midst of brutal executions, going through times of famine and epidemic diseases, Janina and her husband finally landed in Kovno. Their children had all succumbed to typhoid fever.

Kovno, or Kaunas as it was renamed, was the temporary capital of the newly established state of Lithuania. Janina rediscovered in herself unforeseen reserves of energy, courage, and the stamina necessary for a new start. Her husband acquired in the new administration a position that grew in importance and soon earned the couple a comfortable life. They were blessed with two more sons.

Hanna-Janina in Kovno and her brother Khone in Vilna had had for a long time no news of each other. Separated by less then one hundred kilometers, the two towns were nonetheless divided by an impenetrable political wall, in that a war between Poland and Lithuania had for two decades sealed their border. All forms of communication were strictly forbidden. But it did not prevent Janina from exploring the possibility of a contact with Khone and through him, a way to Shmuel.

There are several fragments of stories that come to me from Janina's recollections. She told me about her longing for her older brother and her desire to establish secret contact with him. But that was before World War I, when she was still at the college. Quite often, when taken by the nuns for a walk in town she would stop and linger, for as many instants as possible, near the shop of the mechanic. Spying on the goings and comings of the Nadel household she hoped to catch a glimpse of her dear Khone. She never found the courage to attempt anything more.

I know that on his side Khone once felt certain that among the Benedictine college girls in uniform he saw one who resembled his sister. He ran to the convent's gate, rang the bell energetically, tried to question the

janitor and the nuns with growing insistence (so unlike his usually calm demeanor) but was sent away with anger, with force, and with "blessings."

Their final reunion happened a few years before I was born. A Catholic priest approached Khone and told him that Janina, Grandfather's sister who had been traveling with her five-year-old son on special semi-official papers, had arrived secretly in Vilna and was hoping to meet with him. To get from Kovno to Vilna, she had had to travel by way of Paris.

It was in the summer of 1928. Some years earlier Shmuel had come to Vilna to live with his son Khone, bringing with him his two youngest daughters by his recently deceased third wife. (One of them would become the thickset Communist matron, my mother's youngest aunt, whom I met many years later with her two Italian comrades in Rome.)

Shmuel was in his eighties. One day the family, installed in a summerhouse just outside of Vilna, was gathered around a resplendent Sabbath dinner table. The old man was presiding. When Khone arrived from town he was accompanied by a handsome Christian lady and her small boy, whom he presented as old friends. This unusual situation generated palpable unease. The only one whom this strange intrusion of Christian visitors did not surprise was Shifra. She must have been informed ahead of time. Quietly she lit the candles and proceeded with the blessings. The younger members of the family looked at each other questioningly. And then when old Shmuel started to bless the wine, the Christian guest began to weep aloud. Tears had already been rolling down her cheeks, but now she was sobbing uncontrollably.

"Please forgive me, Father. Father, please. . ."

The old man froze. So did everyone else. He looked at her for a time that seemed an eternity. Slowly he got up from his chair, placed his hands on the stranger's head and with a murmuring and trembling voice, repeated over and over words so difficult to articulate that at first they

were unintelligible. He spoke to her in a murmur. "It was not your fault, my child, not yours. Bad people have made you do it, do it. God will always take care of you. His ways are a mystery to us, a mystery, but you are welcome in your coming and in your going, and I bless you."

Janina returned to Vilna a couple of years after this memorable meeting and again met with Khone, her father, and the whole family. When she arrived for the third visit it was for the unveiling of Shmuel's tombstone. Apparently she then made an acquaintance with my tiny person in the arms of my "Niania," my nanny.

In October 1939 the Lithuanians annexed Vilna, changed its name to Vilnius, and made it their capital. Soon after, though her husband's business kept him in Kaunas, Janina bought a lovely chaletlike house in a green suburb of the town and came with her two sons, Janusz and Victor, to live near her family and her old friends of the convent. Her allegiance to the Catholic Church never troubled the warm and dedicated love among us all. When Lithuania became a Soviet Republic, Janina remained in town. We saw her a lot and became very close. Then Hitler's army invaded.

Strangers, people I have hardly known, have in moments of great danger undertaken perilous actions that saved my life. Words cannot express my sense of gratitude to all of them. But if I had to name the single person to whom I am most indebted from among all the various angels who have risked their lives for mine, I have no doubt that after my parents it would be Janina.

She was our most trustworthy and often our only support in the most horrendous of times. She was the axis of our plans and often their courageous executor. She was the only home port we had. Whenever our boat was in need of urgent repair or on the point of sinking, she was there!

I wish I could have projected myself into Shmuel's village the day he was mourning his renegade daughter. He was certainly sitting barefoot on

the ground, as was the custom. I would have loved to put my hand on his shoulders that must have been trembling with his silent crying. I wish I could have introduced myself to him as his future great-grandson, the one who was to be born few days after his passing, and was therefore entrusted to carry his name in all its forms, Shmuel, Sam, Sami, Sammy, Samek, Samunia, Samuel.

I wish I could have reminded him that in our religion, which he so ardently practiced, the saving of a human life took absolute precedence over all other endeavors. His dear Hanneleh, when she made her momentous choice, even if she could not have known its ultimate effect, must have been inspired by this beautiful ethic of a profoundly liberal Judaism.

But I know that he did not need me. He lived long enough to come to the day of finding pardon in his own heart. He died without knowing what lay ahead for most of his descendants. Yet his murmured benediction on the day of his reunion with Janina must have made her know that he entrusted us to her care. My imagined visit of comfort was unnecessary. Anyway, such visits happen only in books.

SHIFRA (NÉE NADEL) AND KHONE: FAMILY REUNION IN PONAR

I know that the words "family reunion" should suggest happy events. And since the end of Europe's nightmare I have indeed known many family gatherings that I have cherished as blessings, as wonderfully unexpected offerings.

But there are other images that continue to haunt me, other family "reunions." It is hard to efface the memory of huge mass graves, of people executed because they were born in a certain time and belonged to a given group. They are often members of the same family. I tell myself that such images should not be allowed to invade my daily life. I must rid my mind of them as quickly as possible! But the avalanche of current news that the world all too readily supplies makes this impossible. Whenever on the television or in the papers, I see those heaps of anonymous bodies, lying strewn in streets of Beirut, Kosovo, Africa, or elsewhere, a howling sound resounds in my mind—the name Ponar.

Before Ponar (or in Lithuanian, Paneriai) became for so many of us the infamous place it is, it was a lovely suburb of Vilna surrounded by woods. I remember it in the sunny days of the early summer of 1941 that I spent with Aunt Yetta, Uncle Yasha, and my little cousin Tamara. This was after the beginning of World War II. The occupation of East Poland by the Russian army had disrupted our lives. A Soviet general had "nationalized" my maternal grandparents' town apartment and settled

into it with his wife and children. Aunt Yetta and her husband Yasha, who had been living there with Grandfather Khone and Grandmother Shifra, were literally evicted into the street. My maternal grandparents moved in to live with their old friends, my paternal grandparents; but my aunt and uncle had to find a separate lodging. Since Yetta and Yasha also lost their respective jobs, they had to reduce their living expenses by moving to a suburb, where life was cheaper. Their spirits were dashed, but I did not pity them: they lived among flowering meadows, beautiful trees, and small wooden country houses. The area was known for its pleasant summer weather. In my eyes it was a corner of paradise.

This was a special period in my life. The unexpected changes that war brought to our family routine did not overly distress me. Rather they fascinated and made me rejoice, which gave me twinges of guilt. Of course I could not share my enthusiasm with the adults. Deposited in Ponar by my parents, who faced mountains of worries and hardships of which I had only the vaguest inkling, I had there a most wonderful time. I used to walk, with Yetta's permission, in the nearby wood, never venturing beyond the preestablished perimeter of my aunt's watchful eyes. Berries and mushrooms grew abundantly in the vicinity of their dacha, and I used to collect them with passion. Once, after having ventured a little farther than usual, I returned with baskets full but with red stains on my fingers, shirt, and pants. I had eaten some of the berries on the spot, and their strong tinting juice marked my clothes, probably forever. This little catastrophe also involved mushrooms. Although I had been taught to distinguish the "good" from the "bad" and was repeatedly instructed never to mix the two kinds in the same container, the pleasing sight of their colors and textures must have been stronger than my habits of obedience. As a result, my alarmed and angry aunt declared *all* mushrooms to be bearers of death and proceeded with their destruction.

Disappointed, I had to listen repeatedly to the familiar lesson about

things that were better left untouched. There followed warnings about the unexpected dangers I might have met on those grounds: dogs infected with rabies, unexploded mines, bad men. A big boy of seven must understand how to avoid such threats to his precious life.

"In the future avoid unnecessary perils. Stay in the part of the garden that is fenced in. Beware. One never knows." These were Aunt Yetta's warning words about the lovely surroundings of her house. Later, she gave my hands a healthy scrubbing and changed my clothes, as if to drive the evil away.

Up to that time, Ponar's rural silence had rarely been disturbed. But a few weeks after my aunt and uncle settled there, a gradually mounting sound of heavy machinery at work began invading our premises. Suddenly the birds seemed to have disappeared, and with them their beautiful singing. The neighbors told us that the Red Army was digging huge trenches for an underground fuel depot.

A few months passed, and Hitler declared war on Russia. After the Red Army retreated and the Germans arrived, the woods of Ponar became a place of executions; and the deep-dug Russian holes meant for fuel became mass graves of Vilna Jews and the Jews of many neighboring towns. Although the Nazis later tried to eliminate the traces of their crimes and several months before their retreat in 1944 began to destroy all evidence, they did not complete their job. An official Russian estimate spoke of a hundred thousand victims, but many believe that more than two hundred thousand people lie buried there. Ponar is the eternal resting place of many members of my family. My two grandfathers, Khone and Chayim, were the first to enter. In a line for distribution of bread, they were arrested by the catchers, or *khapunes* as they were called in Yiddish, and then shot. The *khapunes* were dreaded units of Lithuanian thugs, often in their teens, who received ten rubles for every Jew delivered to the Nazis. Several months later, on Yom Kippur 1941, my two grandmothers,

Shifra and Rachel, were brought from the second ghetto to Ponar and shot with thousands of others.

The Two Friends' Scheming

Layers of mental cobwebs have covered up the images of my past, and at times I find it hard to recall the faces of my beloved grandmothers. I must shut my eyes and call their names. Of the two, it is my maternal grandmother Shifra who first surfaces. Rachel follows.

No wonder. Shifra was the one whom people would describe as the formidable lady, the lady with a "special and overwhelming" personality. Her death has not effaced her legendary status. What I could not have known from my personal experience as a child, I learned in later years from Mother's numerous stories and reflections. Equally dear to me, Shifra's old friend Rachel must have generated a smaller aura. At first I see her less sharply than I do Shifra, but as I think of her delicate figure and the graying hair that she wore in a grandmotherly bun, her harmonious features come slowly into focus. I perceive her dark and inquisitive eyes, the delicate mouth, and the graceful bearing that still preserves the traces of a very pretty woman. Rachel in her mid-sixties, the grandmother I remember, must have had mellowed with time. The sweet and withdrawn nature of her later years could have been, as Mother believed, a screen that hid a very self-centered nature. It could also have resulted from the handicaps that remained after her recovery from a devastating epidemic. Having lost her sense of taste and smell, she gave up cooking, though she never gave up wearing perfumes. On the surface she was very different from the self-assured and dominating Shifra.

Seemingly perfect counterparts, the two women were cemented in a lasting friendship. In the ghetto they shared everything they had—their dry bread, a bunk in a corner of an overcrowded room, their anguish and fear. I hope they were not separated at the very last moment, and that

riddled by the executioner's bullets, they died in the same instant, holding hands.

Both had loved me unconditionally. I, my parents' only son, had been their first grandchild, their "Jesusl," little baby Jesus, as the God-fearing Shifra, deeply devoted to the Jewish faith of her forebears, would call me with an endearing malice. Years before I was born, when Mother and Father were in their teens they often met on the occasions of their parents' friendly gatherings. The recognition of their children's interest in each other made the two women nourish hopes for a future union. However by 1930 it was too late for parental matchmaking; the world had grown "modern." To prevent youthful resistance, Shifra and Rachel tried to outsmart their worldly offspring by exerting their influence surreptitiously. Pride and prejudice had to be respected.

Jonas and Mizia, my parents, would have smiled at such machinations. They were always convinced that their decision to marry was their own. Perhaps so. In any event, the story was a little more complicated: it was mainly Father who decided on the match.

His way of convincing Mother was quick but not very orthodox. He did it by dramatically brandishing a gun and threatening murder and suicide if she refused him. From the way she told this story I knew she could not have been happier. He had made her feel like a heroine of a novel. A few years later, at a tumultuous period of their marriage, she found the gun; and still believing it to be real and very dangerous, she tried to flush it down the toilet. Had Father been like Mother a reader of Freud, he might have interpreted this act as a message to himself, her flamboyantly promiscuous husband. But I think he missed the symbolism. The result of her action was disastrous. It took a plumber several hours to mend the toilet; and the aftermath was ridicule, embarrassment, and a lot of jokes.

Nevertheless, for my loving grandmothers I represented the concrete

result of their successful secret matchmaking. To them, it was almost as if my parents' part in making me was entirely secondary.

Sharing a Secret with Shifra

Shifra, the undisputed head of the family and certainly an unusual woman for her time, was in charge of a flourishing business. A born leader, respected for her pragmatic intelligence, a master in the art of the possible, she was often sought for her invaluable counsel and was always generous in sharing her wisdom. Obtaining satisfactory deals by means of reasonable compromises was her specialty.

When I think of her, the first thing that comes to mind is our secret agreement, a pact that made me feel incredibly proud. It proved I was reliable and trustworthy. I was about four or five, but she, in her great sagacity, made me feel her equal. We had concluded a deal by which I engaged not to divulge secret information that she revealed to me about the true nature of ice cream. I must explain that until then I had been convinced that ice cream was a sort of hot drink. Because of my chronic bronchitis there was an absolute ban on letting anything cold go down my throat. All the adults around me obediently implemented the pediatrician's decree, but they misinformed me in the process.

I was never deprived of ice cream. Like all the other "obedient and good children" I was allowed it, but in a special way. In the municipal gardens ice cream was distributed in a lively kiosk called Little Paradise. We, the "good" children, were given money and made to wait patiently in an ordered line, without pushing, at the kiosk's window. It was an "important lesson in urban behavior" taught by well-dressed parents who frequented this enchanting spot in the hot summer months. There were cages with green talking parrots and a little monkey in a red fez that handed out candies, randomly chosen from a big container. The monkey was accompanied by a grumpy old man in thick black glasses who

collected in a velvet bag the money that was handed out to his hairy assistant. A fat lady would rent and sell huge hoops of light metal or wood that children loved to push and chase with the help of a little baton.

The adults waited next to the window that distributed our orders, observing us with admiration, pride, and some concern. Enthusiastic games sometimes generated brawls. Unpleasant encounters between Gentile and Jewish children had to be avoided. Preferably!

With the ice cream in my possession, letting it slowly melt in a small container brought for the purpose, I would quickly return home. Ice cream wasn't supposed to be eaten in the street. That would have been an "unhealthy and rather vulgar comportment." However, brought home and melted on the kitchen stove and poured into the appropriate cup, it could be drunk with circumspection and pleasure. Consuming it in this manner was good for my throat, and it avoided making a mess of my jacket and pants!

Well, Grandmother Shifra had no patience with the pediatrician's overprotective rules and totally disregarded them. Our exclusive Saturday outings would bring us to a small zoo, to the Café Sztral where they played lovely music, or to a local cinema for a Yiddish film in the afternoon. Or when the weather was warm, we would go to the Little Paradise of the municipal gardens. There Shifra, opening my eyes to a very special and unexpected treat, showed me a world in which ice cream was something cold. Moreover, she let me realize the importance, the seriousness, and the weight of our conspiracy, and made me solemnly swear to keep our "very naughty and unforgivable behavior" (with a forgiving smile) an absolute secret. A secret from the entire family, from Xenia, and above all, above all, from my own Mother!

It was quite a bittersweet challenge.

Sixty years have passed since I walked with Shifra in the city gardens of Vilna and I savor it as if it were happening now. I can see myself atten-

tively observing her oval body with its heavy and low bosom undulating above her swollen feet, limping slightly in forever uncomfortable high-heeled shoes. I am trying to cling to her and to remain sheltered in our "portable" patch of shade that her mandatory summer parasol casts over us. Under its radiant fabric we remain well protected from the bird droppings that rain from the majestic trees guarding our passing. I realize that this must be the main reason for her carrying this beautiful object. It makes me admire her wisdom that has so thoughtfully prepared her for all that may happen. Grandmother Shifra is like the icebreaking boat on a sea of ice that we admired on a recent newsreel. Few people have ever conveyed to me such a feeling of protection and shelter.

Shifra, as her plump figure attests, is a great lover of ice cream. The multitude of flavors, of which she is a matchless connoisseur, is expanding my perception of the world. My awareness of our sinful conspiracy and the fun of sharing this treat with her have an additional benefit: they offer a powerful lesson about the delicious nature of forbidden fruit. It is a heavenly beautiful day, the sky is blue, and the philosopher in short pants thinks of the story of Adam and Eve. He knows that naughty acts are hard to hide, and starts to realize how complex our universe is. Besides, reality can be misleading. Things are not always what they seem. Who would ever have thought that the normally warm ice cream could also be consumed frozen!

I wonder if the child I then was could have articulated these confused thoughts. Nevertheless, whatever I project into the little boy of that time, my first insight into the complexity of our knowledge of good and evil comes directly from this experience. It is still alive and resonating.

The Price of Treason

Revelation comes at a price. I began to dislike the hot drink, but in order not to arouse the least suspicion of my lost innocence, I had to con-

tinue drinking it from time to time at home, and to pretend to like it. In front of Mother, my complicity with Shifra made me feel terribly guilty.

At that time I was convinced that my most hidden secrets were popping up in clear writing on the skin of my forehead. I was sure that whenever Mother wanted to know the truth about my thoughts, she could easily read it there. She must have thoughtlessly told me about such a special talent of hers, unaware of my literal mind. I used to worry a lot: "Will I be able to hold back the writing and prevent it from giving me away?" So well had Mother succeeded in fixing this belief in my mind, that even now, whenever I am in a stressful situation, red stains appear above my eyebrows. If Mother were alive today she would burst out laughing at the very fact of my writing this.

"You always blamed me for everything. You were barely one year old when you came up with your first sentence: 'It's all Mother's fault.' Shame on you! At your age! You are older today than I was when I died. Shouldn't we declare a moratorium on blaming parents?" And she would certainly conclude it with one of her unique chuckles. There would be no way of making her accept my view that if I allow the whole world to see my anguish on the skin of my forehead, it is because of her and no one but her.

I had to wait for the right moment to confess to Mother the ice cream agreement with Shifra. It remained a secret for years. When I did confess, I was already a young adult and harbored other, much more troubling secrets concerning my complex relationship with her. These had to do with my growing interest in the other sex, and my inner conviction that any female friend who got close to me would be viewed by Mother with a jealous and rejecting eye. Mother's only son had to struggle. The past had loaded our shoulders with heavy burdens, but I had no desire to continue being the "man of her life." My old conspiracy with Shifra had long been forgotten, or lain dormant, when one hot day on the balcony of

Mother's small flat in Tel Aviv I sat glued to an uncomfortable terrace chair, licking an ice cream. Suddenly I felt a pang of discomfort. It was the thought of my secret agreement with Shifra.

I realized how endearing the whole story was and knew that Mother was going to love it. It was no longer a question of finding the courage to admit my "betrayal." It gave me the opportunity to admit obliquely my present intention to be unfaithful to her, but to do it in a lighthearted context. As I expected, the ice cream story made her laugh until she cried, but these were not the tears usually associated with mirth. My story had, for a moment, made us feel Shifra's loving presence on this balcony in the land that had been promised to her forebears, but on which she, the one who had all the merit, had never set foot.

Reparation

Shifra hardly knew how to put limits on my inexhaustible list of childish fancies.

The inventive spirit of Grandfather Khone constantly, and sometimes mischievously, enriched my interminable inventories of wishes. In connivance with him I came to discover that Shifra, besides all the other qualities for which she was known, was a mighty fairy. To Grandfather's knowledge she possessed the magic power to fulfill any wish. (Certainly her magic had a strong hold on him.) Grandfather told me that all I had to do was to ask her to grant my wishes. It was good advice and permitted me to manipulate her into competing with Rachel. Today I can well imagine how my scheme must have amused her. I remember Shifra listening to me with a straight face, pretending to ponder very seriously my humble requests: A real steamboat with fire and smoke, to play with in my tub while taking a bath. A radio with a transparent back that lets one see all the little men who produce its music. A tube of watercolor that instantly paints white and black checks, and another for multicolored

stripes. A cream that renders little boys invisible. A small sledge driven by a troika of white ponies. The lists went on and on.

The family could hardly recognize her in the way she treated me. Severe, demanding, and strict with her own children, she would become a different person when attending to my most absurd whims. She was as forgiving and as loving as a grandchild's self-centered fancy could desire. Who knows whether her special way of spoiling me was not the answer to her own need for some kind of reparation? The pragmatic business-woman, impatient and perhaps skeptical of the idea of soul-searching, might nonetheless have been trying to compensate for having been an overworked and too little available mother. It is possible that my small self, by helping her establish a domain in which the child was king, had begun repairing some of the losses and regrets of her early years.

Grandmother's Parents: the Nadels

Shifra was born into a tough world and at a difficult time in her parents' lives. She had known hardship, debasing poverty, and—worst of all—the scarcity of parental love.

The saga of the Nadels has always been of major importance to our family's self-awareness and pride. I have absorbed it from a vast mosaic of fragmented stories, many told by Mother. The occasions on which they resurfaced were very special. It was after the end of the war, and I was living among survivors of the Holocaust who were in need of telling over and over again their experiences of the recent years. We would spend endless evenings, sometimes entire nights, listening in public to an outpouring of stories. Pain, loss, and bewilderment were everywhere. Talking about people from our past, and in particular about those who had perished, gave us a sense of rescuing them from extinction. As if the dead were being summoned to cleanse us of the guilt of having survived. The saga of my family and of countless other families were told and told

again. Many adults who in later years chose to become mute were able, in the safe environment of a shared traumatic past, to tell their stories almost obsessively. It has made me realize how great a solitude many of them had to embrace in later years, surrounded by a world that did not share their language and their experience and thus failed them as audience.

Unlike those postwar tellers of stories, today I summon the dead on the screen of a monitor with the help of a word processor. For the time being I am in an advantageous position. As long as my stories remain with me, I can revise, correct, and get closer to their heart. I can also shut off the computer whenever they cause too much pain. I know that there was much of it, and today it is part of me. After all, doesn't every man's life start generations before his birth? The drama in the story of Shifra's parents, the Nadels, starts to unfold from a given point in the 1880s. Whatever happened before that resides for me in total darkness.

Shifra's father, Isaac Nadel, a hardworking precision mechanic, barely earned a living. They dwelled close to the market, in the heart of the ancient Jewish quarter. Her mother, Yentl, helped out by selling fruit and vegetables in a small grocery. The hardships of Yentl's life did not soften a character that had always been rugged and sharp. Persistent poverty made her also stingy. Toward her husband Isaac she was resentful, reproaching him for being a poor breadwinner who lost time in idle occupations. She disapproved of his passion for music, his pleasure in storytelling, and especially, his lack of financial ambition. A series of miscarriages and infant deaths exhausted her and made her look old before her time. The grocery added another heavy burden. Their only son, Arno, then in his early teens, used to spend a lot of time with his father, but little of his father's profession rubbed off on him; the boy was a dreamer, a poet, a good-for-nothing. And then she found herself pregnant again.

The Speck of Steel

A few days after Shifra's birth, Isaac had a small work accident: a speck of steel flew into his left eye. Flying particles of metal were not uncommon in his type of work, but the chance of such an accident is always heightened by inattention, a sleepless night, or worry over a crying baby. Whatever the case, the accident triggered a lot of adversity, and Yentl developed an obsessive conviction that the arrival of the newborn girl was the chief cause of their misfortune. Certainly the lives of everyone in the family were changed. What seemed to be a small injury, to be treated at home, turned into a serious infection. It was a real disaster. Medical help was expensive, and Yentl counted every penny. When at last the couple decided to seek professional help, it was too late. Isaac was in danger of losing his left eye, and the local doctor advised a trip to Koenigsberg, in Prussia, where a more advanced German medicine could provide a treatment unavailable in Vilna.

Distraught and anguished, the couple was obliged to sell their small house and Isaac's shop, to rent out Yentl's grocery, to place baby Shifra with a nanny. With Arno in hand, they put all their money in a bundle and left for Koenigsberg. By the time they got there, Isaac was critically ill. The German doctors managed to save his life by removing the infected eye, but then the infection spread to the other. Following a consultation of specialists, the Nadels left for Berlin in search of a famous professor who "with God's help" might save the remaining eye. It was not to be. In Berlin they found only despair. To survive at all, Isaac had to accept the loss of his remaining eye. Then the situation worsened, and he nearly succumbed to a generalized post-surgical infection.

For days Isaac hung between life and death and then, when all hope seemed lost, miraculously his situation stabilized. The day came when he was able to get on his feet. Confronted with the need for extended care

and the prospect of a very long period of recovery, the hospital threw him out. The long stay in Berlin had consumed the Nadels' funds. Penniless, in an alien and hostile city with no possibility for the slightest credit, Yentl was in the street with a disoriented boy and a very sick husband. Barely making herself understood in her native Yiddish, she found a way to her only hope, the city's great rabbi, the respected leader of a prosperous community. Yentl asked for an audience and was granted the privilege. The three Nadels in their worn rags, despair written on their pale faces, hardly able to stand, hesitatingly presented themselves in the rabbi's elegant quarters. Well aware that the German Jews distance themselves from their "primitive brothers from the East," the very intimidated Yentl still managed to find the words to speak. To her great relief, the rabbi heard her story with compassion. He saw that the blind father was too deeply depressed to be comforted by him and that his wife was near the end of her strength. The rabbi was most impressed by the boy Arno, whom he found to be bright and eager to learn. In the end he not only gave Yentl the necessary means for their return to Vilna, he also offered her the possibility of leaving Arno with him. He told them their son would join them later, as soon as they could make a new home and return to "normal" life. Yentl accepted the generous proposal with immense gratitude.

Arno's strange new world surpassed his most daring dreams. He opened his mind to this new and greatly privileged community of Berlin's middle-class Jews. Becoming part of the rabbi's household, he prolonged his stay indefinitely, well aware that the ordinary circumstances of Vilna, the life of poverty before his father's accident, would never have given him this chance for study and growth.

Yentl returned to Vilna and took back the grocery. In the beginning she resigned herself to life as sole provider for an infant and a severely disabled husband. Insofar as she could empathize with Isaac, it broke her heart to see him withdrawn from the world. Where were his former stamina,

his enthusiasm and joviality? Now she reproached him with having lost any interest in those close to him. And who can blame Yentl? Who, in similar circumstances, would not have been tempted to bitterness and anger?

Distanced from her husband, she regarded little Shifra with growing apathy and could not love her. She blamed the child for the family's misery, and as soon as she could afford to, she let others take care of her rejected daughter. The girl had to learn to cope with a mother who was on the border of mental breakdown. The father was a warm presence despite his depression, but he had little support to give. Over time Shifra discovered that total strangers offered her more affection than her parents did. A need to establish restitution by caring for strangers eventually became one of her dominating traits. Forces that might have destroyed others endowed Shifra with unusual power. Well prepared to cope with what lay ahead, blessed with an energy and intelligence that made the best of every situation, she transformed her life of deprivation into a story of success.

Meanwhile, to everyone's surprise, while Yentl sank into bitterness, Isaac's mood improved. Gradually he began to move around the house, to perform simple mechanical tasks, and to recover the use of some of his old tools. Soon his acute ears and his fine sense of touch permitted him to resume certain aspects of his former work. People were attracted to him. Who has ever heard of a blind mechanic? Again he sang at work. He talked, listened, and told stories. He hired assistants, instructed them in the basic theories of mechanics, and taught them to execute complex tasks. He could tell from sounds and vibrations whether the work was being well executed. He learned to choose the most able and devoted apprentices, and in time grew better known and remunerated than he had been before the accident. When Shmuel Yochel, the father of Khone, heard about this successful mechanic's shop, Isaac Nadel had already started to prosper and be beleaguered by a waiting list of assistants. Shmuel had little hope that his son would be chosen.

Khone's Return

It must be that my fate's angel, knowing that only the union of Shifra and Khone could bring my mother (and subsequently me) into the world, decided to intervene and persuade the blind man to accept Khone as apprentice. The young man became a member of the Nadel household, where Yentl treated him no better than she did her daughter or husband. The homesick boy found refuge in a growing affection for his employer, Isaac, and in time became the blind man's most reliable help and his closest friend. A surrogate son of sorts, he filled the void left by Arno. The real son did not dream of returning from Berlin. In his new life he was collecting honors in every domain of his studies: in philosophy and linguistics at the university, in rabbinical studies at the theological institute, in musical composition at the conservatory, even in the plastic arts. He wrote poetry and published translations from Yiddish into German. He was blossoming. His parents had to accept his lengthening delay in returning to Vilna and assuaged their sadness by a great dose of parental pride. In later years some of Arno's expressionist drawings adorned my grandparents' dining room. Khone and Shifra regarded the works with misgivings, aware of not knowing how to understand them.

When as a child I asked them to explain the pictures to me, they would say wisely, "Wait until you grow up." Nevertheless they were absolutely certain of Arno's judgment, so when he told them that I should be an artist, they responded by giving me every opportunity and encouragement. Arno Nadel's story would merit a separate chapter. But those chapters have already been written and can be found in old encyclopedias.

For Shifra, Khone was not only a son to her father, but a surrogate brother for her. Slightly older than she, he developed a protective attitude toward this bright girl who was so openly rejected by her mother. Yentl, whom one might have expected to welcome her husband's return to work

and the consequent improvement in their financial situation, shifted her pathology instead to a fear of infections and an obsession with cleanliness. The stories of her various fixations were told to me with an air of amusement. Today I see how sad they were.

During the war between Russia and Japan, Khone served at the front as an ambulance driver, a mechanic, and an inventor of devices to make more bearable the hard life of his frontline unit. It seems that he was the first Jewish volunteer to leave Vilna, a Jew ready to die for the czar. What an oddity! He had also hoped to see the world: St. Petersburg, Moscow, Manchuria, Port Arthur, and "with God's help," Tokyo. Alas, the Russians had promised an overwhelming victory over Japan but obtained instead a terrible defeat. And Khone returned to Vilna with an injury and a shaved head. The injury healed, but the shaved head he kept all his life as a token of his status as a veteran, which in his eyes redeemed his own father from having escaped the draft. He also brought with him from the wars a rich repertory of exotic tales. People loved them.

In later years, on the many occasions that brought us together, I listened to his stories with an open mouth, mesmerized and bewildered by their strangeness. At my request he would tell and retell them to me, and with a child's passion for accuracy, I would point out the discrepancies among his versions and correct his many embellishments.

When Khone returned, the Nadel family received him with open arms. Even Yentl embraced him, to everyone's surprise. He resumed his former position, but something was different. Shifra had grown into a pretty young woman, and her beautiful eyes troubled him. The blind father, with his acute senses and great wisdom, detected the young man's feelings and rejoiced. His secret dream of one day marrying off his daughter to Khone began to look possible. Thus Isaac approached him ceremoniously. Khone was overjoyed. Now, that Isaac had spoken, he could confess his feelings to himself.

The two men seemed to be of one mind, but what about Shifra? Khone had never dared to show her anything that went beyond an accepted fraternal affection. He admired her intelligence. Sometimes she made fun of him and teased him: "Khone the dreamer." He had lovingly accepted her pestering; he had always felt at ease with the girl. But the emerging young woman was somewhat intimidating. How would she react? What would she say?

Khone saw in Isaac a reliable messenger of love. Isaac had first to consult the mother of the bride-to-be. Knowing Yentl's state of mind and the nature of her character, the two men expected the worst. To their great surprise, Yentl seemed happy with her husband's choice. She knew that Shifra, who had taken over the grocery and noticeably improved its business, had to be kept at home at any price. As Khone's wife she would remain with them. Also, Khone wasn't demanding a dowry, and this was his most likable trait. The parents were in accord. Now they had to make their decision known to their daughter. They were sure she would be overjoyed, and they were in for a surprise.

Khone???

Shifra can hardly believe her ears, "Khone, of all people?"

He was the last man she would have thought of as a future husband. She had liked him as a brother, but that was all. She could hardly remember a time in her life when he was not around. True, she had been happy when he returned from the front, happy as if he were a brother, but that was all. Had they misinterpreted her welcome? She was quite sure there had never been anything more in her heart than a feeling of gentle liking for this short young man with his round face, clear eyes, protruding ears, and now the shaved head that made him look like an unassuming Mongol, a Cossack. What had nourished her and made her able to cope all those years with her numbing chores had been the hope that one day she would depart. Depart from the stale reality of her parents' home,

the blind father and the unloved mother. This could only have been achieved by uniting herself in marriage to someone far away. Extensions of the family existed in Kiev and in Odessa, with many cousins, relatives and friends. Why didn't they search farther than the four walls of home? Her parents' choice would force her to remain and rot. Unacceptable!

There was always a pinch of coquettishness in Grandmother's descriptions of her pre-marital despair, exaggerated and adorned for dramatic effect. She reveled in relating what torrents of tears she had shed between the day Isaac made his paternal announcement and the day of her wedding. She enjoyed telling how her swollen eyes made her practically as blind as her father, the one advantage being that this obliterated the sight of her future husband. She obviously loved to tease my grandfather. When Shifra was little she cared for Khone like a sister. Later she learned to accept, respect, and cherish him as a devoted husband and father. She finished by loving him forgivingly and tenderly, as if he were her only child.

After the Wedding

After the celebration of the young couple's wedding, Yentl, more mentally ill than ever, retired from work and withdrew from the world. The grocery being now Shifra's exclusive domain, the energetic young woman began expanding the business, importing and exporting fruits and vegetables and undertaking other types of commerce as well. Her talent made her prosper. With time she became the respected, and sometimes dreaded, president of a company composed of herself and ten male associates whom she controlled with an iron fist. My adored and adoring Grandmother Shifra, the plump and oval woman whom I see next to me in the semidarkness of a movie theater, squeezed into a narrow chair, secretly shedding a sentimental tear over the poor heroines on the flickering screen, could be proud of her exceptional achievements. She provided the livelihood of a family, sustained the occupation of a husband, and

raised four children, two girls and two boys.

She saved, yes literally saved more than once, her adored Khone from the loss of his beloved workshop, and even from bankruptcy. He was too naïve, too honest, and too impractical for the tough realities of a competitive business world, so she became his devoted sponsor. With the passing of time, and the availability of material means, he gave in to the flamboyancy of his creative impulses and turned his old mechanic's shop into the magical cave of an inspired inventor.

Mother, the first of the four Yochel children, was born in 1911. Her name Mizia, a diminutive of obscure origin, soon became her official name. She was followed three years later by another little girl with the same kind of light eyes and blond hair, my Aunt Yetta. Her name was intended to perpetuate the memory of the deceased Yentl. Shortly before the eruption of the World War I, the boy Rakhmiel was born. He was to become one of the founders of a small kibbutz in the upper Galilee. Inheriting Khone's stocky frame and good nature as well as his poor head for business, Rakhmiel was to spend many years overseeing road and plant construction in the rain forests and jungles of Africa. The second son Izia (Isaac), was conceived after Khone's return from the front in 1918.

Again the war must have been terrible for Khone. He never spoke to me about this second military experience, his time spent on various fronts, his exposure to the Russian civil war. He did not know that the grim events he considered me too young to hear about would soon be overtaken by horrors that were far greater. Horrors that would end his life and forever change mine. All I know of this time in his life is that when he finally reached home—thin, worn, and hardly recognizable in a torn and filthy uniform encrusted with aged dirt—he scared his wife and even more his children. For a long time his three-year-old son spoke to him as if he were a total stranger and refused to speak of him as anything but "that man."

Wartime permitted Shifra to display her extraordinary resourcefulness. People were ready to pay any price for food, which she, better than many of her competitors, was able to provide. Well aware of the risks in those years, she would acquire entire harvests of fields, or the produce of whole orchards, supply the packaging, and assure transportation under hired guards to well-protected warehouses in the city. It all meant a lot of traveling under very hazardous conditions. In order to be free to comb thoroughly the adjacent villages, to search for the foods that were later sold for a good price, children and home had to be left in total control of a nanny and a housekeeper.

Shifra would never fail to return on Fridays for the blessing of the Sabbath candles, and always she came with a beggar or two, picked up in the courtyard of the old synagogue. Feeding them was for her a sacred obligation. Perhaps the homeless mendicants served her as a kind of guarantee for the survival and safe return of her husband from the front. Sometimes she helped the maid clean these beggars so that at the festive Sabbath table they wouldn't smell too foul. She often collected or bought them clothing. All this was part of the ancient communal Jewish concept of *zedakah*, charity. The children hated these evenings, with the perpetual presence of the scary, smelly, and noisy strangers who dripped wine and smeared food on the white tablecloth. In their eyes, they robbed them of their mother's attention in the precious moments when she was home and they might have had her to themselves.

In order to forgive Shifra her fixation with charity, her children had first to become adults, by which time they had developed for their mother an esteem and adoration ordinarily reserved for legendary idols. But I wonder if they ever grasped the complexity of Shifra's motivations, which I think were composed of more than a deep religious devotion to the idea of benevolence, or even of a good businesswoman's belief in the logic of deals, charity in exchange for the life of her husband at the front. The

image of her brother Arno and her homeless parents desperately seeking help in the inhospitable streets of Berlin was etched into her consciousness. In caring for these homeless people she was caring, vicariously and in retrospect, for her own family. Also, these acts relieved a guilt that must have haunted her, given her remarkable profits in a time of general impoverishment. The tradition of hosting poor strangers at the Sabbath table continued after Khone's return. Poor people waited in the doors of the great synagogue, in prearranged turns, to be invited to the Yochels' Sabbath dinner.

Shifra's concern about her excessive wartime gains was a wasted worry. The profits of these years were in a currency that would soon lose its value. Years later, among my toys I had a small leather briefcase containing beautiful papers covered with imperial crowns and eagles and lots of numbers. They were stocks in the czar's railway and other bonds of the empire, all of them worth less than the paper on which they had been so beautifully printed. They were a part of the lost riches of Grandmother's golden wartime era. I guess that the people who looted them from our apartment in 1941 could petition the present Russian government for a return on their value. Good luck!

As a child I ended up with only one part of Grandmother's savings. Other banknotes and coupons were carefully hidden from potential thieves, sneaky visitors, embezzling servants, and regular burglars in the huge porcelain stove of their never used and never heated "salon." This treasure fell victim to the overly zealous maid, who decided to celebrate the master's return from the front by quickly removing all the white dust-covers from the newly upholstered furniture, polishing the floor, and lighting a nice fire in the stove. The thoughtful surprise nicely warmed up the room and at the same time consumed months of Shifra's hard work. It was a monetary catastrophe, but the miracle of Khone's homecoming put it in perspective. God's will had again triumphed over human pre-

sumption. The maid was told to stop tearing her hair and howling like a beast, because the master needed a lot of sleep.

Khone's Return to His Own Self

Khone's head, once it had been properly washed and given a fresh close shaving and plenty of rest, started to bubble with ideas.

For him the world was ablaze with sunrises. The progress of mechanical inventions, the domestication of electricity, the possibilities of "robotization," and the perfection of precision tools, all of recent invention, gave him extraordinary hopes for the twentieth century. In sharp contrast to the feeling I and many others have as I write these lines looking back over the century from its final year, Khone, who would be a victim of one of its most horrible crimes against humanity, optimistically believed in the power of human progress. Grandfather felt that ordinary mechanical equipment like carpentry tools, sewing machines, knitting devices, and other domestic items had a long way to go before they reached perfection. His shop, which undertook repairs of the most common kind, started to propose modifications that were not requested, or even particularly desired. Leaving the daily chores to his assistants so that the shop would cover its running expenses (which nonetheless it never did), he focused on his passion for invention.

I remember one of his machines. It was hidden in Grandmother's attic. Her housekeeper, carrying a basket of laundry to be dried, let me accompany her and took it upon herself to show it to me. After we cleaned off all the dust and placed the object in a good light, I was free to observe this singularity. It looked like a small fairy-tale castle and it had wheels. Two green flags on two pointed towers, which had long since lost their golden glow of polished brass, gave it a medieval flair. It was a mousetrap.

There was an open gate to which a small metal bridge, painted to look like wood, was cleverly attached. The bridge would jump up as soon as

the unfortunate mouse, attracted by the promise of cheese whose smell was floating in the air, ventured inside. The mouse was to enter, but not necessarily to its doom. An exercise wheel permitted the mouse a pleasurably extended run, while its turning activated a little glockenspiel. Thus the mouse was rewarded for its healthy exercise by delicate background music, while the owners of this not inexpensive object, if they were at home, would be alerted to the presence of the intruding animal. One need only open a small side door to allow the escape of the exhausted prisoner and the return of silence. Advised by his assistants to give the mousetrap a more utilitarian character, Khone added, as an afterthought, the option of letting the little musician fall into a hidden receptacle filled with water and drown. However, an appropriate lever permitted animal-loving owners to avoid this brutal option.

The housekeeper must have read on my face that I was thinking with great sadness of all the poor mice that had lost their lives in this elaborate device. She reassured me quickly that the whole thing had never worked. It had only been kept for some time in the salon as a conversation piece. "Finally," she added, "it bored everyone." She thought the task of dealing with mice should be left to the cat. Otherwise God would never have created cats. The family cat had rendered Grandfather's invention unnecessary. I would have loved to bring the small mechanized castle home, but we too had a cat.

Another extraordinary machine, one that had been tried and really worked, was relegated to an inner room of his shop. It took up so much space, and over time was so covered with junk, that I could never figure out how it must have looked in its prime. It had been a fully automated plant for the production of a simple, indispensable and banal object used daily by millions of people. On a different continent, an American genius more practical than Grandfather had created a similar plant for the production of cars. But in Vilna, Khone's plant was intended to make some-

thing much humbler: a comb. The metal arms of his robot would seize a large block of wood and transform it through a series of complex mechanical actions into hundreds of neatly packed boxes containing thousands of wooden combs, ready for use. Two or three days of the machine's work would produce more combs than the Vilna market could absorb in an entire year. Was there a link between Khone's genius, encased in a perfectly shaved head that had radically rejected the use of a comb, and the creation of a comb-making machine destined to remain unemployed? The fact that his machine worked at all gave him a lot of satisfaction. The rest was unimportant.

Not all of Khone's inventions (and I am familiar with no more than a fraction of them) met such an ignominious end. A fully automated machine for knitting wool socks won second prize and a silver medal at an international exhibition held, in Warsaw, I believe, in the late twenties. I can see the certificate in its silver frame, partly protected by a cracked glass and hung on the same nail as Grandfather's dark Borsalino hat, attesting, with those signatures not covered by the beautiful brown felt, to a poorly exploited triumph. It was a missed opportunity. A famous maker of German sewing machines noted that this naïve inventor from Vilna had never bothered to register his invention, and started to market excellent versions of Khone's idea. Grandfather's conviction that they were much better than anything he himself could have afforded to make effaced in him any desire to fight for his intellectual property.

The German producer, unaware of Khone's passive attitude and eager to avoid a legal issue, which Shifra's lawyers might have threatened, settled by giving the Yochels an agency for the sale of his company's machines in Vilna. The agency and retail shop were put in control of the very young Aunt Yetta, whose duty it was to keep her beloved father as much as possible away from the business. It was well known that whenever Khone was confronted with a potential customer for one of the

sewing or knitting machines, so beautifully displayed in the agency's windows, there would be no deal. Grandfather would inquire about his or her health, his or her marital status, the number of children or grandchildren, and sources of income. Often he would come out with convincing reasons why a hand-held needle and thread, or a simple pair of knitting needles, could do the same job and be far less expensive. People loved him. The settlement with the German firm brought the repair shop an invigorating flux of money. It was partly cleared and refurbished by having more stuff banished into its unused back rooms, while the front became re-equipped with the most modern machinery of Swiss and German manufacture.

The guardian of all these expensive tools was Nero, a big black mongrel who used to spend most of his time dozing under Khone's desk. The dog adored his master, made a visible effort to accept my person's rights to Grandfather's affection, and never hid his fondness for the cookies of good will that I brought him on my visits. An unenlightened observer might have seen in Nero a fierce and noisy creature. But the dog's impressive barking was too often discredited by his wagging tail. Unfortunately Grandfather disregarded such sign of warning and counted on Nero's service as a provider of security.

That is why one morning Khone was appalled to find the dog snoring under the table, the better part of the shop looking very empty, and all the fine machinery gone. The remains of a huge piece of salami, probably filled with sleeping pills, was the only evidence left by the criminals. Hardly able to control the sob in his throat, Grandfather ran to Shifra's company, pulled her out of an important meeting, and gave her the devastating news. Shifra congratulated him on the healthy instinct that had kept him from running to the police, notoriously inefficient and corrupt. She told him to remove the sleeping dog, give the assistants a few days off, close the shop, keep silent about the whole event, and allow her the time to deal with the situation.

A few days after the burglary all of Khone's precious "toys" reappeared in the shop in their habitual places. It happened at night when nobody was present. Khone never asked about the price. But his pride in his wife's savoir faire, her good relationship with the Jewish semi-clandestine "protection" services, and above all the speed and efficiency of the whole deal, was so great that he could not keep his mouth shut as he had promised. Rumors began to spread. Khone felt that his most reliable confidant, the barber who daily shaved him, had to be updated on the story's details. This was an unfortunate thought. Khone's self-congratulatory flow of reportage was interrupted one day by an innocent-looking middle-aged man, seemingly a regular customer, but in reality a police agent in civil clothing. Politely the man asked him to come along to the station and sign a deposition on all he knew.

Four or five of the less important members of the "organization," the actual "executants," the hardworking thieves, ended up in jail. The families of the convicts, deprived of their principal breadwinners, were plunged into real distress. In the powerful rabbinical court (a remnant of the times of Jewish autonomous rule), they indicted my grandparents for irresponsible chatter with grave consequences. This was a tribunal that no self-respecting Jew would ever have dared to ignore. The rabbi ordered Shifra to pay minimal salaries to the defendants' families and assure their offspring proper education for as long as their providers were in jail. World War II put an end to this arrangement. Separately from this story, it has also revived one of Khone's old passions, the production of sweet kosher wine for Passover.

The Kashe

Khone always felt that his homemade wine was cheaper and much better than the produce coming from Palestine's vineyards. The wine he concocted at the time I remember him had nothing in common with the

sophisticated product of his earlier days, when he invented a special device designed to speed fermentation and improve the taste of his ceremonial drink. Let me tell its story.

Grandfather's special wine, served to the family and a good number of guests who gathered at both nights of the Seder, had to be excellent. It was a matter of prestige. The original device, invented by him, consisted of various receptacles, an array of pipes, an electrically monitored pump for the increase and decrease of pressure, and a number of security valves, all of which produced a sweet sound of intriguing murmurs. His children would hear in them messages from another world. The need for constant control over this delicate process required that he bring the whole machine from the cellar and give it a place in his elegant but little-used salon, an arrangement that Shifra regarded with suspicion but accepted because it kept her husband happy.

One day when Khone was away from home, working in his shop, the fully automatic gadgetry exploded. It blew out the salon windows, drenched the wallpaper, curtains, and upholstry, and sent Shifra running to the synagogue to thank the Lord that her husband was still alive and that no one was injured. This was when the family shifted to the exclusive use of expensive wine from Palestine, which in the final analysis was much, much cheaper. All this was before my time.

The Soviet occupation made Khone return to the production of domestic wine. The last Seder with my grandparents happened a short time before the invasion by the Germans. It was in Chayim and Rachel's home, where Shifra and Khone lived after the Russian general seized their home and unceremoniously threw them into the street. In Chayim's place Khone had found a container full of old raisins and spent many happy hours trying to lose himself in the manual production of a Passover wine. Since it was very slightly fermented and resembled grape juice, I was permitted to share it with the adults. Aware of the very dark clouds that were

hanging over our heads, I was reluctant to admit to myself, much less to others, how I loved the blessings of war. I had my four grandparents and my parents all to myself. No hordes of strangers to tell me how incredibly tall I had grown since last year's Seder, and no competitors, smarter and often better prepared than I to ask the four *kashes*, the four traditional questions asked by the youngest child present.

Nobody had explained to me that *kashe* comes from the Hebrew word *kushiah*, which means a difficult query, a "Why?" which in the ceremony is followed by the story of the Exodus from Egypt. I was given a general sense about the meaning of the four questions, but I preferred my own version. In Yiddish *kashe* was porridge. Any silly devil of a child who would learn that string of incomprehensible words in order to ask for four such plates deserved the avalanche of numbingly boring sounds with which the adults responded, invariably putting one to sleep.

True, instead of porridge one got the *afikoman*, a Greek word for a special piece of matzo to be redeemed, that pronounced in Yiddish sounded like "on top of the chimney." This made sense to me, since the traditional place of hiding the matzo was behind the porcelain stove. The *afikoman* was redeemed by money, and the stove was the place where money was burned. With a little thinking, this big misunderstanding between children and grown-ups, called Seder, could be great fun. Much more so in former years than this time, when everyone was sad and apprehensive. Of this gathering, only Mother and I were destined to be spared the fate of most European Jewry. Only we remained to carry on the memory of our dear ones and of the sweet taste of Khone's last wine.

Koymens (chimneys), and dark clouds spreading ashes over a whole continent, were entering my soul, to emerge one day as metaphors in my art. The resulting paintings became a way of blending my personal need for elegy with the eternally difficult question: Why? That was the real *kushia* for which there could be no answer.

THE AQUARIUM

Two large doors at the rear end of my grandparents' entrance hall led to two very different worlds. To the left, always open, was the gate to the heaven of food and jovial company. A long dining table, which could easily seat twenty people, was the center of a gregarious life. To the right was the entrance to the "good salon," their little-used living room. The salon was considered to be too stuffy for their unassuming style of life, and Grandfather Khone had appropriated it for his various personal needs. It was, among other things, the domain of his singing birds. Its door was closed most of the time, and on the occasions in which Grandfather fed his beloved canaries he locked it in order to exclude the hazardous presence of the household cat.

At times when Grandmother Shifra was away from home, Khone shut himself in the salon, closed the windows, inspected thoroughly all possible corners behind curtains and under the furniture to be sure that the cat had indeed been locked out, then furtively opened the cages and let his birds fly around for several minutes. He believed that it was good for their health, their mood, and indispensable for their voices. He would observe them while seated at a small table, on which rested a little snack for himself and for his prize singers. With a light knock of a fork he summoned them to come to him. They would fasten their little claws on his plate's rim, taste some grains, and gently let themselves be brought back to their cages.

On privileged occasions I was allowed to participate in this ritual. I understood that the matter of letting the birds come out from their cages had to be kept from Grandmother. It wasn't, by any means, a conspiracy between Grandfather and me. He had never asked me to hide anything from his wife! But I knew how much she hated to find the involuntary bird droppings on her precious upholstery, on the carved wood of the commodes, or on the beautifully waxed parquet, and I understood that there was no particular merit in making her sad by giving out such aggravating information. I also knew that Grandmother was very wise, and nothing ever escaped her observation. Had she believed that Khone could refrain from such mischief, she would never have kept all the better chairs and furniture under white shrouds. They gave the contents of the room the bizarre air of a congregation of ghosts.

The few accidents the little canaries had were harmless, and I loved to help Grandfather clean them up. I liked the sight of the birds flying around in the room, and I listened to their song. Several were considered real champions of singing and were brought to participate in local contests. But the room's main fascination for me was something quite different, a mesmerizing spectacle, a perpetual show in slow motion and in total silence performed in Grandfather's gigantic aquarium.

This octagonal glass construction, complete with artificial rock and a little waterfall activated by an electric pump, rested on four muscular and sturdy bronze lions' paws that were armored with menacingly shiny claws. A lush marine flora surrounded the silent tropical fish that glided through this enchanted world with apparent indifference. Their shapes and their colors baffled me. They were also watched intently for hours on end by the gray-striped tomcat, who like our own cat, and like most tomcats in Vilna, was named Mourka, a tribute to this species' mysterious art of purring. He was permitted into grandfather's "sanctorum" after a thorough check and recheck of the bird cages' doors. Ready to strike at

any moment, he balanced himself, motionlessly and with astonishing skill, on the rim of the aquarium and didn't appear at all fearful of plunging into the water.

Neither the foreboding newspaper headlines nor the worried letters sent from Berlin by my grandmother's brother Arno, whose strange etchings adorned the walls of the living room, nor even the arrival of the first refugees, bearers of unbelievable accounts of Nazi brutality, could disturb the peaceful angling of the tomcat or the tranquillity of the fish.

Not until Hitler penetrated into western Poland and the Russians occupied Vilna in June 1940 did the marine life in my grandfather's house fall into turmoil. A Russian general confiscated the Jewish middle-class apartment, and among the things planned for appropriation by this hero of the Soviet Union was the "capitalist's" aquarium. Since in Grandfather Khone's opinion this was an extremely important object, and he knew how much it had fascinated me and how much I desired to have it, the family decided to smuggle it out and install it in my parents' apartment. I don't remember exactly how this move was achieved, but it must have been enormously difficult and could only have been accomplished with the help of various experts. They had to do it at night, and at a price of great personal danger. One thing I do remember, however, was our maid Xenia scrubbing the glass with green soap, all the while throwing murderous glances at the impatient fish, as they splashed about in several pails and covered her highly polished parquet floor with puddles of water.

I also recall the long garden hose attached to a faucet in our bathroom that led through my parents' bedroom to the hall and from there to the dining room, which was to harbor the huge aquarium. It took hours to fill. I still remember that my father worried out loud, with a gesture of ironic exaggeration, whether the floor could bear such a weight of water and if we wouldn't one day find our aquarium in the apartment below us. And then there was Mother's long silence, her very sad smile and the tears

in her eyes. She remembered, so she said, the day when the aquarium had been installed in her parents' home. Obviously, the object had belonged to a world that was disintegrating. What did I know? Protected by the sheltering walls of my home, ignoring all the rest, I was contented to have the marvelous fish totally to myself.

Back in their underwater paradise the fish seemed particularly happy. Liberated from the confines of the pails that had served for their transport, they proudly displayed their undulating multicolored fins. Now I waited for our cat, our Mourka, to assume its position of observing hunter. I knew that he would never venture into the water. But he threw at them a nonchalantly indifferent glance and left, as quietly as he had appeared. Stupid cat! What a lack of aptitude to profit from life's unexpected offerings! I knew that war was causing much upheaval and unhappiness. But it had some unforeseen blessings. The aquarium was one of them. In view of the general mood I had to keep this thought to myself.

The next moment a major tragedy descended on us. When the maid set the breakfast table the next day, she saw the fish floating belly up on the surface of the water. They had succumbed to the traces of the green soap, which for them was poison. Xenia hurriedly disposed of those of the victims still in their last throes. And the aquarium, in a sort of a silent prophecy of times to come, remained in the dining room—a useless, lonesome object. Emptied, with no water, no vegetation, and no waterfall, it looked foreboding. Nobody dared tell my grandfather.

But no one took this omen seriously. In Germany and in many occupied countries, Hitler proceeded to make the world *Judenrein*. In later years I learned that fish were an old symbol of Judaism. However, what might have been interpreted with clarity in ancient Rome was ignored and disregarded by contemporary Vilna. Grandfather discovered the aquarium catastrophe on Yom Kippur. Only on the highest Jewish Holiday did Shifra succeed in getting her atheist husband into the synagogue.

Even then it was not his way to spend the whole day among fasting and praying people. At the moment when the whole congregation covered their heads with the prayer shawls, he sneaked out in order to recuperate in the apartment of his eldest daughter, my mother.

His departure never escaped Grandmother's observation as she tried to "control" him from the women's section above. Had she been allowed to sit next to him, as in many of today's temples, with her hand firmly gripping his forearm, or even better, her shoe ready to catch and immobilize his at the slightest indication of flight, never would he have taken such a liberty. But this was not the case in a traditional synagogue where the separation of men and women permitted some unexpected individual freedoms for both sexes.

At the moment of his departure, Shifra would intensify her praying and crying, aware that she alone was left to repent for the sins of her household. With great devotion she asked her God to grant pardon and forgiveness. The difficult times filled with an increasing dread of advancing hardships made the demand for His divine help indispensable.

Shifra could have never imagined that she had only one year to live, precisely until the next High Holiday, and her husband Khone even less. A few months later Vilna was occupied by the Germans, and the persecutions of the Jewish population began. One day, as I have told, Khone and Chayim went out to find some bread and both disappeared. Shifra never learned what happened to them. She hoped they were in one of the labor camps from which communication was impossible. On the next Yom Kippur, in 1941, she was torn away from her prayers and sent with Grandmother Rachel and thousands of other Jews from Ghetto 2 to be shot in the woods of Ponar, where, in one of the huge mass graves, the bodies of my two grandfathers had already been lying. Shifra wasn't given time to realize that for many weeks both women had been widows.

Fragments of information about my grandparents' deaths reached us

much later. The year before, in 1940, during the service of the High Holiday, she was praying to her God. Deep in her heart, the devout Shifra must have been confident that in spite of her husband's desertions of the synagogue, some of her intense prayers for the safety and well-being of her family would be granted.

When my Grandfather discovered the empty aquarium, he did not show the reaction for which I, in my fear, had been prepared. The events of the past year, the fact that he had been thrown out of his home and his business, the fear of the menacing future, the growing rumors, and finally his age (my age of today) must have changed him. Probably they had diminished in his eyes the importance of all earthly possessions, the beautiful fish included. The event that had been for me a real catastrophe had left him detached and unconcerned.

"May this be a *kapore*, a sacrifice for the welfare of all of us," he said, and went back to the synagogue.

On this day, for the first time in years, he and his wife had been accompanied to the synagogue by my other grandparents, Chayim and Rachel. I remember the year of the Soviet occupation, between June 1940 and June 1941, as a time of relative happiness for me. How even closer to each other my two sets of grandparents grew to be, living now in the same flat. And how available in their patience for my little person they became during this interval. There was often a special gaze in their eyes when they looked at me, as if all their fears about the dreaded future, now piled on my small shoulders, had infused them with a feeling of resignation and an infinite docility.

In a memorable moment of this dreaded future, as Mother and I were pushed out the door of our home by Lithuanian policemen, to be taken to the ghetto, I quickly tried to fix in my memory our apartment, with all our belongings and my toys; and I threw a last glance at the empty aquarium.

It was not an easy object for the looters who must later have ransacked our home. I hope they smashed it to pieces. If ever the plates of glass could conserve a memory of the lush marine life they used to reflect, a universe indifferent to human heartbreak, I like to think it was destroyed and gone forever. The cold fish, frivolous, proud, and self-absorbed, were of no help. The *kapore* was not accepted.

CHAPTER NINE

Many Loves and a Deep Friendship

YIDDISH AND LOVE

Kaporeh is a word in Yiddish. It had not been part of my early vocabulary. For me, in the beginning the world was created in Polish, and the Russian language of Xenia the housekeeper and Niania the nanny, who always had a lot to talk about, was added later. Both women spoke in very soft and melodious tones that had nothing in common with the syncopated, pounding, and scratchy sounds of the mother of all languages: Polish.

A few years later I found out that there was a third language, different from the two others, mysterious and incredibly important. My grandparents and parents used it mainly for things I was not supposed to know about. But they also spoke it occasionally among themselves and quite often with a large number of poorly dressed and common-looking people. Like us, these must also have been Poles, with the same "something" that made all of us slightly different. We had no church on Sundays, no symbol of the cross on our chests, and, regrettably, no Christmas tree. We were Jews, and since the word "Jew" in my language, *Zjid*, was a very ugly word, and I had been taught not to use it, the best I could do was to consider myself as belonging to "Moses' faith" and present myself as such.

I spoke a beautiful Polish, burnished by young female students from the University of Vilna. They mostly came from central Poland, preferably the area of Krakow, and lived with us to serve as an antidote to the "inferior" local accent. My Polish had to have a refined quality so as to improve my future opportunities. In a country that was ruled by a highly

class-conscious and reactionary party and a notoriously anti-Semitic government, a proper accent was an asset. Mother explained to me the general reason for the young girls' presence in our house, but she did not go into details that a small boy could not understand. She conveyed to me the feeling that I was privileged, that I lived in a well-deserved paradise. My parents were determined to give me everything in their power and to permit my own accomplishments to prolong and expand this state of things. I was a very lucky boy. I was to believe that this was the best of all possible worlds.

Too small to read the papers, I had no idea that at this very time hoodlums in Nazi Germany were breaking Jewish shop windows and that the Polish parliament in Warsaw was debating whether to let the Jewish population retain its Polish citizenship. I was being well prepared for a world that hardly existed. Should I have suspected in my parents' plans a trace of snobbishness? They were far from being naïve. Was it on their part a sort of denial? If so they were soon to be cured of it.

Whatever projects they might have had for me, mine was to conquer their secret language, Yiddish. All I knew were a few words. One was used to designate my person: *der koten* (the little one) and the others had to do with the shape of my ears: *shpitsike oyern*. According to what I could make of their mysterious talk, whenever I tried to understand their conversation, my ears became pointed. This transformation must have been swift and brief, for I never managed to catch sight of it in the mirror.

An unexpected event made possible my conquest of Yiddish. One morning I was to be taken to the kindergarten, a fashionable, modern establishment "for children of the families of Moses' faith" (elsewhere called Jews). There only Polish was spoken. At home the governess must have been gone, for Mother brought me there and later came to take me back.

It was a lovely afternoon. We were on our way home. Suddenly a rough youth shot up in front of us, barring our way.

Up until then I had been following in Mother's steps, absorbed in thoughts of how Grandfather Khone had shown me the lines on his work-darkened palms and explained that all those miniature tracks might have future events magically inscribed in them. It had interested me greatly. I looked carefully at the paving stones, where a mysterious network of tiny ant roads lay clearly visible under my feet. The world was like the huge palm of a hand, full of lines on which we small beings followed one another. Now, walking behind Mother, I thought not only of the ants but also of the fissures and crevices of the sidewalk, and of my sacred obligation not to step on them. A moment ago they might have been roads where tiny, invisible creatures, totally unaware of the giants above their heads, were peacefully strolling. Now I imagined that a horrible avalanche of disaster would be released if I did not succeed in my self-imposed assignment. Who knows what fate lay hidden under this tangle of dark lines?

"Hurry up, and stop jumping around in this ridiculous way!" Mother's voice tried to call me back to a different world.

Did I start to fantasize about catastrophe so early as that? Did I really feel such power and responsibility? Mine was the imagination of an only child, a first grandchild of four adoring grandparents who had made him the center of their world. Perhaps it was natural to see my own small person at the very core of events. But I also knew the rewards of unconditional love. Like most happy children, I knew my importance, and it gave me great pleasure, though it required a lot of patience and tolerance from my beloved family. Mother, raising her brows, had taught me that I had to keep these arrogant feelings to myself. They were impolite and in very bad taste.

Looking back, I see my five-year-old self walking that day with my

mother, in my round cap and my short pants, my little coat, the two gloves connected by a string and dangling from my sleeves. It is a pleasant Vilna winter day. In my child's easy assurance I am playing a common and innocent game. But I am about to be severely shaken.

Suddenly the rough youth! With a provocative and rude expression and an insolent spreading of his legs, he appears from nowhere. What kind of game is that? His ears stand out under two flaps of an old Russian fur hat, a *chapka*, and give him the allure of a big and kindhearted dog. But his eyes are sinister. He squats, meets my surprised stare with a frightening twist of his lips, and hisses piercingly: " *Zjid!* Filthy kike!" A warm splash of saliva covers my face, and before he disappears almost as fast as he had materialized, Mother is already on her knees wiping my face.

I saw the two of us reflected in the huge window of the Bata shoe shop next to our building. There a pile of shoes was being rearranged, and our image overlapped them as if we were two translucent ghosts. For a moment I thought I was looking at a film. I did not see the expression in Mother's eyes, because they were shaded by her hat and delicate veil, but I remember her trembling voice.

"This was a repulsive, disgusting fellow. We have nothing to do with *shkotzim* like him. He was lucky your father wasn't with us. He would have taught him a lesson to remember!"

Three years later something much more memorable was to happen on the same street. By then we had fallen under Nazi rule and had lost all our rights. Mother and I, along with thousands of other Jews, passed before these Bata windows as we were being marched to the ghetto by shouting Nazi officers and Lithuanian police. These windows, which must have been blown out in one of the air raids, were now covered by various boards of old plywood, and we streamed blindly by them in the street, a caravan of human ants carrying their bundles and suitcases. The sidewalk was by then forbidden to wearers of the yellow star.

But on that earlier day of my memory the elegant lady is still kneeling on the sidewalk paving stones, caring little that her expensive silk stockings are being ruined. Shaken and humiliated, she silently cries in front of a bewildered boy with the splash of saliva dripping from his face. This episode affected my entire childhood and finally introduced me to the Yiddish language.

A few days later Mother led me to a new kindergarten. Here all of the children were bilingual. Polish might have been used in many of their homes, but in this new place where from now on I would spend my mornings, they spoke and were spoken to exclusively in Yiddish. I knew there had been a lot of talk in the family about the "spitting" episode. Some was spoken openly and some I overheard. My parents took their decision calmly, after a lot of thought. But I considered it a major upheaval. When I mentioned this to Mother years later, she tried to explain her reasons. Because my face had been spat on, I had to understand the why of it, to realize what it meant to be a Jew. I had to acquire our language and culture. Surely the thug never imagined the outcome of his single gesture, nor was it likely to have been the worst of his actions. Such hoodlums in their teens were later hunting Jews in the streets of Vilna and sending them to their death.

His nasty impulse was my "existentialist" experience. I was made into a Jew by the act of the "other."

Mother was, deep in her heart, a passionate Yiddishist. The secular world with its promise of assimilation had given her a short-lived illusion that she in turn tried to convey to me; but that hoodlum brought her back to reality. I suspect that deep in her heart she was happy to have me learn the language of *amkho*. But I can hardly describe how perplexed I was. Only a few days before it all happened, I had overheard a conversation in Polish between Mother and my former teacher, who complimented her on the excellent work of my recent governess. I saw how proud it had

made her to listen to the teacher's praise of my achievement, and I was overjoyed. There was nobody in the whole world I more wanted to please.

Recalling this, my earlier desire to unveil the secrets of Yiddish diminished considerably. Then too there were other high costs. I was to lose the place I loved, to miss my friends, to be introduced to new teachers, new premises, and a new walk from home. All this scared me.

The new place was in an old and dark building. I was presented and asked to participate, but my mind was elsewhere. A strong yearning for my old kindergarten's sunlit rooms, and for my old friends, haunted me for days. My longing must have made me idealize that lost world of huge toys, immense color images projected by a magic lantern, daily sessions of gripping fairy tales, and above all a collection of the prettiest little girls in the world. With their curls and silken bows arranged to resemble Shirley Temple, they looked like dolls. Like most small boys of those times, I had been educated to pay attention to the beauty of the opposite sex. And indeed we were the beneficiaries of a constant competition among the girls' mothers to outdo each other in the presentation of their "princesses."

I was in love with one of those princess-dolls and had secretly considered marrying her. Would Mother be pleased? I tried once to mention in carefully chosen terms the delicate subject, without referring to my secret love. It was for the sake of exploring my most profound desire, which concerned the possibility of marrying Mother. But Mother only suggested that I look for someone my age, adding that anyway she was already married to my father. Thus I had obtained a formal permission to marry, but inexplicably I felt that if I ever dared do so, I would be breaching a sacred loyalty.

The loss of my little Polish-speaking sweetheart was painful, but my being only five turned out to be an asset, for the grief was more easily overcome than expected. New circumstances pushed her image into the

background and later into total oblivion. In the new place, a new passion for a tiny blond girl, a passion possibly set up and encouraged by the smart teachers, helped me to overcome the feeling of being a stranger in my own land. Little by little I gave up my isolation and started to participate in the games. By nature not gregarious, I focused my interest mainly on my new princess. My attachment to her evolved rapidly. If I close my eyes I can see myself waiting, with a pounding heart, behind the entrance hall of the kindergarten, trying to guess which one of the many ringing sounds of the doorbell was announcing the arrival of my new beloved. Our attraction must have been mutual, for we spent hours together involved in various games, often disregarding the others. It was one of those arranged unions that worked out exceedingly well. Since the object of my love was fluent in Polish but sometimes spoke to me in Yiddish, I began gradually to absorb the new language. As the weeks passed, Yiddish became increasingly familiar, and I started to venture using it with a few carefully chosen new friends. However, until I had become completely fluent, I refused to utter one word of it at home. I tried hard to please my parents, but the words wouldn't come. I recognize, today, the paralyzing syndrome of the proud perfectionist, which began in me when I was very young and has often made my life difficult.

There is one scene in particular that returns to me from that new Yiddish world, a story of being in love, of failing as a performing artist, and above all of being destroyed by the fear of disappointing my loved ones. This is how it happened. My first words in Yiddish, uttered after a lot of solicitation, were encouragingly applauded by my teachers. At this time the kindergarten's resources were being monopolized by the production of a show. I was given the undemanding part of Old Man Winter. Dressed in a huge white coat created of layers of cotton wool, I was supposed to resemble a mountain of snow. An imposing white cotton beard and wig hid most of my face. I had to appear on the stage and walk around slowly,

keeping pace with the scratchy sound of a phonograph. In the early rehearsals the music would stop in the middle of the action, but this flaw had been fixed. My role was to say a small number of simple words that I easily memorized and to finish my performance by throwing into the air handfuls of confetti, resembling snowflakes. A change in the background music would then announce the arrival of my new beloved. All I had to do was patiently wait for her appearance, bow to her, and leave the stage in a dignified manner. It couldn't have been simpler.

She, my "secret fiancée," was the star of the show, a beloved tiny Princess Spring with lots of paper flowers pinned on her ballerina's tutu. Her name I do not remember. Who knows what later happened to her? War made her disappear from my life. Was she shot in the woods of Ponar with thousands of other little girls? It might have happened not more than a couple of years after this performance. I prefer to imagine her surviving the horrors of the war, leaving Europe, marrying, and raising many children.

Once years later in Tel Aviv, when I was already the father of two girls, I was walking in the street with Mother when we encountered a middle-aged lady accompanied by a young woman. They were pushing a sleeping child in a baby carriage. Mother and the older lady knew each other from Vilna and were overjoyed to meet. They were amazed. Didn't we, the younger ones, recognize each other? It appeared that when we were small we used to spend a lot of time together. I looked well at the face of this total stranger. Premature lines had marked her forehead and her mouth. Her ample figure was thickened by too many pregnancies. I shook my head. Also she had no idea who I was and looked at me questioningly. Mother cried out "Arianna!" The name evoked in me some Sundays in the stuffy apartment of a doctor, in company of a delicate and sweet companion and a huge grand piano on which I used to produce a lot of noise. A thought flashed in my mind. Was this heavy woman the secret fiancée

of my childhood? Embarrassment prevented me from pursuing the inquiry. I preferred to leave my beloved Princess Spring, the little girl who had the secret of accelerating my heartbeat, in the kingdom where one does not age.

In my mind I chose to return her to Vilna, to the production of our play in which she was going to grace us with a few turns, a deep bow, and the most glowing of smiles. A meaningful rise of her magic wand was to be the sign that spring had chased winter away. We had tried it out in many rehearsals, and it had always worked well. The day of the show arrived. The kindergarten children, the teachers, and their helpers were all transferred to the Jewish Club of Commerce where the actual performance was to take place. It was a huge, dark, wood-paneled room with portraits of foreboding bearded faces in heavy frames. Beneath them, united for this occasion, was an assembly of armchairs and sofas mostly covered in worn black leather, which had been fixed with thousands of round-headed nails that shone like eyes of evil cats in the night. All this set the stage for my ordeal.

A curtain had been improvised to give our show the air of a real theater. A platform and a painted background of lovely little trees completed the picture. While I was being costumed, I kept incessantly repeating my lines to reassure myself that they were easy and that I had indeed mastered them to perfection. I knew it was the least expected from a clever boy like me. I felt almost confident and hoped to survive the test with my pride intact. The music gave me my cue to enter the stage. My hands were full of white confetti, and much more hung in a big sack on my shoulder. Part of the fun of my role was the mess I got to make. The teacher took me by the hand and led me to the stage. I made a few steps and looked into the large room. In front of me, in the audience, on the very first sofa and against a background of anonymous pink ovals, there emerged five very familiar faces. Their eyes were riveted to my little figure;

their identical smiles pierced me with limitless love. A magical glow radiated from their presence, as if they were priestesses of an ancient fable, vesting me with a huge, overburdening, and paralyzing weight of responsibility.

Aunt Tsilla, Grandma Rachel, Grandma Shifra, Mother, and Aunt Yetta!

All at once I was seized with fear. Mobilizing all my will power, I made a few more steps and stopped. My legs weighed tons. My heart was pounding. Was I going to remember my lines? Was I up to my family's expectation? And most of all, would they realize, seeing Princess Spring, how enamored I was? Was it permitted? When Mother told me to look for somebody else, did she really mean it, or was she testing me? Had I the right to give away a portion of my love to a total stranger, a little girl who wasn't part of the family? Shouldn't love be kept at home and for domestic use only?

I knew that love at home and love outside of home were not the same thing. The subject was complicated. My parents' voices behind closed doors had brought me troubling fragments of discussions. I heard words that were beyond my grasp. Words like fidelity, modern times, what will people say, betrayal, and many, many more. Was I a traitor? Was I as bad as I suspected my father was, who sometimes caused Mother to hide in the bedroom and cry for unclear reasons? So absorbed was I with these thoughts that I did not hear the voice of the teacher who kept whispering to me my forgotten lines. I stood there in the center of the stage, motionless with my arms paralyzed in midair, clutching the paper confetti and reducing their handfuls to two paper balls; and my face was on fire.

The music was over, my love was pushing me energetically with her magic wand to make space for her central performance, the magic wand got entangled in the cotton wool of my coat, and I stood there unable to react until the caring hands of my teacher led me away. "Never again," I

told myself, "Never again will I perform in front of anybody, and my feet shall never ever step on a stage."

With time the art of painting has become my principal occupation. It still is a form of performance. But the margin of safety is greater. First I do my job, and only later do I call in the public to see and judge. Yet the theater still attracts me, and for some years I created scene designs and costumes for the stage.

At age thirteen I stopped speaking Polish with Mother, and Yiddish became our unique and exclusive language. She spoke the beautiful Vilna Yiddish, which is a standard in itself. We wrote scores of letters to each other. I have conserved most of them in old shoe boxes. Almost thirty years after her death I am still unable to look at the beautiful lines of her handwriting without a feeling of pain.

Yiddish, which I learned through the medium of a secret love, has remained deeply rooted in me. But the ever fewer occasions for practice have left it rusty, and through the years my life's changing circumstances have overlaid it with other languages. Yet for me Yiddish remains the language of affection. The mere thought of it generates nostalgia for a whole world that was created in its image. Whenever I read some lines in Yiddish, or hear its sound, I am filled with an infinite sadness that is unrelieved by the dearly acquired knowledge that all life is made of losses, which are only partly offset by gains.

Still I think it is not my lost Yiddish that has given me the blues, but rather that my blues have found a home in Yiddishland. My childhood paradise was not simply lost, as any Eden must be, but rather destroyed by eager human cruelty and meditated violence, and my art is centered on the memory and meaning of that destruction. So I face a double task. I have to retain access to the happiness of early security and love: to the contemplative boy on the sidewalk who has not yet been halted by the spitting ruffian, to the enamored child in school for whom forgotten lines

are still the extreme of terror and humiliation. And Yiddish will always provide that link for me. Yet I must also protect myself from excess of memory lest I be overcome by too vivid a recall of the flood of horrors that swept away that tender time.

Perhaps that is why I have relegated both the child's love and the following terror to a shared place of exile, where they dwell not so much in opposition as in ritualized interconnection. I know that a number of young devotees of Yiddish believe in the possibility of a renaissance of the language. They study it, they teach it, they delight in its unique humor. Sadly for me, it evokes the mourning of loss. As a cemetery allows us a designated place for grief, set apart from the blessings of our daily lives yet available for visits, so this place of exile permits me to enclose and contain the past and live my present life in peace and even serenity.

SAMEK AND SAMEK

The other day I was working on a painting that is based on the image of the most famous of all Holocaust photographs, the *Warsaw Ghetto Boy*. It is to me the Jewish Crucifixion. With his arms lifted in an attitude of resigned and bewildered surrender and his spent gaze focused on the viewer, he has never stopped questioning me. So I paint him again and again as if the process of letting him materialize on my canvases were going to supply the two of us with an answer to his silent query. That day his slender legs that were stretching out from under his short pants and his feeble knees must have been trembling in the horrendous circumstance in which the snapshot was taken. They triggered in me a chain of associations and uncontrollable reflections that projected me far, far off.

Suddenly I was five years old, transported to a lazy Saturday afternoon under the dining room table at the home of my parents' friends. It was in faraway Vilna. I was with their son, my pal Samek Epstein. We were the same age and we bore the same diminutive of the Hebrew name Shmuel, or Samuel, which in Polish became Samek.

From the days of our earliest childhood we were very often together. His mother, Mania, Mother's closest friend, tried to educate him and to dress him as if we were twins. He did not like to draw and he did not care about painting as I did, and he must have been of a much more physical nature, yet we felt very close. Often we would pass our thoughts to each

other with our eyes only. Lola, his father, a widower with two grown sons, had married Mania at the time my parents had celebrated their union. I used to envy Samek his older "ready-made" brothers. They gave him a shield of security and a lot of self-assurance. In our games he was often the leader, while my role was restricted to supplying the imaginary content and little-needed control and supervision for their unfolding.

So while a part of me was still in my studio in Weston and not in Vilna in 1939, my mind had departed on a familiar journey. We have just finished a heavy Saturday meal, and Samek and I can hear the blurred voices of an animated adult conversation. Everybody seems to agree that the world is in a mess. The politicians are thieves, the military are criminals, and the bankers are robbers. It is fun being robbers! Samek and I are robbers, and we ambush an innocent victim. Our target of today, the Epsteins' maid, is very close. The heavy ankles and deformed shoes of the unsuspecting prey who serves tea are the focus of our attention. The part of her that we can intermittently see appears and disappears from our vision. We pretend to be scared and it is great fun. We giggle. There is a narrow opening, a limited area between the carpet and the heavy table-cloth, which creates our hiding place that lets us see her on and off when unexpectedly she materializes before it. We know that it is only a game, but we pretend so well that we feel the tension in the air. There is the imminent danger of being discovered and maybe even being killed by our enemy. I am reassured and comforted by the friendly presence of the menacing claws that belong to the wooden feet of the dining table's sturdy legs. This monster is our coconspirator. Such heavy furniture is made to protect its owners. It is as reliable and as permanent as all the long corridors, the brilliantly waxed floors, and the heavy drapes that shelter so well their confident proprietors from the invasion of a hostile world.

Three years later, in the ghetto, I am being told that Samek was found hiding in the cupboard of a Gentile woman's flat. I have not seen him

since the Germans occupied our town. I suspect that the woman was the same Christian maid who used to work for the Epsteins. A futile thought flashes through my mind. I remember our games, and I conclude that now he might observe her through a gap in the cupboard's door. Who knows, he could have observed her the way I used to contemplate, slightly embarrassed, the ladies in my Aunt Tsilla's boutique for corsets. But already at nine I have a feeling that this type of futile memory belongs to another epoch, to a different planet, and that my thoughts are rather silly. The matter is grave. Seemingly his parents have paid her a fortune to keep him with her.

I am told that the *goye* (Christian woman), the Epsteins' maid, was a loyal and a decent person. With her, Samek seemed to be safe. She had treated him lovingly. Often, as long as he remained shoeless and silent and kept away from the window, she would let him leave the cupboard and move around in her room. Only on rare occasions would she leave him in the cupboard for the night, in particular when there was danger of unexpected visitors. She did her best to be very discreet, very secretive. But somebody in the neighborhood denounced her. They found the boy and arrested the woman. At the sound of this news my heart tries escaping from my chest. Mother attempts to calm me: "There is hope that she was sent to one of the labor camps."

"And what happened to Samek?"

"We don't know."

Later, with all my attention focused on what the adults were saying to each other, at moments when I can pretend sleep or am able to listen to their whispers, I learn the truth. The Lithuanian police dragged a crying Samek to the courtyard, shot him, and left him lying in a pool of blood. It was intended to serve as a lesson to the Jews who tried to remain outside the ghetto and to all those "Christian criminals" who dared to hide Jewish children. The building's terrorized inhabitants remained

barricaded in their flats until much later when some other men of the Lithuanian police removed the body.

I try to imagine Samek after his death. My breathing accelerates. Tears burn my eyes. It is hard to be a man and not cry. My heart searches for some comfort, and I try to imagine what the nuns of the convent who hid me would have told me to think of all this. The reality is too frightening. I had heard many inspiring words, but I can hardly turn my thoughts to what I was taught.

I am now a big boy of nine and am again in the ghetto after my long stay in a Benedictine cloister, where the devoted nuns who hid our family also undertook to continue my education and save my soul. I became quickly fascinated by a multitude of unexpected revelations. I learned to adjust some formerly acquired notions of the Bible told to me by Mother to make room for what I was being told by the nuns.

I try to think of angels. Angels are great! Before my arrival at that peaceful Benedictine oasis, which smelled of ancient wood and burned wax, I would never have imagined there were so many of them. Beautiful, as shown in various pictures, with aureoles around their heads, they were our guardians. The angels and numerous saints protected us from mischief and intervened on our behalf whenever God was too busy to do it Himself. And above all there was the Almighty Jesus, master of miracles, who particularly loved children and who, with his red and bleeding heart crowned by a wreath of thorns and placed on the immaculate palms of his hands, smilingly asked them to come to him. A small glossy postcard of his figure is always hidden in the pocket of my pants, even in the ghetto.

I try very hard to imagine Samek singing the glory of God in a choir of boys in heaven. How does he look now? Has he become as skinny as I am? Since he has died of bullets he must look pretty awful. Did he get there with all the blood on his clothing? I should not worry. They must have given him a beautiful gold embroidered gown.

But I am not very sure.

I was told that to get to heaven one had to be baptized. I don't know if he was. It is even quite possible that Samek had never heard about all the unfortunate mess with Adam and Eve and their universal sin and the apple and the showing of the embarrassing parts that should have remained hidden under huge leaves. Did he realize that we Jews must bear the responsibility for all of that unless we are baptized? Did the Christian woman who tried to save him care for his eternal soul? "There are many ignorant people," the nuns said, "who, in spite of favorable circumstances, have rejected salvation. Unlike your Mother's smart aunt Janina who as a mere child chose to become a God-fearing Catholic." How incredibly wise Aunt Janina must have been! Not only has her baptism saved her, but it has also made possible our survival. At least up to now. Still I wonder. Has it really saved her? I know how scared she is that the Germans will find out she's the daughter of a Jewish family.

Luckily for me, I had been baptized. It happened at a dramatic moment, between the hiding in the convent and the departure to the ghetto, when the loving hand of Janina had reached out for some dripping water from a faulty faucet. Holy water would have been preferable, but in cases of emergency like this it did not matter. She sprinkled it on my head and pronounced some magic words. A personal blessing reinforced the well-known phrase that mentioned the Holy Trinity. Her voice was trembling with emotion. I try to believe that this event has put me in a very advantageous situation. I hope that in the matter of guardian angels, I have become much more privileged than Samek.

My thought may sound egotistical, but it was a time in which one had to do everything possible in order not to die.

The nuns made me understand that in dangerous times like ours, angels had to be given every chance to do their job adequately. Being baptized was part of an indispensable security arrangement. The other adults

were saying that even if it didn't help it couldn't hurt. What did they mean? Did they imply that it was better to have two religions than one? My thoughts wander again toward my dead pal Samek.

And what about the question of fairness? True, I was entitled to be in paradise and to sing for Jesus because it was I who gave up being a Jew and became a Christian. There are the well-known rumors that the Germans do not accept such a change, but we shall have to wait and see. This hearsay may be right; otherwise Catholic conversion would take us out of the ghetto. A troubling thought passes my mind. At present, in the ghetto, in the most horrendous of situations, I am permitted to live more safely because angels are taking particular care of me. But does it mean that I shall remain separated from my best friend for ever and ever and up to the end of all time and beyond? It is a difficult idea to accept. Mother, when I most need her, is reluctant to speak on this subject.

It is hard to have all those thoughts in the ghetto where I cannot possibly share them with the boys in our courtyard. Had they discovered Jesus' image in one of my pockets, they would surely have beaten me up. Even the adults have little patience for the ideas I have brought with me from the convent. I tried to speak about it with my parents, but I was embarrassed and at a loss for words. Mother tried to make it very simple. She told me that it was useful to memorize "Our Father who is in Heaven" and some other Polish Catholic prayers, in case I had to prove to the Lithuanian police that I was a good Christian. She had some difficulty hiding a sadly embarrassed smile. "God forbid," she added. "It is only if and when some unforeseen circumstances should bring about such a turn of events." She also explained to me, as an answer to my insistent questions, that when "God forbid" bullets go through your body, as in the case of Samek, one instantly falls asleep. There is no pain. Of course she did not mention him but I knew what it was all about. And I had already heard a lot of stories about the Lithuanian police who were making

money helping the Germans keep order in Vilna. The Lithuanian thugs were being paid ten rubles for every Jew delivered to the Germans. Busy fighting the Russians, the Germans badly needed volunteers, and were very grateful for their help. It was important to finish this instructive conversation with Mother on an uplifting tone. She said that everything would end well because "God is a Father."

What God? Jewish? Christian? That may have been when a tiny seed of disbelief started to germinate in my confused head. I wondered: what if God has nothing to do with how things end up? I am being told that he will forgive the Soviets who have destroyed his churches and did not believe in him. He will make them win the war in order to liberate all the Jews from all the ghettos and camps and help them return to their homes and reunite their families. Those words are spoken with little conviction, and I can't help doubting that they are really believed. Meanwhile the Lithuanian police continue to chase the Jews with the assiduity of rat hunters. Whenever they find a boy or a man they make him drop his pants to be sure about the nature of the prey.

I knew that Jews urinated with something very different from what was used by the Gentiles, and I imagined that the police made people urinate before they listened to their prayers, in order to tell who was who. I could not explore this question with Mother because of a strange and unexplainable embarrassment that I felt when it had to do with my "peepee," my *pisher*, best translated as my urinator. There had been some strange sensations of pleasure that came to me sometimes from this area, and they had to do, of this I was sure, with Adam and Eve and their mismanagement of eternal paradise. The wise and saintly nuns, who explained to me the proper position of my hands, which were never supposed to play with or touch this area, were not very explicit when they hinted at the complex connections among all these matters with which in any case I was too small to be concerned. And who could have said that

Mother had an answer to all these questions? More than once had I over-heard Father telling her precisely these words: *she didn't know what she was talking about.*

I must have lost my best pal Samek and my unquestioning belief in the certitudes of the adult world at the same time. Have I indeed lost him? The soul plays strange tricks on me, which I shall never fully understand. I have painted many canvases about the well-known image of the Warsaw ghetto boy, the child with arms uplifted as if they were nailed to a cross. For a long time I considered it to be a kind of self-portrait. It might have been a slightly presumptuous idea. We do not know if the authentic boy survived or not, while I did. True, in my ghetto in Vilna I was his age and I looked—as did thousands of other children—exactly like him. Same cap, same outgrown coat, same short pants. He was my alter ego, my counterpart.

Recently, something unexpected has happened to me. Whenever at present I look at these paintings I see Samek. And when he has eyes, which in many of my paintings he does not have, Samek looks back at me. We mirror each other. What would he say, had he had the power of speech? Would he send me a message? Or is his presence an eternal reminder that very little, yes very little, separated me from the destiny that was his. It gives me comfort to think that in some way I can live today for the two of us and that his future wasn't totally obliterated, since by living in me he is still being remembered and he helps me to remember all of Them. For how much longer?

I know these are idle thoughts, and I know there is really very lit-tle that I can do for him. I guess that at least I should title one of my paint-ings with his name, Samek. Since it is also my name, I would be doing it for the two of us.

CHAPTER TEN

Events Follow Events

STALIN LOVES US

Horsecars, taxis, and other vehicles, even passers-by, had to abide by instructions that were signaled by Soviet military police and take an indicated detour. The curious were stopped on the edge of one of Vilna's central squares to observe an unusual sight. In front of one of the city's official buildings, a whitish structure in Greek temple style, heavy army trucks were unloading huge and mysterious blocks of cast stone.

I was on my habitual route for a visit to Grandfather Khone's shop, accompanied by Mother, and this hectic activity in a relatively calm neighborhood intrigued me greatly. It was late summer in 1940, and I had already celebrated my seventh birthday. The Soviets had just annexed Lithuania, with our city as its freshly appointed capital, turning all Christian and Jewish inhabitants into new citizens of the Union of Soviet Socialist Republics.

This temporary detour, imposed by the new authority's military police, might have been preparing the stage for new political scenery, but for the workers moving the puzzling blocks it permitted an unhampered display of frenetic activity. Irregularly shaped blocks of cast stone, sometimes piled one on top of another but mostly spread pell-mell, covered the ground. They created a new geography that looked to me like the layout of a huge map, like the freshly printed map of the Soviet Union's republics that Father had brought home and Mother had helped me to study. These stones of bizarre shapes must have been hollow, as they seemed not to

weigh much. A small group of technicians was taking measurements. Others, simple soldiers in weathered Red Army uniforms, drivers, and several operators of a transportable crane—young and energetic men covered in dust and stains of mud—were digging a foundation.

Two days later a tall and imposing pedestal emerged from the very center of the square, and on its top stood two stony boots. Sturdy iron rods protruded upwards from them. It was an artwork in process. The job was finished a week later, and I could view it in its entirety. I could also focus on a detail and observe the thick index finger that belonged to a hand that stretched out from the colossal figure. The figure represented a confident, pristinely clean light gray Stalin displaying a beautifully trimmed moustache of stone. The finger, pointing in the direction of a few young trees, clearly indicated the promise of a glorious future. But the radiating glory of Stalin's pledge must have been shining on a horizon beyond the trees and rooftops. Invisible to the naked eye, his promise was resplendent in some sphere beyond our own indifferent blue-gray sky.

I removed my eyes from Stalin's finger and focused them on the delicate branches of the trees, which patiently hosted a multitude of agitated birds. Did the birds admire this majestic figure of hollow stone the way I did? The prompt erection of such an imposing monument was bewildering. But the innocent-looking birds may have been ignoring the bravado of the technical achievement, absorbed by other plans. Were they scheming some wicked plot? Were they planning to cover the freshly erected monument with their droppings? For the child in me, dirt randomly falling from the skies was a bearer of dark prophecies.

Things that can be assembled and taken apart have always fascinated me. I believe that this attraction is a painter's second nature. Cézanne assembled and disassembled apples, Rubens did the same thing with plump matrons. I began my artistic career by observing the dismembering

of my world, and in my imagination I tried to reassemble whatever remained of its surviving landscapes, objects, and people. This is how over time I remembered less Stalin's monumental statue than its remarkable pedestal. It generated in my work the image of a self-contained cube made of building blocks so huge and heavy that they might have belonged to the child of some legendary giant.

In one of my larger canvases, an urban blocklike island is lost in a sea of stones and sand. In essence it is a square-shaped base that instead of supporting some monument, contains one *by its absence*. Consider the picture: seen from above, a colossal stone cube in the form of a city displays in its center a huge hole shaped like the Star of David. Yellow facades of broken and discarded homes have been dumped into this star-shaped depression and huddle below the cube's surface. It is a devastated city contained within a stonily indifferent outer city, isolated from the rest of the world. This was the first of my series of "Ghetto" paintings completed in New York City in 1975. It appears also on the jacket of the first edition of *Ghetto in Flames* (1980) by Yitzhak Arad, a detailed history of the struggle and destruction of the Vilna Jews in the Holocaust. The jacket's frayed borders speak of how many times I have immersed myself in this captivating book. Although I had witnessed crucial events as a boy of seven, eight, or nine, my direct observation, however creative or intuitive, was limited by the childishness of my perception. Without the knowledge of collective memory, and of geographical and historical context, I could not fully grasp the significance of what was happening around me. As an adult I had to relearn this history from a broader perspective. Studying it in Arad's well-informed pages, I have learned how to put my own mind's huge heap of fragmented details into the larger picture.

His book has also given me many precise dates, of which these few delimit the span of my story:

1918—The new Lithuanian State was born from the postwar agreements that had redesigned Europe's national frontiers. Vilna, later destined to become its capital, was captured by Poland and unilaterally annexed to its mainland in 1920.

1939—September 1. Hitler invaded West Poland.

1939—September 19. The Red Army occupied Vilna.

1939—October 28. The Russians gave back the Polish city to the Lithuanian state that finally declared it its capital.

1940—August 3. After intense political maneuvering, Lithuania became a Soviet republic and was integrated in the USSR. (A few weeks later I observed the erection of Stalin's cast stone figure.)

1941—June 24, 1941, until July 13, 1944, Vilna agonized under Nazi rule.

What happened during this five-year period now fills numerous history books. But as I have said, my protected childhood knew little of what went on beyond the walls of my home. The sword of virulent anti-Semitism that hung over our heads, the antagonism between Poles and Lithuanians, the collaboration of the latter with the Germans, the secret agreements among enemies like Hitler and Stalin—all were beyond my domain. What did I know! Although the faces of my beloved family reflected their knowledge and their forebodings, my mind was focused on different matters.

A whole year before Stalin's impressive stone figure landed on one of Vilna's city squares, I celebrated, amid my loving family, my sixth birthday. Culturally we were Lithuanian Jews, with our distinct Yiddish and our special pronunciation of Hebrew. Politically we were Polish citizens,

and our city was part of Poland. The whole family was reunited for my birthday in a large dacha in the countryside. I was so tense and nervous that I could not stop coughing. Happily I liked the sweet and sticky cough syrup they gave me. Both grandfathers had supplied me with new mechanical toys, and both told me that I had the right to dismantle the gifts only if their springs broke and they became disabled. I did my utmost to overcharge the springs and cause them to split. Taking things apart was far more amusing than endlessly repeating their intended use. This passion of mine knew how to search and to find favorable occasions. One of the gifts was a shiny olive green tin tank, with a cannon that refused to fire. Some cough syrup clung to it and later dried and peeled off its shiny varnish. Moreover, after its first fall from the table, it stopped being able to climb over even small obstacles. Was this intentional? Not really! But to my joy it easily gave up its original purpose, and after a few simple manipulations (with Mother's strictly forbidden scissors), it split into two halves and revealed an interesting structure of metallic intestines with a jumpy steel ribbon that greatly amused Mourka the cat. Soon these pieces joined my vast collection of dismantled clocks and other treasures I kept in a special box under my bed.

A few weeks later came days of great tension, when everyone seemed shaken. I tried to engage the grown-ups in some games, but they were absentminded or hardly available. Even Mourka must have grasped that we were going through a crisis. Hitler had passed the frontier of Poland, and after a couple of weeks the Red Army entered Vilna.

The cat loved to sit close to our huge church-shaped radio and observe its evil-looking green eye. It slowly lit up when one turned a particular button and seemed to have a life of its own. It looked to me as if it possessed the power to decide what we were about to hear. Also, the radio loved heat. Only when a multitude of bizarre lamps specially hidden in its mysterious insides, a heating process that took forever, sufficiently

warmed up the whole apparatus, would the radio's green eye enter into action. The loudspeaker, hidden behind a brown fabric and carved columns of wood, would bring into our peaceful home the voices of orators and announcers in a babble of languages and the sounds of whistles, static, and entire orchestras. The radio on its special commode was treated like some shrine or altar. Permanently placed between the dining room's two heavily curtained windows, it connected us to the infinity beyond the rooftops, spires, and distant hills.

I recall the expressions of concern, impatience, and nervousness on the faces of the adults who used to gather near this object whose facade reminded me of Vilna's cathedral. I would see them listening to waves of news and casting at each other inquiring glances. Like Mourka, the adults seemed to be mesmerized by the radio's magical eye. But unlike our cat, they were greatly affected by the disquieting news and puzzled by the different versions they heard.

At times loud arguments would erupt in which the debaters demonstrated a surprisingly intimate knowledge of what went on in the minds of the world's most prominent leaders, their desires, their secret schemes, their hidden goals. The Russians arrived but did not stay long. Our family—along with the entire population of Vilna as well as the city's rivers, bridges, churches, hills, and castles—was given over to the independent state of Lithuania. Now Vilna was renamed Vilnius and Bak turned into Bakas. Food became scarce, and gangs of angry people started to roam the city's main streets. Going out became dangerous, especially for Jews. For me there followed the monotony of interminable days alone at home. I was disconnected from my friends and playmates who in other times were brought to our home by their mothers or governesses. Even visiting my grandparents was inadvisable. I spent the long days drawing and learning to read. Then gradually a certain calm set in. Father returned to his work and Mother to hers.

Acquaintances and friends returned to fill the animated evenings around my parents' table. Again the adults were joking. This was good, and I took it for a sign of normalcy. Someone would say: "Did you see the new army's great parade? It seems that in order to impress Vilna's population the Lithuanian government has borrowed from Latvia both its tanks, and added them to the one they possess." The others would laugh, explore further ways to make fun of the current authorities, and shift their jokes toward a sphere that provoked subtle coughs and meaningful glances in my direction. Then Mother would send me to bed.

Often Grandfather Khone would take me for walks in the park. When I observed with interest some military men in unfamiliar attires, Grandfather told me that the Lithuanian soldiers, with their piteous faces, shaved heads, and czarist uniforms, reminded him of his younger days. The bad smell of their cheap leather boots, and their bad breath from daily rations of cabbage and pork soup, were only too familiar to him. During our lengthy promenades he would return to his repertory of stories from the Japanese front in 1905. I loved them. I loved the story of the soldier whose head was blown away by an artillery shell, but the poor fellow, unaware of his mishap, continued running.

Soon after the arrival of the Lithuanian administration came waves of Jewish refugees from German-occupied Poland. Our home became filled with people many of whom required Father's dental services. Most were trying to continue their voyage to the Americas, via the Soviet Union and China. The stopover in Vilna helped them with the indispensable papers and visas. Documents, passports, permits, tickets, valuables, and exchange rates were the main subjects of their conversations. I was always around, listening with fascination to the stories of their escapes and adventures. Trifling details of their chitchat would often touch me more than their heartbreaking stories of disruption and loss.

Weeks and months went by. Gradually the number of these refugees

started to diminish. We lived on the brink of crisis, but everyday life had turned into a repetitive routine. It wasn't peace, nor was it war. Nine or ten months of this limbo made me think that it would go on forever, but time did not stand still. Distressing news about the increase of *aktions* against Jews in the countries controlled by the Nazis started to spread among the adults and greatly affected the general mood. There was more and more talk of emigration, but such a solution required a lot of courage and a lot of means. The free world had practically closed its gates on most of the uprooted Jews. The admittance to the exclusive club of nations that were removed from the direct danger of Nazism required exorbitant sums of money. This was the general belief, and few of those who still lived in the comfort of their homes and still had their worldly goods tried to move. The tribal ties that traditionally kept Jewish families together did not encourage individual departures. And the stress of uncertainty about our future only reinforced the power of such ties.

The former Lithuanian capital, Kaunas, was easily accessible after the annexation of Vilna, and Father reconnected with the family of his long-lost cousins. On Mother's side, Aunt Janina, Grandfather Khone's sister who had converted to Catholicism, had resettled in Vilna. I went with my parents to visit her in her lovely house surrounded by trees and shrubs. Seated in a meticulously kept dining room, on plushy upholstery that was protected in all its sensitive areas by small napkins of lace, I felt crushed under the imposing portrait of her husband's uncle, the Archbishop of Warsaw. But I ate the most exquisite dumplings filled with homemade cherry preserves and drank tea served from a silver samovar. There were many such moments of joy to sweeten our anguish. But the newspapers and radio saw to it that they did not last. The political tension between the USSR and Lithuania started to mount, and even I, still only seven, was aware of the dangers surrounding us. Later came the great turmoil, independent Lithuania's collapse and the return of the Russians to Vilna.

It brought about the establishment of a new Communist regime in a Lithuanian Republic that now became "Socialist."

The last of the refugees who used to gather in our home, and whose number had been diminishing, disappeared overnight. The Red Army and the Russian police were everywhere. They searched homes and looked for anti-Communist propaganda, foreign agent provocateurs, and illegal arms. These were also the days when a Soviet General kicked Grandfather Khone and Grandmother Shifra out of their apartment and settled into it with his own family. This is when our home became host to Grandfather Khone's huge aquarium that was supposed to hold the collection of his rare tropical fish.

Father, Mother, and I fared better. We had the right to remain in our flat but had to give away one of its rooms to a Soviet colonel. I was happy to welcome a decorated military hero, as he was presented to us, in exchange for the former noisy and invading guests—among them a few plump ladies who used to cover me with salivating kisses and leave stains of red lipstick on my face. I did not miss them. I hoped that they had obtained the precious visas from the Japanese consul in Kovna, and I imagined them on their way to Shanghai. Xenia, our housekeeper, was morose. With the gradual departure of our temporary guests, many of them Father's patients from Warsaw, she lost a substantial source of additional income. Now she was faced with the invasion of her sacred domain by an officer of the Red Army. Also Mother was very apprehensive. She disliked the military on principle. For her, officers were Polish cavalrymen whom she viewed as pompous anti-Semites in corsets. Father, on the other hand, was more practical. Given our new situation, good relations with a highly placed person could be beneficial. He welcomed the Russian officer with great friendliness and showered him with charm.

The tall officer's coat was long and impressive, and his army hat hid under its visor bushy eyebrows, glowing black eyes, and curly black hair.

He was much younger than we anticipated, better educated, and very accommodating. Taking possession of his room he admitted to never having lived in "such luxury." He helped us out with food, very valuable in times of rationing, and ate at our table, often at lunchtime and sometimes in the evenings. Xenia had to admit that the boxes of Russian preserves, caviar, wines, and all sorts of other edible goods that the colonel's aide-de-camp brought to her kitchen were highly desirable. Yet, for our housekeeper's fanatic nature the Soviet officer was a sworn enemy. Only her own person was the rightful representative of the true Russian soul. She appreciated his helpfulness but hardly graced him with a friendly look. He seemed to ignore her, and Mother tried to fill in where Xenia's services remained lacking.

The colonel liked me. He gave me candies, papers, crayons, and illustrated books in Russian. Sometimes he played with me. I was promised a Red Army uniform in my size, but this gift was never to materialize. Once he approached the huge aquarium, which stood empty and orphaned in a corner of our dining room, and smilingly asked me what kind of meal Xenia had prepared with all the fish that used to live in it. But I thought he was kidding. Later he suggested that I fill it with some water and drop into it a spoonful of his caviar. Perhaps it would give us new fish. I knew that caviar was essentially made of fish eggs, so this time I was sure he spoke seriously.

For Mother he reserved a lot of attention. He looked at her with friendliness and continuously spoke to her about his beloved wife, a teacher in one of the Soviet universities. They often discussed *War and Peace* and Pushkin. Sometimes his attention took the shape of Soviet soap, unpalatable Soviet military chocolate, and even flowers. Mother was touched by his thoughtful gestures. The more sympathy there was between the colonel and Mother, the less Father liked this friendly man.

One evening we were to dine with the colonel. The suspended golden

silk lampshade lighted our round table from above, but the rest of the room was dim and only the dial of the radio glowed in the dark with its reddish dial and green eye. An orchestra was playing sad tangos. Mother came in wearing a crimson dressing gown of light velvet. The colonel jumped up from the place where he had been trying to engage Father in conversation and helped Mother with her chair. He complimented her on her lovely evening dress. Mother laughed. "This is just a sort of a negligée," she said, "only the fabric is heavier." Father tried half a smile and lit a cigarette. The colonel got up and gallantly invited Mother to dance. Mother suggested that he must have learned his elegant manners from some French films. They started to circle, and I could not follow their conversation. Father focused on smoking his cigarette, and I looked into my empty plate. Suddenly I was shaken by terrible fits of coughing. Mother rushed to my chair, but it was Father who quickly snapped me up from it, returned to his place, and let me sit on his knees, embracing me as if I were a baby. Xenia entered with the food. The colonel sat down, but I did not dare look into his face. I had the feeling that I had lost my promised uniform.

About the time my very first school year started, our colonel was ordered to another town. He was very upset. Everyone else, even Mother, seemed relieved. Not having him around seemed to be good for us, even at the price of losing his generous rations of food. This was because the black market had made considerable progress, and as items became available, the colonel's contribution lost some of its power. Both parents agreed that his transfer happened just in time, and the main reason concerned my obligatory schooling and the problem that came with it. School opened late that year because of the political events. But now my first day in a Socialist grammar school had arrived. The school was to teach me Yiddish and Russian and introduce me to the Lithuanian language. Its building was only two or three blocks from home, and I could

get there without crossing dangerous traffic. My parents agreed that I could walk there daily by myself.

"By myself like a really big boy?"

"Yes!" This promotion to one of childhood's higher ranks made me excited and very proud.

But on the morning of that first day, having perceived Mother's nervousness and seen her expression of worry, I had to accept a slight change of program. She would accompany me this once. I agreed, but on condition that she would leave me at the school's threshold. Later I would return home by myself, like the "big boy" about whom we had spoken. Besides, for my return I had the company of another Jewish boy, slightly older, who lived in a separate wing of our building.

The new pupils had to gather in a special corner of a large gymnasium. I kissed Mother goodbye and joined the others. We were a large group of anxious children surrounded by smiling adults. Bursts of laughter emerged from a lively conversation. Many children of my group showed their apprehension by clinging nervously to their mothers or grandmothers. I started to realize that my initial feeling of pride in my independence was quickly waning. In view of the reassuring presence of the other pupils' close family members, I suddenly felt angry. I was furious at being so thoughtlessly treated by my own mother. The rage gave way to a feeling of abandonment, loss, and panic. To leave me alone in this alien territory! I did my utmost to control the spasms of coughing that were mounting from my lungs and filling my throat. It wasn't fair! Surrounded as I was by indifferent faces, who was going to take care of me?

Soon the mothers were asked to leave, and this request was followed by a few bursts of heartbreaking crying, laughter, and teasing. A pleasant feminine voice demanded silence. The voice belonged to our new teacher, a smiling young woman in a tight-fitting dress and complicated hairdo, who gathered us in and led us to our new classroom. She assigned us to

our places and did her utmost to dispel our tension. Seated on uncomfortable benches we faced a blackboard covered by a huge map of the USSR. Above the map, like a powerful eagle over a royal coat of arms, hung the imposing and familiar face of a man with a heavy moustache. His monuments and pictures were all over town. Every child in the class knew that his name was Stalin. I do not remember all the preliminary explanations our teacher gave us, the checking of our equipment, and the tedious introductions among classmates that required us to repeat our names a number of times. Some of the names, of which I have no recollection, provoked bursts of mocking giggles. But I shall forever remember the story our dedicated teacher told us. It was the central event of that morning, and she did it with a lot of emphasis, gesticulation, and emotion:

"This is the story of Liubotchka, a dear, dear little girl who lived with her grandfather, a loving good old man who took very good care of his granddaughter. Everyone loved Liubotchka. Everyone loved this beautiful child."

The teacher's voice had a hypnotic power and soon all laughter stopped. There was dead silence.

"The girl's father, Piotr, was far, far away, working in a coal mine where he had managed to triple the output of his team. He was a Stakhanovist. Do you know, children, what a Stakhanovist is? Never mind, I'll explain it later. Now, Sonia, the little girl's mother, a famous engineer, was in the Uralls. She was in the midst of supervising the construction of a giant electrical dam."

Our teacher's hand pointed to the precise point on the map where Sonia was to be found.

"Now children, Liubotchka's grandfather was very, very old and he knew that he was going to die. All children whose grandfather died, please lift your hand. Thank you! Let's go on. Liubotchka's grandfather

had therefore to bring his granddaughter to her mother, and for that pur-
pose he had to travel by train, from here in Odessa (look at this point), to
this place in the Urals. It looks short on this map but in reality it is a long,
long journey. At times Liubotchka would fall asleep and then wake up,
but her hand was always clinging to the coat of her beloved grandfather.

"Suddenly she woke up realizing that she had been holding on to the
coat of a stranger. Her grandfather had disappeared, and nobody knew
what had happened to him. When people die they disappear from our
lives. You see, children, I speak to you as mature and intelligent citizens,
and do not fill your heads with fairy tales of souls or of heaven. But let's
go back to our real story.

"The desperate Liubotchka began pushing her way among the travel-
ers, calling the name of her grandfather, but to no avail. He did not
respond and no one had seen him."

At this point some girls in the class started to sob, and even I, a boy,
was so moved by the unfortunate fate of the dear, dear Liubotchka that I
had to let my sleeve absorb a few tears without letting it be seen by the
others. The teacher indulged, with a mounting voice, in endless details of
the little girl's feelings of despair and loss. She was thousands of kilome-
ters away from her home, with no railway tickets to indicate the name of
her final destination, and no address of her parents' working places. She
was lost in the midst of the Union of Soviet Republics that hanging on the
blackboard looked rather small but in reality was limitlessly huge and
powerful.

The teacher's voice was trembling with emotion: "The train halted in
one of the many intermediary stops. Sobbing and shivering, Liubotchka
felt the gentle touch of a grandmotherly woman in a uniform of the rail-
way company. This kind person was a citizen train-controller, who took
Liubotchka by her hand and directed her to the exit of the car. There
another kind citizen put his arm on the girl's shoulder and brought her to

the office of the stationmaster. His office was filled with travelers. She looked at the strangers around her, but their faces were unfamiliar and even frightening, and their smiles did not touch her. How could she trust people she did not know? Her sobbing would not stop.

"Suddenly, in a second, a wonderful feeling of appeasement and peace overwhelmed our dear Liubotchka. It happened that she saw on the wall a big picture of Tovarish Stalin! Children, imagine, the very picture you have here over our blackboard! 'Do not worry about me, dear citizens,' said the little girl; 'Whenever I see the picture of Comrade Stalin I know where I am, and I know that I am being protected. He is a father who loves me even more than my own parents do. Now I am safe,' concluded Liubotchka, who thus triumphed over her fear and feeling of loss." So ended our teacher's story.

When I gave Mother a detailed report of my first day in school, she summed up her response in a very resolute manner. "It was your first, but also your last day in this rare school." When she said "rare" she meant worthless. "You shall never return to a place that feeds children's heads with such rubbish." This concluded my brief experience as a pupil in a standard institution of the Soviet Ministry of Education. My staying at home, which might have been illegal, was greatly facilitated by the colonel's departure. A doctor's certificate that spoke of a chronic bronchitis and persistent cough did the rest. For the time being we owed no additional explanations. Mother tutored me in her free moments.

The Communist economy had forced many inhabitants to accept substantial changes in their standards and ways of living. Father's habitual clientele became impoverished and could not keep him fully employed. Nor could he employ his former assistants. He started to look at various jobs that a state-controlled health service offered to specialists of his profession, but the possibilities were limited and the outlook was bleak. Then arrived a surprise. The colonel, shortly before his departure from

Vilna and still unaware of the assignment that would force him to leave town, had tried to pull some strings on Father's behalf. He knew and associated with some highly placed executives in the offices of the Lithuanian State Rail, people who must have owed him favors. When he interceded for a specific employment for Father, a job that would have obliged him to travel and be frequently away from home, the unlucky colonel had no inkling that it would materialize too late to serve his own interest. A few days after the disheartened colonel's departure, when everything about his discreet job hunt for Father was completely given up and almost forgotten, his former string-pulling had an unforeseen result.

Father was appointed head of the State Rail Company's dental services. It was an enviable position. It gave us better food cards, no obligation to host military personnel in our home, and less concern about being singled out by the always suspicious authorities for deportation to Siberia. So now, with the handsome colonel far from our home, a decent salary, and the prospect of frequent travel, Father was as happy as he could be. His work in the paramilitary structure of the Soviet rail required him to wear a military type uniform, and his was custom-made by Grandfather Chayim's clever tailors from excellent English fabric, precious stuff that was reserved for generals. Father was again the most elegant of men. His large and long dark brown leather coat, more impressive than the colonel's, was the envy of his associates. His incessant travels, nominally concerning the creation and supervision of small dental care centers for the railway's employees, made him often absent from home. Mother, who had been so cheerful during the "colonel" period, and so happy to learn about Father's assignment, gradually slid into a state of irritability and sadness. It was a worrisome time.

Was I trying to help by being more and more focused on my coughing and giving Mother a good reason to spend her nights at my bedside? The fact remains that my chronic bronchitis metamorphosed into a bad

whooping cough, and this terrible ordeal made me run a fever, at times lose my breath, often throw up, and in general be quite ill. By the time my health returned to the acceptable norm of nervous coughing, we were in the beginning of summer 1941. In the streets of Vilna, at ten o'clock in the morning on Sunday, June 22, the sirens started to sound. The German forces had attacked the Soviet Union. Factories, shops and offices were closed, but the devout Catholics who were in the churches had to rush home. Anguished people crowded the air-raid shelters and listened to radios. And the news was showering them with all sorts of foreboding information and confusing announcements. All military personnel of the Red Army were being evacuated. Thousands of panicking and disoriented Jews, aware of what the hordes of Nazis were going to bring, were trying to follow in the steps of the Red Army's retreat and find refuge in Russia's mainland. The ones who had been actively involved with the Communist authorities fretted the most. On rail, in vehicles, and on foot, on roads that hardly permitted such a volume of traffic, people tried to escape and save whatever they could.

Our doorbell rang. My parents, who had been glued to the radio, rushed to the door. I followed them. A breathless pair of Father's friends, men associated with his work, stood there clad despite the warm weather in several layers of garments, a familiar sight on the trails of refugees. They spoke hastily and their words overlapped, but the message was clear. A truck belonging to the rail company, with papers for a special clearing of privileged routes, stood at the door of our building. Its engine was running. We had five minutes to pack one small suitcase for the three of us, wear on ourselves anything else we hoped to save, and join them in their vehicle. It was our last chance to escape the claws of the German beast.

Yes or no, our definitive answer had to be given on the spot.

It looked to me that Mother was having great difficulty breathing or

uttering even one single word. With her face whiter than I had ever seen it, she sank onto a nearby chair. All she said was "How could I . . ." A few seconds passed. Father, with his hands on the frame of the open door, intensely scrutinizing Mother's thunderstruck look, slowly shook his head and repeated this movement a number of times.

"Good luck," said the men. They turned on their heels, hastily descended the staircase, and disappeared from our view. Father slowly closed the door.

In later times, not only under Nazi rule—in the convent, the ghetto, or the camp—but even after the war in Landsberg and Israel, Mother would return to this episode and retell it, again and again. She would start by saying how stupid she had been, how shortsighted, how stubborn. Then she would compose for every new edition of her story a new speech that she believed she had given to the two brave men who proposed to save her, her husband, and her child. These speeches were composed of lists of all the important bonds that tied her to Vilna, to her family, to her friends, and her possessions. Lists of weighty reasons that meant she had had no choice. Of course it was herself she had to convince. In fact, as we were to learn years later, had we left we might well have been among the thousands of refugees whom the Germans bombed or gunned down on the crowded roads of escape.

The first time Mother evoked our missed chance of escape was shortly after the event, in a few brief phrases addressed to me. It was on that rainy day that brought us into Vilna's ghetto. Lithuanian police were yelling orders. The Germans were supervising. Having been forbidden the use of the sidewalk, we dragged our soaking feet in the muddy water of the gutters. We passed a street that opened onto the square that had once displayed Stalin's monumental figure. Stalin's head was gone, and the body was in shambles. I noticed nearby a large heap of rubble. Was it a random bomb or a premeditated destruction? I still do not know.

TO THE GHETTO

Early September 1941. Previously, in June, the German army had occupied Vilna. Mother, our Russian housekeeper Xenia, and I were left in the large apartment that suddenly looked empty and haunted. It became dangerous to go out, and no one came to see us. The celebration of my eighth birthday in mid-August was postponed to an indefinite date. Our reserves of food were exhausted. Xenia had found a peasant who was ready to barter Father's tuxedo for a sack of potatoes, and we lived on their nutrient power. Father was in a labor camp cutting turf. It was safer for a Jew to be assigned to hard and often demeaning work than to remain in town, subject to arbitrary arrest and disappearance. New decrees were constantly diminishing the span of our freedom. First we had to wear armbands that marked us as Jews. Soon after yellow stars, sewn on the chest and on the back, designated us as such. We were no longer permitted to use the sidewalk. A group of prominent Jews was taken hostage and an exorbitant amount of gold had been demanded for their release. People of the Jewish community passed from one Jewish home to another collecting coins, jewelry, and wedding rings to meet the ransom that would save the hostages from a summary execution.

Soon after a Jewish couple that lived in our building came to us with a report of the latest rumor. They said that in several streets of the ancient and predominantly Jewish part of town, a massive evacuation of inhabitants was taking place. It was probably done for the establishment of a

ghetto. The Christians were being transferred to other lodgings while the Jewish families had one day simply disappeared. They believed that soon each one of us was going to be turned out of his home and dragged to the new area that would restrict all our future movements. Our old neighbors looked small, bent, and depressed. They were expecting the worst.

I listened to them with a sense of growing apprehension. When they left Mother locked the door, gave me a smile, and made a little uplifting sign with her shoulders. It meant that this whole story could very well be questioned. Her attitude would have appeased my worry had she not immediately become absorbed with the preparation of a small suitcase. "Just in case," she said. The packing took her a long time and kept her busy. She started with a middle-sized suitcase, tried to lift it, unpacked the contents, excluded many items, reduced all superfluous weight, and ended up with a much smaller and handier package. She told Xenia that we might be obliged to resettle in another part of town, that the little suit-case was for a first night only, and that in case, in case one day the worst really happens, we shall have to come back for our remaining affairs.

The "worst" happened sooner than we thought.

Being left without a telephone, radio, or newspapers, Mother and I spent hours at our windows, looking at the sky and into our courtyard. We were like the prisoners in Plato's cave parable who were figuring out the reality of the whole world from shadows on a wall. We tried to guess what some incidental passing of one or of a few furtive silhouettes might signify and figure out how it would affect our lives. Then on a very rainy day that seemed to resemble the onset of a new flood, a few Lithuanian policemen with guns and clubs in their hands arrived in our courtyard. After crossing it between the spreading puddles of rainwater with quick and determined steps, they disappeared through the heavy doors that led to the stairs. Thereafter several of our Jewish neighbors started to emerge, carrying bags and small suitcases. Obeying orders that we from above

could not hear, they waited motionless in the pouring rain. Suddenly our doorbell rang and continued to ring uninterruptedly. The entrance door was also receiving powerful bangs that made it shake in its frame. The harrowing noise reverberated in my ears like a falling bomb. With trembling hands Mother opened the door.

Two men, whose faces were hidden in the shade of their wet hats, stood in the door. In dripping raincoats, a heavy middle-aged policeman and a younger assistant entered our hall with a very decisive gait. And while the older one was interrogating Mother about the number of persons present and ordering her to take whatever we were able to carry and quickly descend to the building's courtyard, the younger turned around and nonchalantly touched with his menacingly outstretched club whatever object he fancied.

My eyes searched for Xenia but she was nowhere to be seen. I ran to my bed to say a quick goodbye to my old and decaying teddy bear. He was nicely tucked in under my blanket and his little sad head was resting on my pillow. I knew that I was too grown up to take him along, but my heart felt some pangs of remorse. I quickly turned my head to all sides, casting my gaze at everything, trying to fix in my memory the apartment, the furniture, the rugs, the paintings, and the large and empty aquarium that stood in the dining room. Mother was already waiting in the hall with her little suitcase. She was shivering as if a chill had seized her suddenly. We were almost at the door when she begged the policemen for another moment. She disappeared in one of the doors and returned with my pillow, which she quickly handed to me. I seized it with both hands. A disturbing thought flashed in my mind. Did she drop Teddy to the floor? I didn't dare ask. I felt that the pillow had to mean something more than the object it was. I embraced it in my arms as the representative of all the comfort and all the belongings we were leaving behind.

We came out to the landing. In the dim light of the staircase I could

distinguish two women who were looking at us intensely. Xenia with her arms folded on her bosom was next to the janitor's wife. No words were uttered between us. Water was dripping from a window and descending the stairs in small rivulets. In spite of the grayness that the very rainy day had imposed, I focused my gaze on her face and tried to read in it something. But it showed no emotion. I smiled to her but I do not know if she remarked my smile. The moment was short, the light was scarce, and her face remained blank.

We followed the policemen to the courtyard in a state of speechless numbness and joined the group of our Jewish neighbors. They hardly looked at us or at each other. Orders were given to start moving beyond the gate. On Wilenska Street I cast a last glance at the large windows of the Bata shoe shop, but they had been blown out in one of the air raids and replaced by boards of old plywood. It was their good luck. Had they conserved their former mirrorlike quality they would have been ashamed to send us back such an infamous and humiliating reflection. We were like a caravan of ants, carrying bundles, blindly following the steps of the ones in front of us. The sidewalk had long since been forbidden to us. Chased from our homes, we dragged our soaking feet between the puddles of the road, trying to find a hold on the slippery cobblestones. Rude voices continued incessantly to give orders and a hard rain drenched us to the bones. "The sky is crying," said the people who walked in front of me.

My pillow absorbed more and more water until it was too heavy to carry. Although I clasped it with all the determination of a reliable and responsible transporter, my arms could not sustain the effort. Drenched in rainwater, with my wet socks sliding down my legs and creasing in my wet shoes into hurting pleats, I was shivering as badly as if this were a winter day and not late September.

"Mother may I. . . ?" She glanced at me with a look filled with endless helplessness.

"Throw it away."

It landed with a splash in a puddle. When I cast a quick peep backward, I saw many feet stepping on it, as if it were part of the road. "For goodness sake, look how you tremble. Why didn't you put on your overcoat."

"I was very hot."

"Nonsense. Stop talking as if you were a child!"

We arrived at a junction of two roads where a large crowd was being corralled. The crowd had to pass a newly erected gate that from now on would control the traffic of the new ghetto and keep us confined within its boundaries. A huge deployment of men in German uniforms was supervising the operation. We had to pass a sticky and crushing bottleneck of soaking wet people. I held fast to Mother. In order to avoid being separated we had to push and pull energetically. Finally the incoming stream of people propelled us, and we came to a narrow street where the crowd was sparser. Many appeared to be marching in a trance, as if they were still trying to grasp what was happening to them. Mother started to look at the house numbers. Then her hand caught my sleeve and we stopped in front of a door that led to a narrow staircase.

"This is where Nissan's daughter lives. Let's go up."

We went in expecting to climb the stairs, but an elderly man was sitting on the steps, obstructing our passage. He got up, looked at us, and almost collapsed in Mother's arms. I recognized him at once. It was Nissan, one of Grandmother's associates. His clenched mouth was mute, but his eyes and his whole face spoke of a great distress. He took me by my hand. After two flights we entered a small flat whose door was left ajar. A fallen chair blocked the entrance to a large kitchen that was directly accessible from the hall. He moved it with his foot. There a table, covered by a partly pulled tablecloth, exhibited a variety of objects in great disorder. Some plates still carried remains of food. Milk that must have turned

sour was left at the table's very edge, and everywhere slices of bread were drying and bending. A child's truck and a few helpless lead soldiers added a surprising dimension. Clearly a meal had been suddenly interrupted. Unmade beds and strewn pieces of clothing were visible beyond the open doors to other rooms.

Nissan came out from one of these rooms carrying a child's small overcoat of a dark herringbone fabric. He held it patiently while I put it on.

"He was your age." He spoke sadly. These were his first and last words to us.

Mother thanked and tried to cheer him with hopes in which she hardly believed and promised to bring back the very practical and useful loan as soon as his grandson returned.

We came out into the street. Gradually the rain had stopped. More and more people were crowding the sidewalks, the narrow streets, the courtyards. Mother interrogated some passers-by, tried to find anyone she knew. She inquired about the evacuation from the area in which my two grandmothers used to live. It seemed that they had been sent to a second ghetto in a nearby part of the old city to which we had no access. There was no use wandering around. The day was closing, and we had to find a place for the night.

We ended up in another apartment. It once belonged to a Jewish family unknown to us, whose photos were still looking from their various frames and wondering who we were. It was now occupied by two dozen people, like us freshly ejected. Was it that the former owners' sudden removal had left less evident traces of brutality, or was it the mess and the noise of all the new arrivals? I realized that something made this place less foreboding than Nissan's had been. I ventured to the kitchen, which was already taken up, and looked into a few cabinets for traces of food. Too late. More and more people were spreading blankets on the floors and

defining the limits of their territory. Soon it became impossible to circulate. There was sitting room only. Air was scarce and pervaded by the smell of drying shoes and wet wool. On the floor above, a door that had been locked was torn down, making another flat accessible. Some of our people migrated there. Finally it became possible to stretch out comfortably and sleep on the floor. The sadness, the fatigue, the desire of many to escape into worlds of dreams diminished the general hubbub, and I fell asleep. I woke up early to the noise of an angry voice.

A woman was rebuking her husband because he had forgotten to take with him the key of their apartment. He was apologizing. Being chased from his home was not a common occurrence, he tried to explain, and the key had remained on the inside, stuck in the lock of the door. Some other people made remarks about the absurdity of their little scene. Soon there was a wave of laughter that woke everybody else. Someone came up with a joke about a key. He did not finish his story. A terrible scream followed by sounds of agitated voices, banging doors, and running feet erupted from the side of the entrance hall. That night, a man had decided to bring an end to his suffering and had hanged himself from the stair's rail. He was dangling in the shaft, and some of the men labored to take him down.

Mother held me silently in a tense embrace. Then she stood, shook her coat that had served us as a blanket, picked up our little suitcase and, taking my hand, quickly led me from the flat. I plunged down the stairs behind her with the greatest speed possible, as if I were haunted by the ghost of the hanging man. In the courtyard, a group of workmen was building a wall. Others were blocking out windows that opened on the Aryan side. The streets of the new ghetto weren't yet tightly enclosed. We entered several courtyards and tried out a few passages, but either men at work or German sentinels made our exit impossible. After a few such unsuccessful attempts, we found a door of a small forgotten courtyard that had in the past been used for the delivery of merchandise. Mother

tried to force its handle. It was rusted but it gave way to her insistent effort, and when it opened we found ourselves in an empty narrow lane.

Suddenly it became clear that we were on the other side! Mother's able hands quickly removed the yellow stars that had been fixed on our clothing. To stop one of the few droshki that still circulated in town and give out my Catholic Aunt Janina's address was too dangerous. The state we were in, our looks, especially mine, might have aroused suspicion. We took narrow alleys and little-used side streets, hoping that our good fortune would continue and that it would bring us to her suburb and her house. We had no plan and no idea about what would happen next.

HIDING IN THE BENEDICTINE CONVENT

I was often brought to play on a small public square across Wilenska Street, just opposite our apartment building. It contained a few trees and several stone benches, on one of which my *panienka* (young governess) would sit and read while I ran around chasing my hoop with a wooden stick. In the center of the square stood a tall, columnlike pedestal topped by a marble bust of a bearded man with white expressionless eyes. I was told that it was Monjuszko, Poland's famous composer of operas. All that was left for Mr. Monjuszko to do was observe the few nannies with their prams or the small children who often ran around his base. The poor armless and legless musician was to me very unsettling. I felt that in view of all the anatomically complete statuary of madonnas, saints, and angels gracing niches and roofs of Vilna's numerous churches, Monjuszko's monument did the helpless composer a great injustice.

But whenever I inquired about it I was told not to worry—Monjuszko was since long dead, and he belonged to another world.

Behind Mr. Monjuszko stood a high wall that was part of the convent of Benedictine nuns. The sisters were known never to exit its closed premises. Creeping plants climbed to its top, as if to peep into this prohibited realm. The convent was adjacent to the Church of St. Catherine and formed with it an entire block. When I had asked about the life behind its walls, I was told that this too I must consider another world. However I was soon to learn that Mother's Aunt Janina, who many years earlier had converted to Catholicism, was once educated in that convent's exclusive

college for girls. Simple chance had brought her Jewish niece, my mother, to live across the street with husband and child.

But the hazards of life were to bring us even greater surprises. The massive medieval Benedictine convent was to shelter me twice under its roof of dark tiles, and its *clausura*, its inner cloister, the most secluded part of this secret world, turned out to be our first and, much later, our last place of hiding from the Germans. Both occasions of life-giving shelter happened thanks to Mother's Aunt Janina. She had kept throughout the years a very warm relationship with her former educators, who remembered her as a bright and loving pupil. Janina, who later married a nephew of the Archbishop of Warsaw and raised a respectable family, was highly esteemed by the convent's sisters. They gave her great respect, affection, and care.

After the Nazi occupation of Vilna, events fell on us very quickly. Father was sent to a labor camp, and soon after Mother and I were expelled to the ghetto. I spoke of how we managed to escape and find a way to the "other side." Now we had to put our trust in Mother's blond hair and her Aryan look and to hope that some of this magic would also rub off on me and render me invisible as a Jew. Abandoning whatever we had carried in our hands, we walked calmly and pretended ease, choosing side streets and little frequented roads, bypassing the many points of police control. We reached Janina's home miraculously unharmed. Seeing us alive, Janina was overjoyed, but her joyful expression did not last long. She could not hide her worry. For us to remain in her house was unthinkable. Exposed to the interrogating eyes of the neighbors, and worse, to sudden searches by the police, our presence in her home was not only a danger to ourselves, it would also expose the secret of Janina's Jewish origins. What should we do next?

It was at this point that Janina asked for the convent's help. The mother superior, with the authorization of her bishop, agreed to create a

hiding place for a woman and child in the heart of the convent's *clausura*, the closed cloister. This privilege was extended later to Mother's sister Yetta and her husband and my father.

I shall always remember our arrival in the newly prepared hiding place and our first introduction to the convent and its nuns. Janina ordered a "droshki," one of those carriages drawn by horses that did most of the transportation in town. Lithuanian police used to stop passers-by and check their papers. She thought it was less conspicuous for a Jewish woman and child to be seated in the shadow of a carriage's black hood than to walk on foot. The "droshki" stopped at the entrance of St. Catherine's Church. The interior was dark and penetrated by a strong odor of incense and ancient wood. Aunt Janina asked us to wait for her in one of the pews and pretend to be absorbed in prayer. Then she disappeared through a small door. We waited. A strange feeling of guilt seized me. Before the war had broken out, before the Russians, the Lithuanians, or the Germans had made Vilna their territory of transiting occupation, we lived in a seemingly peaceful Poland. It was then that I clandestinely visited this same church, accompanying our housekeeper Xenia on her various errands. Xenia preferred to take me to Russian Orthodox churches, but I insisted on visiting the church across our street. These visits were a secret between us, which I never admitted to my parents.

Now kneeling with Mother in a pew, I was in that very same alien territory and the aliens were going to save us. A nun came out from the small door and gave us a sign to follow her. We went through a row of corridors, inner courtyards, dark forbidding doors set in whitewashed walls covered by crosses, very dark paintings, and wooden statuary. We were in the heart of the *clausura*, which was, as Mother whispered into my ear, totally forbidden to strangers. But thanks to Aunt Janina's intervention we were given a special permit by the authorities of the church. The name of her husband's uncle worked miracles.

Finally we entered a big, simply furnished white room. The first to join us was Janina herself. I could read on her face that everything was working out for the best. Then three black-clad figures entered, in ample robes with the most extraordinary head covers I had ever seen, constructed of white, starched material overlaid by perfectly round black hoods that hung in deep folds down the back. Their faces were three glowing, benevolent masks. Janina kissed the three hands that were stretched out, and Mother did the same. Then all eyes turned to me. I understood what I was supposed to do, but total paralysis seized me. Kissing a lady's hand was a matter of gallantry, reserved for adults. Was a boy in short pants expected to do it? One of the hands touched my hair and rested gently on my head. I looked up. The glowing mask became a smiling face that looked at me with tenderness. It had a perfectly round shape, a most healthy looking skin, and was beautifully framed in the white starched fabric. Its age seemed indeterminate, its goodness unlimited. It was the same face that half a century later looked at me from the yellowing pages of an old book dedicated to the *Hassidey Haolam*, those rare and courageous Gentiles who believed in saving Jewish lives even at the cost of their own.

In time we became very good friends, Sister Maria and I. I always waited impatiently for her daily visit. She supplied me with paper, colored pencils, and old and worn children's books, gave me lessons from the Old and the New Testament, and taught me the essential Catholic prayers. After several days Mother's sister, Aunt Yetta, joined us; later her husband, Uncle Yasha, and Father, after they managed to escape the turf camp in which they had been long interned, were granted the same asylum.

My parents encouraged my Christian education. A fair knowledge of it, they thought, would be an asset in a future that was so very uncertain. I did not ask them how much such an asset would serve a circumcised boy when an anatomical test could decide life or death. I took it with all the

appropriate innocence of a child. And I accepted all the legends, doc-trines, and magic that came with this education. I was promised that we all have our own guardian angel, which though invisible is always there, and I fell in love with his reassuring presence.

I did not yet realize that I lived in a world in which a war between good and evil, between angels and devils visible and invisible had gone on since the first light of creation. Certainly Sister Maria was one of my visible guardian angels. How much so I realized only later, when at the brink of our total despair her magical reappearance gave tragic events an unex-pected turn.

Before our "safe" stay in the convent came to an abrupt end, our life seemed to have settled to a regular pattern. We were confined to one big room. Washing and taking care of our other needs was only possible in the middle of the night when everyone else was asleep. Mother and Aunt Yetta did a lot of knitting for the charitable projects of the sisters. Father and Yasha learned to do some bookbinding and restored ancient books. I drew and drew and drew. The convent provided me with pencils, papers, religious images, and an illustrated Bible. Maria explained to me many of the events that were beautifully depicted by a French artist in a huge and very heavy volume. I started to accept that the Christian God was more powerful than the God of the Jews. The terrible punishment that his cho-sen people had been subjected to demonstrated it easily. But it seemed his people bore a great deal of responsibility: they had remained blind to the prospect of redemption. True, all people are full of sins, partly inherited and partly of our own making, but the promise of a pleasant life after death to those smart enough to confess and get a timely pardon was another point in favor of the Christian God.

The Son of God, who was a Jew just as I was, had also suffered hor-ribly. In the cloister there was a life-sized wooden statue painted in oil colors. God's Son, covered with blood, his back lacerated by deep purple

wounds, was tied to a make-believe stone pillar with heavy ropes that cut into his flesh. He looked very alive. When I first saw him I was so impressed that a lump formed in my throat. His face was a grim red mask in which two black pupils were turned upwards. I could not take my eyes away from the rivulets of blood that poured from his bruised forehead with its heavy crown of thorns. He was all by himself in an empty gallery that I discovered while being secretly brought to the church next door. This was on the occasion of a festive mass Maria had let me witness by hiding me on one of the most inaccessible upper balconies. I was left close to a forest of metal pipes that suddenly startled me with a thick reverberation of sounds. Music was pouring from them, but surprisingly some of the notes made me think of our river's large steamboats. The unpleasant taste that had sprung to my mouth at the sight of the tortured Jesus was gone, and I was plunged into the memory of happy promenades with my grandparents on the banks of the Vilyia.

But I knew that these thoughts belonged to a different world and that there was no sense in drowning in them.

Only Mother Superior, Maria, and one other sister knew of the presence of two men in the cloister. They had a special code of knocking on the door. While other nuns were visiting, the men had to hide under the beds or behind a small folding screen. The screen hid our covered chamber pot, which was to be used very sparingly since it was intended only for cases that the nightly visits to the bathroom couldn't solve.

The nuns shared with us their rationed food as well as the few vegetables that were grown on their own grounds. An old and very tiny sister was entrusted with the delivery of our cooked food. She was half deaf and used to speak with a very loud voice. Her aged mind was cloudy, which confused her enthusiastic conversation and made her utter odd observations. The two hiding men were often snorting with suppressed laughter. Their inopportune behavior made Yetta and Mother chuckle, and I, in

particular, found the situation hilarious. The old nun shared our gaiety with a polite smile. But her expression told us how amazed she was that people in the throes of mortal danger could always be in such an uplifted mood.

A few quiet months passed. The German occupation of the Soviet Union progressed. The local authorities started to seize various properties that belonged to the church. German officers were examining such premises. There was a good possibility that one day they would penetrate even the sacrosanct cloister where we were hidden. Mother Superior asked Father and Yasha to prepare a place for a temporary hiding that in such an event could hold us tucked away for several hours. She suggested a space above an unused room that was at the other end of our long corridor. The room had heavy beams and a wood ceiling above which a small attic, inaccessible from any other space, seemed to offer the appropriate solution. The men worked for several nights with the greatest circumspection, using only small instruments in order not to make noise. They created an invisible trap door that permitted rapid access to the tiny attic. A tall ladder was to be left in that room in permanent readiness. There were plans to equip the hiding place with water and some preserves of food. But a heavy snowstorm severely slowed down the city's life and made the job seem less urgent.

On two or three nights Soviet planes penetrated our area and launched a few bombs, lifting our spirits. Everything was not lost. But suddenly, early in the morning after the last raid, German trucks and soldiers with guns in their hands surrounded the convent. Sentinels were placed in front of all the entrances. Maria came running in panic. The Germans were accusing the sisters of giving light signals to the Soviet pilots. Mother Superior was trying to prevent the officers from entering the cloister, but the Germans carried a warrant that put all the sisters under arrest.

We were hurried into the room from which we had to climb into the attic. The ladder wasn't there. It had been removed on a former day to do some repairs. Father and Yasha rushed to bring it back before the Germans reached us. Precious moments were being lost and seconds seemed to last ages. But they returned with the heavy ladder just in time. Maria and another sister held its base while we climbed up. That sister must never before have heard of our existence, for she stared at us with a look of total bewilderment. Once the trap was in place the sisters had to remove the ladder quickly. German voices were nearing. Finally the trap was lowered. We were saved.

Presently when I think of how many times I stood on the brink of a precipice, as in a bad movie, I can hardly believe that such things were an everyday part of my life. Again and again I tell myself that the odds of surviving were much less than one in a hundred, and that ten improbable miracles were necessary for a person to survive. As I write this today, from a comfortable distance in time, I remain perplexed. I look back on these events with almost the same sort of disbelief that has so often been encountered by survivors, especially in the early years after the war. I know how much that disbelief hurt those who tried to tell: I was among them. Yet no wonder the tales were doubted. Ten improbable miracles were the minimal rate for survival. Nine miracles, if the tenth did not happen, were not enough.

The trapdoor was lowered, the ladder moved away, and we found ourselves under a very low roof of dark tiles that were set in an ancient framework of wooden rods and beams. Part of the floor contained old debris of broken tiles, wooden rods of various sizes, pieces of rope that must have been used in some former repair jobs and a large box of rusty nails. A heavy layer of dust lay over everything. The small roof was covered from the outside by a thick layer of snow that muffled the noise of shouting voices and moving vehicles that rose from the occupied courtyard. A tiny

window that was supposed to give some light was also covered by snow, and only a pale glow passed through its frozen surface. The dim light enabled me to look around. I was the only one able to stand upright in this tentlike space and that only under the roof's highest point. The others were bent or crouching. Two unfamiliar faces of young women looked at me. My parents seemed to know them. I realized that they must have been hidden in another room of the same cloister.

Luckily, at the time the panicked Maria alerted us, a snowstorm had created a shortage of wood, and the fire in our room's stove had died out, forcing us to wear all the clothes we could put on and to top them with our overcoats. These clothes now sheltered us from the attic's freezing cold. Our breath filled the space with clouds of vapor. We sat immobile on two heavy beams of wood. It was important to prevent the attic's old floorboards from creaking and transmitting the sound of our movements to the room below. It was easy to tell from the tumult downstairs that every corridor and room of the convent was filled with armed men. Was it a temporary search or a definitive expulsion? The accusation of collaboration with the enemy: Was it just a tactical threat or was it to serve as justification for a seizure of the convent?

Later we learned that the sisters were evacuated with incredible brutality and sent off to a labor camp. They were formally accused of collaborating with the enemy, a rather common excuse in those years for persecuting religious orders and confiscating their properties for military use.

But meanwhile, all we could hear from our bitterly cold little space, bent under the very low roof, was the sound of the German soldiers' boots, their sporadic singing, and sometimes the yelling of their orders. When the hours of the early night had plunged us in total darkness and the place became much more silent, Father risked opening slightly the trap door and listening more carefully to the few sounds that troubled the stillness. It seemed that a descent for the sake of exploration had to be

attempted. He had previously untangled several of the abandoned ropes, tied them with heavy knots, and fastened the whole length of the new cord to one of the beams. Some snow that he gathered by moving a couple of the roof's tiles let him moisten the old ropes in order to prevent them from shedding dust and marking the floor under the opening to our hiding place.

Father had worked on all this with great diligence, trying to finish the new cord before nightfall. What he was going to attempt would bring him back to years in which he had practiced exercises on parallel bars, rings, and trapezes. His athletic body was going to display its agility, not in a spectacle of physical elegance but in saving our lives. He opened the ceiling's trapdoor, which let in a very faint light from the rooms below. We held our breath watching his silent descent. He was back after a minute or two. The signs of the sisters' disappearance and the proof of a heavy German occupancy were unmistakable. We quickly closed the trapdoor and waited for the first light of morning. Leaning against Father's knees I melted some sooty snow in my dry mouth. It calmed my thirst.

It was clear that our island of safety had been shattered sooner than we could have anticipated. Now we were totally isolated in a freezing cold space, where we would not last for another forty-eight hours. We had no proper clothing, no food, and no water. We could reach out to some blackened snow and wet with it our lips, but that was all.

The two men clenched with the frozen tips of their bare fingers large rusted nails and started to scratch at the mortar that blocked an ancient opening in the wall of an adjoining attic. After a day and a half of work that had to be done in the most silent manner possible, several bricks had been removed and an opening let us pass to a second attic whose floor was considerably lower. Again Father's powerful arms performed the unimaginable. I was permitted to carry his overcoat, which was hampering his remarkable agility. We reached a third attic and then found

ourselves trapped by a heavy iron door. It was our third day without food, and the hunger and cold air made us shiver hard. Luckily the second and third attics were warmer, since tepid brick chimneys crossed them from bottom to top. We rested for a while, leaning against the rough bricks and letting their warmth calm our trembling. A late afternoon beam of light told us that the day was coming to an end.

Yasha figured out that the iron door that kept us from advancing must lead to a staircase of a building the church was renting out and was therefore not part of the seized convent. A window set high above the door opened into the shaft of the staircase. Again Father had to take off his coat and perform one of his miraculous exploits. Clinging to one of the roof's vertical beams, he mounted to the window's level, reached the sill, hoisted himself on it, broke with a kick the dusty glass, and opened the frame. He jumped down, and we heard him land on the other side. A short grumbling voice signed that he was all right, and the sound of his descending steps seemed to confirm that his legs were intact. We waited, suspended in a time that had stopped and in a state of paralyzed anticipation.

A key turned in the iron door. A small graying man was standing next to Father. It must have been the custodian. He looked at us with a puzzled expression and when he saw me he opened his eyes and his mouth, as if he wanted to say something important. Father hastily took his overcoat from Mother's hands and handed it to the baffled janitor. We passed him quickly. The staircase brought us to a street. We walked on the narrow alley's sidewalk, in the opposite direction from the convent's main gate that was blocked by heavy vehicles, without ever looking back. In the street some soldiers with rifles were smoking cigarettes. Other passers-by were absorbed in their thoughts. Nobody seemed to look at us. The alley brought us to a larger street. Ironically, we had to seek refuge in the ghetto as a place of last resort.

As if preordained by the same merciful fate that had led us to this very place, a group of Jewish men and women were walking in the middle of the icy road. Bundled up with scarves around their ears, huge padded gloves, and felt boots, they were coming from various work units that were spread across town and returning to the overcrowded streets of the ghetto. A glance in our direction made them grasp our dangerous situation as fugitives from some detected hiding place. We joined their group, and they rearranged their formation to shelter us inconspicuously between their marching rows. Seeing that there were no yellow stars fastened to our clothes, several of them undid the ones they had pinned to their jackets or dresses under their heavy overcoats, and handed them over to us. We arrived at the ghetto and luckily passed through the gates without being arrested.

We walked through a street that was swarming with people. Mother looked at Father with a great deal of concern.

"Look how you are trembling, Why did you give away your coat?"

"I had told the janitor that we were fugitive priests and sisters who had disguised ourselves to escape the Gestapo's grip. But when he saw Samek———"

"You should have mentioned the Immaculate Conception."

"Thanks. Next time I'll leave our negotiations to your special gifts of argumentation."

The ghetto was to house us for many months. Now the convent again belonged to another world, forbidden and far away. Nevertheless we were elated. We had had another narrow escape.

* * *

Our arrival at the ghetto coincided with the end of a series of murderous actions by which the Nazis had destroyed half of its enslaved population. Being hidden in the convent during that horrendous period was in itself miraculous good luck.

It is not my intention to relate the history of our ghetto. Historical documents, authentic diaries, and excellent books published over several decades have done it in a most exhaustive manner. Just the night in which the ghetto was ordered to deliver unto the hands of his executioners the partisan Vittenberg, a sleepless night that had seemed to me to be our last, is material for a complex book, a drama, or even better, an opera. And there were many other dramatic events whose echoes shall forever resonate in my memory.

But our immediate concern was finding a place to sleep and some food for our empty stomachs. What did the boy in me observe? An outline of occurrences that began with the emotional moment in which we reentered the ghetto and met in the street with Vera, Uncle Yasha's mother. A changed person, aged, worn out and shabbily dressed, no more the elegant and haughty grand dame she used to be, she fell in our arms. The last days that preceded the ghetto's liquidation sent my uncles and Vera to the death camps and us to the HKP. Between these two events my parents changed our temporary domiciles a half dozen times. Mother became employed in the accounting offices of the Judenrat. Father was sent to work in a welding unit on the outside. An acquaintance of Father, a ghetto policeman, helped us to get our last and more decent lodgings. It was also there that I met my beloved teacher Rokhele, and the two poets who by showing my drawings in an exhibition turned me into a small celebrity. I have tried to tell about them in the chapter dedicated to the old *Pinkas*. It was there that I described my escape from the HKP camp and my arrival at Janina's home, the port from which we would depart toward our most apprehensive explorations, and unexpected dénouements.

FROM THE BRIDGE

This story begins on March 28, 1944, the day that has followed the children *aktion*.

Hidden under our cell's bunk I lay in expectation for a sign from Father. Meanwhile, Mother, in Janina's house, was anxiously awaiting the housekeeper's return from the mission to bring me to her.

Janina was suffused with mounting dread. In spite of an unfaltering belief in the help of God and of all his saints, whose benevolence she never questioned, she faced a deeply disturbing problem. To find an adequate hiding for a Jewish woman and child was becoming increasingly difficult. Lithuanian police and German authorities had unearthed many of the hiding places that had previously sheltered Jews. The executions and the severe punishments they inflicted upon both those who hid and those who hid them had badly reduced the number of possible choices. By the time I finally arrived in her home, we still had no prospects. Mother's desperate embrace conveyed to me something of our situation's hopelessness.

Janina's housekeeper, the Christian woman who had been sent for me, was relieved to hand me over to the two anguished women and expected Mother and me to depart quickly now and disappear from her life. She had been told that her involvement would be brief, her risk small. She must also have received a substantial reward. She had been cool at first but was now filled with soaring anxiety. We represented real danger. She started to imagine that hostile neighbors were becoming suspicious. Not

only could they jeopardize Janina's and her two boys' lives, but their denunciation could implicate the housekeeper too. She saw in us such a source of trouble that she began to regret her part in my rescue. The panicking woman had to be solemnly promised that we would very soon be gone. Inevitably Janina's trust in her waned, and in order to calm her, she finally told her that we had already left.

Unaware of the situation that she had created, the woman had us in her grip. Not only was it impossible to reduce the hours of her work, which might have aroused suspicion, but to send her away and turn her into an enemy was unthinkable. Whenever she was in the house, Mother and I had to hide in the attic's small mildew-infested closet.

We had to be very careful. She was a vigorous and enterprising person. The slightest sound could send her up to us, armed with a broom to chase the suspected mice. Meanwhile Janina searched a shrinking terrain, and our hope dangled by a thread.

Aunt Janina's last few venues had to be approached with utmost care, and they took time. Any false move might have irremediably exposed her to the authority's watchful eye or to the vengeful blackmail of the habitual profiteers. We could see her only in the evenings, when our descent from the attic permitted us to eat and to refresh ourselves. She looked more and more worn out. Her strained face showed the painful pressure of our incriminating presence. It could hardly boost our morale. There remained in the end only one option. Somebody gave Janina the address of an old woman who had been hiding a Jewish mother with her small daughter. For unknown reasons, mother and child had left. Had they suddenly run short of money to pay her? The woman was notoriously greedy.

A name of a street and a house number were scribbled on a piece of blue paper.

"We shall go there and we shall remain, whatever the nature of that person and whatever the conditions," said Mother. "Since it is the only

choice left, it will have to work. Let's go." Janina looked somewhat relieved. Later in the same afternoon we left for our new place, accompanied by my great-aunt. It was important to choose that time of the day when a mantle of diminishing light would cover us. A large cap belonging to Janina's younger son hid my dark head while Mother's blond hair was left well exposed. We had no papers, but some food stamps of the current rationing, bearing Christian family names, had been put in our pockets. For once I was walking on the Aryan side of town without a star—and on the sidewalk instead of in the gutter. It was a long walk. We had to cross a bridge over the growling waters of a river newly risen from the heavy rains and thawing snow. My hands were gripping the hands of the two women, and my look was focused on the paving stones. Whenever an army vehicle or soldiers on a motorcycle passed us by, my breath came fast. Finally we reached a courtyard of a very old house.

Some of its mortar had fallen off, probably in an air raid. Such raids had become frequent. Following the regime's rigorous orders, the windows of the dark, unlit staircase were masked by black paper. We had to mount to the fourth floor in total darkness. The light of a match confirmed to us that we had found the right door. Janina's knock provoked the sound of steps. A croaking voice interrogated us. The door, held by a chain, opened slightly. A tiny emaciated hand reached out for the paper on which this address was written, a precautionary measure for which we were prepared. Finally we were admitted. The house was chilly and suffered from the rancid smells of cooking, of smoke from a bad stove, and of old floor wax. These in turn were mixed with an overpowering odor of cat urine.

The elderly woman who admitted us was short and skinny. Dressed in a widow's tight-fitting black coat she wore thick glasses, giving her face the strange look of an owl. She seemed very practical, lost no time. First, she asked to see the money to pay for her service. Janina opened her bag

and showed it to her. Silently the woman opened the hall cupboard and pushed aside the several coats hanging on its bent rod, revealing a secret door leading to a small closet. Inside there was no opening for light or air. The cracks in the wood had to suffice. An old mattress of a child's bed covered the entire surface of the floor.

"That's it. I know it's small. But you can come out at night and use the bathroom. I shall provide you with food. Cold stuff only, which I shall have to buy on the black market. And as you well know that costs a bundle. You wouldn't expect me to feed you with my rationing cards, would you?"

My eyes were following a gray and balding cat whose belly almost touched the floor. Mother glanced at Janina and again at the tiny hole that was being proposed to us. The woman turned to me. "I am happy to see that you are a courageous little man who will take good care of his mommy. I hope that the two of you are not ridiculously afraid of mice, because frankly we have a problem. My tabby is very old, and alas not much of a hunter. The mice have become much bigger. Lately he has become afraid of them. It is a real affliction. Before your coming, I had here a woman with a little girl. They gave me a lot of trouble. They could not control themselves. Whenever they saw one of those unwanted visitors with long tails", her malicious eyes focused on me, "the women screamed, and especially the spoiled little girl. It became dangerous. They had to leave the place. They even invented a story of having been bitten . . ."

"Thank you very much," said Aunt Janina. "Since we have two other proposals to examine I shall let you know." The woman lifted her shoulders as if to say "you know best."

Mother did not protest. We rushed down the pitch-dark stairs, clinging to the rail as our sole guide. We were in a hurry to reenter Janina's house. Suddenly her attic looked to me much larger and much more comfortable than before. But it was a very transitory solution, and it could not

last. That evening was quite silent, so we slept as usual on the first floor but dressed and with our shoes on. Wakened in the middle of the night by the sound of heavy trucks passing and repassing the neighborhood, we hurried back to our attic. The next day brought from downstairs the housekeeper's noisy chatter. She was speaking of police raids in the vicinity. The Germans were after young Polish partisans. This suburb was near wooded areas, and the police vehicles were constantly circling it. Afternoon brought back the silence. The housekeeper was away, the boys were out, and Janina must have been queuing up for a distribution of rationed food. No one was in the house. We came down. Mother reached for her coat. "Come," she said. I followed blindly.

Many years later, a year or two before Mother's death, the two of us were sitting on the sunny terrace of my home in Israel. It was a warm summer day, and the leisurely hour made us recollect old times. In the garden my girls were playing hide-and-seek. The accomplishments of the present were measured against the flimsy chances of surviving the fateful moments of our past. We were blessed with extraordinary luck. Suddenly Mother had a confession to make. She had to tell me about that "sudden" departure from Janina's home. Although I already knew about it, having once overheard her sad tale, I was very moved by her readiness for the present revelation. Her objective, she said, had been to reach the nearby bridge and from there, with me in her arms, to jump into the rushing waters of the river. To put an end to her loneliness and despair, she was ready to kill us both. At that time of the year, the Vilya was streaming with great power, carrying chunks of ice, broken trees, and dead animals. Had she been alone she wouldn't have hesitated. But the idea of causing my death had paralyzed her. Unknowingly I saved her life.

Let me return to the desolating spectacle of the river's floating debris and the long moment spent on that bridge. Mother is leaning against its railing. I have no idea what is going on in her mind. Her presence has

infused me with a sense of security, and my observing eyes are merely reg-istering data. She is immobile and her eyes are fixed on the reddening horizon. The day begins to darken. The sirens announce curfew. In the distance a few passing figures accelerate their steps, but we do not move. She puts her arm around my shoulder and holds me fast. I wonder why we are waiting, since at any moment a German patrol will appear.

Suddenly her hand seizes mine and we run, the sound of our running feet mixing with the warning sirens. Other people are hurrying to reach their homes before being shot for breaking curfew, but we have no home! We are still running. A few more alleys, a narrow passage along an ancient wall, and we stop in front of a small door. I hear the resolute banging of Mother's fist.

My daughters' voices return me to the present. Mother is saying, "As I was bracing to jump, a thought flashed through my mind, like a sign. Aunt Janina had mentioned that Sister Maria might be back at the con-vent, the one seized by the Germans while we were still in it. You must remember Maria. She was the nun with the round face. You used to like her a lot.

"Well, Aunt Janina heard that a few sisters had been released from the labor camp to work as cleaning women and were encouraged by the church to keep an eye on its property. The convent had become Rosen-berg's headquarters [the Nazi headquarters for collecting the archives and documents of conquered territories]. The presence of Germans made it dangerous, and Aunt was afraid to contact the sisters. But my desperation gave me courage. I realized I had nothing to lose. The faint hope that we might find a nun who'd shelter us held me back from the railing. Who would suspect that Jews were hiding in a German army facility?"

Mother's banging on the door brought to us the sound of steps on the cobblestones. A small, bent, seemingly elderly woman, clad in drab gray working clothes opened it. Her graying hair showed from under a dark

scarf. She let us in and closed the door. All of a sudden she stared at us disbelievingly and with a yelp enclosed us in her embrace. Then her hand flew to her mouth: "Whisper, please whisper." This was Sister Maria. So very different from the one I remembered from earlier days. Where was her habit, the beautifully starched architecture of white and black cloth that used to transform her into an unearthly creature? The past two years had changed her face incredibly. Only the light remained in her eyes. Quickly locking the small door behind her, she led us across a small courtyard cluttered with crates of various sizes and a heap of discarded convent furniture. We entered a small room that was directly accessible from the yard. The place welcomed us with a familiar scent of days gone by. I took off my cap. Dangling from a vaulted ceiling, a feeble lamp threw a pale light on ancient church benches. Maria stroked my hair and asked us to wait for her. A few endless minutes passed and she was back, carrying dark bread, a jar of a butterlike spread, and a pot of steaming chicory coffee. "You must wait for me again. I shall have to lock you in. Don't be afraid, it's only a precaution. Don't make a sound. Give me a quarter of an hour, not more."

When the door opened again, a more upright Maria reentered. "I might be able to help you. But we must wait patiently for the darkest part of the night."

She was back after two hours, this time accompanied by three men. They wore threadbare dark clothing, and their feet were clad in strange slippers made of rough linen. One of them, short with glasses and a round head, approached Mother with a signal as if he knew her from before. He whispered into her ear a lengthy explanation. Maria gave me a sign with her finger on her lips to keep quiet. After a few minutes, they gestured for us to follow them. Maria, who was to remain behind, said, "We shall be seeing each other. But before leaving you must take off your shoes. Carry them in your hands."

We went through a couple of doors and came to a long and vaulted gallery that served as corridor for a good number of rooms. A weak flashlight showed us the way, its incandescent circle revealing an unexpected landscape. I could perceive thousands, perhaps hundreds of thousands, of volumes, mostly in covers of old linen, piled up in many layers against the corridor's ancient stone walls. It was a grotto of bound documents, leading to a maze of still other book-filled rooms. We followed the men through a narrow canyon between two high-piled ridges of books in a chaos of hues and sizes. The somewhat unstable stacks reached to the ceiling. Some of the volumes were enormous. The spines had been marked by numbers and by Cyrillic letters. The closer we came to the end of this corridor, the more we had to climb over fallen bindings that littered the floor. We walked uphill, stepping on hundreds of volumes. Finally we stopped in front of a huge wall of books. At the level of my knees there was a small opening into which we were told to crawl.

Later, when I was on the other side, it became clear to me that this huge partition of books had intentionally shortened the very long gallery. Behind a wailing wall of looted manuscripts, in a secret space made from a small slice of the corridor's last section and of the last room to which it led, several survivors of the liquidated ghetto had formed an ingenious shelter.

But before we could crawl through the very narrow tunnel that was the secret entrance to our future hiding place, a large number of volumes had to be placed on a few ends of rope and carefully stacked atop a little shelf-like step that surmounted the narrow opening. These precarious towers were ready to collapse as soon as the rope was pulled from the other side of the tunnel, causing a big heap of books to fall and mask its secret opening. The tunnel itself was braced so that the additional layers of books filling it could be removed to allow passage and then replaced to hide the entrance. In case the fallen books should be suddenly removed,

the filled tunnel would still give the impression that it was holding all the heavy load of the upper layers.

We were soon to learn the history of our new hiding place. The former convent housed the notorious looted archives of the museums and institutes belonging to towns that had fallen under German rule. Trucks loaded with confiscated riches arrived daily to be unloaded in the ancient building's courtyard. There the nuns, dressed now in civilian poverty, met a number of Jews who were sent every day from the ghetto to carry and pile the thousands of volumes, documents, and rare books that filled its rooms and corridors.

One small group of them created a hiding place for the days that they foresaw would follow the final liquidation of the ghetto. The evening Mother and I arrived was a few months after that liquidation. Three Jewish families were now living buried under the books. A whole set of inevitable rules and regulations had become their second nature.

Sister Maria and Father Stakauskas, a Catholic priest and former professor of history who was employed to supervise and sort the looted material, were providing the hidden Jews with food and other necessities. Had the authorities discovered their selfless acts, they would have been tortured and executed. Their courage and devotion went beyond anything I have ever encountered. It was Maria who convinced the group in hiding to take in a woman and a child. She explained to them our state of total despair. Sending us back would have meant our death. The nine people had a hard choice to make, and they vacillated, as clearly we would take up a part of their space as well as some of the very limited portions of available food. Moreover, a few of them were afraid that our presence could increase their chance of being detected. But Maria made it clear how much she cared about us. The group could not afford to alienate her. All this came to our knowledge only later, but it provides one more link in our chain of miracles.

Accepted as part of the group in hiding, we were "initiated" by being made to put on the special linen slippers. They were made from the fabric of old bindings and everyone wore them in order to avoid the slightest noise. Speaking was strictly forbidden. Sneezing or coughing had to be done in a special place and in a manner we had to learn. Silence was essential. It was true that the thick walls of the medieval building were supposed to absorb a lot. But one never knew. Above our room the head-quarters was packed with Germans.

The large former dormitory that housed us had a vaulted ceiling, its irregular and cracking mortar sealed with whitewash. Both windows were covered to their last windowpane by a thick wall of books rein-forced by two heavy wardrobes. These in turn were filled with additional volumes, to shield us from stray bullets and the splinters of exploding artillery shells. Aside from these, the furniture consisted of volumes and volumes of the bound documents that packed our living space. The beds were platforms made of books, and the table and chairs were the same. It was a crazy paper fairyland that sheltered our new extended "family." It consisted of a physician with his wife and daughter, a historian and an engineer with their wives and the mother of one of them, and a single eld-erly teacher. The relationships among the various members of the group were complex, but a common desire not to exasperate the already high tensions of such forced intimacy assured a polite veneer that on our arrival was already well established and properly oiled.

Since we could only whisper in each other's ears, conversations were minimal. The historian was thought to be a Communist, the teacher a revisionist of the right, while the doctor was comfortably middle class. A bon vivant by nature, married to a daughter of one of Vilna's finest fami-lies, he had little in common with the other men. The engineer and his wife were taciturn. One would have expected a social leveling and an ide-ological tolerance, but this was not the case. Perhaps the dire conditions

of life, and the struggle for survival at any cost, had reinforced in them their different identities and beliefs as a way of maintaining their self-respect. They welcomed Mother and me by setting us up on a newly erected platform of bound documents that was to serve as a bunk for sleeping. They called those volumes "Acts" because they recorded the lives and deaths of thousands. They were more than a century old. They came mostly from the Kiev police of the czar and dealt with interrogations of illiterate peasants accused of helping political prisoners. The historian pointed this out to us with some pride in his long-dormant expertise. He and his wife had chosen to sleep on hundreds of eighteenth-century folders of documents that dealt with sales of the larger properties of Minsk. Those properties included "souls" for sale, the extended families of farmers. Our historian worked on a long paper concerning the horrendous conditions of life of the enslaved peasantry as his way of killing time.

We used to see Maria every night. She would knock lightly on a wooden beam, three knocks that were the sign for us to dismantle the bundles of books inserted into our tunnel. She always came with some food, some necessary medications, and, most important, with good news that the German armies were losing on all the fronts and that the days of our ordeal were numbered. Her optimism and her courage nourished the energies that were vital for our survival. Maria's responsibility for the nightly cleaning of the Rosenberg headquarters enabled her to check them out carefully and to reassure us that no one was there to detect us. Our clandestine passage through the pitch-dark corridors and the clogged galleries led us to the toilets and the quick shower that each of us was allowed to take in turn. Our food was simple. It consisted of the usual wartime dark bread that contained a large amount of sawdust and tasted like wood. We would cover it with an unidentifiable oily spread. When the upper offices made their stoves work, we were able to light ours. Its

smoke would join theirs and fly away from the same chimney without arousing suspicion. Hot chicory coffee, tea, or quickly made noodle soup would give us a lot of pleasure.

Father Stakauskas, in the eternal dark gray trench coat that must have replaced his robe, used to visit us once or twice a week. Graying blond hair fell over his bright smiling eyes. In his old black leather case that was stuffed with papers, he brought some hidden carrots, a few dried fruits, or a piece of cheese. But his main contribution to the boosting of our moral was his summary of the BBC news. A village friend allowed him to listen to a clandestine radio in the basement of his barn. The Germans were retreating on all fronts. A map of Europe of my own making and movable little red flags indicated to us all that the Third Reich was shrinking. It was a question of a few weeks or maybe a month or two. We had to hold out. The intensification of Soviet air raids confirmed our hope that the end was nearing.

Maria brought us news from town. The fires caused by recent bombings had unearthed several hiding Jews, who were summarily executed. We had never been more tense. Mother tried to get news of the labor camp, hoping to find a way to communicate with Father. But all the others of our group put a definitive veto on her project. It was too dangerous. It could have exposed us. She was shattered.

One night I woke up feeling the strong start that had torn Mother from her sleep. I listened to her breathing and felt that she was silently crying. "What happened?"

"A bad dream. I saw your Father. He was waving to me with his hand. A huge black X covered his chest. I felt that his life was taken away. But it was only a dream."

The days were more and more shaken by the sounds of the nearing front with its thundering explosions and tremors. Some windowpanes flew out above the wardrobe that was supposed to protect us; a few

stacks of books were blown away; and splinters of a shell imbedded themselves in the window's vault. Army trucks were still packing up officers and matériel, and the courtyard was swarming with febrile activity. We tried to find shelter beyond our tunnel, in the large gallery of books—first under a staircase, then in some closets—but unfamiliar voices made us rush back in panic and hide in a corner behind our own wall of books.

The Germans did not leave Vilna without fighting for every street and house. The noise of planes, artillery, machine guns, bombs, and mines interrupted the never ending sirens. It seemed to me that the end of the world had arrived. Then came an unexpected lull in the terrible noise. We had not washed for days, our clothes were gray with dust and debris, and all our bones hurt. We stretched and reentered our former room. There was a good chance that the Germans had left the building. Should we risk lighting a fire to make a warm drink? The group was pondering the move. I was on our bunk; Mother, two steps away. Suddenly a frightening blast and I was covered with more dust and splinters of wood, stone, and mortar. Luckily, I had lowered my head in time and Mother was on the floor covering her head with her hands. I looked up. The wall over my bunk had just been pierced by a number of bullets.

And then came the big bang. A part of the building on the outside crashed down. The shattered window blew out completely, creating a large opening to the courtyard. Smoke started to penetrate from every direction and with it the voices of people shouting, evidently the voluntary firemen from the neighborhood. Their chief was known to have recently discovered a Jewish family in hiding and delivered them to the Germans. Men whom I had never seen before were screaming and gesticulating, pointing at the various fires that were spreading in the yard. They stared at our terrified group with bewildered eyes. We were paralyzed by panic. It was clear that we had been discovered and that this was our end.

What an absurdity! On the very last day, when the liberating army would arrive in a matter of hours!

The chief of the firemen yelled at his subordinates, "Keep guard on those dirty kikes. I'll get the Germans. "

He had taken a few steps in the direction of the courtyard when another round of machine-gun fire dropped him to the ground in contorted convulsions. His bleeding hands were clutching his intestines. The men left us and ran to bring him help. Framed in the opening of the shattered window stood Sister Maria. She must have been praying. Her hands were making the sign of the cross. Had she been there all the time? With a sign of her hand she told us to hurry and find a new shelter. Another day and it would be over.

Indeed, on the next day Mother and I ventured to make our first steps in a half-destroyed, smoking city, vaguely the Vilna we remembered. It belonged now to the Soviet Union.

IN RED VILNA

The great offensive of the Red Army to recapture Vilna began on June 23, 1944. By July 13, the city was in their hands.

Vilna was in shambles. Many of its frightened inhabitants were barricaded in air-raid shelters. Some hid under sturdy flights of staircases; others on ground floors, behind walls of piled-up sacks of sand. Sporadic shooting was still heard, but the clouds of black smoke that had been floating over the city's many fires began to dissipate. People came out from their hiding places. The dead were removed from the streets and buried. The charred tanks together with many carcasses of other vehicles disappeared. Since convoys of troops and heavy caravans of equipment required unobstructed roads, the rubble of the bombardments had been quickly pushed to the side. An embattled front raged not too far away.

Newspapers in Russian, Polish, and Lithuanian were being pasted on walls for people to read and learn from. They contained specific orders about hours of curfew, food rationing, and other new regulations for our daily life. Anyone who broke the law would be severely punished. The papers brought news about all that was going on in the world and on the fronts and told us how to interpret and understand them. The Allies were still struggling to subdue the Nazi beast and its associates. Huge portraits of Stalin, and some smaller ones of his heroic generals, were placed all over town. These supernatural heroes looked upon us with a gaze of trustworthiness and benevolence promising a prompt victory and a

future of peace. From the Soviets' former occupation I remembered that the covenant between the bearers of the red banner and their "Great Communist leader" enthusiastically spoke about an attainment of perpetual bliss.

Aunt Yetta too had miraculously survived, and her return with my five-year-old cousin Tamara sparked in Mother an explosion of unexpected energies. Now, together with them, we were a small family of four. Father had been killed, but the fate of Tamara's father, Yasha, was still uncertain. News of his death would reach us later. In our small family Mother became our breadwinner, and Yetta took upon herself the care of us, the children. For a while we went on living in Aunt Janina's lovely house, but as time passed it became clear that we had to move closer to where Mother had found employment. Having a steady job was an important asset but getting there was a problem. Public transportation did not exist, and her daily walks from our green and lovely suburb to the city's center were exhausting and dangerous.

We had been liberated and the Lithuanian Socialist Republic reborn, but in the west the battle that raged on many fronts was slow in coming to a resolution. Vilna's civil population was exposed to the usual hardships of wartime: lack of water and electricity, shortage of food, and harassment by a police in constant search for dissenters, deserters, or hidden arms. Although the Red Army was pushing to get to Berlin, German air raids still occurred, bombs fell, and the struggle among the various factions of Polish partisans brought acts of random terrorism. Other dissenters targeted the military and their equipment. Lengthy curfews paralyzed our lives. Finding a proper lodging in the city center was difficult, next to impossible. The newly appointed civil administration as well as the military had quickly confiscated hundreds of buildings, among them our former home. Thousands of people had been thrown into the street or lost their homes to bombs and fires. All searched for shelter. Houses

that because of extensive damage or deep cracks had been considered dangerous and were barred from access became our only prospect for lodging. Not all were properly guarded, and those that were not were being seized by refugees.

Mother's current boss was aware of our need for lodging in the center and made good use of his connections. Thus our little family settled in a pleasant, light-filled room, whose large windows were miraculously intact. They opened on a small and tranquil courtyard partly in ruin but embellished by a living tree. Our new place had a little kitchen and even a waterless bathroom. The rest of the flat, of which we occupied only a small part, had been too badly damaged for use. Its rooms had no window frames, the doors had been blown away, and pieces of broken furniture were strewn on a parquet that was full of holes. It was fascinating how much of the lower floor one could see through them. In a defunct music room stood an old piano of unknown origin, whose lovely inlays of precious woods had hardly been damaged. It must have been too heavy for looters. Now the four of us, with a lot of effort, rolled and installed the piano in our new room, instantly bestowing a cachet of elegance. There was no electricity, water had to be carried from the yard in buckets, and the place had many other defects, but it was heaven to us. Weren't we blessed to have the support of Mother's boss, our priceless protector!

Our good fortune was imbedded in a chain of lucky events. Shortly after our liberation it had become clear that no private or public organizations would take care of the few Jewish survivors. A Communist regime could not tolerate private groups of inter-aid, and the public authorities ignored our needs. We had been liberated from the danger of death but were hardly capable of dealing with life. In order to subsist one had to work. The Soviets had no place for "social parasites." Little did it matter that many of us were badly shaken and that our recovery took time, or that employment of any kind was scarce. In spite of all this Mother had

found a job in a state-owned food store. Its management was looking for someone to fill the little-coveted position of charwoman, and Mother seized it. This was the first link in our chain of good fortune. Since the rationed food was given out very sparingly, her idea of placing herself close to a source that distributed comestibles proved excellent. We did not have to wait in line, and we could redeem our rationing cards advantageously. Mother's employers liked her and sometimes took advantage of her knowledge of bookkeeping.

The general population was starving. Whenever there was a distribution of bread or other basic foodstuffs, frustrated and angry civilians formed interminable lines. People stood in them for hours, pushing and even coming to blows, often leaving empty-handed. It was the sad pattern of ordinary life in any wartime. Inevitably, a black market would soon flourish on this grim reality. For the four of us, the prospect of a black market was a hidden time bomb. It jeopardized Mother's job and thus our future.

Yet when Mother first found this job she deemed herself the luckiest of women. Soon after she had begun her demeaning cleaning work, the store was upgraded. It became exclusively reserved for the heads of the secret, and less secret, police as well as the top officials of the Lithuanian administration: all in all about one hundred customers. Its empty shelves suddenly filled with an extraordinary choice of goods—Russian vodkas, French wines, German sausages, all sorts of hams, and beer. Simultaneously Mother's position was upgraded from cleaning comrade to assistant bookkeeper, and from there to chief bookkeeper. In no time she was assistant manager. The choosy customers were mostly wives of the upper echelon. As noted before, the general public was famished. Even the soldiers on the front were hungry, but this did not concern the privileged class. This state of affairs amazed me. Where were the basic ideas of equality and justice that theoretically grounded the Communist society?

It was clear that Mother's patrons had views that hardly reflected such ideology. For them it was important to get and keep all they could for themselves. Impractical ideas of egalitarianism had to be preserved in their theoretical purity as beautiful slogans on billboards and inspiring captions in the official newspapers.

Mother, who tried to help me understand this paradox situation, apologized for turning me, at my age, into a cynic. I wondered what this word "cynic" meant. Her concluding advice was that I keep her reflections to myself. To be frank, these dilemmas hardly affected our small family. We had plenty to eat and that was wonderful. But there was a problem. The higher Mother was raised in the hierarchy of responsibilities, the less well she slept. Her direct bosses changed frequently. Often they disappeared, and the others who came in their place would later be arrested on real or imaginary charges. The most common accusation was black marketeering. Pointing a finger and saying the ominous words "black market" amounted to pointing a gun. In reality the unlucky bosses were succumbing to ongoing struggles for power and influence. From the lowest to the highest echelons, people battled to survive and walked over living bodies.

The authorities' decision to keep Mother's workplace running smoothly assured her a relatively stable position. Being number two was better than being number one. But for how long? She realized she had to plan a way of retreat. Too many of the people she dealt with, even in modest or unimportant positions, had suddenly vanished. I vaguely remember some of their smiling faces. When I was introduced to them they would stretch out their hands and gently touch my head. They must have ended up in what is known today as the gulag archipelago. All we knew in those days about deportations was that people were sent to work in Siberia. To me it was an obscure name with little meaning. Absorbed in the exploration of my own world I was hardly aware of Mother's anguish about how to safeguard her breadwinning position.

This was our situation when a new distress descended upon her, and it came from a different direction altogether. Suddenly there was the fear that I might be taken from her, sent to Moscow, and placed in a special school for gifted children. The idea had been aired by a few well-meaning friends and gradually grew to become a grave concern. Would she lose me? It was an unacceptable idea, but there was no way of knowing. At the root of it were Avrom Sutskever's published reports about the German crimes. He had temporarily put aside his pen of poetry and written bleakly about our life in the ghetto. He described it in its most harrowing as well as heartening moments. His public of readers in Soviet Russia added this weighty prose to the heavy load of other testimonies about the Nazi atrocities. Two hundred of his pages would appear in Ilya Ehrenburg's *Black Book*. My story appeared among Sutskever's lighter chapters that were intended to soothe devastated readers with a few happy endings. Jewish writers, poets, artists and readers of Yiddish began to speak about a nine-year-old "prodigy" from Vilna who had managed to survive. My relative fame, which was evolving far from where I lived, now offered an unforeseen threat to Mother's determination to keep me at her side and her secret resolve to escape this Communist paradise and depart to the Promised Land.

Peretz Markish, the most famous of the Jewish writers in the Soviet Union, holder of the prestigious Order of Lenin, had come to Vilna. A welcoming ceremony, in which I had to participate, corralled around him all the city's Jews. One could not imagine that this handsome man with his imposing mane of hair would one day be among the victims of Stalin's madness. Markish, speaking to Mother with satisfaction and pride, informed her that an order for my transfer to an exclusive institute of "geniuses" was on its way. It was a school for the greatest talents in music, chess, mathematics, and fine arts from all of the Soviet Republics. The heroic war might have been slowing the administrative process

(military orders having priority over civil needs), but the decision to place me in that school had been taken, and the papers would soon arrive. In a few weeks, at most in a few months! He embraced her and heartily congratulated her, and the blood froze in her veins.

Mother knew that the civil administration of the Soviet Empire was very slow. This was an advantage that allowed for some hope. She expected such a nonessential order, concerning the fate of one little boy, to get stuck in the immense labyrinths of the Soviet burocracy and hoped that at least a year would pass before such papers arrived into the hands of the local authorities. By then the war might be over, and a timely emigration would distance us from the unfortunate initiative. The famous writer brought me not only the promise of admittance to the prestigious school but another, more practical, and much more auspicious gift: a pair of thick woolen socks. I was overjoyed! My old socks—many times mended—had become bulky, and it was difficult to squeeze them with my growing feet into my old shoes. But the new Russian socks revealed themselves to be a poisoned gift. I could not tolerate them. They were unbearably itchy. I had to tear them off my feet and cast them away, together with the Soviet Union's disturbing plans for my near future.

Meanwhile life went on. Soon after the liberation I tried briefly to attend an improvised Jewish school. A couple of teachers attempted to give to Vilna's small number of Jewish children a vague idea of Yiddish grammar, some mastery of Russian, and an introduction to Lithuanian, our Republic's official yet little known language. The new Soviet-Yiddish spelling, which had been cleansed of all dependence on classical Hebrew, looked to me impractical and weird. The small school, installed in an old and dusty flat, bored me, and since we were secretly planning to leave anyway, Mother and I agreed that instead I should work on my art. Her decision that the study of art was more important than a mediocre basic

education would be often repeated in the future. She launched a search for an appropriate teacher.

In the beginning there was the very distinguished Mr. Makoynik, with his rimless glasses and an endless collection of frayed bow ties. Makoynik seemed to belong to other times. We were months away from the end of war. The battle was still raging a hundred miles from town, and from time to time we had to seek shelter from air raids. Impervious to the howling of sirens Makoynik would lecture me about the roots of civilization and the pre- historic origins of art, and in particular the importance of Greek drama and stage structure. He spoke of the unity of time and space, and I realized that he would never teach me to paint an apple that looked like an apple.

Then came the sweet and slightly spinsterish Professor Serafinovicz, with her angelic name and manner. She lived in a very large room, an artist's studio that was cluttered with numerous canvases, hundreds of books, all sorts of knickknacks, and a large player piano. She thought very highly of me, and I in turn became very devoted to her. To demonstrate her ability she painted my portrait in oils, for which I had to pose in a state of excruciating immobility. She portrayed me peering from behind a couple of flowering branches of an apple tree. "A young artist in blossom," she said. When the painting was dry and varnished she made a gift of it to Mother and me. Although something in this portrait troubled me, I cherished it for the sake of my beloved teacher. Sadly, I lost it on one of our wanderings, but this belongs to a later story.

I would spend long hours in Professor Serafinovicz's disorderly lodging. Bent over a sheet of sketching paper, next to a warm stove, I would work on charcoal studies of ancient friezes. At other times I made drawings of broken plaster casts. The casts came from a wing of Vilna's academy of fine arts that had received a direct hit, and my devoted teacher had with her own hands picked them out from under heaps of rubble.

These casts, separate parts of the human physiognomy, might have represented what happens to a human body in a bombardment. But that was not why she had me draw them. It was a basic exercise, tedious but indispensable. It was meant to teach an aspiring art student how to measure proportions and render light and shade correctly. Many years later, in the early seventies, these abused fragments reentered my art and filled many of my canvases.

After these sessions I would rush back to our room and cover pages on pages with free- flowing watercolors. I painted whatever surfaced in my imagination: landscapes, objects, figures, and people's faces. I tried working from reality. My little cousin Tamara did not know how to sit quietly, but my Aunt Yetta posed for me willingly. The walls of our room became covered with the outpourings of my art. These works, together with our essential furniture and our few belongings, as well as the four of us, Mother, Yetta, Tamara and I, were all being guarded by new angels.

The angels were no fantasy of a boy of eleven but a concrete pair of dark bronze female figures with expressionless faces and raised arms holding branches of highly decorative leaves. Both had large open wings. Each angel was perched on a perfectly smooth sphere of black marble that rested on a golden rectangular base. These angelic guardians were two candelabra. Now they towered over the old upright piano whose few missing keys gave it a toothless and weary air. The spent instrument served them as an altar and found in this its best use. A young musician who was supposed to teach me on it confirmed its inadequacy. Besides the missing notes, the piano sounded as if it were afflicted by a terrible cold, and the musician who tried to play a Chopin nocturne on it swore profusely, declared the instrument unusable, and left.

The candelabra were the only remaining memento of the family riches of Aunt Yetta's husband. The prewar Yasha had been the only grandson of a wealthy man and son of an overpowering mother; he was a charming

and slightly egomaniacal person whom some found snobbish. His care-less behavior toward his young wife, especially during her very difficult pregnancy, made my parents quite critical of him. But time changed their opinion. I too learned to love him, and looking back I esteem many of his qualities.

I can still see the receding line of Yasha's well-groomed curly hair, his narrow face divided by a thin and longish nose, and his drooping eyes. His front teeth overlapped, and this fact troubled me; I expected them to move. I was also enormously impressed by his abundant body hair, a real fur. When in the summer, on the beach along the Vilyia, he spread on himself a pungent cream that was supposed to remove it from his skin, everyone ran away. Proudly, I was the only one to hold my nose and keep company with this smelly uncle of mine. His family's fortune was rooted in a not-too-distant, but rather shady, past.

In the months we spent enclosed in the same room of the convent, I learned to know and like him much more. He had a good disposition and joked often. He had long tried to rival my father in masculine elegance, but our present circumstances showed the foolishness of such trivial com-petition. Yasha badly missed his little daughter Tamara who had been entrusted to Janina's care, so he gave me a lot of his attention. Uncle Yasha was fun. Rarely do people improve under dire conditions. Yasha did. The ghetto transformed him, revealing all that was best in him. Indeed, he became a different person—friendly, caring, devoted. I last saw him shortly before he was transported to one of the death camps. People who remembered him in the final days of his life spoke of him with affection.

Back in Soviet Vilna, in a country at war, there was little or no news about the ones who had been sent to the camps. We did not know yet that Yasha was dead. Yetta looked at every possible source of information. One morning, after our move to the new lodgings in the bombed house,

she left for an obscure errand and returned with a heavy bundle. In it were the two bronze angels. She told me how she had managed to get them back. Her face was still flushed by emotion. Was Yasha sending her a signal?

Grandmother Shifra and Yetta's mother-in-law, Vera, used to live in the same building. My aunt, trying to see if anything had survived of her own family's belongings, had found these winged creatures of Vera's on the floor of a dark basement full of junk belonging to the building's old janitor. This man had never expected to see any of these Jewish family members again. He gave her his word that their two apartments, now occupied and inaccessible, had been totally emptied by the Soviets. He invited her to inspect the basement, assuring her that she would find nothing there. He insisted on proving his amiability and clean hands. In the basement's murky light, however, the angels' wings suddenly materialized behind some rusty pipes, and Yetta pulled them out without difficulty. The embarrassed janitor, having had no inkling of their value, must have forgotten them. In fact they had once been the pride of the best antique dealer in town.

To me the candelabra seemed messengers from a world that was no more. They had also witnessed stuffy Saturday teas in Vera Norman's salon, to which I was brought dressed as if I were Little Lord Fauntleroy. Carefully led by my hand and placed on a velvet pillow that protected an armchair upholstered in rare petit point, I was told not to move. The room was a sanctuary in which everything had to remain beyond a young boy's touch. Vera, a lady of great elegance and distinction, who when in public spoke to her son mostly in French, had been widowed and divorced a number of times. She lived with her ageless old mother, a taciturn widow always in strict black, who shared with her the floor above Shifra's convivial and joyous home.

Uncle Yasha, a chemical engineer specializing in sugar, had given up a respectable profession acquired in the Belgian University of Liège in order

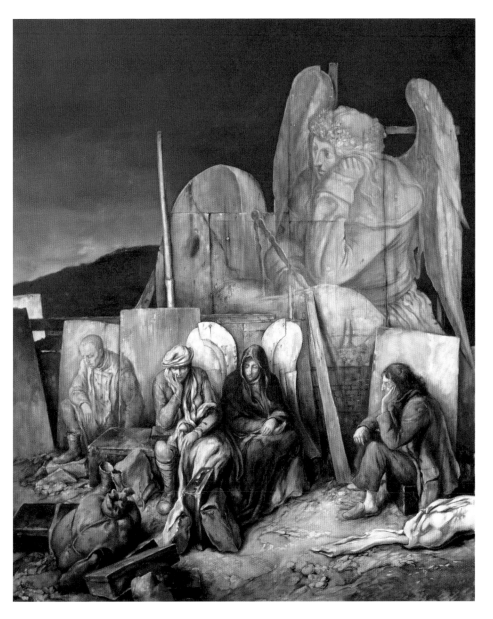

Present in my paintings since three decades, Dürer's winged melancholia, witnesses in the "Angel of the Travelers, 1987" the experience of being uprooted.

LEFT TOP: In 1958, Mother visited me in Paris. Apprehending her disapproval of my "look", I reduced the size of my newly grown beard to a strict minimum.

LEFT BELOW: *Structures*, painted in Paris in 1959.

RIGHT: Rome 1959. In my new studio on the Cassia Vechia, near Rome.

BELOW: Rome 1959, perhaps a sight that reemerged from Vilna's tragic memories: a painting of metal bridge.

Childhood Memories, painted in New York in 1975. The pear, possibly the fruit of knowledge, evokes to me the loss of paradise and discovery of war, which is hell.

TOP: March 4, 1992, with my three daughters, from left to right, Ilana, Daniela, and Mikhal, on the occasion of my wedding to Josée.

CENTER: Annalisa (née Cantoni), the mother of my three daughters, on our honeymoon in Venice, 1959.

RIGHT: Josée (née Karlen), to whom this book is lovingly dedicated, entered my life in 1986. Photograph taken in 2001.

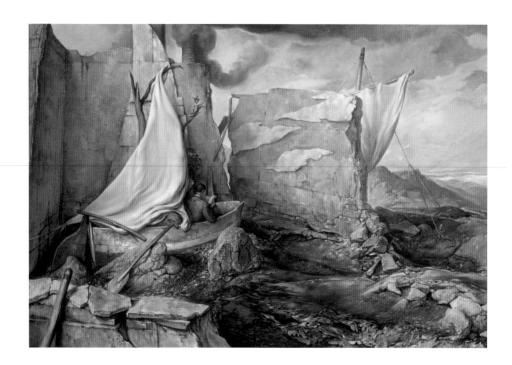

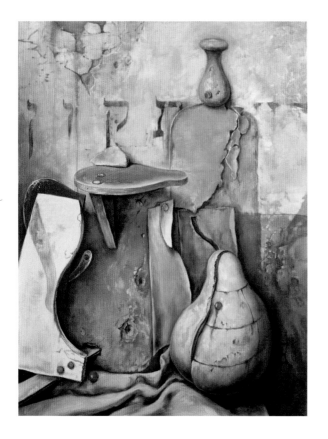

ABOVE: *The Reader*, in his impossible boat, owes this painting to the precious memory of my prewar afternoons spent in Grandmother Rachel's home.

LEFT: The possibility of repair, the repair of a broken world, the *tikkun haolam*, is an important meaning contained in my numerous variations on the subject of still life.

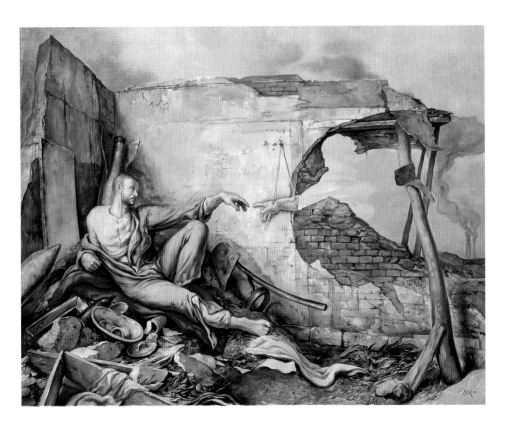

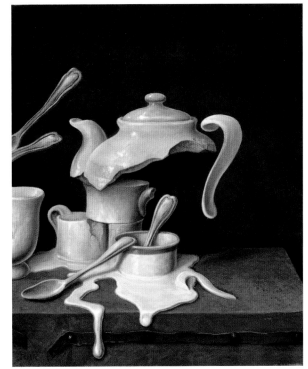

ABOVE: My childhood's fascination with the stories of Genesis, and my admiration for the genius of Michelangelo, blend in this post- Holocaust revisiting of familiar territory.

RIGHT: Still lifes — in times in which life is never still, never sufficiently protected, nor granted to everyone — attracted me as metaphors that are full of symbolic implications.

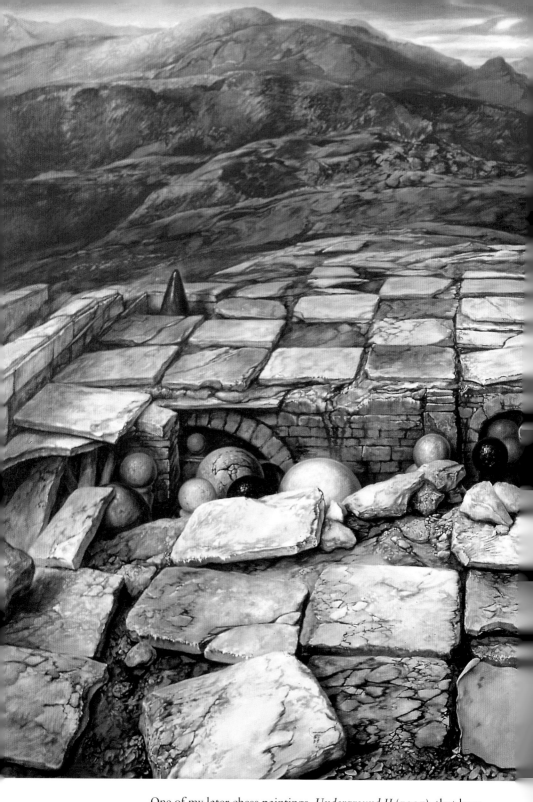

One of my later chess paintings, *Underground II* (1997), that have always been dedicated to the memory of my stepfather Markusha.

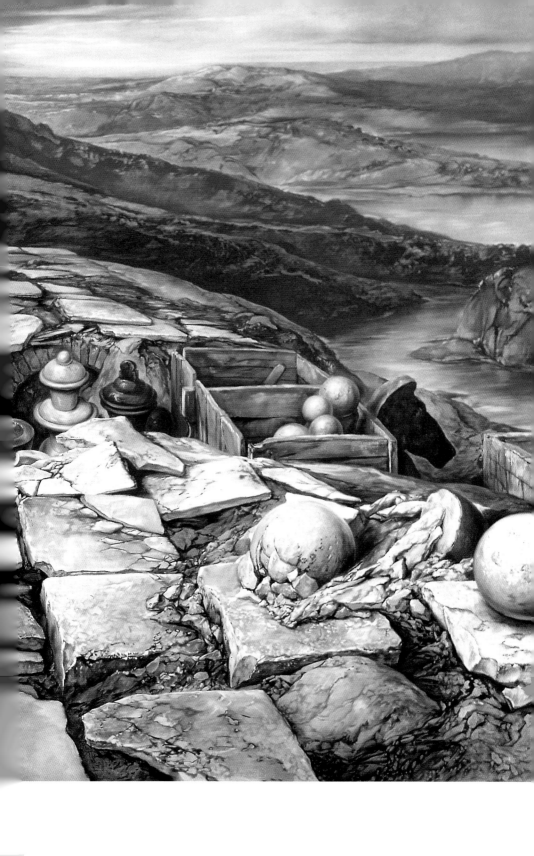

ABOVE: 1973, In my studio in Savyon, Israel.

RIGHT: *Ghetto*, the painting I created in New York in 1976. The picture was later used as a jacket for Yitzhak Arad's book on the struggle and destruction of Vilna's Jews.

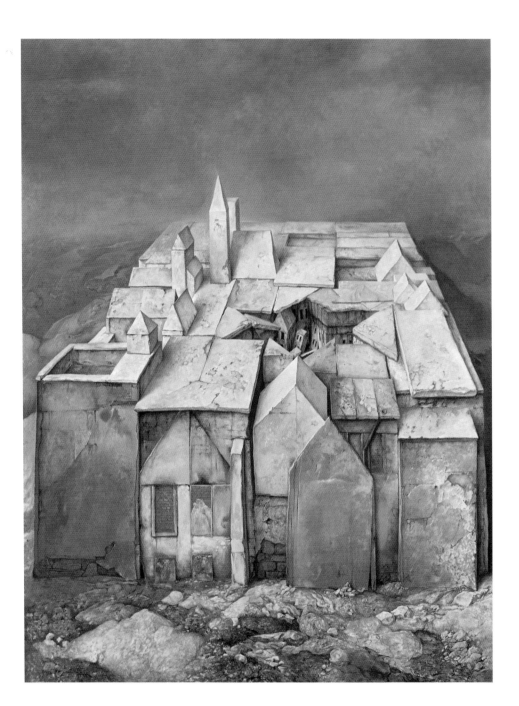

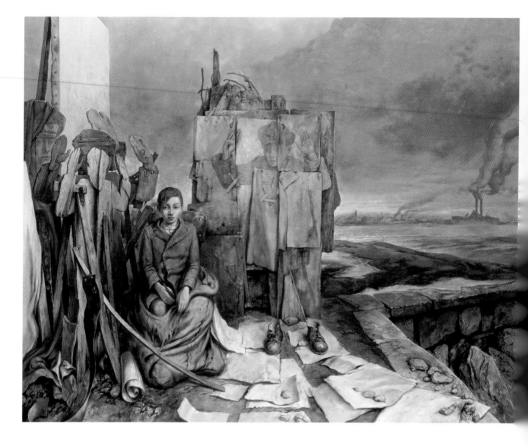

The boy from the Warsaw Ghetto along with Samek Epstein, my murdered childhood friend, and the memory of myself as a child in the tragic years of the Shoah, appear in the large self-portrait, and in many other variations of this inexhaustible image.

The triptych *The Source, God's Name,* and *City of Jews*, painted in Savyon, Israel in 1978, is one of my most "theological" works on the theme of the Holocaust. It traveled to countless exhibitions in European and American museums, and has aroused many interpretations.

Sketches of sets and costumes for the 1964 Berlin production of Sholem Aleychem's play *Amkho*, in which I blended Jewish popular theater with elements of *commedia dell'arte*.

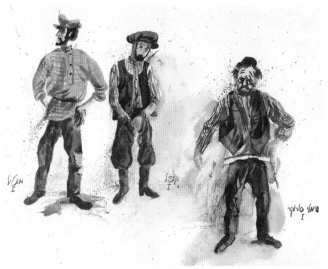

Me in 2001. Photograph by Cary Wolinsky.

to accept the direct inheritance of his grandfather's business. All this happened before I was born, and shortly before he met Yetta and fell in love with her plump and sexy form. He had been on the point of marrying the heiress of a Belgian sugar fortune, but his grandfather's unexpected death required that he return immediately to Vilna and take over the family business. Apparently Yasha had no father. On his mother's orders he broke off the engagement and began dealing with what were for him unfamiliar responsibilities. His lucrative family business had to do with the control and fixing of wholesale prices on the fish market.

Before the war, Yasha worked from 3 A.M. to 5 A.M. six days a week. Clad in a heavy coat with a fox collar, wearing a dark hat, and carrying a cane that was meant to lend him age, he was brought to the wholesale fish market by his grandfather's former assistants and placed on the old man's chair. He had to wait for various evaluations and negotiations, and subsequently for some information that would tell him how much to pay for the day's entire catch. Yasha spent his nights in restaurants and cabarets, and slept in the hours of daylight. He never ate fish.

When he married Yetta I was two; my parents had left Shifra's apartment to create a home of their own; and the young couple moved in with my grandparents. That is when Vera rented the floor above the new domicile of her only son. Her apartment was carpeted in dark red, and the rest was mostly in black and gold. The two angel candelabra that later resided on our decrepit piano were in those prewar times part of Vera's somber décor. I was told that such a setup,—funerary, according to Grandmother Shifra—was called Napoleon III. I was familiar with the name Napoleon and knew how it tasted, but Vera's impressive apartment had nothing in common with Xenia's specialty.

At age ten or eleven, in a Vilna totally transformed, I had a rich recollection of our former times. But these memories focused on trivial details: Xenia's cakes, our cat, my toys, Grandfather's tailoring dummies, and

Father's evening garb. I rarely brought up with Mother the losses that had so deeply hurt us, my dead father, lost grandparents, our home. These scars asked to be left untouched.

We survivors were badly equipped to deal with loss and mourning. Testimonies that gave proof of death were rare. Many of our dear ones who disappeared might still be vaguely hoped for. Denial, too, led us to avoid considering them lost. In our own family, Yetta's miraculous return reinforced the uncertainty we felt about all the others. Even where we were certain of the fate of our loved ones, as in the case of those murdered at Ponar, the setting evoked such horror that it offered no place to commune with the dead or search for solace. As there were no funerals and no rituals that could put things in place, our mourning had to go on for years.

Mother buried herself under a mountain of work. When she learned about Father's death she fastened a black armband on my sleeve. I hated displaying in public my status as fatherless child. I felt that it diminished me, and this wounded my pride. Mother's stare, whenever she cast a glance at this sorrowful symbol, pained me. Her soul harbored an immense anger. I was aware that she wouldn't dream of forgiving Father for not having survived. Today when I reflect on this painful period, I see much more clearly than I did then. Time has given me an understanding that was not available to the boy of ten.

I remember my fascination with churches and with Jesus. Vilna is a city of churches. Several of them had been damaged by war, but many survived. Mother knew that I was attracted by the Catholic faith. Aunt Janina's presence in our life, her extraordinary devotion, and her share in our survival were an important part of it. Although Mother made it clear to me that with the Germans gone my little bundle of catechisms and Christian prayers were no longer a lifesaving device (as if they would ever have worked with the Nazis), she did not object to my going to Catholic services. In the city, attendance at prayers had mounted. Crowds dis-

mayed by the increased hardships did not protest against God; the strict discipline of accepting His will had quite subdued them. Instead the blame turned inward. Long lines formed in front of confessionals. Priests had never been busier. In such times honesty is hardly affordable, and people felt guiltier than ever. Most needed forgiveness and exoneration from their many sins. In short, the churches were full.

I loved the beauty of the ritual, the electrifying feel of the holy water, and the seething sound of organ music that poured to me from the immense vaults. I adored the smell of incense, the chiming of little bells, the sacramental robes of the priests. I practiced the kneeling and the gestures of crossing myself with gathered fingers in a movement that suggested the power of magic. The churches were full of huge dark paintings that looked at me. They depicted fascinating scenes. Evil executioners tortured or put to death beautiful maidens. Sometimes they sacrificed elderly men with long white beards. But the victims, with their eyes turned to God, had expressions of ecstatic bliss, as if they had reached the high point of their existence. I liked the sense of fulfillment that the Christian faith ascribed to suffering. The various representations of Jesus' figure on the cross moved me greatly. Painted crucifixions abounded, but I preferred the sculpture. His muscular body, in stone or wood, evoked a sense of yearning. At times the statues were painted with colors that seemed natural, and his blood looked real. His ordeal was like Isaac's; he too was sacrificed by a powerful and determined father. In some ways I felt luckier than Jesus. My dead father, a miserable prisoner of a Nazi camp, never pretended to be all-powerful. He was no master capable of creating worlds! Yet he saved me in the direst of circumstances from certain death, whereas Jesus' father, willing to see his son suffer, ignored the plea "Why have you forsaken me?" and let him die on the cross.

Bad weather, ice, slush, and the lack of heating in churches cooled my religious fervor. Mother's apparent indifference to my soul searching

allowed my fascination with the church to fade even more. I shifted my enthusiasm to the cinema. Across the street from our house stood a huge barnlike structure, a former German army cinema that now showed films to soldiers of the Red Army. At times it sold inexpensive tickets to civilians. Mother delicately suggested that since I was in a state of mourning, visiting cinemas before I had respected an appropriate period of bereavement might be incorrect. "What would be the appropriate period of time?" She did not answer at once. After some thought she told me that no form of particular behavior could return to us the dead. She said that I had to decide about it by myself.

"In that case I shall go to see a film this afternoon."

I began to visit the cinema assiduously. The films were uplifting, patriotic, and inspiring—full of evil men and heroic figures. Like the church, they were packed with images of sacrifice and death. Some of the ancient Russian kings with their unmanly haircuts resembled Jesus. Weekly newsreels gave me an idea of what was going on in our great world. Smiling girls in uniforms raised flags. Great men shook hands. Brave women in huge factories proudly produced mountains of shells and bombs. Choirs sang patriotic songs. Long lines of German prisoners, poorly clad in tattered uniforms, shivering from cold, were marched off on snowy roads.

Sometimes large groups of Russian soldiers in the city on a short break, drunk and noisy, occupied most of the cinema's space. Like the Lithuanian soldiers of former times, they smelled strongly of cabbage, leather, wet wool, tobacco, and perspiration. But often I had the cinema to myself, and the projector's operator, an elderly Russian in army garb, introduced me to a secret passage that through an outdoor toilet and a broken fence offered me ticketless access to the magic world of films. In later years, in various cine-clubs, I rediscovered many of the movies I had seen during my year in "Red" Vilna—masterpieces of Pudovkin, Eisenstein, and other great directors of Soviet film. But it was in Red Vilna I

discovered that my mind could pierce the screen, enter the flicker of its imaginary spaces, and live their black-and-white realities as if I were inside their world. The cinema turned me into a real believer in the different reality that was being proposed to me. I also strongly believed in the substance contained in the pages of books. Mother guided my reading, and sometimes my passion for mental travel kept me awake through the night. I have never fully recaptured this marvelous state of being.

When not painting, reading, or watching films, I would take my little cousin Tamara for walks or accompany Yetta and Mother on visits to their few surviving friends. At times we visited Misha, Slava, and their daughter—friends who had survived the liquidation of the HKP camp. A complete family. What a rarity! I found no boys my age to play with. Aunt Janina's older son, Janusz, very devoted to Mother and Yetta, was an adult, and her younger son, Victor, was so indifferent to the things I cared for that we hardly connected. I lived among adults who, in a world tattered and transformed by catastrophe, must themselves have felt like abandoned and lost children.

From time to time I would visit my two friends and patrons, the poets Avrom Sutzkever and Shmerke Kaczerginski. Both had returned from the partisans. In order to conserve their status as veteran fighters they dressed in a semi-military fashion. Shmerke used to interview various survivors, scrupulously transcribing their oral testimonies. He worked on these texts for endless hours. Sutzkever too wrote and wrote. He had so much to say. With the end of the war he was invited to bear witness in one of the Nuremberg trials. Both collected documents and objects they believed to be of significance for a future museum of Vilna's devastated community. Thus the present Jewish museum of Vilnius was born. They asked me for some works and I promised to give them the paintings I did not intend to keep for myself.

The walks I took with Tamara were always in company of her teddy

bear, a much used toy that must have had many owners and had been passed on to her by Aunt Janina. The bear, a dumb-looking straw-colored animal, had a plushy fabric covering so worn that its sawdust guts were on the point of spilling out. When it was too heavy for the arms of my five-year-old cousin, mainly when soaked by rain, I had to carry it, which I did by holding it upside down by one of its legs. After all I was a boy of ten, maybe eleven, and the bear was an embarrassment. Besides, I was haunted by the image of my own teddy bear, by the sad look he gave me on the day we were banished from our home and sent to the ghetto. My faithful friend, alone and abandoned in my bed and expecting the worst! At present when I chase away these sentimental thoughts, I still go over and over in my mind those long walks with Tamara. I realize that I always avoided taking the streets that led to where my grandparents once lived and never crossed the corner of our own prewar home. These places had become taboo. I have never returned to Vilna.

In May 1945 the war in Europe ended. As former Polish nationals, we were soon offered the chance to leave Soviet Lithuania. This period indeed saw a massive shifting of populations. Mother hesitated to tell her current boss about her plans for departure. Aware of her key position in the store, she was afraid she might be ordered to remain. Under a regime that rejected any notion of personal freedom, he was more than entitled to do it. Secretly she applied for expatriation papers. But our daily life kept on streaming with its usual flow.

For the Russians the war was over, but in the Pacific, the Americans were still fighting. Soon, gray and blurred newsreel images and strange pictures of smoking mushrooms would familiarize us with unusual names like Hiroshima and Nagasaki. That summer our papers for leaving Vilna were approved. Apparently no one in the current administration took the trouble of checking Mother's situation with her employers. We were given the exact date on which we had to be at the city's railway sta-

tion. Now it was a simple matter of waiting and letting the hoped-for day take us to a new life.

But our plans faced a new and unexpected obstacle. Mother's current boss, himself an ex-officer of the secret police, was arrested and indicted for violating party discipline and for black marketeering. The investigators invited Mother to their headquarters for a thorough conversation. She was amiably and well treated. Mother was their chief witness. They advised her to forget her plans about leaving the city. When she tried to explain that she had no indicting information, they smiled. The date of the trial had not yet been set. The man had first to be interrogated; subsequently she would receive all the information she needed.

I was not fully aware of the panic that must have seized Mother and Yetta, but I understood that our departure had to be hastened. Yetta managed to move our date forward by accepting for us a much smaller space in a railway car. The packing of our meager belongings demanded little time. Only the candelabra and my paintings required special attention. I quickly selected the works I considered worthy of taking up space in my small cardboard suitcase next to my precious portrait in oils. These paintings would later be lost in a German railway station. The rest was brought to my poet-friend Kaczerginski, but the date of our planned departure was not revealed even to him.

Since the early months of our liberation, Mother had been suffering excruciating gall-bladder attacks. Several times we had to call a doctor in the middle of the night, and twice she had to be taken to the hospital directly from her store. This antecedent was now an asset. Mother managed to get hold of hospital stationary and prepare a document that certified an admission due to a sudden worsening of her chronic condition. Our scheme was meant to allow us the time needed to leave Vilna, reach the Polish frontier, and pass the border control.

We were to leave on a Saturday morning. Mother figured out that not

until Monday or Tuesday would the local authorities realize that she had actually escaped. Normally it took three to five hours to reach the border by train. Who could ask for a greater margin of safety?

Our departure was kept so secret that there were no goodbyes, not even to our closest friends. Early on the day of our planned departure a trustworthy messenger was sent to the store with an envelope containing Mother's medical certificate. Another young man, equipped with a hand-drawn cart, helped us to put on it all our worldly belongings: a very good small box spring from one of our beds; two suitcases, one midsized and one much smaller; and a bundle of two pillows and a military blanket. There was also an old tin baby bath with two heavy metal handles in which a humble collection of pots, pans, and such was carefully wrapped in old newspapers. The young man was paid to accompany us from the door of our room to the door of our cattle car.

We followed inconspicuous narrow side streets. I walked with a tight stomach, realizing that I was saying goodbye to the city of my birth, to the only world I had ever known. It was like a funeral procession. I followed behind the small cart, in a state of such agony that I can hardly remember the scene that was unfolding before my eyes. Even my cousin, concentrated on the effort of carrying her bear, was quieter than usual. The tension that I could feel in Mother and Yetta was palpable. Besides, images of other departures, other escapes, other moments of passing along the edge of catastrophe, pulsated in my head.

A huge crowd was gathered at the train station. The place itself was a mess. Pieces of metal and broken glass still covered the ground where a Russian munitions train passing through the station a fortnight ago had been bombed by saboteurs. No one revealed how many were killed in this act of terrorism, or who may have been responsible for it. But the charred cars, torn cables, bent posts and remaining debris spoke of the magnitude of the explosion.

This was my last view of Vilna.

Several locomotives were sprouting a pitch-dark smoke, as interminably long chains of cattle cars waited for the expatriates of that day. Pushing, pulling, screaming, yelling, swearing, fighting our way through tunnels and platforms cluttered with refugees like ourselves, we managed to find our car and the spot designated for us. We were surrounded by all sorts of luggage, mountains of objects that witnessed the pain of uprootedness. As if there were not enough human bodies to fill the filthy caravans, this strange litter filled every crevice of remaining space. Our young porter was very helpful, but the space allocated to us was smaller than we had expected. The box spring Mother had brought for us to sleep on had to be stood on its end. On the straw-littered floor there was barely enough room to sit. Yetta was wiping tears. Mother murmured something into her ear, and my aunt was suddenly seized by spasms of laughter. How strange! Soon everybody around was smiling. Some of our new neighbors began telling jokes; others took out games of playing cards. Mother's smile waned quickly. It was still very early, but our arrival had already closed the list of the car's occupants, and we were ready for the whistle that would signal departure.

Indeed, in the late afternoon of this momentous day, a day whose exact date I do not recall, imperceptibly and without any fanfare our train did start to move. Along with me, invisible to the other travelers, came my dead Grandfather Chayim. I saw him as the young dissident of czarist times leaping on a moving train to make his clandestine escape to Paris. To be fair, I added to his company Khone, Rachel, and Shifra.

They travel with me still.

The train accelerated gradually, and the locomotive's steady heartbeat filled us with confidence and hope. It was hot and the majority of the passengers opted for leaving the cattle car's sliding door open. The acrid smell of coal fumes became more intense when at a sweeping curve of the

railway a black cloud of condensed smoke reached us, invading the car and remaining trapped there. To chase away the smoke's metallic taste, people lit cigarettes. I observed the traveling landscape, which the late sun illuminated obliquely. The size of the houses was diminishing. Some lucky areas looked untouched by the war. Vilna's distant skyline was fading away.

"At this speed," said Mother, nervously exhaling the smoke of her cigarette, " it will take us a full day to reach the border."

The open door looked like a screen on which fields glided past us, untilled fields interspersed with stretches of wheat, forests, farm animals, and solitary huts. Some remains of charred military vehicles spoke of lost human lives. Sitting on one of our pillows, leaning against Mother's arm, I fell asleep. When I woke it was early morning, and the sky was luminous. The train must have stopped some time ago. Several of our traveling companions had stepped down and were now lingering on a stretch of dry grass. In front of a few bushes, positioned with their backs to the rest of us, men were peeing. A gentle wind brought us refreshing air that smelled pleasantly of cow manure. This radiant picture was framed by the door's opening, a background to the dark silhouette of Mother, nervously smoking.

"At this rate it is impossible to know. . . " she said to Yetta.

Somebody passed and gave out information. The Red Army was moving heavy equipment; military convoys had a priority over civilian trains; we had to wait.

The journey to the border now became a nerve-wracking experience. It lasted four full days, days of short advances and long periods of waiting. Every new start was greeted with enthusiastic clapping, but the movement was feeble and short-lived. Mother's tension increased by the hour.

Once, while we were waiting close to a forest, Russian soldiers appeared at the car's door. Most of the travelers had gotten out into the

air, but our small family of four was inside. The poor light of our far corner hid us, but I could well see the paleness of Mother's face. I tried to cling to her, but she gave me a sign with her hand not to display emotion. We quickly learned that the soldiers needed able-bodied men to help remove an obstacle from the rails. A few passengers volunteered and left. Some of the women began to alarm each other with conjectures. They spoke of summary executions, of Russian cruelty. Mother did not join their conversation. We were the only Jews in the car, and there was a polite distance between the others and us. She was focused on her chain-smoking. I began to worry that at such a rate she would quickly finish her reserve of cigarettes and start going to pieces. Then came another scary moment. At one of the interminable stops, Russian policemen entered to check documents. By then Mother had whispered to me the details of our daring escape, and I now shared her spasms of panic. But the policemen, searching for army deserters, looked at men only.

Finally, early on a gray and rainy morning the dreaded moment arrived. We reached the border control. The night before, Mother and Yetta had hardly managed to sleep, and it showed in their faces. Our clothes were glued to our bodies. The locomotive's black smoke encrusted our hair and skin. Mother nervously reached for her handkerchief, spat on it, and tried to clean my face. I was overcome by disgust and indignation: such treatment befitted my small cousin Tamara, not a boy my age, but I did not dare to protest. Lithuanian policemen, accompanied by an officer of the Red Army and Polish border guards, appeared at the door. The Russian said that he would read a list of several names of people for whom he had messages. We were asked to pay attention. Mother's hand gripped me by the shoulder. Our name was not among them. Later the guards examined our papers thoroughly, cast a glance at our meager belongings, and after less than a minute, a minute that seemed to last ages, allowed us to cross into Poland.

It was not until later, when the train's unburdened heart was happily pounding and rhythmically gathering speed, that we started to look at each other, at first with incredulity and then with immense relief. The precariousness of our situation had to be kept from the other passengers. The less they knew the better. Tamara, asleep with her blackened teddy bear in her arms, must have been dreaming of fairylands. I felt that somebody was watching over us. Perhaps Vera's bronze angels? I imagined them hidden under the pots and pans of our tin baby bath. I saw them exerting their hidden powers, effacing Mother's name from all Soviet papers that demanded her arrest. I imagined them stretching their tired arms, expanding their wings, turning their heads to each other and, at the moment of our border crossing, smiling with self-congratulation. How could I thank them for having given us this safe passage?

Now that we were much more relaxed I felt that I had the right to ask Mother to let me know the secret joke that at the outset of our journey had provoked in Yetta so much hilarity.

"Well," said Mother, " I told Yetta I had just realized that Vera's candelabra, well and carefully packed, had remained stupidly forgotten by the stairs of our lodging. They were not destined to accompany us."

"This made her laugh? What is so funny about it?"

"And who told you it was funny? Silly boy! Didn't you see the tears in Yetta's eyes?"

* * *

Our trip through Poland dragged on for days. The journey, like that we had experienced before crossing the border, was a mix of slow traveling and prolonged halts. Instead of heading south, we now turned southwest toward Poland's newly acquired territory in the west. The four of us were still wearing the clothes in which we had boarded the cattle car. The train's smoke-filled summer heat was at times suffocating, yet fresh nights and some intermittent showers made the air breathable. Drinking water

was distributed, but food had to come from our own reserves. Luckily the many stops allowed us to replenish them. Peasants popped up at every stop and offered for good prices their basic merchandise: greasy sausages, sour cheeses, and stale bread.

The transitory nature of train travel, when it is not weighed down by worries, tends to encourage many passengers to a congenial openness. Thus we began to converse with our closest neighbors, a middle-aged couple and their teenage daughter who traveled with an intriguing bird, an unusual canary in a small cage. All three were highly concerned about the bird's depressed behavior, and this soon became our main topic. Its owners tried to understand why, in spite of its being so comfortable, so unimpeded by any competing traveling birds, so well fed and cleaned, with much more space for its movements than we had for ours, the unhappy bird seemed to be on the point of a nervous breakdown. Perhaps it was longing for its familiar view from behind its bars, the sight of their dim and quiet dining room. To cheer our Polish acquaintances we told them some unimportant stories about ourselves, only happy stories. Later we politely listened to theirs.

Waiting for a new locomotive wasted a full day at a station on the out-skirts of Warsaw. I observed the landscape trying to imagine, beyond the blackened ruins of many industrial structures, the fascinating and elegant city that Father had regularly visited. But all I could see was devastation. Meanwhile, a few people descended and others took their space; but most passengers continued in the direction of western Poland. There, a forced expulsion of all German nationals was opening the space required for the Poles newly expelled from Russia. The changes in Europe's borders caused this unprecedented shifting of masses. The ground on which mil-lions of people and their forbears had been born suddenly became foreign to them. We were a trainload of migratory birds.

Mother and Yetta had no desire to remain in Poland and therefore did

not intend to go to the west. Their plans foresaw a stop in Lodz, a city where Jewish refugees who sought to take the tortuous road to Palestine were likely to find some practical support. Rumors had reached us in Vilna that a clandestine organization, the Brichah, functioned for this very purpose in Lodz. Besides, we knew that Misha and his small family, who had been among the first to leave our city, had already arrived there. We had to find them and get their advice and help. Our plan was clear. Unlike me, most of our Polish traveling companions were very worried. They had no inkling of what they would find in the new territories that had been torn away from the defeated Reich. Lucky us, we felt quite superior to them. We had on Poland's map the name of a precise point, the wonderful city of Lodz, a base from which we would depart, as Mother planned it, to a Jewish state. I thought that the fact that such a state was yet nonexistent was a minor handicap. But time would correct even this.

However, there was a problem. After leaving Warsaw it became clear that our train would not pass the city of Lodz. Mother and Yetta had knowingly avoided the direct train, which was to leave Vilna several hours after the one we took. They vaguely foresaw the present problem but anxious to get out of Vilna and having little confidence in the information of the Lithuanian administration, they opted for the first train leaving the station. Mother had her conviction: "In a world that is upside down, who says that the direct train to Lodz does not end up in Moscow?" I understood now a scene I had observed as we were climbing into our cattle car. People on a distant platform, people whom Yetta seemed to know, were gesturing to us over the hubbub. A woman pointed with both her index fingers at their waiting train, while a tall man turned his finger around his temple, indicating that we were in the wrong place, crazily opting for a big mistake. Indeed, they knew that we too planned to reach Lodz, but they had no idea of our urgent need to get out fast.

"Take it easy and relax; tomorrow or the next day we'll reach Kutno,"

said our Polish neighbor, "and from there you can take another train to Lodz."

We knew it already, but Mother thanked him politely for his excellent advice. Outdoors a hazy sun was lazily playing hide-and-seek, and it was drizzling. The train inched along. Several passengers, eager to move their feet, had equipped themselves with umbrellas and old army capes. They had descended and were strolling next to our car. The neighbor's wife was cleaning the empty cage, while the daughter, holding her beloved bird on an outstretched finger, gently touched its little head with her cheek. Suddenly the bird opened its wings, rose into the air, made a little circle over our heads, and flew out. Sudden thunder would not have so transformed the expressions on our neighbors' faces. The father jumped out of the car, nearly fell, quickly regained his balance and ran toward the locomotive signaling with agitated arms. "It is a domestic bird, a domestic bird. . . ." sobbed the desperate daughter. Her mother, clinging to a rosary tightly clenched in both hands, threw herself with tightly closed eyes into speed-ily recited prayer. Various saints were entreated. The father's timely inter-vention brought the train to a halt. In spite of the light drizzle, everyone, except the praying mother, descended, and a bird-search party was quickly organized.

I remained near the cattle car's open door. One never knew. Inter-minable minutes passed in frenetic searching, punctuated by the ups-and-downs of the daughter's wail. Curious people from other cars leaned out from their doors and began to question us. Luckily the rain had stopped. A few birds flying in the sky caused quickly belied exclamations of hope. Later the disappointed searchers gathered near the devastated father who was holding the sobbing girl in his arms. The misfortune was God's will, and it had to be accepted. Suddenly there was an outcry of joy. Someone remarked the tiny fugitive. It was perched on a rod that held up the step beneath our car's door, at an arm's length from where I was standing.

The scared bird, with wings that seemed glued to its miniscule body, looked more dead than alive. When I took it in my hand it did not protest, but its heart was pounding wildly. "That is a very good omen," said Aunt Yetta. But nobody listened to her observation. Our companions were busy congratulating the proud and beaming mother, whose fervent prayers had doubtless, so they said, brought about this quasi-miracle. " I know my saints," said the Polish woman. " They have never disappointed me!"

"Look on what they waste miracles," said Mother into my ear.

"Wake up, wake up. We are in Kutno!" A hand was shaking me with force and tearing me from a dream. It must have been the middle of the night. Tamara was weeping. In the door's opening, a silvery curtain of rainwater was illuminated by a dim bulb. Beyond it everything was black. Our neighbors quickly helped us lower our two suitcases, the tin baby bath, the bundle of pillows, and finally the unused excellent prewar box spring.

We had been traveling in one of the last cars, and the train's excessive length did not grant us the comfort of landing on a platform. It was raining hard, and the uneven ground was soaked and slippery. Minutes later a whistle was heard. The train started to move and to accelerate with an unusual speed. By the time I had finished reflecting on how perceptions of speed differ, I was completely drenched.

The departing train's red taillights disappeared in the darkness. Lost in space, like interplanetary travelers grounded on some distant moon, we were left with our strange mix of belongings among a tangle of wet rails and deep puddles that feebly reflected a railway station's distant lights. Tamara was crying: "I and my teddy bear, we hate to be wet." Mother and Yetta were exhausted and nervous. "You'll have plenty of time to dry before your wedding day comes!" The baby bath with all our pots and pans was filling with rainwater and becoming very heavy. To deal with the

bed frame was altogether impossible. Mother gave an order: "Let's take the children, the suitcases and the bundle. Forget the rest."

Inside the old, partly dilapidated train station of Kutno, some Polish travelers slept on the few available benches. All chairs were taken up with suitcases and bundles. A few buckets that had been collecting water were now overflowing, and the water that dripped from the stained ceiling was creating lovely ponds, lakes, and islands. The ticket counter was closed. It was too early for any information about our connecting train. We sat on a stretch of dry floor and took off our soaked shoes. I imagined all sorts of collisions between speeding locomotives and box springs and baby baths abandoned on the tracks. It dawned on me that the angels of Vera's candelabra must have foreseen the fate of our tin bath, and so saved themselves from being disfigured and torn apart by hundreds of heavy wheels. What a bitter end in the middle of a heartless Poland! The clever angels had wisely decided to be forgotten and to remain in Vilna. Anachronistically they might well have employed the phrase: "Better red than dead."

"Wake up, wake up! The train for Lodz is soon going to arrive!"

LODZ

The New Lodgings

As the years pass, my feelings about photographs become more and more confused. At times I see in them cruel mirrors, witnesses of a fleeting time, unsolicited evidence of our deterioration and mortality. But at other moments I admire their unique and irreplaceable capacity to preserve past events and safeguard human memory. When I listen to specialists speak about the traumas of child survivors I learn how old photographs support the rebuilding of a positive sense of self. My own sense of self is forever on the alert. Perhaps being an artist has made me question my capacity to experience total fulfillment. Although this sense of self has been nurtured by the love of a devoted family and many supporting friends, as well as by a satisfying professional career, it always craves bolstering and confirmation. I must confess that many old photographs warm my heart.

I wish I had a photograph of Mother and Yetta at the close of our short stay in Lodz. Had it been taken shortly before our departure, around October 1945, I would have especially cherished it. I would love to focus on a physical image of the two sisters. As I evoke them in memory, they wear the dashing secondhand prewar raincoats that Yetta picked up on her wheeling-dealing escapades. The coats are tightly tied at their narrow waists and both women wear fashionable high-heeled shoes with extremely thick cork soles. But what I like most about their outfits are the two chic masculine fedoras. They wear them tilted, but not too

low over their eyes. Both look stunningly beautiful! Who would guess that they had just survived the inferno of a most harrowing time? Alas, no one took such a photograph, but the more I project myself into those far days, the more the image comes up clear and sharp.

On the other hand, I am happy that there is no photograph of the four of us—Mother, Yetta, my little cousin Tamara (with her shabby and balding teddy bear), and myself getting off the train that had just arrived from Kutno. Our exhausting journey in a dirty car had held us packed and entrapped for many hours. When the train halted and the doors were opened, the human mass started to move and we were dragged with it. A sliding lava of body parts ejected us onto the platform. Hooray! We were in the overcrowded and noisy railway station of our destination, Lodz.

It was the initial station in Mother's resolute project of getting to Palestine, where she was to reunite with Uncle Rachmila. One last time I saw him he must have been in his early twenties and I was six. I remembered him, tall, suntanned and with a glowing mane of hair that would tell the wind where to blow. I greatly admired this Zionist pioneer, this rebel against maternal authority, insurgent fighter against the British, and founder of a heroic kibbutz in the middle of swamps infested by malaria. The stature that his two sisters attributed to him was legendary, and it gave me a clear idea of my uncle. The small and stocky man who met us in Haifa three years later on our descent from the boat, destroyed this childish image forever. But in him I did find a dreamer who was sweet, devoted, and pragmatic. His story, however, belongs to another chapter.

Meanwhile we had just arrived at the Lodz railway station, where everything was dark gray—platforms, concrete walls, train cars and travelers. And whatever was not dark gray looked black. Black coveralls of mechanics, black metal tracks, and black puffing machinery. This present blackness mattered little since the skies of Palestine would be blue and its palm trees of a resplendently glowing green.

No one awaited our small family, and no one looked at us. Obviously there was no photographer to immortalize our dismal appearance. Luckily so. We were creased, terribly dirty, and tired beyond words. Our occasional attempts at minimal hygiene while on the train had poor results. We bore all too clearly the marks of our run from Vilna and our nearly two weeks in the cattle car. Tamara's lovely blond curls looked like the sad fur of a stray dog. And very little could be done about the pitiable state of our clothing. It was penetrated by a sticky layer of coal dust that also clung to our skin and hair. I glanced around and realized that all the others looked like us. Our pitiable appearance did not stand out against the rest of the crowd of other miserable refugees, dreary representatives of uprooted nations.

Luckily we managed to find the address of our dear friends Misha and Slava. There was an extraordinary bathroom in their surprisingly well-equipped and richly furnished flat. Weren't we fortunate? It had previously belonged to a German doctor, but he had disappeared with the retreat of the Wehrmacht, and Misha's new employer, the Polish Health Administration, had requisitioned the flat. When, shortly before our arrival in Lodz, Misha had begun working as a surgeon in the local hospital, his small family was allowed to move in and temporarily enjoy the luxury of the premises. The apartment had only three rooms, but in my eyes it was a palace. The bathroom was a heavenly facility that let us feel the joy of rebirth. Its pampering walls, covered with glittering white tiles, spoke of other times and another world. A capacious water tank, joyfully whistling over a wood-burning furnace, provided us with warm water for long periods of pleasurable soaking. This earthly paradise even supplied slightly abrasive Wehrmacht bath towels that glowed with a slightly grayish cleanliness. And the German army soap, of which our friends had a huge supply, did not reek too badly. I remember Slava handing it over to Mother and Mother's inquisitive look. Perceiving her hesitation Slava

assured us that this particular soap was not the notorious product of questionable origin (perhaps Jewish fat?) that an irresponsible rumor, surely untrue, was spreading among our people. When she left, Mother took out our small piece of Russian military soap that vaguely smelled of fish and left the German soap on the sink.

This moment of unease did not trouble our overall enthusiasm. Who could have dreamed of a better welcome? To me, the dull city of Lodz was enchanting. And so it remained for some weeks, until my first days of school.

In the beginning everything moved in the right direction. Even the mint condition of our belongings that had traveled so long a time in our crushed suitcases surprised us. Wrapped in a water-resistant cloth they had survived the rains and the dampness of our journey. Aired and ironed by Mother's and Yetta's clever hands, our modest stuff looked like new. Even my Vilna watercolors and the oil portrait of a sadly smiling me, diligently painted by Professor Serafinovicz, had arrived intact.

Our friendship with Misha and Slava was anchored in the special bond that we carried from the days in the HKP labor camp, when Slava, by dragging us to her cell, had saved my life. Now, in Lodz, they cared with the utmost devotion for our well-being. Two or three days of rest and relaxation restored us. Again we belonged to the human race, and Tamara's blond locks evoked a prewar memory of Shirley Temple. I looked at myself in the mirror of Misha's bathroom. I was as fresh and as pink as in the painting by my beloved teacher from Vilna. Professor Serafinovitch had portrayed me peeking from behind apple blossoms, and much as I admired her art, I now found my appearance in her portrait too cute, almost girlish. I was nearing twelve and a doubt of this kind troubled my boyish sense of self. I hoped that in reality I looked hardier than that.

Lodz looked strikingly different from Vilna. Since the city had barely been burned or bombed, it evoked something outlandish, something

quite unlike the postwar devastation to which my eyes had become accustomed. The picturesque shabbiness of many of its streets, their gradual aging that did not speak of a sudden brutal aggression but rather evoked time's serene flow, made it look peaceful and welcoming.

Four or five days after our arrival we moved into lodgings of our own. This was an important step. The less than modest place, verging on squalor, befitted our meager finances. We had no money and Mother was too proud to ask for help. Besides, the few Jewish aid organizations that were just then being created were barely functioning. The difficulty of our material situation was a result of Mother's high moral standards. She had a very elevated sense of what was morally right, and this attitude, which many of her admirers thought highly laudable, proved in times of chaos, inflation, and a black market economy to be rather impractical. In Vilna Mother had adamantly rejected any form of profiting from her key position in the well-equipped store that catered to the upper echelons of the Communist administration and never allowed herself an income "on the side." This had limited her savings to what could be retrieved from the income of a modest Soviet state salary.

This was the state of our affairs when we said goodbye to the elegant street of Misha's bourgeois building, goodbye to his spacious rooms and lovely porcelain bathroom. "Guests are like fish," said Mother. "After a few days they start to smell like soap." We went to live in a long, damp, and narrow room on a fourth floor, with only one window that opened over a landscape of blackened roofs and dilapidated chimneys. The view was our lodging's best feature. Indoors, a telltale design of fascinating stains on the ceiling conveyed to us a clear warning about what to expect on the first rainy day.

"We must prepare buckets to collect rainwater," said Yetta. "It will be wonderful for shampooing our hair; people will be astounded by the softness of Tamara's locks."

It was a humble neighborhood of prematurely aged buildings that had been hastily erected in the later years of the nineteenth century for housing poor textile workers. Our building, like many others, had a large prisonlike courtyard with wooden balconies that surrounded each floor. The balconies, accessible by exterior stairs, served as corridors and led to a multitude of dwellings. Day and night the place throbbed with activity. It took me a moment to identify the pungent smell that welcomed us. The balconies were drenched in chicken filth and feathers. I noticed hundreds of small cages made of wood and wire netting. These flimsy cages, which contained a massive population of chickens, were stacked one on top of another and considerably narrowed the space for human passage. This poultry industry, which in principle the city had outlawed, seemed to bother no one. The cages were often left open and their winged inhabitants strolled about freely, covering the balconies with slippery and foul-smelling dirt. Sometimes the chickens clashed with each other and brutal battles ensued. Seeing a terrorized chicken fly down several floors, screeching at the top of its lungs and desperately beating its inadequate wings before safely landing on the ground's cobblestones, was a spectacle that the children adored. They surreptitiously provoked such occurrences. All this was part of an improvised postwar urban enterprise that supplied the families with eggs and poultry-meat, the children with living objects for fun, and the courtyard rats with adequate leftovers.

In order to climb the stairs to our new place, we had to pass some open doors of smoke-filled kitchens. Stoves were lit and many pots and pans must have been producing palatable odors. But the air was permeated by the sickening stench. The stench was always there, and only heavy rainfalls accompanied by wind could cleanse it partly away.

"It is advisable," said Mother, "to become accustomed to this stink as quickly as possible. Let our noses become desensitized and rapidly forget about it." Then she smiled and her eyes shone. "Anyway, dear children,

all this is temporary. Palestine smells of orange blossoms and cool Mediterranean breezes!"

I saw that in spite of Mother's optimism things were not necessarily improving. On the whole, we were less comfortably installed here than in the partially bombed building in Vilna, the place we had called our own. Yet perhaps everything was a matter of "compared to what." I thought it over and realized that we were much, much better off in our poor lodgings in Lodz than we had been in our cell in the HKP camp. Here there were no Nazi guards, the adults were not forced into slavery, and our lives were in no imminent danger. The room contained one bed, one old box spring (similar in size to the far better one that we had abandoned on the tracks of Kutno's train station), a cupboard, a small kitchen table, and two chairs. A rusting sink with a faucet that dispensed a thin flow of reddish water completed our humble amenities. The lavatory was on the floor below, and this was lucky since a line of noisy and unpleasant people often stood in front of its door.

Such was then our home, and as we were on our way to Palestine, these conditions were to be considered temporary. Patience, patience. Whenever I complained, Mother would repeat to me that in the ancient Jewish homeland of milk, honey, and oil, an eternal summer was awaiting us. She considered herself an unfaltering Zionist. It was a postwar Zionism born of the tragic events of the Holocaust. She had contacted the Brichah, the organization that would provide us with papers for the rest of our trip. They also said: "Patience." I did not like this use of the word "patience," and its purpose worried me. Every time Mother mentioned Palestine as our final destination, my heart stirred in protest. What about the magical city of Paris, the city to which I fervently believed I was destined? But I kept quiet. I vaguely anticipated a confrontation, but it was to come much later.

The Lodz summer was not yet over, and the open window brought

some fresh air that helped us to forget where we were. Yetta examined some passing clouds and said that she eagerly awaited a rainstorm. She had to wash her hair and set it nicely for a forthcoming date. Altogether we considered ourselves quite happy.

Going to School

The neighborhood school was about to open its doors, and Mother signed me up. Although we hoped to resume our travel any day, it was impossible to tell how long we would have to wait for the indispensable papers. After all, the Brichah told us to wait patiently and let them do their job.

"Why linger aimlessly?" was Mother's question regarding my schooling. I should join children my age, children who had always gone to regular classes, and acquire a foretaste of the experience I would get in "a normal school in the Land of the People of the Book." I badly needed such preparation, and Mother thought that going to school in Lodz would bring me two benefits. It would enrich the Polish language that she and I used together, and it would let me meet boys my age. I must admit that I was eager to compare the learning I had acquired over the past five years with that of other boys. Mine was the combined result of Mother's tutoring, the teachings of the nuns, evenings spent with my teacher in the ghetto, and extensive reading. How would this compare with the general knowledge that a normal boy my age possessed, a boy whose life had not been so badly disrupted. I was curious.

Upon entering my new class, a room of shabby green walls and windowpanes still carrying the tapes that prevent flying glass in an air-raid, I noticed over a grayish blackboard a dark crucifix. It reminded me of the Benedictine convent and gave me a pleasant feeling of security. I tried to choose a seat on one of the old wooden benches but was repeatedly asked to move elsewhere. I understood that several boys who wanted to be

seated next to their old friends were saving these places. A skinny boy with thick glasses seemed to be pleased that I chose to sit next to him. Also our principal teacher took an immediate liking to me. She was a middle-aged woman with strikingly dark eyes and undulating black hair. A shiny silver cross rested comfortably on her large bosom. She pointed out to the others that in spite of my "northern Vilna origin" my accent was impeccable, my spelling more than correct, and my grammar exemplary. She liked to have me read aloud and asked the other pupils to emulate the clarity of my diction. Her well-intentioned remarks triggered an outburst of sneaky mockery and derision. I was singled out and condemned to remain an outsider. The most troubling moments came during recess, when the teachers were out of hearing range. My classmates would come up to me, sniff me out and murmur that for "a regular kike" I smelled not too bad. There was no attempt at physical violence, no pushing, pulling, or kicking, but the overt anti-Semitism of a few boys, nonchalantly tolerated by all the others, started to annoy me greatly. I tried to ignore it for several days, but the anguish I felt every morning on leaving for school soon made me speak about it with Mother.

"We do not need this!" she said. "Soon we will live in a Jewish state, and you shall study there in Hebrew and Yiddish. Meanwhile let's focus on painting." (About the Yiddish she was naively wrong; but that's another story.)

This is what I did. I left school and found refuge in the sheltered atmosphere of Professor Richtarski's studio. Mother chose him from among a few other candidates. That she agreed to entrust me to him was considered on her part an act of benevolence. The professor was an elderly man plagued by ill-fitting dentures that gave him a slight speech impediment. In addition to his blurred speech he used a vocabulary that I found difficult to understand. In order to profit from his teachings I had to figure out his real intentions. I did it by observing the work of his other

pupils, young adults and older persons. Their work intrigued me. Engaging them in talk, I tried to gain an insight into the mysteries of "expressionism" and "abstractionism." I found it all very obscure.

In Richtarski's studio I concentrated on portraits and still lifes. My brushwork loosened up. In spite of the crammed conditions of our lodging, I also continued painting at home. Our small kitchen table was often transformed into a base for a painting's model, mostly a vegetable or two, some fruit, and at times a pitcher or a bottle.

"Is it a still life, or can it be eaten?" was my little Cousin Tamara's regular question.

She had a healthy appetite and food was scarce. "Soon the stuff will rot," she would object when I signaled her not to touch the arrangement on the table. I knew that one need only arrange some folds in a piece of fabric, place a few natural or man-made objects in a spatial relation to each other, and the whole setup would become something precious, not to be moved. But I had no idea how to explain all this to a silly little girl of six. Yet it was important to teach her one of the basic rules of art. To create the illusion of reality on paper and make it eternal, one had to arm oneself with a sense of restraint, a readiness for sacrifice. It was one of Mother's slogans: "Art demands sacrifice."

Economy and Adventure

The lodging, food, art instruction and materials, clothing, and other needs all had to be paid for by good money. Since our meager savings were almost used up, and the steadily increasing inflation had made whatever had remained of them look even less substantial, money had to be earned as quickly as possible. It was decided that unlike the arrangement in Vilna, our breadwinner would now be Yetta. Mother was more than happy to delegate this responsibility to her resourceful sister. She took upon herself the household tasks, the care of us children, and all the

errands for the preparation of papers that were needed for our future travel. She wanted time to recover from the anguishing experience of her former employment, the long period of tension that had accompanied our plans of escape, and the frightening border crossing. In order to forget all this she needed some calm.

Employment was scarce. The only profitable occupation was the black market, which required the courage to delve into illegal transactions and accept hazardous conditions of transport. Thus Yetta started to travel back and forth between Lodz and the German towns that were being forcibly evacuated. She would take suitcases filled with sausages, cheeses, eggs, or vegetables, and exchange them for clothing, shoes, and utensils. She often returned in the middle of the night. Her knock on the door was gentle, but it woke us children. Mother made tea. Tamara would cling to her mother with her arms and her legs and suspend herself on Yetta's neck. I would tease my little cousin. "Monkey, you are a real monkey." Yetta disregarded my pestering. "Oy Samounia," she would say. "I am sorry my grandfather the peddler whose name you carry, did not live long enough to enjoy all the *nakhos* [gratification] I could give him now with my own peddling!"

Men always swarmed around my aunt, and one or another of them would help her carry the heavy stuff up to our room. "See, I am not only a proud apprentice of your great-grandfather. My own mother, may she rest in peace, would have recognized in me her talent for business . . ." and Yetta would continue to unpack her bundles and embark on endless stories of her most recent adventures.

Since in a postwar economy printed money inspired little trust, a large part of Yetta's transactions, many quite profitable, had to do with simple bartering. Sometimes I would bring Professor Richtarski several eggs, not so much to enrich a still life as for his pleasure in the art of eating. Our small living space grew more and more crowded with the materials of

Yetta's enterprise. The rewarding results of her travels, which she courageously undertook in trains, trucks, or horse-drawn carriages, nicely padded our savings. Although she tried to work single-handedly, except for employing a few temporary carriers, her business could not remain unnoticed for long. Agents of powerful gang bosses who tried to control this lucrative traffic made themselves known. There was a constant struggle over territorial rights, and their watchfulness left little room for individual enterprise. My aunt's efforts to use unexplored venues failed. Yetta, who was but a small sardine in a sea of sharks, began to be afraid.

Cases of murder were not uncommon among these ruthless bosses. I wondered what acts she might have witnessed and suspected that she was aware of terrible deeds. Yetta loved to share secrets of her adventures with Mother, but we children were kept in the dark. Yetta would employ with her skeptical sister such colorful techniques of storytelling that it took some time to dawn on Mother that many of my aunts' tales were indeed true. With the authority of the older sister Mother decided that Yetta had to stop her lucrative activity. Our paperwork had to be sped up. The sooner we left, the better.

By this time I was very sorry to leave Lodz. I had begun to like Professor Richtarski's teaching, his messy studio and several of his crazy pupils. Despite the fact that he said unkind things about Professor Serafinovich, claiming that she was very dry, that she had poisoned a gifted child with obsolete ideas, and calling her scornful-sounding names like "classicist" and "academic," I still managed to like him. I could never ignore the fact that Professor Serafinovich had painted my portrait in oils and given it as a gift to my mother and me. Although she had painted me looking slightly girlish, I still loved her and believed in her art more than I did in Professor Richtarski's. The fact that he never expressed a desire to paint me may have had some influence on my judgment.

Zygmunt

Zygmunt was the name given me by the nuns in the Benedictine convent. Zygmus (the diminutive) was superior to the Jewish sounding Samek "because much safer." At a later moment in our wartime drama, the name's weight was reinforced by a speedy baptism that Aunt Janina performed on me, "officially" naming me Zygmunt. This occurred after our lucky escape from the Nazi-occupied convent, and before our precipitous return from her house to the ghetto. After the liberation, I took up my old name Samek, but Janina prefered to call me Zygmus.

In Lodz, the overly familiar and troubling name "Zygmunt" suddenly invaded our life. It was the name of an elderly man (elderly to me), who was insistently wooing Yetta. Aunt Yetta, hardly thirty, besides being quite good-looking, was a captivating and sexy woman. I was greatly influenced by Mother's negative attitude toward Yetta's suitor and therefore I viewed him with great reserve. How could I have known that he would one day become Yetta's devoted husband, little Tamara's loving stepfather, and an uncle of mine? This man, a survivor of the Chenstochov ghetto where he had lost his wife and children, was over forty. But Mother's disapproval of him was not because of his age. She simply considered him uncultured and stupid; his Yiddish was abominable; his culinary tastes a real disaster; and his siblings, all of whom had fortunately managed to survive the horrors of the German occupation—a unique collection of "mentally deficient pompous asses." Mother was swift and unforgiving in her judgment and very pronounced in her choice of words. And since, alas, Grandmother Shifra was dead and could not protect her silly "Yetele" from the menace of such a mismatch, it was Mother's sacred and self-imposed duty to block all matrimonial offensives from Zygmunt's direction.

However I, personally, did not dislike Zygmunt. True he was quite

boring and his bland looks made him not very exciting, but he had a good nature. Whenever he came to visit us he carried a brown paper bag. We, the children, knew that it contained a little gift for Tamara and me. These were mostly inexpensive dark blue plums, often astringently sour but at times quite sweet. It sometimes happened that the bag that arrived with him would quickly disappear when he learned that Mother and Yetta were not yet home. It would reappear on the occasion of a later, more successful attempt. The always cheerful Zygmunt clung to a "mission" of amusing us with the latest jokes. He possessed an endless arsenal of banal anecdotes that he would tell with a beaming face and an air of self-congratulation. The jokes, of which he often missed the point, were followed by an explanation of what was so funny about them. He vehemently believed in his ability to enlighten us in this domain. His absurd conjectures often provoked so much hilarity that he took himself for an unparalleled entertainer.

Zygmunt and his siblings dabbled in the black market, a common trade in those years, and this is how Yetta met him. In his prewar life he had played the violin in a small group that accompanied silent films. I don't know what happened to his musical career once talkies arrived. Perhaps the outbreak of the war inadvertently solved the problem. Zygmunt was proud of his musicianship. According to him, his specialty on the violin was a particular pizzicato with which he imitated bullet shots and machine-gun fire. He did it in perfect synchrony with the moving images; no other violinist in Chenstochov could claim comparable expertise. It was this kind of bragging and mindless chatter, together with his addiction for explaining jokes, as well as his preference for sweet gefilte fish (in the Polish manner) over the spicy Lithuanian variety, that disqualified Zygmunt in Mother's eyes. Years later she admitted that her judgment might have been hasty. She learned to accept him and moreover to acknowledge his qualities of decency, devotion, and affection. Whenever

she critiqued her brother-in-law she would finish by conceding that he was "a good soul."

When in 1981, on the tenth anniversary of Mother's death, the close family gathered at her grave in the small cemetery of Savyon in Israel, Zygmunt was genuinely moved. After so many years he still wiped a tear over her untimely death. Then he looked at me with a thoughtful gaze and said, "Ten years already, unbelievable!" He shook his head a few times and continued: " Do you know, Samek," and this was said with a clear intention of cheering me up, "how much you would have had to pay today for a tombstone of such beautiful marble?"

Had Mother been standing in the small cemetery next to us, how she would have roared with laughter. But her bones were in the ground and her spirit, split into different ways of remembering, hovered in the separate spaces of our mourning minds. In mine she was making spicy observations on her brother-in-law's well-intentioned condolence.

Back in Lodz in the autumn of 1945, twelve hours before our planned departure for Berlin, it became clear that my little cousin Tamara, who had been struck by a high fever, had come down with mumps. It was not a tragedy; her condition evolved as a child's disease should. But it froze our situation, and this fact was hardly a laughing matter. The doctor's verdict had been categorical: no traveling for three weeks. The long-awaited and freshly received travel papers, special documents that allowed us to cross the Soviet zone to West Germany, were in our hands. They were precious, but their validity was limited and could not be extended. Apparently this had to do with certain details intended to make them look as authentic as possible.

Surrounding Tamara's bed we looked at each other in disbelief. We were more than ready to leave. Our lease was terminated, we had made our goodbyes, we were packed, and the railway tickets were in our pockets. Also ready was our traveling companion, a Jewish girl of fourteen,

who waited with us in our room. She was an orphan whom Mother had promised to bring to Berlin and deliver to her relatives. Now bent like an old woman, the girl was sitting in a corner of the room terrified of catching Tamara's contagious disease. Zygmunt turned to Mother. "Don't give away your tickets. Go to Berlin on this afternoon's train," he said. He tried to look serious and dependable. His luck had given him a chance to be free of Mother's surveillance. "Don't worry, I'll help Yetta overcome this difficult moment. It will be a pleasure to take care of the darling child. Wait in Berlin, and as soon as Tamara is better I'll put the two of them on the first train. I'll see to their documents. Don't worry. By the way, this reminds me, did you hear the very funny anecdote about. . ."

Also at the time of our departure from Lodz there was no photographer to immortalize the three of us—Mother, the Jewish orphan, and myself. I would love to see an old picture of this particular event. I was at the point of leaving forever the country of my nationality (for what it was worth) and my language. But it did not seem to matter. I felt indifference, perhaps a sense of liberation. What was important to me is that we were to travel in a wagon meant for humans, and not in a cattle car. I shall forever remember the pleasure of touching the rounded wooden seats, designed for real travelers, and looking at the glassy surface of a window through which I could see the station's huge clock. It was ticking for me the last minutes of my life in Poland. The window was meant to show us the scrolling by of landscapes we were abandoning with a sense of relief. In my heart I was praying to some superior power whose mischievous nature often interfered with our plans. Yes, we deserved to be forgotten and left in peace. No unforeseen event should shake us from our present purpose. I had been told that only a few hours separated me from our next station: Berlin.

BERLIN

It Is Good To Be a Jew

The direct train from Lodz to Berlin was not as overcrowded as I feared it would be. To travel on it one needed special permits to cross the border, and such documents were hard to obtain. We were privileged. That our papers were counterfeited was beside the point. I sat next to Mother and listened to a flood of the orphaned girl's wartime stories, about her posing as an Aryan, and the family she had lost. There was something lifeless in the way she spoke, as if she were repeating a difficult part. Perhaps her stuffy nose was leaving her too breathless for such tales. Mother, while showing her much sympathy, nervously checked and double-checked the tickets and the precious documents that had been given to us by the Brichah. I knew that Berlin had once been a great city. Now, totally destroyed, it was divided into military zones of occupation. Where shall we settle down? How long is our stay going to be? I knew that our first priority was to search for Uncle Arno, Grandmother's brother. And, of course, we had to wait for Yetta and Tamara.

As the train gathered speed it whistled joyfully. The girl slowed down, took prolonged pauses, and became silent. Absentmindedly we looked at the passing landscape, at the other voyagers, and felt confident. Our imagination could not have prepared us for what lay ahead.

On the day of our departure the headquarters of the Brichah had been searched and a specific order to stop all passengers carrying its papers had

been wired to the border police. This sudden change of policy toward the Jewish organization remains an enigma. Historians are still trying to understand why the Russians decided to hinder the flow of Jewish refugees toward the American zone, and why the Polish authorities of a not yet Communist regime were so compliant. At the end of October or early November 1945, I was ignorant of all that. Instead I was trying to imagine meeting Mother's uncle, the famous Arno Nadel. I hoped he had survived. Mother's attempts to contact him had brought no results, but there was little trust in the functioning of the post, and hope had to be given a chance. Gently rocked by the train's steady rhythm, I fell asleep with my head on her knees. I woke up when the train began to slow down. It was pitch dark and we seemed to be in the middle of nowhere. Then it came to a halt. Suddenly lights were pointed at us. Parallel to the train stood a row of trucks whose headlights illuminated a large area in front of the stopped cars. In the glare Russian and Polish police opened the doors of the wagons and mounted their steps, shouting in both languages: "Everybody out! Everybody out of the train! Prepare your papers for Control!"

The three of us looked at each other in disbelief. It was clear that something unexpected was happening. This was not a simple border control. Something had gone very wrong. Mother grabbed our rucksack and cardboard suitcase, told the girl to follow, and stepped out on the darkened side of the train. The beams of light that shone through the wheels reassured us that this side was not guarded. No one had seen us descend. We started to run forward toward the engine. Fortunately, a continual shouting of orders from the other side covered the sound of our footsteps. I feared that my heart would get stuck in my throat.

Today, when I close my eyes and recall the image of our three hurrying silhouettes, a shudder of the old panic still seizes me. I see us run over an invisible ground that is treacherously uneven. Mother holds onto our

stuff, the rucksack and the small suitcase, while the girl and I cling to the tail of her coat. We advance as quickly as we can and reach the head of the train. The steam of the puffing engine engulfs us. Mother climbs a couple of steps and knocks on a heavy metal door. A dark figure, certainly the train engineer, opens it. Mother tells him in Polish that we must get to Berlin. Urgent family business. Perhaps a funeral. As she speaks, she removes her cheap wristwatch that glitters in the dark and hands it to him. A deal is made. He tells us that we cannot travel in the engine but he will take us to a safer car. He descends, walks with us the length of two wagons, and opens a door that admits us into a dark space. I take it for a wagon of goods or luggage. He pushes us in, hands over the suitcase, closes the door, and disappears.

The first impression is of total blackness, then gradually contours start to emerge. Strange animal-like sounds and bizarre smells filter into our small space. We are in a sort of anteroom that gives access to the rest of the car. Two or three Red Army men in heavy coats, reeking of vomit and alcohol, are spread on the floor and snore. I hear distant voices and see some light filtering through the side of a closed door. As the train begins to move and picks up speed, I can hear the rhythmic knocking of the accelerating wheels. I listen to it attentively. It tells me that the worst is over. Suddenly a man in uniform opens the door; and in the dim light I can see around us half-dressed soldiers and women lying on mattresses. Mother hugs us children to her bosom and tries to put her arm over my eyes. I cannot see properly, and it annoys me. I angrily turn my head because I want to know what is actually happening. The girl traveling with us is meanwhile trying to hide behind Mother. In spite of Mother's clear "Shshsh" she is unable to refrain from audible whining. A deep male voice is saying something. I can hear Mother explaining in Russian that we were put into this car by mistake. This authoritarian voice, perhaps that of an officer, tells her to stay put and no one will harm her. From my

uncomfortable position I hear merry voices and lots of laughter. I try to identify the strange smell that is invading us. Is it vodka, sweet perfume, or human perspiration? These odors seem to be mixed with an unfamiliar smell that might belong to the heavily breathing animal, or animals, that are being transported with all the rest.

At the next stop some soldiers, whistling and laughing, mount our car and try to prevent us from leaving. But we manage to descend and rush back to a passenger wagon. We find it half empty. A man sitting there tells us that a lot of people were detained at the Polish border. He whispers that if we are traveling with "bad" papers we'd be wise to throw them away immediately. Mother hurries to the toilet.

The sky starts to lighten. Our train takes us through the outskirts of Berlin. We see endless stretches of bombed and devastated landscapes swarming with drab Russian soldiers, muddy military vehicles, and heavy machinery. Groups of war prisoners and civilians are at work collecting rubble with their bare hands. Before the Berlin gate there is another checkpoint, and the train stops. This time the armed officials are in Russian uniforms only; many look Mongolian. Their officer, a type from southern Russia, has a Semitic look. When he demands the always important papers, Mother looks into his eyes, takes a short pause, and boldly tells him in Yiddish that we have no papers, but we must absolutely get to Berlin. "It is there that I have my only living relative. We have had enough sorrows. Please leave us alone. Please."

The officer stares at us intensely and offers us a faint smile. He looks at the indifferent expressions of his soldiers and quietly answers Mother in Yiddish, "Okay, you can go." All this was over half a century ago, but to me it might as well have happened yesterday.

When we emerged from a ruin that used to be a beautiful railway station, everything looked familiar. Before us were bombed buildings, silhouettes of walls with bits of tattered wallpaper still clinging to them.

The landscape of devastation reminded me of Vilna. We walked through long stretches of labyrinths that used to be streets. Intricate parts of a devastated subway system were now exposed to the light of the day. Mother found lodgings in a room of a fourth-floor flat in a building of which only the staircase shaft and a small sliver of several floors had remained standing. I would stay there alone for hours, looking out at the sad perspective that spread into the far distance, imagining how it must once have looked. Mother had a lot to do. At first she had a hard time finding the girl's relatives. (Today, I ask myself if I ever knew the girl's name and what might have become of her.) Later, Mother made an all-out search for Uncle Arno.

Her effort brought us very sad news: Arno Nadel and his wife were sent to Auschwitz, and no one had ever heard from them again.

Meanwhile a week or two passed. At an address that was connected with the Jewish organization in Lodz we regularly inquired about Yetta's arrival. Now she was the only reason for us to stay in Berlin. Finally, instead of her, there arrived a message. "Please do not wait for me," wrote Yetta. "I have decided to marry Zygmunt. We'll meet with you in Bavaria; leave your address, when you finally have one, with the organization that traces relatives! Wish me good luck. Don't worry. I'll find you."

Mother read it with an amused expression. She later observed, "Such things happen only to my sister."

Consequently it was time to continue our journey. We left our rented room and made our way to a refugee camp about which we had inquired. It was in the American sector, in an area called Tempelhof. The city of Berlin, divided among the four victorious allies, floated like a besieged island in the Soviet zone of occupied Germany. Rumor had it that the American camp provided safe transportation to the west, and that it was the only way to escape the suspicious control of the Russians. Mother was determined to get to the American zone in South Germany. It was com-

mon knowledge that any Jewish refugee who dreamed of reaching the Promised Land had to pass through Bavaria.

The Tempelhof camp was a group of military buildings, barracks, and tents. Arriving there we passed a multitude of trucks, jeeps, and numerous groups of American soldiers. They looked better fed, better dressed, and much better equipped than the Russians. A huge crowd of refugees stood lined up in front of one of the gates from where they were being led to an adjacent building. We could hear them speaking in a babble of languages. Mother interrogated some and discovered that we were waiting at yet another checkpoint, this one to ascertain whether or not we were Jews!

"I cannot believe my ears," she said. "Not again! Even the American army. . ." She was on the verge of tears.

Some people who spoke to us in Yiddish tried to explain: "The army's reason is very different from what you think. They must filter out 'undesirable elements.' The American army is not anti-Semitic. At least officially they are not. They even say that a great commander has given precise orders to treat us well. If you are Jewish they will help you cross the Russian zone and reach one of their own camps where they do more for us Jews than the British, French, and Russians put together. "Don't lose courage. *Es wet zayn mit mazl*. All will go well." I looked around. There were obviously many Jewish survivors among us, but some people looked as if they belonged to other nationalities. Some even looked like Germans trying to pass for Jews.

"It is a pity," said Mother looking at them, "that Hitler did not live long enough to have the pleasure of witnessing this."

"It seems there is a rabbi behind this door who makes the important decision about who is Jewish," said one of the men in the line. "He asks people to recite prayers, or say some *berahot* [benedictions]." A number of people in our crowd began to stare questioningly at each other, some

started to panic, and several tried to recall old forgotten prayers. Rudimentary and at times erroneous concepts of "Jewishness" were being exchanged. Mother refused to participate in all this and silently continued to wait. When our turn came I looked at her and saw that her face had paled and she looked sick. I tried to figure out her state of mind. Was I guessing right, did she feel a terrible humiliation? It must have had to do with our Jewish identity. As we entered the rabbi's room, my eyes searched for an elderly man in black with a yarmulke, sidelocks, and beard. None of the young military men in the room resembled such a person. One of the army men behind a desk, slightly older than the others and clean-shaven, in an impeccably ironed uniform, asked Mother in an alien-sounding Yiddish if she was, as she claimed, *really* Jewish.

He had hardly finished his sentence when Mother opened her mouth, and her trembling voice carried with it all the fatigue, anger, and mortification of the recent days.

"You son of a bitch, how dare you?" Her lips became tight: "Go, go and fuck your mother . . ."

This in a vulgar Russian that never before had I heard her use! And then in Yiddish she added, "Where have you found the chutzpah to ask me such a question! Look carefully at this boy and make up your mind." While I was trying to guess if the young rabbi knew Russian, and if he understood the unspeakable advice that Mother had given him, he turned ashen, clumsily apologized, signed a paper, and expedited us with his approval to an exit where smiling soldiers with cigarettes in their mouths covered us with a heavy cloud of DDT powder. Thus did the American authorities certify us as Jews.

Checkpoint Charlie

Mother and I remained in the camp only a few days, sleeping in a large and overcrowded dormitory. When we left Berlin we were packed with

about thirty other refugees in a huge army truck driven by two men in uniform, a mature dark-haired one, and a light-haired, skinny, and boyish assistant. Both smiled at us, waved their hands, and even offered cigarettes. As we were later to learn, they were hazardous drivers and not very experienced mechanics. Vehicles of the American army, employed for military use, were not supposed to undergo Soviet scrutiny. A heavy and watertight cloth meant to give shelter from rain covered the truck's platform and conveniently hid us from the sight of the Russian authorities. Was it to be another clandestine border crossing? Such a thought bothered me, but I refrained from asking questions. Instead, in the hands of the two representatives of the most powerful nation on earth I told myself we were safe. What other choice was there?

In 1965 I returned to Berlin. Twenty years had gone by. My plane landed at the Tempelhof Airport during a heavy snowstorm, and I was quite shaken. But my comfortable room in a modern hotel that belonged to a world far from the memory of that camp's crowded dormitory helped me to relax.

Nevertheless, I was so loaded with the weight of the past that I arrived in the city of Berlin with little enthusiasm. The reason for my short stay was to design scenery and costumes for a play by Sholom Aleichem that the prestigious Volksbühne Theater of West Berlin had decided to produce. Intensely taken up by my work during the hours of the day, I had several free evenings and decided to dedicate them to performances of Brecht's Berliner Ensemble in East Berlin. "Nothing could be more simple, Herr Bak," said the managing director of my theater, "I'll call them, and you will find your tickets waiting for you. Take the underground train to Checkpoint Charlie, show them your Israeli passport, and once you are on the other side, continue by taxi."

It was a cold, wet night. When I stepped out from an almost empty train onto the platform of the terminal station, I was one of three travel-

ers. A few neon lights blinking at random gave this underground space a sinister look. I followed inscriptions and arrows. My two traveling companions suddenly disappeared. A door guarded by armed policemen in heavy coats brought me to a greenish corridor. From there I entered a room designated for passport control. It was a concrete cubicle with one door and one small window through which an employee stuck out his hand. He silently signaled to me that he was waiting for my document. "I am here for the theater," I said. "One moment, please," he said, and a metal slide closed the small window, leaving me disconnected from the rest of the world. I sat down on a small bench. "Solitary confinement," I said to myself, almost aloud, trying to make fun of the creeping feeling of angst that was overtaking me.

Time passed. More and more frequently I looked at my wristwatch. Luckily the play would not begin for another hour! Time was passing more and more slowly. Why the hell did I have to bring all this anguish on myself? Does theater, however well performed, justify such agony? My mind started feverishly to fabricate scenarios in which the East German authorities contact the Soviets about an elderly child prodigy who together with his criminal mother in the summer of 1945 had escaped arrest by their police. Other scenarios dealt with Israeli espionage, Polish persecutions, and such. Twenty minutes later, when the man in the little window returned my passport, wishing me a pleasant evening, I was covered in cold sweat and an invisible ring of steel had compressed my stomach into one agonizing cramp.

"Border crossings and I are not made for each other," I said to myself, but Brecht is Brecht and life has to go on. There were no taxis on the other side of the checkpoint, and the street through which I had to walk to the theater was very dark. A light rain kept falling gently, soaking my coat. It distracted me from minding my crumpled shirt, equally soaked by cold sweat.

[414]

From the North to the South

The truck that in 1945 was supposed to transport us from Berlin to the American zone in West Germany had previously been used to remove rubble. It was a heavy and noisy machine, probably difficult to maneuver, constantly squeaking and puffing, and at times producing shuddering explosions. There were a few improvised benches fixed to the vehicle's side flaps, but most travelers sat on the meager bundles or suitcases that littered its dirty platform. We were leaning against each other to prevent being thrown sideways by the fast curves taken by our enthusiastic drivers, whose efforts to gather speed caught all the bumps and jolts of a battle-scarred road. I clung with both hands to my small suitcase, concentrated on not throwing up, and prayed in my heart for another quick breakdown of the engine, of which after a couple of hours there was an entire series. Mother's plan was to get as far as Munich, but we had no idea what our intermediary stop would be, or where we would be spending the night. I asked a few people how far we were from Munich, but no one knew. The many stops during which the two American soldiers tried to repair the truck's capricious engine grew less a nuisance than a somewhat expected distraction. Most of the time it was the dark one who toiled, his entire upper body stuck under the heavy truck's hood, or lying on the cold asphalt with his feet protruding from under the cab.

His skinny helper was sometimes ordered to bring a few tools, to manipulate one of the many levers, or touch some of the buttons; the rest of the time he stood idly by. Once he touched a wrong button and the entire platform, as if suddenly determined to dump its travelers, began to mount at an angle. The panicky assistant had no idea how to stop the motion. People rushed to the rear flap, and anyone who did not jump down in time slid helplessly to the ground amid bundles, rucksacks, suitcases and remains of debris. The young man, visibly embarrassed, tried to

show how sorry he was. But seeing that there was no real damage, he soon joined those who were laughing at the whole accident. He obviously had a poor notion of the mysteries of truck mechanics but amazed the younger among us with his remarkable mastery of manipulating bubble gum, something we had never seen before. Mother, looking at the heap of luggage that was strewn on the ground, and at the few last travelers who were shaking their limbs, silently muttered "Garbage." I wondered what she meant.

Smiling and philosophically lifting his shoulders, the skinny soldier made clear to us how little he knew about what was going to happen. The truck resisted ever more stubbornly our drivers' efforts, and the two men, now soiled head to foot with black motor oil, were at a loss. Luckily some passing military vehicles came to our help.

Toward evening it became clear that we had reached the British zone of occupation. Since there was a language barrier between the drivers and us, we could not inquire why they had brought us here. Had they misread the maps? What we ascribed to their stupidity might have been a case of their following precise orders. Perhaps it was American policy to transfer some of the refugees to other zones? That is how we got to the suburbs of Hanover and said goodbye to our recalcitrant truck and the Americans with their smeared faces.

"There are two men here," said Mother, "who propose that the two of us leave this crowd and come with them. They are to meet friends with whom we shall all continue to Bavaria. It is nice to meet helpful people." Indeed the two, who strangely enough had made the trip from Berlin before, were now carrying our rucksack and showering us with useful information. "There are several international organizations," they said, "with magic names like the J.O.I.N.T. or U.N.R.R.A. that take wonderful care of Jewish survivors. Life in the displaced persons camps in southern Germany is like living in a luxury hotel, indescribable." Mother

observed that all this luxury was irrelevant. We would be gone in a matter of days, or of weeks at most, since we would *Im irzeh hashem* [with God's will], be again on our way to our beloved Palestine!"

But how to get there?

It is hard to describe the chaos in Germany toward the end of 1945. The railway stations were always crowded, and trains circulated, but they did not go on time or in the direction one wanted. I began to understand at that time that successful people did not let things happen to them; if they were smart they knew how to make things happen. Our new companions and their friends, luckily for us, seemed to belong to that latter kind. "Do not worry," they told Mother. " You'll get to Munich. But you must allow us to use your boy to transport some delicate merchandise. No danger, no harm; it is an easy and foolproof operation."

This sudden demand troubled Mother, but nothing came without a price. We were in their hands, and with my approval she let them use me for their money-smuggling scheme. I allowed myself to be wrapped with some peculiar sausages made of women's stockings and filled with all sorts of bank notes. I was dressed and undressed several times and the wrappings repeatedly changed before our black marketeers were satisfied with the way I looked. As we went through different checkpoints nobody paid any attention to the "little fat boy." But the constricting material was a heavy burden that restrained my movements and made me perspire. In the city of Kassel our benefactors brought us to the railway station, blocked our entire group in one of its toilets, liberated me from their merchandise, gave Mother a few banknotes, and disappeared.

Munich was still very far. After a sleepless night in a crowded waiting room, we emerged onto the area that led to various platforms and started to search for people who looked Jewish. To help clarify their and our identity we murmured the magical word *amkho*. The ones who answered were as lost as we were. A squeaking voice over a loudspeaker gave the

number of a platform from which the next train to the south would leave. "Let's hurry!" Mobilizing what was left of our energies we hurried through several underground passages and emerged behind a huge crowd that was barring the approach to an overcrowded train. Some passengers were getting off the wagons by climbing through their windows.

"Impossible to get on the train," said a woman standing next to us. "This is how all these trains look. I've been here for five days and I have never managed to get close to one of the cars."

Jewish young men, some of them in their teens, refugees like us but better dressed and looking healthier than the rest of the travelers, approached us on our third day in Kassel and offered us their help. They were collecting money to bribe a railway employee, and asked if we would like to become part of their group. All in all, the group consisted of forty or fifty people. Mother looked with some apprehension at the faces of these youngsters but agreed to pay, and when an elderly German in the uniform of a stationmaster came to take the money, she felt quite relieved. The man we bribed reserved for us a railway car that was added to one of the packed trains. We felt a wonderful sense of elation. We were finally on our way to Munich, sitting in a third-class car. The uniformed German asked us to lower the blinds of the windows and lock well the doors from inside. For "all that money" he said, we deserved to remain undisturbed.

However, we traveled like this for only a few minutes. Then the train came to a halt. What followed was the noise of our car being unhooked! The rest of the train departed whistling happily, but we remained standing still. "The usual maneuvering," explained Mother, yet as we went on waiting our euphoric mood changed to one of grave concern. Suddenly the younger men in the group, the ones who had collected the money, became very nervous. They lifted one of the blinds. The car had stopped in a dangerous area, they said, probably an off-limits military compound. People stared at each other, what should we do? Our guides began to

shout that we must leave the car at once, run back to the station and run fast. They would take care of the luggage and meet us there. I grabbed the rucksack that was partly hanging on my shoulder, caught Mother's hand, and off we went.

Some time later, surrounded by many of the "paying" passengers, we waited in vain for the men who had retained all our luggage, including my cardboard suitcase. We never saw these men or our luggage again. The suitcase with my girlish oil portrait by Professor Serafinovich and all my works from Vilna and from Lodz that I had so carefully chosen must have ended up decorating a garbage heap somewhere near the town of Kassel—my first exhibition in postwar Germany! I was very young when I discovered the advantage of not possessing an artistic past. Without the cardboard suitcase and the weight of all my works, my soul felt freer and the journey much easier.

We traveled from railway station to railway station, sleeping wherever we could find a corner on the floor. Slowly we got closer to Munich. In Munich we discovered that we were somehow unlucky. Just a few days earlier they had stopped allowing new admissions to the Feldafing DP camp, one of the best according to some of the mavens. We also learned that there was a real possibility that the very best, or second best (here opinions diverged), the Landsbeg DP camp would also soon close its gates.

We had to hurry to Landsberg immediately. Mother found some other refugees willing to share the cost of the fifty-kilometer trip and rented an open truck that was the best our group could afford. The truck driver had trouble negotiating the curves in the road and we were thrown from side to side as in the good old times of traveling with the two Americans. Whenever we approached a curve there was a road sign saying *Achtung Kurve*. In Yiddish this meant "Beware of the prostitute." I found this hilarious and would have loved to share the joke with Mother, but the

thought made me blush. Perhaps I was too young for such subjects of humor. *Kurve*, prostitute, slut, whore, *lakhoudreh*—these words were not funny.

Our perilous journey was over. After all the disregarded warnings our driver seemed disappointed to discover that we had survived his prowess. We had reached the small and lovely town of Landsberg am Lech. On its outskirts stood the DP camp that would host us for the next three years. It certainly deserves a chapter of its own.

LANDSBERG REVISITED

The DP camp of Landsberg in 1945 was an important oasis on the road of our nomadic postwar life. It was a place that allowed me to regain many of the pleasures of a "normal existence." Things that people take for granted: a decent space to live, sufficient food and clothing, some schooling, direction and care from the elders, close friendships, and the freedom from fear for one's life.

Having arrived at that DP camp at age twelve and left it at fifteen, I passed there some of my most formative years. A teenager in a post-cataclysmic and confused world, I was making my way on ever shifting ground, yet Landsberg left me with memories of warmth, content, and even moments of happiness. The dormant memory of our transit in Landsberg was rekindled in 1995 when the Jewish Museum in Frankfurt, which was to publish a small volume on my early works, asked me to write about my experience in this Bavarian camp. While I was on the point of undertaking this task, an unexpected event brought it into an even sharper focus. That event was my first visit to the Holocaust Memorial Museum in Washington, D.C. Going there was a somewhat dreaded undertaking. Although I acknowledged an almost sacred duty to visit it, I felt apprehensive, a need to take "precautions." Thus in order to feel protected and supported I went there with my wife and a couple of close friends. We made a pleasant journey, settled in an elegant hotel, dined in a first-rate restaurant, and dedicated the next day to a visit of the National Gallery's art treasures.

Then came the day of our pilgrimage to the Holocaust Memorial. The weather was agreeable. From the windows of the taxi that took us there I observed the gigantic obelisk, the familiar silhouette of the Capitol dome, the rows of monumental architecture, and the broad alleys filled with busses and cars. Suddenly, my eyes seized upon the surprising course of a deer that was precariously cutting its way through the steady flow of traffic as if it were running for its life. The panicking animal vanished behind one of the buildings. We arrived to the museum's desk early, picked up our reserved tickets and joined a huge crowd of visitors waiting at the door. Inside, the people became hushed, ceased to exchange glances, and followed each other in a solemn procession. The various documents, models, posters, artifacts and photographs that looked at us from behind walls of glass, filled the air with the expected sense of irreparable loss. I felt they were asking from the world some sort of repair, or *tikkun haolam*. Was the world ready to meet that challenge?

Some of us were on familiar ground. Having been part of the story I found little that was new to me. Moreover, I had always considered myself relatively "at ease" with these specific subjects. But the combination of images and artifacts, the effect of their presentation, and the powerful presence of the museum's architectural spaces, all this had an unmediated power, and my ancient scars began to hurt. I began to question the wisdom of this visit. Wasn't my art itself a sufficient daily pilgrimage to the sanctuaries of the *Shoah*? Was it really necessary to expose myself to this additional massive dose of painful recall? Overpowered and weary I detached myself from my group and hurried toward the museum's exit. But the sound of an amplified voice seized my attention and made me look up at the screen of a video monitor. Its flickering black-and-white footage was stirringly familiar. My heart started to pound. Within seconds, with my eyes riveted to the screen, I was back in 1945, walking the central street of our displaced persons camp in Bavaria. The

video's recorded voice must have been offering various other kinds of information, but to me it seemed only to repeat time and again: Landsberg, Landsberg, Landsberg.

Then came an image that stopped my very breath.

It was *myself* on the screen. I was thirteen but hardly looked my age. On the screen I was painting with visible concentration a street scene of an imaginary *shtetl* or ghetto. I realized that someone must have told me to fake the creative act in front of a camera, and I did it with excessively unrealistic speed. I have a photograph of this pose, but no recollection of the existence of such film footage. Half a century separated me from the boy on the monitor. But that large watercolor of an old woman and two children hangs now in my house in Weston, and I was familiar with each one of its brushstrokes. (Their boldness still amazes me.) Unexpectedly I was seized by an almost shameless elation. My sadness and sense of oppression had evaporated. Never had I felt more alive! What was happening to me? I realized that I was confronted for the first time in my life with an objective and undeniable proof of my survival. The overpowering weight of the respected museum, its impressive building, and its vast collection of shattering images had something to do with my exhilaration. Next to the gray, grainy, and blurred faces of thousands among millions who did not "make it" was my boyish and anonymous face. I was there as representative of the few who did manage to escape and were spared. A phenomenon, a real rarity. The image of the running deer on Washington's mall flashed through my mind.

Yes, I told to myself, the respected museum acknowledged the fact that I had survived, and it furnished me with certified proof. Right here in the public domain. This unsettling visit began to make sense. I had to make an effort to keep an inappropriate smile from invading my face. The morose expressions of the other visitors made me regain my self-control, and a certain self-protecting irony helped me gather my spirits. I looked

up. The dependable technique of a short video loop made the young me wonderfully disappear and reappear on the gray screen. Patiently I waited for my wife and friends to join me in front of the screen. Wasn't I somehow frivolous? They were the last people on earth who needed proof that I was alive.

When we emerged from the turning exit door I knew that I was being swept by an irrational and egocentric reaction. I apologized to my companions for feeling so happy. What was the weight of my little personal story in view of all the horror and suffering with which we had been confronted over the past few hours? The noisy and overcrowded cafeteria, by the museum's door, with its insipid coffee served in huge paper cups, was an appropriate setting to reconnect with reality and ponder.

Back home I took a good look at the large watercolor. It was not my best of that period, but it must have been chosen for that filmed sequence because of its size. Now I tried to invest it in my mind with a mission like that of Proust's madeleine. I hoped that it would raise from my past's semi-opaque depths of a desired oblivion sizable fragments of well-ordered recollections. The timing of the Jewish Museum's request for a written memoir seemed perfect. I prepared myself for a flow of orderly remembrances; but instead an avalanche of disordered memories overpowered me, and like material stuffed into an overloaded closet, it tumbled out as soon as I opened the door. Still I clung to the sight of my juvenile watercolor and forced it to return me to my recent Washington visit. To the old black-and-white film footage. To the instant in which my eyes were trying to pierce the video screen, enter it, and walk again on the camp's main road. As I did so, the gray and grainy film image began to develop the vivid colors of my remembered life in Landsberg.

I saw myself arriving with Mother and waiting with a group of similarly exhausted and anxious newcomers at the door of the office for the allocation of living space. I saw a man of the local administration, my

future stepfather Markusha, explaining to us that Landsberg was overfilled and that we had to move on to a different camp. The road that brought us to his office was the one that I would later use to take me to the camp's improvised school.

A whole collection of teachers' faces emerged on the screen of my mind. They floated, as I recorded them, against the background of a map of Palestine and tacked-up Zionist posters that decorated the few small rooms in which the camp's children were packed at school desks that must have been requisitioned from some German institution. Some of the teachers tried to give us a notion of Hebrew, others taught us in Yiddish; few had proper qualifications. All the pupils had experienced the Holocaust, and many under the direst conditions. I saw myself sitting next to Alex, the boy who would become my closest friend. He was the son of the chief of the camp's autonomous administration, Dr. Samuel Gringauz, a survivor from Riga. Alex had lost his mother in one of the death camps, and his father's new wife seemed to have emerged from one of the Grimm brothers' tales. I also thought of my friend Peter, a blond and uncircumcised boy from Prague, whose Christian mother cohabited in the DP camp with a Jewish survivor. We came from countries with different languages. Of various ages, precocious maturity, and a mixed bag of knowledge, we challenged even the most experienced teacher. Since the school didn't offer me much, I preferred to remain in my room and immerse myself in my painting. Painting and listening to stories were what I loved most. Landsberg provided me with good opportunities and ample time for both.

There was something miraculous about this reemergence of a Jewish small town, a *shtetl* as it were, on the outskirts of a Bavarian urban center. Landsberg was notorious for having lodged in its comfortable prison the young Adolf Hitler and provided him with the ideal conditions for writing *Mein Kampf*.

The camp was installed in the former compound of barracks and warehouses of the German army. By the time Mother and I arrived, the continuous flow of Jewish refugees from the East had generated such overcrowding that the American authorities had been forced to enlarge the camp by evicting the German inhabitants from many of the camp's surrounding streets. We were initially lodged in one of the large dormitories, in a lugubrious building filled with dirt and noise. Later with Markusha's help, we found a small room in one of the buildings that had recently been added at the camp's perimeter. It was heaven: in our new flat we shared a kitchen and a bathroom with barely more than a dozen people. Later, when Markusha and Mother married, we moved to an even better lodging. The house was surrounded by flowering trees, and it stood in a small garden. I had a room of my own.

The camp's inhabitants—refugees, uprooted people, survivors of death camps, sole living members of decimated families—found in themselves unsuspected sources of resilience. There was an ardent longing for a return to normal life. Thus Landsberg began bubbling with activity. Men were looking for women and women for men. Giving birth to a Jewish child was a form of retaliation against the brutality of their recent lives. Soon voices of newborn babies were heard crying from lit windows in the night. Personally I would have preferred such joyous disturbances at a greater distance from my own window, but I had to partake in the general celebration of life reborn.

In this ferment of awakening, old political parties began to reconstruct themselves, class-consciousness resurfaced, and even the age-old ethnic antagonisms revived the traditional tensions between the *Litvaks* and the *Poilishe* (the Lithuanian and Polish Jews). It was another proof of the resilience of Jewish collective memory. Groups of young dreamers who had visions of collective settlements in Palestine got organized and created a kibbutz. A newspaper, a local theater, and various cultural

events were promoted by a group of better-educated Jews from Lithuania. Most were Markusha's friends from Kaunas. They also controlled the camp's autonomous administration. Mother immersed herself in work that dealt with social issues, while Markusha worked hard for the betterment of the camp's living conditions. The comfort of our personal, newly re-created family had been greatly enhanced. I wonder if I was aware of the advantages that came from my parents' leadership roles in the camp.

In our camp the industry of gossip thrived. In its café, called Bamidbar (In the Desert), decorated by my murals depicting imaginary scenes of our biblical forefathers' wandering, people constantly exchanged the latest rumors. They had plenty of time. Not many of its residents were involved in voluntary activities, like Mother and Markusha. Some chose the only available form of free economy, the black market, and it accelerated the divide between the rich and the poor. I was too young to understand how healthy it really was for us to be re-creating a normal society with all its inevitable imperfections.

But underneath all that simmered a need to speak out, to unload, to tell the most horrendous tales of death and survival. This was possible only among people who shared similar terms of reference. Only we, the survivors, were able to guarantee to the storyteller conditions of total safety. Many people who in the camp immersed themselves in liberating catharsis, chose later, when confronted with the outer world, to shut up. Who would believe them? But we believed. For endless hours I listened to tales of survival, to the interpretation of those tales by other survivors, and to the scrutiny of those interpretations in the intimacy of my newly re-created home. Many years had to pass before I realized that some of the stories were wishful fantasies. Even this impulse to remake the past was proof that we were all returning into the ordinary stream of life.

Before my observations slide into a socio-psychological field in which many learned and well-informed researchers have more pertinent things

to say, let me go back to the camp's road, so well seen on the video screen. On that road I learned to use my prewar rusty bike, which was bought for me on the black market. It was incredibly heavy and made me spend hours repairing the constantly reopening punctures of its tires. But it gave me the freedom to move around in the camp and to visit the nearby countryside. Sometimes it took me to the office of my friend, the American UNRRA officer, Dr. Leo Srole. He showed me great affection and provided me with reading material and above all with paper, paints, and crayons. The painting materials were bought specially for me by his wife Esther and sent via the army mail. Leo gave me also a lock to safeguard my bike from being stolen, though in Landsberg the word "to steal" did not exist and was substituted by the term *organizirn*, to organize. Concentration camp survivors had a hard time unlearning those doubtful wartime habits to which often they owed their lives.

The road I have mentioned also led to the camp's cinema, which I visited several times a week. It enabled me to recover the passion for films that I had first known in Vilna's cinemas. Here the darkness allowed me to dive into unknown spaces of unfamiliar cultures and faraway epochs. I loved to listen to alien languages like English, French, or Italian and to become part of the sufferings and victories of those very good-looking heroes. They had one thing in common: they were on celluloid film that often broke apart and had constantly to be spliced together. Unlike our real lives, the celluloid ones could be mended as if no rupture had occurred.

It was also on that central road of the camp that I once spent an entire night watching the making of a feature film. It was to be called *Lang Iz Der Weg* (Long Is the Road), a film by survivors about survivors. Several months later Mother and I were invited to its premier showing. I liked in particular the few seconds of "traveling" that I had actually witnessed being shot. I also quite liked the heroine who slightly resembled Mother but did not seem to me as good-looking. Nor was she capable of articu-

lating one single word in Mother's juicy Yiddish. She spoke only German, which I found detestable in the mouth of an actress pretending to be a survivor.

"Kitsch!" was my mother's resolute verdict about the film. "They are trying to show a sweetened image of us, 'better' than reality. It is ridiculous. Just imagine, *mein kind*, they are trying to show the world that the survivors have forgiven the Germans. To whom do they try to sell us?" Mother was a proud woman.

But in some ways we were indeed a disturbing and uncomfortable "merchandise" that was trying to sell itself and longing to be acquired. The DP camp was supposed to be a place of brief passage, but the world did not want us and we had nowhere to go. It often felt like belonging to some rare species in a zoo and being visited by well-meaning observers who came from distant places of opportunity and freedom. In fact many of them were very decent and devoted American Jews who watched our plight with pained hearts. I wasn't aware of the heavy anti-Semitic inheritance of the Roosevelt period and the complex realities in which the Jewish leaders of that time had to operate. I thought I knew everything about America. Hollywood of the forties, which weekly inundated us with its syrupy products, gave me a good share of misconceptions. Meanwhile we were condemned to wait and to wait and to wait. The hoped-for Jewish State was not for tomorrow. "But maybe for the day after." Jewish leaders acted energetically. One of the most prominent speakers was Moshe Shertok, known later, when he became Israel's premier, as Moshe Sharett.

Shertok, Ben-Gurion's second in command, and I met on the pages of the Palestine weekly *D'var Hashavua*. He was on the cover, photographed reading the United Nations representatives a paper demanding the establishment of an independent state for the Jewish people; while inside, on a three-page spread, were my drawings and a dark self-portrait staring sadly at the reader and asking for his attention.

Other enriching encounters were brought about by my growing fame as a small art prodigy. Ben-Gurion, the great Jewish statesman, came to visit the survivor's diaspora in the DP camps of Germany and made a stop in Bad Reichenhall, not too far from Landsberg. For us he was an object of admiration, a sort of Moses incarnated in our times. In later years, as the wise and beloved head of the new State of Israel, he proved on many occasions his total indifference (if not ignorance) to the visual arts and was, of course, amply forgiven. But this indifference was still unknown in 1946, and the organizers of his visit decided to present him with an exhibition of a young and promising Jewish artist.

My paintings were hung on the walls of the building in which he delivered one of his fiery speeches. Somebody presented me to him. I remember Ben-Gurion's tousled mane of hair, his piercing look that was directed above my head, and his warm smile that unveiled some ugly upper teeth and poor dental work that my father, had he survived, could have rectified. Then came the quick and vigorous handshake and his even quicker steps as he rushed past my paintings without a single glance. I understood that we had to fight for a Jewish state, there was no time to lose, and the muses were invited to wait patiently for a more propitious moment.

Had all the muses to be silenced? No, not completely! And this was one of the many contradictory messages with which Landsberg's "University of Life" inundated me, and which often I could not understand. The muses that were hushed during one event were invited to sing on another. Once it was an orchestra created by a young and very promising Jewish genius that everyone seemed to adore. He was named Leonard Bernstein, and he had arrived in our camp directly from the United States. Accompanied by a jovial group of American journalists and photographers, he announced in a much publicized event the birth of a Survivors' Symphony Orchestra.

Bernstein produced the miracle of a real concert in the DP camp of Landsberg. I remember an upright piano totally out of tune on an improvised stage in the huge communal dining hall, on which the conductor himself played Gershwin's *Rhapsody in Blue*. He was accompanied by an orchestra, of which not too many were professional musicians, dressed at his suggestion in the striped uniforms of the Nazi concentration camps. Bernstein declared that the musicians had taken an oath to perform in those uniforms as long as they were forced to remain outside a free Jewish state in the land of Palestine. But the photogenic allure of the chain gang attire did not agree with the deeper feelings of the musicians or the public. In the next concert, led by a conductor from one of our camps, there was no trace of stripes. And Bernstein, after his much admired passage among us, proved the full extent of his musical talent by conducting a broadcast concert with Radio Munich's German musicians. Spellbound we listened to it on our cracking wireless, proudly imagining this glamorous young Jew giving strict orders to a bunch of embittered elderly Germans.

Another Jewish genius, this time the bearer of a resounding name that proclaimed its Jewishness to all of *amkho*, Yehudi Menuhin, came to postwar Germany. But he made the terrible faux pas of playing first with a German orchestra, before moving to demonstrate his outpouring love for his unfortunate brothers in the camps. He was unanimously proclaimed a traitor and his love rejected! The camp's paper commissioned me to produce a drawing of a violinist under which a caption, conceived by its editor, proclaimed: "He plays for the devil."

Mother was right. Jewish forgiveness was slow in coming. But my folders containing paintings, drawings, sketches were filling up very fast. The American *Daily Forwerts* reproduced several images of my works. Some of my art reached South Africa and Australia. The various publications brought me an unexpected offer. The American Jewish Joint

Distribution Committee (commonly called *"der joint"*) decided to award me a scholarship to study art in Paris, then considered the capital of art. I was thrilled. A dream that must have originated in the ghetto of Vilna, or even before, was to come true.

But suddenly thunder struck. The United Nations approved the creation of a Jewish state.

Mother stated emphatically that for now there would be no Paris: we would be going to the new, yet unborn State of Israel! Her decision shattered my dearest dream. Devastated, I listened to her solemn words:

"We will live in a Jewish state where you shall get, for the first time in your life, proper schooling. Certainly, you will serve in the army and carry a rifle and no non-Jew will dare to tell you what you can or cannot do. And later, my child, if you decide to study in Paris, you will go to Paris with a Jewish passport. A passport displaying the proud blue and white Jewish Star of David that will have restored our broken world and wiped out any trace of the yellow one. Your sweet name shall be nicely marked down on it in beautiful Hebrew letters and you shall show around this precious document with pride and self-satisfaction!"

Mother's determined character should have prepared me for this speech! Why was I so shattered? Had I been living in total denial of her postwar Zionism? Paris was out and I hated the idea of being separated so long from that city! As a small child I had heard Grandfather Chayim, say the word "Paris" followed by a long and nostalgic "Ahhh." The melody of his sigh was almost painful. In that city he had spent his few years as a young socialist, a political fugitive, hiding from the czar's police. Despite those difficulties, he adored Paris. I felt that Grandfather's dream of returning one day to Paris merited a just reparation, a *tikkun*, only I could provide. That I was dreaming of the magical world's capital of art, a place different from his, did not matter. My Paris was the shrine of art! I visualized a temple with young novices on their knees before their

easels, receiving secret recipes from older artists who, like priests of the one religion that made sense, transported the young initiates to the threshold of revelation. Now Paris had to wait. Mother won this round.

From my vantage point today, I am glad her will prevailed and that we left Landsberg in 1948 for the Jewish state. The years I spent in Israel enriched my life and gave me the knowledge of a language that is indispensable to the immense culture of which I am part. It helped me forge a sense of my own identity. Identity, ethnicity, nationality, justice, religion, faith, allegiance—it was not an easy endeavor to find one's way among all these concepts at an age that yearned for clear-cut answers. Yet there, I learned infinitely more than I would have learned from a Jewish boy's standard preparation for his thirteenth birthday.

For while Mother won our struggle over Paris, I won the struggle over my Bar Mitzvah. In Landsberg I had started to suspect that the true believers in God were those who refused to go to synagogue, and that only nonbelievers needed the synagogue's heart-warming rituals. This perception, for whatever it was worth, brought me to refuse a traditional Bar Mitzvah. It wasn't an easy matter. Mother had found in the camp what she called a "modern rabbi with a shaved face" who prepared boys for their Bar Mitzvahs. When I met this rabbi he was just starting to grow a beard to prepare for a meeting with an American Orthodox congregation that was to give him an affidavit to enter the United States. His teaching system was simple. One had to repeat after him sounds and intonations, to memorize prayers that one did not understand. This instruction had to be done quickly because the rabbi was packing and only the slow regrowth of his facial hair kept him in the camp.

I, on the other hand, wanted to discuss with the rabbi some critical questions: Was there a God? Was it preferable to believe that there was no God and accept the thesis that all men's actions, even the most horrible, were their own responsibility? Or should we believe in a God who was a

witness to all that happened but did nothing to prevent it? Soon I learned from Mother that I was upsetting the instruction of the other boys. She was angry with me because she felt that a Bar Mitzvah had nothing to do with God or religion; it was the social key to becoming a proper Jew.

I wasn't sure that God should be kept outside the picture. I proposed a deal. I told her that if God would come to me and apologize for the deaths of my father, my grandparents, and millions of my people, I would celebrate a Bar Mitzvah. My chutzpah made her even more angry. "You are beside the point and you reason like a child." I told Mother to remember her own mother, the only religious member of our family, Grandmother Shifrah, who on every Yom Kippur used to spend all day in the synagogue crying her eyes out and taking on herself all the sins of the other members of our "worldly" family. Shifrah was shot by the Germans on a Yom Kippur.

At this point my stepfather, Markusha, intervened. "Mitzia," he said, speaking to Mother in his very serious and quiet way, "believing or not believing in God is a very grave question. Like a political choice it should only be made by mature men, and not by thirteen-year-old boys." We agreed to wait and decided that there would always be time for a Bar Mitzvah.

Mother and I had most of our lively conversations in Polish. However after that discussion, and out of respect for my stepfather who was from Lithuania, I began speaking to her in Yiddish. We communicated in Yiddish until the last day of her life in 1971. When I became a mature man I did not follow Markusha's advice. The question of God receded to a sphere beyond my reach. There is still too much I do not understand. Is it because I am only sixty-six and far from having attained the "full potential" of a hypothetical wisdom? This is especially true when it concerns my art. However, I do practice a ritual of painting, I have a belief in the possibility of human decency, and I produce works that are anchored in

what I understand as being a meditation on the Jewish experience of my century.

Some people tell me that I am creating religious art. At times I tend to agree with them. But often I feel very reluctant to take a stand on this subject. My personal experience is that artists' statements are more often limiting and misleading than not. It pleases me, nonetheless, when I discover that viewers find in my art a dimension that makes their minds resonate and expands their perception. I take it as proof that the effort to reach out past the golden solitude of an artist's studio has not been in vain. I have never fully clarified to myself all the reasons behind my obsessive need to produce art. Partly it must be a desire to give meaning to my miraculous survival. Like a Jew who visits a cemetery and leaves small stones on the graves of his beloved ones, I add painting upon painting as acts of remembrance.

When I am at work, the paper or canvas, carrying the traces of pencil or brush, loses its concrete presence and become metaphysical space. The materialization of my vision fascinates me as if I were the first man to witness the birth of a new world. For this revelation to occur, I must turn my studio into a base or station from which my mind departs every day to the world of my making. On my nomad's road as Wandering Jew, the Landsberg sojourn was all-important. It first gave me the physical and mental space to build my worlds. I was hardly thirteen when I first saw that my art is a fusion of painting and storytelling, the two pursuits I still love above all others. These have kept me whole through the traumas and recoveries of my journey and permitted me to lead a life I can be grateful for.

The child-painter of the museum's video screen could not have asked for more.

FROM LANDSBERG TO HAIFA

Mother, Markusha, and I left Landsberg for the newly established State of Israel in the summer of 1948. But I would like to begin this chapter by making a little excursion outside that time and space.

Three decades have passed since my first visit to the United States in 1971—less than two months before Mother's sudden death. Between 1974 and 1977 I lived and worked for three years on the Upper East Side of Manhattan. It was a rewarding time for my artistic career, and I began to think about a permanent move to the U.S. But a complex family situation prevented it. As time passed, I continued regularly to visit, established an important working relationship with an art gallery in Boston, acquired many local acquaintances, and developed meaningful and warm ties with a small circle of new friends.

In 1980 I moved from Israel to Paris, and in 1984 from Paris to Lausanne. These changes of residence had reasons that were anchored in my professional obligations. They also accelerated the end of a marriage that had long been troubled. Then Josée entered my life. In the beginning of the nineties the kernel of my old idea to move to the States started to germinate. It had obviously found a fertile ground in the life I shared with a loving and devoted partner. In 1992 we married, she retired from her work, and the following year we decided to emigrate.

We believed that new surroundings would enrich our lives as a couple. Uprooting ourselves from a pampered but somehow stifling and profes-

sionally arid setting was an exciting, and at our age quite adventurous, prospect. For a moment we toyed with the idea of moving to the capital of the arts, New York City, but the needs of my career as well as our desire for tranquil surroundings favored the choice of Boston.

Moving from one continent to another is not a trifling affair. It took courage and commitment, and we felt that such a special trip should be made aboard a ship. I imagined us standing on the deck of an elegant ocean liner and admiring our approach to New York's familiar, unique skyline. How many times I had seen similar scenes on the screen! Now the two of us would be waving to the world-famous French immigrant lady of the New World, the Statue of Liberty. But alas, this beautiful project had to be set aside, and for several reasons. Apparently hardly any ships of the kind we imagined sail from Europe to the New World. Such travel today is available only on cruise ships—luxury hotels for vacationing on the ocean, real floating cities—not the ambiance we wanted. Furthermore, the price of such a journey would have been exorbitant.

There was yet another catch. The date on which we had to present ourselves to the American Immigration and Naturalization Service was approaching, and at the same time an exhibition of my works at the Jewish Museum of Frankfurt required a lengthy stop in Germany. These two dates left us with very little time for the romance of a maritime passage. Surprisingly, I was not overly sad at the loss. Too many questions bothered me. Did I really want to pass entire days roaming the ship's various decks? And what about seasickness? Ancient, troubling memories arose in my mind. In 1948 I had traveled to Israel by sea, and that experience had marked me for life.

From the day I moved with Joseé into our house in Weston, a lovely suburb of Boston, unpacked the belongings that had arrived in a huge Swiss container (yes, our lucky stuff, unlike its owners, traveled by sea!), placed the furniture where it still stands, and hung the collection of our

paintings on the walls, I developed a routine of work. My days began with an encounter that perpetuated itself until two years ago. This would take place after my morning coffee, as I climbed the stairs to my studio. Before reaching the door I would glance instinctively at the sad eyes of a boy, and his eyes, sheltered behind glass in a wooden frame, would look questioningly back at me. Every day I saw his face emerge from a darkness that had been rendered by bold and decisive brushstrokes. A self-portrait. I had painted it when I was twelve, shortly after arriving at the DP camp in Landsberg in 1945. Now it hung on a wall next to my studio door, together with a small collection of other early works. I liked the reassuring presence of these old watercolors. They were reminders of past times, for me still very much alive. They were also rare mementos of what my beloved ones, those who had been torn from me so abruptly, had given me: love, trust, support, and a priceless feeling of worthiness that would sustain me during all the hours I painted.

Two years ago a retrospective exhibition in another German museum obliged me to take down this entire group of watercolors and send them overseas. When the paintings returned, I was deeply immersed in the writing of this memoir, and I stored them in a room that holds most of my older works. They still wait to be unwrapped.

Why didn't I put them back in their former places? I must have felt that I could do without my daily scrutiny and wanted to test this possibility. Why was I writing my memoir, if not to recover that whole world and bid it a proper goodbye? The paintings' role had now been taken over by what my burdened memory had unloaded, hundreds of pages magically stored in the computer's hard drive. Would this process grant me a newer and stronger sense of inner liberty? That is an ambitious hope.

There was a very long time, since my late teens and until one particular day when I happened to be close to forty, in which these early paint-

ings, along with many others, seemed to have disappeared from my life. As often happens with young artists who are absorbed by thoughts of the future, past works get little attention. But then one winter morning in 1972 or early 1973, I rediscovered them in Mother's orphaned flat in Tel Aviv. It was a whole year after her untimely death and a couple of months after the death of my stepfather, Markusha. Markusha had been seventeen years older than Mother, and he died peacefully in an advanced state of Alzheimer's disease. I accepted his death with a sense of sad relief. But Mother's urgent surgery, swift decline, and sudden death at age sixty were a different matter. Shattered by the loss and totally unprepared to deal with it, I let many months go by before bringing myself to enter her flat. Her humble belongings had been patiently waiting. They had endured a stiflingly hot summer, and with the passing of seasons found themselves in cold and humid rooms whose closeness to the sea had caused corrosion and rapid decay.

I remember turning the key in a recalcitrant lock, smelling the foul air, opening the windows and pulling up the lowered shutters. I see myself stepping out on the balcony and for a long moment gazing at the skeletal remains of plants that once adorned its dingy space. It was from here that Mother loved to observe the horizon. Its elusive line was forever suspended between Tel Aviv's hazy sky and the sky's reflection in the distant sea. Looking at it now I searched in it for some returning reflection of Mother's irregular gaze. One of her eyes saw close things well, the other was farsighted. It gave her a singular look, and made her eyes a metaphor for her complex nature.

A blast of loud music put an end to my sad contemplation. It came from a new neighbor's powerful amplifier, aggressively disrupting the calm sound of breaking waves. The noise sent me back into the flat, locking the balcony door and closing the windows. Going over the inventory of Mother's belongings, silent witnesses to a humble life that was deeply

affected by Markusha's declining condition, I discovered, wrapped in dark plastic and tucked away in a small closet, a large collection of my early works. I decided to dispose of most of her stuff, but took home a few small items, and of course all the paintings that she had so carefully packed. When I opened the closed parcels, the number of drawings, sketches, and watercolors that Mother had preserved surprised me. I hardly remembered our taking so many when in 1948 we made our way from Germany, via Marseilles, to the newly established state of Israel. These parcels must explain the extraordinarily heavy suitcase that Mother and Markusha dragged, sweating, panting, and swearing, through the various stages of our voyage to the embarkation pier of the *Pan York*.

The *Pan York* was a Cuban cargo ship, large and rundown, designed for transporting bananas. It had already offered passage to the Promised Land to many thousands of illegal immigrants, most of whom ended up imprisoned in the British camps on Cyprus. After the birth of Israel immigration became legal and that particular boat was to take us, together with thirty-five hundred other survivors, on what felt then like an interminable passage. Crowding the ship to its maximum had not improved the conditions of travel, but in those days people knew no limit to their readiness for sacrifice. Today the *Pan York* is part of Israel's history.

Many decades have passed since these heroic times, years of austerity and burden. But this particular journey marked me as I have said. Along with several earlier journeys, already described in this narrative, it established in me a basic distaste for travel. Even now, whenever I undertake the chore of traveling for pleasure, I must secretly remind myself that a voyage can also be fun and that acting normal is in my best interest.

But let me return to my story of our journey in 1948 from the DP camp in Landsberg to the port of Haifa, then the only gate to the new-born State of Israel. The struggle for Israel's creation was not limited to

the twentieth century alone. Countless generations of dreamers and pioneers had sacrificed their lives to make it happen, and their history fills many books, some of which nourished my education and broadened my adult understanding. However, my personal recollection of that political struggle in our DP camp is narrowed to the perspective of a typically self-centered, relatively carefree teenager, who used to be irritated by the demands put on his life. I was supposed to listen to vigorous Zionist speeches, march for hours carrying angry banners, be photographed among thousands of protesters, and pray that such photographs would reach the eyes of a sensitive, or preferably an outraged, public in a world that deemed itself free, democratic and humanitarian. Every one of the DPs participated in the endless protest marches, even the people who never dreamed of going to a Jewish state. I accepted these impositions grudgingly, preferring to eavesdrop on the endless discussions among our family friends. They seemed to know quite well how to solve the world's most urgent problems, and even better, how to joke about them intelligently, and how to laugh.

Then in mid-May 1948 things began to evolve rapidly, and after two and a half years of patient waiting there came the day that saw a whole people's dream come true. The British Mandate ended, the English soldiers in their round army berets and baggy Bermuda shorts left a Palestine torn between Arabs and Jews, and quite suddenly, after a painful intermission of two thousand years of pogroms, expulsions, and genocide, the Jews had an independent state of their own. Although the establishment of Israel by the United Nations was a result of the Holocaust's immense tragedy, and it was meant to give a homeland to hundreds of thousands of survivors, its proclamation plunged the newborn state into a bitter war. The departure of the British was hasty and disorganized. It opened the way for a military attack on Israel by all its Arab neighbors. The Jews had to mobilize every resource, fight with all their forces, and

cling to independence, indeed survival, with bare hands. Their painfully won victory transformed that part of the world forever.

War or no war, since Israel had opened its gates to all Jews, we had to leave Germany and go there. Mother's determination to abandon our relative comforts and venture into an embattled country was not to be questioned. In her youth she had kept a watchful distance from the circles that dreamed of a Jewish homeland, but her postwar fervor was absolute. Her determination was imposed on me (Good-bye, Paris!), as well as on my placid and accommodating stepfather, Markusha.

Markusha had toyed previously with the idea of emigrating to the United States, to a totally unknown town called Waco, Texas, from which his distant family had sent him an affidavit. Mother's project to move to an Israel at war found in him little enthusiasm but even less courage to oppose her. He had learned that when confronted with an unflinching decision of hers, it was in his best interest to give in at once. Willy-nilly he accepted that we were on our way to the Promised Land. It would be unfair to Mother not to mention her complex reasons for choosing Israel. Although Zionism had a lot to do with it, her resolution was not purely ideological. My Aunt Yetta, who in 1946 had joined us with Zygmunt and Tamara in Landsberg, had also decided to make aliyah, and the three of them counted on our doing so too. Besides, the two sisters had received news from Izia, their youngest brother, badly injured when battling in the ranks of the Red Army. He had escaped to Italy where he was being treated for severe head wounds, and he too planned go to the new Jewish state.

The principal motive sending all three siblings to Israel was their shared longing to reunite with their brother Yerachmiel, to have all four siblings together again in a single country! Our contact with Rachmila, as they called him, had been reestablished with the help of members of the Jewish Brigade. My uncle had been a Zionist pioneer, a member of the

socialist Hashomer Hatsayir who had settled on the eve of World War II in one of Palestine's kibbutzim. An important part of the family that he had considered lost had instead miraculously survived, and he was now impatiently waiting to embrace us. To Mother, the prospect of falling into the arms of her younger brother offered a kind of repair for all her grievous losses.

For me the summer of 1948 in Landsberg was a time of excitement and anticipation mixed with a lot of sadness. The DP camp's inhabitants were mainly divided into two groups, one making aliyah to Israel, and the other waiting for affidavits to the United States. Few Jews desired to continue their life in Germany. Things were coming to closure, and there was a fever in the air. The camp's small Jewish-town existence was to be disrupted; friendships were to be lost, and many questions about the future hung over our heads.

When the documents for our travel to Israel arrived, I was told to say goodbye to a couple of close friends and start packing. I was aware of the fact that boys with whom I had shared many happy hours would disappear from my life forever. A grief came over me, a feeling of weakness that I hesitated to confess even to myself. Again I was obliged to face loss. In my mind memories of a painful past began to resonate with the present. Leaving Landsberg meant abandoning a place that had become a home; parting from accustomed landscapes; losing the languages I was accustomed to, and having to substitute for them a new and very difficult one, Hebrew. And above all, losing friends whose shared past gave us a special bond. But I knew that the Zionist fervor, which painted the future in clearly defined lines and a lot of pink color, had no place for such self-indulgent reflections.

These were the troubling thoughts that went through my head when with Mother, Markusha, and a whole crowd of excited refugees, I was deposited by the Jewish Agency at Landsberg's railway station. We did

not travel alone. The group was accompanied by scores of very heavy suit-cases. Relatively decent trains transported us to the station of a small French town near Marseilles, where rented trucks awaited us for the con-tinuation of our journey. The trucks brought us to temporary lodgings in a crowded small hotel. "Be patient," said the people who took care of us. "It is only a matter of a few days. The pioneers who left for Palestine before the war, and thus avoided being slaughtered like helpless sheep, did not travel in better conditions."

The place looked as if it had been ransacked by its former occupants. An abandoned orchard of nearly dead apple trees surrounded the build-ing. The trees cast crooked shadows on a collection of wooden benches and chairs. "That is where we shall meet daily," said the dedicated Israeli *shelichim* (envoys). Ostentatiously clad in proletarian khaki and not like us in secondhand American surplus, they failed to understand our odd hang-ups. But they smiled on us lovingly and promised to take care of all our needs. They also took it upon themselves to force us, destitute sur-vivors of an annihilated world as we must have looked to them, into patriotic enthusiasm, ideological conviction, and manifest happiness. Weren't we living in the most extraordinary of times? We were taking up from where the Jews had left off at the destruction of Judea two thousand years ago! The word "shalom" was often on their lips, along with the expression *Yehie tov*. "Do not worry, it will be all right." A poorly played accordion and a small *halil* (flute), accompanied daily lessons in Hebrew songs. The Hebrew words sounded alien, but the music had a familiar Russian flair. Such songs were supposed to forge in us souls of steel, which we badly needed to match with the newborn state's overwhelming pride in itself. The devoted *shelikhim* did their best to make us love them. They were my foretaste of Israel and gave me an uneasy apprehension about what lay ahead.

We waited and waited, and the days were long and hot. Mosquito

bites covered our skin, and we were continuously scratching. It was clear that the French authorities, faced with considerable pressure from the Arab states, were making it difficult for boats headed for Israel to leave French ports. They also tied us up in a lot of red tape. But special messengers reassured us that we would soon overcome the typical arrogance of the French, their prostituted politics, as they gently put it. "The Jewish genius can certainly deal with this," said one of the messengers, tapping his fingers against his temple. But time seemed to stand still. We ate daily the identical menu, endless salads of tomatoes with a lot of raw onions (bountiful generators of intestinal gases), wartime bread that had been enriched by sawdust, and tasteless margarine. Our morale was declining and we needed some boosting. Special speakers lectured us on all sorts of subjects. Inspired by the idea that one could teach people to swim by throwing them into deep waters, they read to us Hebrew poetry we did not understand. They must have hoped that some of its beauty would rub off on our souls. And in case we did not have enough knowledge of the extensive Israeli repertory of songs, they taught us additional ones. People listened absentmindedly, more focused on not passing wind than on absorbing information and wisdom. Perhaps the hot weather and the fat French flies had softened our minds. We sat and looked at the speakers. I well remember the smiling eyes of a stocky man in khaki, perhaps not very bright but endowed by agile hands with which he tried to enhance his description of the paradise that Israel was preparing for us. Apparently hundreds of thousands of Arabs were leaving their fully equipped homes. In towns, suburbs, and villages tens of thousands of rich properties were awaiting us. All we had to do was to move in, take possession of the contents, and continue with productive and meaningful lives.

I must confess that I was not then appalled by what I heard, nor do I remember anyone pointing out the huge human problem implicit in such a scenario. The experience of what had been done to us Jews, and of what

we had been forced to do, must have coarsened us. It took me several years to recall this "well-meant" but troubling speech and retroactively to reject it as it deserved. I wonder if today I know any better what should have been done. The factors that generated those views and events are still with us. They are very complex, and "justice" is bitterly entangled in contradictory perceptions of historical truth.

Listening halfheartedly to patriotic indoctrination took only part of my time. Sometimes I ventured into the nearby village. I did not dare to enter the few places that sold lemonade or sweets. I was shy and cowardly, and the barrier of the French language was absolute. Trying to immortalize Pelisanne, with its church and its *Monument aux Morts*, I enthusiastically continued to employ my camera, an old Voightlander from the late twenties that I carried around with its heavy tripod. The monument consisted of a large pedestal on which a World War I soldier, covered with pigeon droppings, was breathing his last in the arms of a beautiful lady. The lady, probably France herself, held over his head a crown of laurel. Her face was brown with green vertical streaks, and it strangely resembled the photos of the Statue of Liberty. She too had not been spared by the inconsiderate birds. Is this the real monument of Pelisanne, or do I confuse it with other monuments to unknown soldiers that in later years I observed on France's many roads? I cannot tell. But millions of soldiers had died, multitudes more were dying even as I was contemplating their monuments, and who knows how many would die in the future. The mourning face of that sad lady, corroded by tears of cruel acids, always had the power to affect me greatly.

Our patient waiting finally came to an end. A hot evening of gathering clouds, biting flies, and distant sounds of thunder brought to our hotel a group of young people sent by the Jewish Agency. They carried folders with various documents and spoke tensely to each other. With them came several trucks that were now ready for the road. They urged us to pack

and at the same time distributed among us documents intended to give us new identities.

"New identities?"

Did we have to steal across another border? I wanted to understand the purpose of these papers. "Are this documents fake?" Somebody said that the papers were good, and that the fakes were ourselves.

"Don't ask inappropriate questions. Memorize your new name, it is important that you remember it! Time is running out. This night you'll be on the ship."

People started to murmur feverishly. These new identities were strange. I was given the name of a woman, my stepfather Markusha was somebody's child, and the three of us had three different family names. The others did not fare better. People looked at each other in bewilderment. But there was a lot of excitement. It was the beginning of our last chapter, the chapter that would close the saga of our wanderings. Such names, other names, what did it matter? To care about trifles, however incongruous, was improper. The few incredulous giggles were quickly silenced. "*Smokh*. Rely on us. We know what we are doing."

We left, as expected, late the same afternoon. Small side roads brought us to the huge agglomeration of the port of Marseilles with its endless procession of huge black cranes against the darkening sky. Finally we saw the immense body of a dark cargo ship with a big smoking stack, the *Pan York*. Hundreds if not thousands of dark silhouettes were forming lines. It took us another hour to get on the boat. We had to drag our heavy suitcases over a narrow bridge that led to the upper deck. The luggage seemed to be constantly increasing in weight. Mother and Markusha, rubbing their hurting fingers and using ugly words, began to lose their civil manners. Having reached the upper deck we were asked to deposit the suitcases, take with us a few necessary items, and follow instructions without asking too many questions. Time was precious. An impatient and

pushy line slowly moved to a door that led into the depths of the ship. In the dim light of a few feeble lamps I saw several other doors and many more people. We started to descend. I realized that this was my first encounter with the sea, but I hardly saw the water. I looked into the inner space into which we were moving. The steps and floors were made of a grid of narrow boards. The spaces between the boards were meant to give ventilation to other decks beneath us. Later I learned that there were four of these. The overcrowded steps were slippery, and one had to hold on to improvised handrails of rope. Because of the darkness, and also of the multitude of people, we had to move carefully. Inadvertently someone overturned a bucket of water and the water instantly poured down through the slats, splashing people on the lower floors. There was a lot of shouting and cursing.

Having descended two flights of stairs, we were told to remain there. We now belonged to the second deck. The stairs continued to other depths. On the bottom deck was the hiding place created for young men who were volunteering to fight in the ranks of *Zahal*, Israel's army. These young men had to keep a low profile. Apparently the French authorities, eager to show how opposed they were to such a presence, were expected to exercise special surveillance. Each inner deck had triple-level berths made of platforms that extended in every direction. The passages left between them were very narrow. Three berths times four decks meant twelve floors of platforms, about three hundred people per floor, nine hundred per deck.

It occurred to me that the twelve superposed platforms full of sleeping immigrants were creating a monumental, multilayered Napoleon cake. I wanted to share this thought with Mother and joke about it. But the image of this special cake, one of the prewar glories of our home, brought to my mind our Vilna, the kitchen and Xenia's cooking, long lost riches, and I decided to keep these memories to myself.

Someone indicated to us a place on the middle tier that contained three mattresses and blankets. The place was close to an opening that let in salty fresh air. That was good luck! Under us, hundreds of people were crowding the lower tier, and equally many crowded the top one. Directly above my mattress a little child was crying. I crawled into my place. Mother and Markusha lay next to me. A few minutes later something dripped on me. It smelled vaguely of urine. I jumped up, and banged my head. "Keep quiet," said Mother "No one ever died of a little child's urine. Think of when you were a baby and how many times you wet me."

I must have awakened early. My blanket was wet. Strange noises were traveling through the cavernous space, and I tried to identify their origins. Many came from the cracking of the ship's body. Human steps, blowing vents, snoring, babies' cries, and the rhythm of heavy engines converged into one cacophony. A strange sense of swaying was bringing something to my throat. My head felt awful. Mother and Markusha were moving, trying to disentangle themselves from sleep. I crawled out from my berth, tried to stand on my feet but had to hold on to whatever my hands could catch. A few silhouettes climbed the stairs. I followed them and soon discovered an almost empty deck.

So this was the sea!

Thousands of white crests of foam surrounded a gently rolling *Pan York*. "Blue Immensity, feeling of insignificance when confronted with the size and the power of natural elements." These, and many others, were the words that with the help of various readings I had prepared for an encounter of this kind. But I felt nothing of that sort. I felt bad, really bad, and all I wanted was to get as quickly as possible to the rail and throw up into the foamy waters. "Careful, young man," said a voice belonging to a hand that had caught me by my shirt collar. "We do not want to go overboard, do we?" Two days of rolling were spent on a deck thronging with sick travelers. A pleasant sea air would delicately sweep away the smell of

vomit. On the first day I drank only stale water that tasted of aluminum. On the second day I took a sip of the soup that was our only food. The soup was always the same. When today I try to figure out how many days I spent on that ship, memory fails me. Seven, eight days? Perhaps two weeks?

The days resembled each other and their passing would leave only one tangible sign: the staircases became more and more slippery. Cleaning up, supposed to be organized among the travelers on a volunteer basis, hardly occurred. The crowding brought with it filth. Every day some soup, a mysteriously unidentifiable liquid that was daily brought in hundreds of buckets from the ship's kitchen to the various inner decks, would spill over. At times an entire bucket would land on the floor or the stairs, and leak through all the decks. It was a monotonous passage. The weather conditions would not change, nor the lines of people who needed to use the latrines. Their prolonged waits for a turn in the shoe-box-like constructions of wood, accessible from the open deck but suspended high above the speeding foam, was my only diversion. People told stories and I listened to them. Many, like myself, suffered from diarrhea. The latrines were made to accommodate several users at a time. They would sit in a very narrow space over round cutouts, their knees touching, and perform their bodily functions, accompanying them by coarse but jovial adult jokes. It angered me that much of the humor escaped me. These communal toilets, though visibly connected by ropes and wooden beams to the ship's iron body, were very hazardous constructions. My well-equipped imagination, reveling in scenarios of disaster, conceived a short and funny film. I saw myself stepping out from this utilitarian contraption onto the safety of the ship's deck, while behind me the entire latrine, complete with it its defecating inhabitants and their dirty jokes, suddenly tilted, leaned over, and hung suspended at an angle, threatening to crash into the Mediterranean waters. I must have taken the scene from Chaplin's *Goldrush.*

Whenever Mother made a point about someone's low mental capacity she used a standard form of speech: "Poor thing," she would say. "Precisely when God was distributing brains, he (or she) had to rush to relieve himself, what a pity!" By the time we were nearing the end of our journey, she had spoken with many travelers and categorized them according to her demanding criteria. Now most of these people, the bright ones, the mediocre, and the morons were crowding the upper deck and sanning the horizon. I knew that any moment could bring us the sight of Israel's coast, and for no price in the world would I have agreed to miss this very special event. Being stuck in one of the latrines at the precise moment of such an historic event would be unforgivable. Hadn't I waited for it all this time? My mental effort to control my diarrhea gave poor results, and my belly cramps were constantly increasing. But when a general sound of murmuring voices surged into a wave of excited exclamations, prayers and singing, I knew that the event for which I, personally, had been waiting for two thousand years was happening right now. Shortly after this, the ship docked.

"Am I dreaming? I think that I am seeing Father," exclaimed Mother with a voice full of emotion. We were pressed against the deck's rail by a multitude of excited immigrants like ourselves. The evening light was poor. The danger of air raids had limited the city and port to a strict minimum of lighting. Nevertheless Mother with her farsighted eye had been attentively studying the silhouettes of the people who were signaling with their hands to those on the ship's deck.

"I think it is Rachmila. Yes, I am sure. He looks now exactly like my father!"

But it was a middle-aged man with a bald head, as bald as Grandfather Khone's used to be, whom Mother mistook for her brother. The real Uncle Rachmila stood not far away, and he took us at once to his home on the Bay of Haifa. The night was black. The use of headlights was

forbidden. The suitcases with Markusha and a driver traveled in a funny-looking old British car that Rachmila must have hired for the occasion. They carefully followed his even older motorcycle, on which Mother sat in the sidecar, while I on the pillion seat indicated with a small flashlight our presence on the narrow and luckily empty road. Uncle's good knowledge of the terrain and some wan moonlight brought us safely to his home.

Since Rachmila had left the kibbutz he had been living in a small and rudimentary three-room house, of which one room was rented out. I saw his two daughters, two little blond girls that started to wake, but I was so tired that as soon as their mother, my newly met Aunt Riva, directed me to a mattress on the floor, I fell asleep. I woke up a couple of times and returned to my sleep. Sounds of nearby frogs and distant vehicles mixed with the sound of Mother's subdued voice. In the light of a small gas lamp I watched for several minutes Mother's and Rachmila's dark silhouettes. They seemed to be riveted to the kitchen table. Her lips were murmuring, and he was wiping his eyes. In the early morning light of a new day they were still there. When I got up and neared the table Rachmila was showing Mother a weekly paper. It was an issue from a year ago that he had religiously conserved. On its cover was a picture of Sharet, Ben-Gurion's right-hand man, delivering at the UN a paper demanding the immediate establishment of a Jewish state. But Rachmila turned the pages and opened them to a spread where the reproduction of my self-portrait accompanied a story about a talented twelve-year-old boy. The young artist was being held in one of the Bavarian DP camps, and the article's concerned writer was asking: " Till when?"

So this was my first morning in Israel, my new *Moledeth*, the miraculously reborn motherland. I went to the main door and opened it. The outdoor light was so blinding that I could hardly keep my eyes open. Rachmila, who had followed me, handed me a pair of old brown sun-

glasses with a repaired bridge. They were perfectly round and looked absurdly antiquated. He must have brought them from Vilna. I stepped out on a small terrace and descended a few stairs. Tender branches of a tamarind tree undulated in a gentle breeze. The air carried a slight smell of sea and gasoline that must have been coming from a nearby industrial area. I was startled when a delicate branch grazed my neck. Some prying mosquitoes tried to land in my ear. To my right, tall eucalyptuses, growing behind a thicket of flowering cactus, cast irregular shadows over a few identical semidetached houses. All the constructions were of the most rudimentary kind, with various shapes of recycled boards patching roofs of gray asbestos. The small buildings were perched on stilts of concrete that made them look like giant bugs, to me a most unfamiliar sight. On the horizon, hazy silhouettes of a refinery hovered over a cloud of sand dust. A descending slope of Mount Carmel hinted at pine trees and lush greenery.

The arid grounds around Rachmila's home, irregularly covered by dry spurts of wild grass, swarmed with the buzz of thousands of insects. Tiny lizards clung to decrepit fences, walls of cracking mortar, and drying shrubs. Caravans of huge and energetic ants crisscrossed the sandy ground. On a solitary branch, protruding over some rusty netting, a mysterious chameleon seemed to be posing for a photograph. By the time I returned with my camera, he was gone.

"Wear socks and shoes," said Rachmila. "The place is full of snakes. Also, don't touch the cactus fruits, the sabras; they may be sweet inside but are very prickly on the outside." He laughed.

Was Rachmila warning me about the wild cactus fence, or was he insinuating something "risqué" about Israeli girls? To me my uncle was still a stranger. How should I evaluate his humor? I reentered the small house. Aunt Riva was bent over the kitchen table, ironing shirts. Behind a closed door Markusha snored. Mother too must have been there, trying

to take a rest. After a sleepless night of painful and detailed reporting to her brother she needed it badly. Could she sleep with all that snoring?

"Let me put up some tea for the boy," said my uncle to his wife. They spoke Hebrew, but the little I had picked up in Landsberg allowed me to follow their conversation. So that's it, people's daily life in Israel was in Hebrew. Amazing! Then speaking to me in Yiddish, he added: "If you want to become a real Israeli you must learn to drink a lot of tea." And again to his wife: "Stop for a moment your ironing." Automatically Riva unplugged the iron. "It's hot, be careful," she said, positioning it on the thick rag that Rachmila held in both his hands. He then cautiously inserted this rusty object, one of the largest domestic irons I ever saw, into a metallic contraption that was meant to hold it upside down, put it back on the table, and reconnected it to the power. Meanwhile my aunt filled a kettle with yellowish water and placed it on the iron's hot surface. It would soon boil, fill the house with its piercing whistle, and stop Markusha's snoring.

"This water contains a lot of calcium and iron," said Riva, noting my suspicious glance. She spoke to me in Polish: "It couldn't be healthier! Look here at your little cousins, just look how our Sabras are bursting with health and well-being!" The proud mother looked drained and old. Huge half moons of perspiration stained the underarms of her blouse.

"Tfu, tfu ,tfu," said my Uncle "Why uselessly provoke the evil eye?"

His suntanned face was smiling, and his red and swollen eyes tried to assure me that his magical conjuring was a joke. The two blond Sabras, seated on the floor, paid no attention. They were absorbed by the struggle of a lizard that was trying to extricate itself from the hands of the younger girl, while the detached lizard tail, held between the thumb and finger of the other sister, continued vividly to convulse, as if it had a brain of its own. They were obviously trying to reattach the lizard's discarded tail.

My uncle was pensive: "Observe well the lizards, Samek. This we know for sure, the little lizard doesn't need its old tail, soon it will get a new one. Miracles of regeneration, miracles of regeneration. What a pity that we humans have a much harder time growing back whatever we have lost."

"Grow back? We shall never grow back," repeated Riva mechanically. She sighed. He put his hand on her back. Imperceptibly she moved away. "I am so hot." He touched her forehead. She turned her head. "No, I have no fever. I am just hot."

For several days Rachmila, shaken by the excitement of being reunited with his sister, had a hard time pulling himself together. A practical and tough man, he often had watery eyes. His consciousness now tried to assimilate all the disturbing news that Mother had brought with her, stories of miraculous survival and accounts of death. Formerly, their erratic correspondence had hardly dared to mention painful details. His heart was still rejecting what his mind knew it must accept. Rachmila was a strange combination of his parents' traits, a concoction of bits of pragmatic wisdom and poetic idealism. As a child and teenager he attended a highly conservative religious school in which yarmulkes and small talliths were mandatory. This made his mother, Shifra, very happy. She was less sure about how he spent his afternoons, and in later years many of his evenings. They were dedicated to the youth organization of the Hashomer Hazayir, to which several close friends introduced him. This was a purely secular and socialist movement that called for absolute equity between the genders, total collectivization, and other ideals that demanded a great deal of self-sacrifice. Grandfather Khone, had he not been so apprehensive about displeasing his wife, would happily have endorsed Rachmila's commitment.

Rachmila, having completed his studies, decided to dedicate his life to founding a new kibbutz. Secretly he began to prepare to leave for pio-

neering Palestine, to make aliyah. Yet something kept him until now from speaking about this to his mother. There was another secret. He was deeply in love with a Jewish girl from Warsaw, an active member of the same Zionist organization. The girl was more than eager to become his wife, and he had decided to marry her. Shifra's unusual wisdom, open-mindedness, and readiness to listen had always attracted people in need of confiding. The stories of her personal past, often on her lips, must also have encouraged her son to speak to her. But his revelation of these two conjoining projects provoked a small earthquake. Shifra was shocked. Hurried marriage? Emigration? This was not the way young people were supposed to act. Life was a demanding business! Young men and women had to assume heavy responsibilities in these hard times. Who would carry on the family business? Parents were not eternal. And what about his family's benediction on this union? In her eyes only a long engagement could allow a proper acquaintance with the future bride, as well as with her parents. For the time being, the girl and her family were total strangers, worse, aliens.

Shifra was unbending: a good marriage was more than a transaction between one man and one woman. And Palestine? True, the Holy Land had been waiting for Jews for two thousand years, and some of them, escaping persecutions, had resettled there. But we all lived in a free Poland. Anti-Semitism? Big deal! Poles had always been anti-Semites, so what? Poland in 1937 wasn't Germany. Meanwhile Palestine was in a mess. It was swarming with German Jews. Unemployment had created a grave crisis there. Professors swept the streets and famous violinists fiddled in restaurants. Palestine could wait a while longer for her son. Why this folly of rushing? No, no, and no. Shifra would not lend her hand to such insanity. Anyway, who was this girl? Where did she come from? Rachmila, who seemed very determined, made his mother promise to undertake an enquiry. Thus my father and Aunt Yetta became entrusted

with the mission of going to Warsaw, meeting with the future bride, figuring out the nature of her aspirations, and getting a clear idea about her parents' status and social milieu.

Father and Yetta returned disheartened and embarrassed, with more questions than answers. The girl had clearly the merit of being strikingly beautiful, but there was little to be said about her education or intelligence, and even less about her parents. She lived in one of the town's poorest areas, in a damp basement accessible from a narrow and dark courtyard. It was there, in a room packed with sleeping toddlers, that her tired and ageless mother scrubbed, washed, and cooked. And it was there that her pious father repaired old shoes. Apparently Shifra's future in-laws had been so embarrassed by the unexpected arrival of the two elegant visitors from Vilna that they hardly uttered a word.

Listening to all this, Shifra's face darkened. "Decent, hardworking folks," she said. "Perhaps even honest. But does the girl *really* care for Rachmila? He is not a Mr. Apollo."

The sudden arrival of a draft order for my uncle, obliging him to begin his service in the Polish army, precipitated events. The leaders of the Hashomer Hazayir organization had a very high opinion of Rachmila. He had a winning personality. Resourceful, he knew how to deal with an array of practical problems from construction, plumbing, and mechanics to carpentry, agriculture, and more. His thorough knowledge of Hebrew and his erudition in the latest interpretations of Marx were both highly commendable. Such a combination of rare traits fit perfectly into collective life. To lose such a remarkable young man to the Polish army would be unforgivable. Thus the party decided to send him to Palestine at once, and its leaders took it on themselves to finance his voyage. And what about his wife-to-be? That was not their problem. Anyway, the organization did not think too highly of her.

The obedient, heartbroken, and proud Rachmila left Vilna, but he

postponed his immediate arrival in Palestine. He stopped for three or four months in the port of Saloniki, Greece, to toil there as a common dockworker. Underpaid and badly exploited, he still managed to save up the necessary sum to send for his beloved. She was to join him, as agreed, in the land of their dreams. Of the two, he was the first to reach the final destination. Sent to the Upper Galilee, to the most inhospitable of marshlands that the Zionist organization had acquired and was undertaking to drain for a new kibbutz, he experienced unending hardships. But the approaching date of his love's arrival kept him in good spirits.

It happened when the new settlement was moving its temporary premises from one inundated area to another. Surrounded by swarms of hungry mosquitoes, smeared all over with black machine oil, the exhausted Rachmila toiled over a blocked pump. Suddenly a truck halted and two figures stepped out. One of them was the object of his eternal love, the light of his eyes, the beautiful girl from Warsaw.

"You are such a wonderful man, Rachmila," she said. "How shall I ever be able to thank you? You have brought to my life a sense of real happiness and fulfillment. Please meet here my new friend who works in Tel Aviv for our organization's central committee. We met on the boat that brought us to Haifa. I hope you are not angry. Rachmila, Rachmila. Let's be realistic. We were always a mismatch. I would have made your life miserable. Thank me for releasing you from your promise. My friend and I, on the other hand, are really made for each other. Wish us a happy life."

Such a scene would perfectly have suited one of the many Yiddish films that Shifra used to adore. Generational conflicts, treachery, broken promises, melodrama. Could she ever have foreseen such a fate for her own son? Europe's conflagration prevented her from learning about this turn of events. The proud Rachmila's letters painted pictures of lovely olive trees, herding sheep, gregarious bonfires, and songs of *Haluzim*. Gradually, the war blocked all communications. The Nazis did the rest.

Rachmila went on toiling with pumps, engines, and constructions. His shock gradually subsided into depression. The kibbutz had no patience with this. Moreover it had on its hands another depressed member, a pretty young woman who had been abandoned by her lover. The assembly of the collective settlement voted unanimously to make every effort to bring those two "shadows" together so they could take care of each other. That other shadow was Riva. A traveling rabbi, a specialist in rapid ceremonies, married them off. He provided them with a genuine certificate that was acknowledged by the authorities of the British Mandate. Since Rachmila was in the fields of a neighboring kibbutz, lending his hand to their plowing, and Riva was busy in the cowshed, other kibbutz members stood in for them. They even counterfeited Rachmila's and Riva's signatures. The rabbi was unaware of the substitution. But such acts were common in those times. The rejection of the bourgeois norms and conservative tradition had created a clash between the secular and the religious, but no one seemed to care. Listening to my aunt and uncle tell their story, I gathered they were proud of not having attended their own wedding.

Their angelically blond girls, the genuine Sabras of our family, were born in the kibbutz and thrived there. But Riva's health was too fragile for this kind of pioneering life, and it soon began to deteriorate. Acute attacks of malaria brought her near to death. In 1946 a conscientious doctor ordered them to leave the infested area and settle near a town where immediate medical care would be at hand. The swamps of the Galilee had swallowed up years of Rachmila's and Riva's hard labor, sacrifices, and health. They left the kibbutz socially ostracized and penniless. Their "insufficient devotion to the ideals of socialism" was never forgotten. After time spent in a series of miserable lodgings, they landed in a shabby suburb of Haifa, in the house where I spent my first night in Israel. Rachmila was now an employee of a company that belonged to the Histadrut,

the Jewish labor union of Palestine. With the Histadrut he felt at home. At heart, he was the most genuine kibbutznick I have ever encountered.

On the second day after our arrival we sat on the stairs that led to their front door. He was, as ever, full of practical advice, however repetitive: "You should not be walking around in sandals that are meant for the city. Don't let the heat mislead you. Put on high shoes. This soil carries many dangers. The little sand-colored vipers and scorpions that hide in our ground are quite unforgiving."

To please my uncle I went indoors, opened a suitcase, and brought out my winter shoes. I took off my sandals and was on the point of reaching for my socks when a huge black wasp, later identified as the much dreaded *dabour*, skydived from out of the blue with considerable noise, landed on my heel, and stung me with what felt like a lance of steel.

Three minutes later the pain became so throbbing that I could not help crying out. Cold compresses were of no avail. In an hour my entire leg looked like the leg of an elephant. I ran a high fever. A doctor gave me various injections. I began to recover three or four days after this unexpected attack, but my heel bothered me for weeks. After the crisis was over I rested on their terrace. Rachmila sat at my side and put a hand on my shoulder: "The shock of a Jew's encounter with this land is never simple." And looked at me with what I read as an expression of guilt.

"Stop philosophizing, Rachmila. Go and get your motorbike." Now it was Mother's energetic voice. "I must go to Haifa. I have letters of introduction and I must look up several addresses. We have to find lodgings in the city. And first and foremost, the very best school for Samounia. Enough wasting time! You will see what proper schooling will do for him. In a month or two he'll speak perfect Hebrew. In no time he'll overreach the local boys. He'll become a real Sabra. More than a real Sabra. Take my word!"

Behind Mother's figure, carefully clinging to a swaying branch, a

chameleon turned in my direction one of its protruding eyes. Fixing on me its indifferent gaze it slowly rolled out a long tongue.

* * *

Years went by.

I did learn Hebrew, though it took a long time and a very great effort. But the language never become part of my inner self. (I still count in Yiddish.)

I also learned not to speak of the Holocaust. In the years before the Eichmann trial, young Israelis had little patience for this subject. Like everyone else, I wore the short khaki pants, khaki shirts, and sandals that gave all of us of pre-army age a uniform look. But I never felt like a Sabra, nor did I want to.

Some of my Mother's pride must have rubbed off on me.

CHAPTER ELEVEN

Mother's Tutoring

IN MY FIRST FIFTEEN YEARS I experienced very little formal schooling. My first day in a real school lasted a mere morning and was my final as well as my first day in grade one. I was seven. The Soviets controlled Vilna, and their imminent retreat was followed by the German occupation, which effectively ended all schooling for Jewish children. Then later in Lodz, when I was eleven, I attended classes for an entire fortnight before the other students' blatant anti-Semitism sent me packing. Between the ages of twelve and fourteen I occasionally attended a school for child survivors in the Landsberg DP camp. We were a mixed bag of kids, and most of the teachers were nonprofessional volunteers. I went to classes only when I wasn't painting, and I painted often. Thus, although I knew a lot about the art of survival, the gaps in my formal education were enormous. I had to fill them in by myself, and I did this under Mother's supervision.

My extraordinary, bright, charming, possessive, proud, tough, determined, and above all loving and lovable Mother was my principal guide. Her unique and overbearing personality guided me into adulthood. Unintentionally she added to my life a chapter about the art of withstanding such guidance. I must apologize if this sounds ungrateful. Yet it was no small accomplishment for a young man to withstand the effect of my Mother's towering power. I had to find ways to establish my own balance. That I succeeded at all speaks greatly in her favor. One could also argue that by letting me oppose some of her positions she forged my character and indeed endowed me with many of her own traits.

I owed her my life, and she owed me hers. Her confidence in my talent as an artist was unflinching. It went far beyond what I, myself, would ever

have dared to pretend to. And her deep conviction that whatever might come, I was destined for success, structured me in ways for which I shall always bear her a small grudge and remain eternally grateful.

Inevitably the war, persecution, and wanderings of those formative years upset the course of my education, and the unavoidable shifts among continents, cultures, and languages disrupted it even more. Fortunately, like most children I was blessed with a lively curiosity. My lucky inquisitiveness (besides my passion for art, which is a separate story) bore fruit outside the structures of formal learning and filled my head with all kinds of interesting data. This situation lasted for about eight years, until I was fifteen. When I got to Israel in 1948 I had to bend to a rigorous school discipline. Mastering Hebrew, a language far different from any I knew, was one of my most difficult tasks. So was the acquisition of basic English, a second language in Israel's schools. English had until then been for me a babble heard in Hollywood movies. Another challenge was the need to familiarize myself with the texts of the Bible in all their linguistic and interpretative complexity. Without all this there was no way to penetrate the riches of Hebrew or understand the foundations of Jewish culture.

Here Mother's ability to offer direct help reached its natural limit. But she knew how to scrape together every available penny, extracting it from our meager income, and spend it on private teachers. We were starting "new lives" in an independent Jewish state, and she wanted to give her boy every chance. It wasn't simple. Substantial handicaps followed me from my former life. I did my best, worked day and night, and mastered what had to be mastered. But my Hebrew never lost its slight Yiddish accent, and this accent gave me away. No, I could not pretend to belong to the generation of Israel's fearless founders. I came from that shameful world where Jews, unlike the local heroes, had let themselves be slaughtered.

Before getting to Israel, in a Europe at war and in war's aftermath,

throughout the years of persecutions and wandering, whenever I reached out for information I got it not from certified teachers but from periodicals, books, encyclopedias, and adults I considered trustworthy. At times I found such learning satisfying; often I felt I was wasting my time. In any case Mother's attention to my educational conditions was forever vigilant, and she tried to give me a trustworthy sense of direction. In her eyes my hunger for books was an excellent substitute for formal education. Around springtime of 1946, highly critical of the DP camp's school, Mother got me a private tutor. The tutor was an elderly German, a retired teacher, whom she paid in packets of cigarettes. His great age was an asset as it meant he could not have participated directly in the horrors of the Third Reich. This at least was our assumption. At my first encounter with the old gentleman, he took off his heavy glasses, smiled at me with a mouth of sparse but solidly stained teeth, and vigorously blew his nose.

He must have read in my face the questions circling in my head. While slowly proceeding to wipe his thick lenses with his soiled handkerchief, he looked straight into my eyes and assured me that although he had always lived in Landsberg, only a few kilometers away from the Dachau camps, he had known nothing, absolutely nothing! After the war he had been devastated to learn what had gone on there. The very unfortunate behavior of the Nazis was appalling! No, no, no, he had no inkling . . . He repeated this a good number of times and passed on to teach me German grammar and syntax, and how to write in Gothic letters. Subsequently he engaged me in an extensive course of Greek mythology. His version was filled with stories of endless cruelty. Cruelty, he said, was not an invention of the Nazis; it had its roots in man's most ancient cultures. He advised me to read the Bible.

When I mentioned to Mother that I was not sure I liked this man, she told me he wasn't there for the purpose of being liked. But she would fire him instantly if I chose. Our recent past gave us the sacrosanct right to

hate all Germans. On the other hand, if I felt that this particular teacher was useful for my education I should get from him whatever I could. "Consider this," she said. "The German language was not responsible for the criminals who appropriated it for their vile use." Her own uncle, Arno Nadel, wrote in German. He created in it beautiful books of drama, poetry, and prose. Moreover, he translated Yiddish classics into German. This was the same uncle who had placed on her shoulders the responsibility of educating me to become an "important artist." I should never forget that! She therefore advised me to study moderately and dedicate most of my time to painting.

I think Mother considered herself, on the matter of my future, a representative of our decimated family's desires and dreams. Her conviction that I possessed an unusual talent was thus reinforced by the shadows of our Dead. In her opinion such talent had to be nourished by the greatest of specialists, and she took it upon herself to go to Munich and find for me the best art teacher possible. Her standards were high! Ideally she wanted an old, perhaps centenarian, yet somehow youthful and brilliant "professor" with a past that even in post-Nazi Germany would be above suspicion.

And what about mathematics, languages, history, Hebrew? She felt sure that sooner or later our permanent settlement in a Jewish state would give me the structured education I needed. But during our wanderings, in a world as disrupted as ours, practice in the art of painting had to take precedence over all else. Her determined approach helped shape the values I still hold today. As I have said, I loved her intensely, and with the confused heart of a teenager believed her to be the brightest, but at times also the dumbest, person in the universe. I admired her intelligence and culture and concomitantly rejected what I considered to be her overbearing and stubborn certitudes.

All her life Mother had been "Queen of the Class." Naturally, she

expected to be acknowledged as such by everyone she encountered and especially by her son. Even now, oddly enough, I feel as if she stood behind me with eyes riveted to the screen of my word processor. "Mother, please stop breathing down my neck!" I would like to reassure her, "Yes, yes, you are my Queen!"

At times I felt toward her a brooding anger. There were even secret departures into irrational hate, though they never lasted long. Like every teenager I was awash in contradictions. Even as I admired Mother's extensive knowledge, I reproached her abysmal ignorance. I was in awe of her discriminating taste and culture; I condemned her unforgivable provincialism. These eruptions of adolescent rebellion that today look so idle, tormented me then. But my acute need to be loved, to be trusted and approved, made me keep my irritation to myself. Never did I let her see the extent of my inner conflict. I had no choice but to accept her over-confident control and my own consequent feelings of guilt, and live with both, telling myself how wonderful it was to have such an exceptional Mother.

Mother was a born storyteller. When I was a small child, there was magic in the tales she used to tell to me at the dining table, sitting next to my chair. Watching her lips I would depart far, far away and in great amazement open my mouth to whatever she was trying to feed me. The purpose of her stories was to make me forget my fastidiousness and swallow even the stuff I detested. This was of course before the war, when food was plentiful. A little plump boy was considered the perfect emblem of the comfortable middle class. Besides, with all the dark clouds hanging over the political horizon, and the menace of shortages, a prudent reserve of plumpness was considered a wise precaution. I loved to listen again and again to her stories of our ancient forefathers whose adventures filled the book of Genesis. It was much later, in Israel, that I learned to recognize the metaphorical riches and the great complexity of this material.

For the child in me, Mother's biblical heroes were charming dreamers, killers, liars, thieves, kidnappers, and slave merchants.

After I learned to read in Russian, Polish, and Yiddish, Mother introduced me to the enchanting world of books. When I was five or six I was given some old Russian children's books. Some were missing their covers, and most had pages of stained yellowing paper with engravings in black and white. At times several pages were glued together by desiccated jam. These volumes, which had once belonged to Mother's early years, carried with them the smell of Grandmother Shifra's attic.

Later, when I was hidden in the convent, the devoted nuns provided me with the very best of Polish books. All were about lives of saints and martyrs. It was a collection of intensely inspired tales, which generations of diligent Catholic college girls had filled with unreadable annotations. I was fascinated by the explicit descriptions of torture that often made me shudder but was rewarded by the clarity of the confrontation between good and evil and by the unmistakable triumph of virtue. I loved the stories about child martyrs. They always ended happily in a heaven of bliss.

The ghetto exposed me to books in Yiddish. At the insistence of my beloved ghetto tutor, Rokhele, I read there the classic works of Jewish writers. These books were found in the Straszun library, and they kept me from the ghetto school with its throngs of lice-infested children. The dark and smelly interior of the library projected me into unknown worlds of Jewish history and life in unfamiliar regions of the Diaspora. Mother encouraged me to look there for Polish books written especially for teenagers, and I devoured them. When I was ten, perhaps eleven, she gave me "real" books, books for adults. Not always did I grasp their complicated story lines or the full meaning of their texts, but Mother was available to discuss them with me. My questions never dared to touch the nebulous domain of physical relations between the sexes. A spark in Mother's eye would alert me. I felt it was right that some things remain

shrouded until I should be suddenly and mysteriously a "grown-up," at which time everything would become crystal clear. Was this an intuition? Was it induced by Mother's body language? I do not know.

Being a self-taught and bookish boy I was thus early exposed to what Mother considered serious literature, the only material she thought worthy of her "exceptional" boy. I was sad to see how she snubbed books that I secretly adored. Alexandre Dumas, for instance, whom I discovered in the attic of our house in Landsberg—in a complete leather-bound edition in gothic-lettered German—carried me on his wings. But to Mother this was a mere amusement, a type of disposable writing; she called it "belletristic." There was a third category of books that her severe literary taste banned altogether. These were popular works written for simple and uneducated people. Sometimes, according to Mother, smarter but intellectually lazy people were attracted by such sentimental trash. She would gently shake her head and remind me that unfortunately her beloved but naïve sister, my dear Aunt Yetta, found pleasure in such garbage. This third genre she called kitsch and I had to distance myself from it as from the plague. How was I to know which was which? "Look," Mother would say, "to see if the writer has had a Nobel Prize. For the rest, ask me."

Mother's taste in art was a different matter. In my early years she was my supreme authority. Never would I have dared to challenge her judgment. Later my own judgment evolved, and so did my self-confidence. I realized with the passing of time that I disagreed with her more and more. The fact that she had once studied in an art school gave her, I thought, too much assurance in offering her critiques. In retrospect I must confess that because of a similar shortcoming of my own, I sometimes failed to credit her intelligent and logical observations. It was an obtuseness on my part that today I deeply regret.

Mother believed that art, or Art with a capital A, as she would have

preferred to write it, resulted from a culture and technique that one generation of artists handed over to the other. The more teachers, the better the technique and the greater the culture! She imagined a divine harmony among all the different concepts of style, and she strongly believed that this harmony would give her gifted boy the necessary base for his own evolution as creator and craftsman. This belief might have been justified some centuries ago. In more recent times, when everything is complex and every "truth" constantly questioned, the cumulative result was confusion, at least for a boy struggling to make sense of all the very mixed messages.

In the beginning, in Vilna, Mother, provided me with Makoynik and Professor Serafinovitch. Lodz brought to my life Professor Rychtarski who totally discredited my former instruction. In Munich, the elderly Professor Blocherer's merit might have been a Nazi-free past, but he was not a great educator. He would talk at length about this or that pupil's work, but essentially he remained pretty dull. Munich was an hour's train ride from Landsberg, and Mother would take me there weekly. Often after the sessions in the Blocherer studio, and sometimes instead of them, we would go to the city's museums and immerse ourselves in their collections of ancient and more recent art. There was no artificial light to help our viewing, and changing weather conditions constantly altered the appearance of the masterpieces. Mother tended to favor art that displayed detailed, fine workmanship. I tried to figure out how certain masters attained their look of effortless ease.

When many years later, in 1959, Mother was visiting me in Rome and I displayed to her eager eyes my latest series of canvases, something in her attitude and expression reminded me of our past visits to Munich's museums. In Rome I was deeply involved in my semiabstract period. My canvases were partly a result of the fashion of those years. I would cover the picture surface with thick impasto, pour over it liquid paint juices, let them drip, and later carve into the heavy paint's fresh flesh. The resulting

images suggested urban vistas, bridges, perspectives of a gray and foreboding universe. I tried to get out of these paintings more than I had put into them. It was a matter of principle that seemed to work with certain masters. My results seemed to me a little vague but intentionally so. As I have said, this "semiabstract" language allowed me to keep memory at bay.

"You know, my child," said Mother. "You have attained an incredible degree of precision."

"Precision?" I felt that I was looking for the opposite of what that word implied. I wanted to create paintings that only suggested their topic and let the viewer's imagination do the rest.

When I review my recent works, or revisit them as they hang on gallery walls, I often see again the scrutinizing look of Mother's eyes. It makes me smile to think that almost three decades after her death I am still searching for signs of her tutorial approval.

Yet as it turns out, Mother's old remark has had a certain predictive power. My semi-abstract art has transformed itself into my present "realism," which describes a vision that could only exist in the mind, yet is very specific in texture and detail. In it the precision of the pictorial imagery is mandatory.

CHAPTER TWELVE

What, How, and When: On My Art and Myself

As a STUDENT and young artist I believed that the evolution of art was summed up by three words: *What, How,* and *When.*

What had to do with subject matter. Ancient cave paintings spoke of magic. Roman sculpture celebrated power. Old masters served the needs of religion, portraiture, and historical documentation. Subject matter was the very essence of these works.

My student years of the early fifties seemed to have rejected subject matter in favor of "abstraction." The *How* had become most important. What counted was the way the colors were chosen and applied, the way shapes were formed and defined, and the manner in which the paint was laid on the canvas.

And then there is the *When,* which really means "What's happening now? What is kosher in terms of historical correctness?" God help the young artist whose work is not perceived as avant-garde!

In 1959 I left Paris and settled in Rome. I was in my twenties and my shows of semi- abstract and abstract canvases were doing very well. I was invited to international shows. The museums of Tel Aviv and Jerusalem considered me a legitimate modernist and gave me large exhibits. My greatest achievement had been an invitation to participate with several large paintings at the Carnegie International of Pittsburgh. The show was then a major event in the world of art.

Four years later I turned thirty and began to question my current mode of painting. In spite of my successes, something in me was starting to change. The bubbling world of contemporary art encouraged such reconsideration. The early sixties saw the triumph of the American Pop

Art in Europe, legitimizing the return of subject matter. By using popular icons and glorifying them, artists were permitted to comment on the world, its culture, and its art. One was allowed to go beyond the seductions of abstract art and explore the actual. Thus a new feeling began to unfold in me, telling me that I had been functioning in a world of too much certitude and that my work until then had been only a preparation for something else to come. My dealer was contented and the critics praised me, but I sensed that I was moving toward a dead end. It became imperative to delve deeper into my self and ask the most important of all questions: Why paint?

I realized that I had a special story to tell. There was a past that had been lying dormant in me. Indeed, my abstract canvases were letting it emerge, and as a result they were becoming more and more somber. To me their language seemed understandable, but was it understandable to others? I had a feeling that instead of unfolding my story, the abstract paintings were suppressing it. Now this past that was stirring and searching for expression made me ask myself how to let it speak.

These were years in which theoretically every possible artistic option was defensible. But I did not care to search for justification. It was to be expected that my shifting to another mode of expression would raise many eyebrows. I decided to let my paintings tell me what to do, to let my story (or was it their story?) come without forcing. I observed the ongoing change in my work, and little by little it became clearer to me what it was that I was doing. Mine was a story of a humanity that had survived two great wars and whose world now lay in shambles. Survivors were trying to repair the damage, to reconstruct what had been lost, to recreate something that would resemble in their eyes what was gone forever—and if possible to prevent additional or future suffering. A survivor myself, I observed and understood their need to reinvent life. Their story was my story. And in me it was also a story about a trauma that had been silenced

for too many years. Now, its emergence could be seen as a sign of resilience. These were the elements of my inner self that were asking to be communicated through my art.

There was more to it. Circumstances have made me absorb a complex Jewish culture. Since I am not personally religious, I am able to experience my Jewish heritage unhampered by traditional reverence. This freedom has always been an asset to me. Moreover, for better or worse I have been a Wandering Jew. From time to time I carefully extracted my newly established roots from their soil and folded them into a suitcase. I had to preserve them for new journeys and new transplants. I have lived in Poland, Israel, France, Germany, Italy, Switzerland, and finally in the United States. Different languages, cultures, and geographies have become an intrinsic part of my psyche. All these riches demanded to be integrated and to function as components of my art, to enlarge its perspective—or so I hope.

What I was trying to achieve in my painting was a sense of both immediacy and estrangement. The idea of speaking about a human need for restoration in a language that restored old-fashioned, illusionary vision, a vision made of light and shade and verisimilitude, seemed to me the right venue. My painted images were to be sharp and clear, immediately and unavoidably present to the viewer. Yet in the context of modern art this technique also provided the estrangement that I sought, a means of forcing viewers to see freshly those painful matters that have been dulled by habits of denial. But it came with the risk of being misunderstood. In our time, when the artist's personal style is the logo of his merchandise, I felt my painting had to be impersonal, painted in a style that would echo the traditions of paintings as representation, as in the Renaissance, the Baroque, or the nineteenth century. At the same time my work could not be some exercise in reviving ancient mannerisms: that was certainly not the point of my endeavor.

Stereotypes plague the best of us. I knew that I could be mistaken for a latter-day Surrealist or an old-fashioned neo-post-Modernist. I had to keep telling myself that if I trusted the inner sources of my art, my work would acquire with time its own form or individuality.

As I said before, the defining moment that brought me to the present form of my art happened some thirty-five years ago. It has been no intellectual journey, not the kind of search that many self-aware artists, conscious of their place in the evolving story of art, go through before reaching their characteristic style. Rather I was responding to something that was pushing out from the inside, something visceral, something that takes a long time for the mind to comprehend.

The world of images that populated my paintings thirty-five years ago was very close to what it still is today. I know how my present art is perceived, and I feel comfortable about it. But at that time I had no intention of producing work that would automatically identify me with the experience of the Holocaust. Being a survivor, I was familiar with the world's reluctance to listen to our harrowing stories. This reluctance to expose ancient wounds might also come from a fear of being thought to solicit commiseration. We live in a society that hungers for sentiment. Thus my fragile inner images, ready to be transferred onto canvas, had to be protected from exploitation. And so my antiquated style of painting also served to shield their meaning from too-easy access. I guess that I was looking for a place "far from the madding crowd," for an art that would exude an aura of timelessness.

These representational paintings of mine depicted devastated landscapes of ancient cities, urban constructions that seem to have been made of a child's building blocks. I painted figures that were half alive, and half contrived of bizarre prostheses. I imagined helpless and abused angels. Chess pieces were involved in games without rules. Huge fruit, mostly pears in various stages of reinvention, pears giving birth to other pears,

pears made of stone, pears in the form of hovering planets—metaphors of a world without explanations. My paintings carried no answers, only questions.

Yet although I resisted making the connection explicit, these were questions that for me, personally, returned always to the experience of the Holocaust. Chimneys, sprouting heavy smoke and made of clusters of stones that reminded me of cemeteries, had already been hiding in my earlier paintings. Yet I still named such paintings *Ancient Industries*, hoping that no one would guess what they meant to me. In 1974 a contract with a New York gallery disconnected me from the "old world" that had given me a sense of identity and brought me for a few years to Manhattan. It was there that the Jewish symbols began to enter directly into my work. The Star of David that I had to wear as a young boy in the ghetto stitched to my clothes; the tables of the law, which adorned most synagogues; the extinguished candles of Sabbath. Two decades later I added to them the figure of the Warsaw ghetto boy with his lifted arms, that most iconic of all Holocaust images.

From the beginning I have believed that specifically Holocaust-related interpretation would narrow the meaning of my work. After all, I am trying to express a universal malaise about our human condition. The experience of the Holocaust shed such a cruel light on the vast catalogue of human behavior that its lesson had to be hard to absorb; people needed time to study it and to grasp all its implications. Moreover, thirty-five years ago the Holocaust was considered mainly a calamity only of the Jewish people.

There were several other reasons why I shied away from a direct connection with the Holocaust. First, I did not like the term. In its biblical origin it meant a burnt offering that was proposed to God Almighty by a high priest. I felt it thus carried a notion of self-sacrifice that did not respect the desire for life to which millions of victims had clung desper-

ately though in vain. It belittled the magnitude of their tragedy. Second, most of the art that I then encountered on this theme, art produced in the sixties and seventies, was to my eyes less than acceptable. Some powerful works must already have existed, but I was unfamiliar with them. It often felt as if the overpowering importance of the subject was expected to compensate for the lack of artistic imagination and force. A few decades ago many serious and creative artists refrained from touching the theme of the Holocaust.

Fortunately, this situation has evolved. At present, the challenge of anchoring art in meaningful themes does not scare away talented artists. On the contrary, *subject* now matters. As for the problematic denomination of the Jewish genocide: the word *Holocaust* has become so familiar that it has transcended its etymology.

But there was another reason I hesitated to connect my work exclusively to that portentous event. I suspected that my art was being used improperly. Perhaps, for the purpose of whitewashing a disturbed conscience. Perhaps, for placing it into a space that was temporarily "fashionable." I feared that, unwillingly, I was being launched on an ambiguous trajectory that exploited my grievous personal losses for what could be seen as an advancement of career.

In 1978 a retrospective of my work was planned to take several years and to travel through ten German museums. I was torn between two opposing forces: my willingness to grant permission to show the work and my reluctance, or rather my total unwillingness, to bring myself to revisit Germany. I never made it to Heidelberg's museum to attend the show's first official debut.

It took me months to put aside the hampering feelings of guilt that were blocking me. I had to extract myself from what is commonly called "the survivor's syndrome," take my courage in both hands, and assume the role of an exhibiting artist whom the public wishes to meet. Thus, due

to the patient insistence of dedicated people who were later to become personal friends, I agreed to participate in a subsequent festive opening of my exhibition, this time in the German National Museum in Nuremberg. The opening took on the proportions of a state event. I stayed in a hotel that was not too far from the museum. To get to the exhibition I chose to go on foot. Was this a form of penitence? Perhaps.

I had to walk along the notorious Nazi stadium that was now partly destroyed. I knew it from old films of the Führer with the legions of his perfectly ordered men and his enthusiastic crowds. All of them continued to project themselves onto the screen of my mind. But also the faces of my murdered grandparents, uncles, aunts, and father accompanied me on my way. I walked and I wept. When I finally arrived I had to explain to my hosts that a sudden allergic attack had caused the reddening of my eyes.

It was on the day *after* the opening, when revisiting my show and stumbling on a visit of high school youngsters, that I learned something of value. Listening to a well-informed instructor and to the young people's interaction with him, I understood how important it had been to bring my art to that place. I was witness to a process of their coming to terms with a terrible past, a courageous process. Not too many people in other European countries have been up to it. Suddenly, letting my work be seen explicitly in the context of the Holocaust made a lot of sense. To my personal view my paintings became transformed by the walls of the German National Museum.

My works have always refrained from overly explicit imagery. Everything in them is transposed to an imaginary realm. This transposition must have worked well, because I heard it echoing in the souls of these young Germans, giving them access to a horrendous and until then unmentionable past and stimulating their sensitive minds to new excursions of thought.

I have previously implied that my process of painting was not "intel-

lectual." Actually it resembles a sensual love affair, an affair with tubes of paint, bottles of oils, brushes, palette knives, and the odor of turpentine. Dealing with all the paraphernalia of an artist's imaginary world, the world of shapes, compositions, brush strokes, colors, and hues is a voluptuous pleasure. Moreover, my countless hours in the studio fulfill yet another desire. They allow me to discover the many realities that emerge on the surfaces of the paintings I am making. Bridging the gap between the inner projection of a mental vision and the final, physical result of the completed canvas is the essence of my craft and passion.

At times I think this struggle must be similar to Jacob's wrestling with the Angel, whether one thinks of the Angel as God or as one's yet undiscovered self. After so many years in my profession I have learned to recognize what this wrestling means for me. The process of painting has an inner logic. The way a wrestler knows how to profit from an opponent's energy, so a painter realizes that paintings have a life of their own and knows how to open their door and get out of the way.

And this is how it happens. I am in front of my easel. The radio plays music, the speaker announces a change in the weather, and a part of my mind is busy with all sorts of mysterious creative systems. I feel like an obedient servant who is doing what the painting demands. At the end of the day I may feel satisfied or I may wonder. I may also decide that everything went wrong. Contradictions are part of the game.

Paintings are never finished, yet I myself must finish with them. Sometimes when I revisit them, there are works I like and some others that ask for modification. On another visit my perceptions may well be different. Luckily, since once they are done the paintings no longer "belong" to me, I never touch them. It has taken me thirty-five years to recognize that if I choose the subject, the *What*, and let the artist in me release it in all its force, it will find its own voice, its own *How* and *When*.

CHAPTER THIRTEEN

Closure

JANUARY 3, 2001. As I worked on this memoir, the *Pinkas* kept returning to my mind. I imagined the old book in some dark corner of a Vilna museum, tucked away and then forgotten. Only two of its drawings, the ones that had been published, were familiar to me. I could not recall the rest.

The memoir completed, I went back to a daily routine of painting. This return to my rolls of canvas, stretchers, brushes of various sizes, creamy oil colors, and odorous mediums plunged me into a familiar yet almost forgotten sensual pleasure. A series of new works began to emerge. Most of these paintings explored biblical themes, post-Holocaust visitations of the tales of Genesis. Others dealt with the repair of a broken world, a *tikkun haolam*.

I soon realized that these themes had not emerged fortuitously; they must have been triggered by my recent writing. Indeed, as I told of my lost Vilna, of the ghetto, the camp, and the hiding, a better memory of the *Pinkas* began to emerge. Its pages, covered by endless lines of Hebrew letters, carefully handwritten, reminded me of a Torah parchment. In recollection it all felt very "biblical." This may explain why one day I reached into the gentle chaos of art books on my bookshelves and, browsing among the volumes, stopped to look at reproductions that depicted man's creation.

That is how I came to explore Michelangelo's newly restored frescoes, spread on the pristine pages of a glossy paper. With limitless awe I revisited his divine figures, his angels, his Adam and Eve. All immersed me in

a fairy-tale glory of radiant colors, bold and exuberant. What incredible genius! I had to go back to the days in the Vilna ghetto and thank dear Moses, whose horned image I had once found on a crumpled postcard, for having introduced me to "Mr. Michelangelo." This glorious leader might have failed to save us from the Nazis, but to me he had opened up the world of a giant. My childhood fascination with Moses and the stories of Egypt, and with the tales of the patriarchs, has never left me; nor has my discovery of Michelangelo's unique vision of them. Now, in my Weston studio, all this returned to me with force. And that is how I decided that through my paintings I would further explore this magical merging of our forefathers' myths and their representation in art.

There followed months of long and intense sessions of painting, in which for me time seemed to evaporate. Indeed, having completed most of my work on the memoir gave me a new sense of freedom. It prepared me for a new *bereyshiss*, as it is called in Yiddish, a new "In the Beginning." My studio walls began to be covered by a multitude of fresh canvasses, all candidates for a forthcoming show.

The new exhibit was well on its way when quite unexpectedly the actual *Pinkas* re-entered my life. This event was set in motion by a letter from a Christian Lithuanian from Vilnius (Vilna), by the name of Rimantas Stankevicius. He wrote that he wished to meet with me. Professionally a legal advisor to the parliament, he devoted much of his personal time to the remembrance of those righteous men and women who, despite the barbarity of the Nazi occupation, had committed themselves to the saving of Jews. At the time he sent his letter, he was arranging for a plaque to commemorate Sister Maria, Father Stakauskas, and a certain Vladas Zemaitis. The last must also have been important to my mother's and my survival, but I hardly remembered his name.

One day a small white car parked in front of my house. From it emerged a tall man, his shock of white hair a surprise on his young face.

After the usual words of introduction, we sat down and he asked if he might use a small tape recorder. He also presented me with a book that he had recently coauthored. It is dedicated to righteous Lithuanians, which explains what led him to my benefactors and to our story. His visit, at first slightly formal and embarrassed, ended by our establishing a sense of mutual trust. I told him about the *Pinkas* and about how disappointed I was that the museum's curator had never followed up on my request to see pictures of it. He was surprised. Didn't I know that this curator had died? My jaw dropped. I was deeply embarrassed. When he left I gave him a handful of catalogues and books on my art, easing for me the weight of my guilt. We decided to correspond by e-mail. I first heard from him on August 21, 2000:

> After my lucky journey in USA I am here in Vilnius. And once more I look through the books you presented me, and over and over again listen to our recorded talk in Weston on July 22. Several times I visited the place you lived in as a child and the place you were hidden in the last 3 months of the war. From having been a mere character in a story, the boy Samuel now has for me a concrete form.

The date for the unveiling of the commemorative plaque was nearing, and Rimantas asked me to write a small speech for the occasion. Meanwhile, in faraway Vilnius, he continued researching the story of our small group and its saviors. On August 30 he wrote:

> Latest news from Warsaw: Maria Mikulska was born in 1903 and died in 1994. She died on your birthday, August the 12th.

Surprised, I wrote back at once:

> What fascinating information! When I began writing "The Guardian Angel," my first piece about Sister Maria, to me she

belonged to a distant past. Now I learn that as I was writing, she had only just died . . . That her death should have occurred on my birthday is one of those occurrences that fictional narratives must discard—yet it is an extraordinary coincidence, and it makes me dream.

We continued to exchange frequent messages. Rimantas told me that he had talked with the director of the National Museum and learned that she would soon be photographing the Pinkas. He also reminded me that the day of the ceremony of commemoration was nearing. On September 13, I sent him the following response:

> Here is my text. Thank you very much for letting me participate in this ceremony, to me so very important. I would ask you to translate my words into Lithuanian and read them to the public.

"Dear Friends,

"You are reunited here today to give honor to the memory of three exceptional people: Sister Maria, Father Stakauskas, and Vladas Zemaitis—gray, unassuming, unsung, and (I dare say) unknown heroes. Over half a century ago, in the bleakest of times, they preserved the spark of a deep humanity. By opposing the murderous actions of the Nazi regime, they stood ready to pay for their principles with the most precious thing a person possesses—with their own lives.

"Although all of us must be grateful to those few who kept the light of humanity glowing, however feeble it sometimes seemed, my individual gratitude is limitless. That I am alive today, that I am able to send you this message at all, I owe to these three guardian angels. Audacious, ingenious, and ready for self-sacrifice, they created a secret oasis within the

walls of this convent, filled at that time with Nazi officers. Here they gave refuge to a young Jewish woman and her ten-year-old boy. Had it not been for them, the story of my life would have been quite different. I would have shared the fate of many of my family who, along with thousands of other Vilna Jews, were killed in the woods of Paneriai.

"My new friend Rimantas undertook to recover all this history. And now he has created also an electronic bridge between Boston (from where I write these words to you) and Vilnius, the beloved paradise of my childhood. I see him taking part in a blessed effort to recall a past that is painful but full of meaning for the present. It is said that those who forget the past are doomed to repeat it. Rimantas is one of those who take action against such a danger. I owe it to him that I am sending you this message today, a message of infinite gratitude to my saviors, and of thanks to all of you for celebrating and preserving their sainted memory.

"I hope that, in the spirit of today's celebration, the memory of our three heroes will continue to serve as an important reminder. It alerts us to the fact that despite those forces that separate man from man—be they religion, nationality, or so-called "race"—it still remains possible to be humane, moral, free, and tolerant. Given the cruel realities of today's world, this prospect may seem no more than a dream. Yet in the most nightmarish of times our three heroes never gave up their dreams. Thus they tell us not to lose hope in the possibility of goodness. For them the saving of a few human lives, in a time of colossal destruction, was a brave act of defiance, an act of belief and of hope. They are dead, but their presence endures. Let us learn from them."

Rimantas wrote to tell me that the ceremony was a great success. The people present included not only an elderly woman who had been among our group in hiding but also the chairman of the Lithuanian Parliament, a bishop, the Polish ambassador to Lithuania, representatives from Vilna's now small Jewish community, and a number of writers, poets, and musicians. My words were read, but since they included personal praise for Rimantas, he had asked another speaker to deliver them.

The day after this ceremony, in another of those strange synchronicities that only reality can afford, Alexandras Lilaikis, head of the Lithuanian police under the Nazis, the notorious war criminal who had never stood trial for his crimes against humanity, died in a Vilnius hospital. He must have been over ninety.

Soon after, came the news I was waiting for:

> I visited the National museum and saw the famous *Pinkas* ... It was a great surprise to find 209 pages (if I counted exactly) with your drawings, not all of them finished ... Faces, portraits, figures ... In several drawings I saw your face. As you remember, most of the drawings in that book are in pencil, a few in ink (?) and two or three in watercolors. One would hardly know they were made in wartime, except that several are dated June 24–26, 1943. The size of the book is 30 x 40cm.

I responded at once:

> Knowing that the *Pinkas* still exists and that it contains so many pages of drawings fills me with an indescribable excitement ... I can hardly find the words to thank you.

On September 26, 2000, I received this massage from Rimantas:
Today a photographic copy of the famous *Pinkas* with your

drawings begins the trip from your native town Vilnius to Weston. Let it be a present for the New Year. . . Returning to the history of this book I want to inform you that Mr. Sutsck-ever is alive. He is 87 years old and lives in Israel.

And on October 4, I would write:

Thank you, thank you! A short while ago the material arrived. It is a wonderful gift. I am so grateful to you and to the ones who have helped to prepare it. I am well aware that the artistic merit of my childhood art is very limited, but the weight of it for me as a personal document cannot be meas-ured or expressed in words. I am very much moved, and flooded by memories.

In an e-mail that followed, Rimantas asked me if I would agree to be called "Samuel" instead of "Mr. Bak."

I now look at this pack of photocopies that has arrived direct from Vilna in a creased envelope the color of sackcloth. When I opened it with a pounding heart and trembling hands, its contents fell out and spread across the floor. Gathering them up, I realized that fifty-six years have passed since I last saw them. At present I can look at each one of those pages separately and examine it at my convenience. They arouse in me a strange mixture of feelings. Yes, yes, it is the ancient book, and at the same time it is not the actual thing, not the relic itself. I am glad it is the *Pinkas* yet not the *Pinkas*.

No smell of mildew. No bloodstains.

At first I quickly browsed through the *Pinkas*'s numerous pages, threw a glance at the many drawings that covered them and saw that only a few were worthy of my attention. Several amused me, but most seemed quite childish. They were the earliest of my works to come before the scrutiny of my adult eyes, and they disappointed me. I was baffled to think that my

beloved family had seen in me such "extraordinary talent." Would I, as a parent, have been so supportive? My reaction made me wonder. Why this unease, why these qualms? Had my expectations from these poor pages been too high? I should have known that what memory amplifies, reality is bound to shrink.

Or perhaps my unease had a different source. It seemed to me—or maybe was it only the product of my later imagining—that as a child I had been expected to turn the *Pinkas* into an extraordinary document. And right now, viewing what I had in my hands, I felt I had failed the friends who gave it to me. Instead of depicting the horror of our imprisoned condition, I had filled the precious book with insignificant images, illustrations of stories or films, sketches that only attested to a cowardly desire to escape. How disappointing! I wasn't the brave boy I would have liked to be.

"Don't be a pompous ————-" The voice sounded familiar, and for a fleeting moment two sparkling eyes tenderly smiled at me, revealing a slight gleam of irony. Did they belong to Mother?

So: whether I like it or not, the *Pinkas* is a document. At present, when I look at the energetic lines that my childish hand left on its many pages, I try to be more forgiving to that boy. Shouldn't I leave him alone?

Setting aside my personal additions to the *Pinkas*, I am now struck by the arcane calligraphy and the content of its texts. When I began my memoir I thought the *Pinkas* contained historical records, but I was wrong. Instead it lists all sorts of rules and regulations concerning a Jewish organization for charity. On endless pages the Hebrew letters spell names of members, names of advisors, names of arbitrators, names of benefactors long since deceased—a cemetery of names. Hundreds if not thousands of names, and all of them sound familiar.

In my inner eye I see a procession of men: men in long coats, dark hats, wearing all sorts of beards; a few carry canes; some sneeze or cough; oth-

ers sigh, and many are engaged in arguments. Several must have been telling jokes, because many of the men laugh out loud. Gradually they are obscured by an advancing crowd of boisterous and vigorous women. High over the two corteges hang leaden clouds, but the horizon is still clear and red blotches of a setting sun flicker over the entire throng. Along the road that leads them to some mysterious place, old trees humbly bend their trunks.

Their grandchildren and great-grandchildren, some of whom I must have encountered in my far-off days, peacefully rest now in Ponar, Vilna's lovely wood.

AFTERWORDS

Thanks

THIS MANUSCRIPT has demanded greater physical and emotional resources than I would ever have anticipated. With its completion comes a sense of relief, and of gratitude to my loyal friends. I doubt I could have made it without their love and encouragement.

First and foremost I must thank my friend Irene Tayler, who spent countless hours with me, going over every page of my writing. Her commitment to my project was absolute, and the generosity with which she gave me her time knew no limits. Moreover, Irene helped me to reexamine my ideas and sharpen them. The result is more vigorous and compact.

My friend Bernie Pucker strongly believes in the value of my art. He is also a knowledgeable and discriminating reader, and a scholar of the Holocaust. Realizing how much my stories would contribute to a better understanding of my paintings, he affectionately supported the writing and publication of this book.

Many thanks go to the writer Amos Oz, among other things for his generous foreword, written under the duress of recovery from a painful surgery. Amos tried his best to convince me that his evaluation of my text is not merely a function of personal friendship. I am bound to accept his word for this.

I am grateful to Scott-Martin Kosofsky for the time and great talent that he committed to the design of the book. His intelligence, experience, and good advice are reflected throughout the finished work.

Janusz Rushkievich, Aunt Janina's son, assures me that I could not have made a greater gift to the ever-extending branches of our family. And

what about my dear friends Adaya Barkai, Rosalind Barnett, Solon Beinfeld, Nat Durlach, Ora Gissin, Larry Langer, Wren Ross, and Saul Touster, all of whom read my manuscript with attention and empathy, and provided me with their precious words of reassurance? My thanks go to each of them.

And I thank in particular Vera Laska for her careful reading of the draft; her suggestions and encouragement were most welcome.

Most of all I thank my wife, Josée, who has patiently followed all the stages of my struggle with the memoir, and to whom it is dedicated. Her love and her invaluable encouragement have been indispensable to the making of this book.

Boston, January 2001

A Postscript

Boston, June 2001

THE IMPORTANT EVENT happened a month ago. On May 14, 2001, Josée and I boarded the Lithuanian Airlines on a direct flight from Paris to Vilnius. A journey that had been deeply desired but apprehensively deferred became suddenly a reality. Only a few months before, such a visit had seemed unimaginable—a return to the city of my birth after 56 years of absence and so much loss. It was perhaps another step in the endless process of healing, a "tikun" that has evolved through my paintings, this memoir, and now a pilgrimage to the land of my abbreviated childhood.

The inspired idea of revisiting Vilnius was first proposed by Rimantas Stankevicius, a senior advisor to the Lithuanian government and a man with whom readers of my memoir's final chapter are already well

acquainted. His suggestion was vigorously supported by Emanuel Zingeris, who directs the Lithuanian Jewish Museum and devotes his life to sustaining the memory of Vilna's Jews. These two helped me overcome my wavering and welcomed Josée and me with friendship and warmth. I owe them more than words can express.

I did not travel to Vilnius to rekindle the memory of past horrors; these are, and they must remain, part of my being. What I feared was that this pain would block my access to new experience. But my fear proved ungrounded. As I walked through the streets of the old city a pleasant sensation settled in my soul: the Vilnius of today felt very familiar. Moreover, after half a century of trying to keep its old images alive in my head, I expected their reality to be disappointingly small and different. Not so. The ancient city with its winding streets, old buildings, and many restored churches, was more beautiful than I had dared to hope. It had a different tonality; the prewar shades of gray have been replaced by joyful pastels.

In spite of the inevitable pain that lay at the core of this pilgrimage, the days I spent in Vilnius were rewarding. With Rimantas at our side, Josée and I began by visiting the National Museum. There, in a spacious and elegant room among the archives, carefully spread open on an ancient table, my old Pinkas lay patiently waiting for me. It was larger and heavier than I remembered.

Later, in the Jewish Museum, I saw that dozens and dozens of my early works had been miraculously extricated from under the ruins of the ghetto and later salvaged from the hands of the Soviets. Now taken from their folders, they were shown to me with trepidation and pride. The works surprised me with their expressionistic boldness, childish imagination, and adult audacity. Wherever we went, Rimantas's reassuring and discreet presence made of him a kind of guardian angel. He took us to the building where I had lived as a child, walked us through the streets that

had been the ghetto, and explored my old hiding place in what had been a convent of the Benedictine sisters. We visited the former HKP camp with its small memorial erected on the spot where Nazi gallows had once stood. Lithuanian children were playing ball and joyfully chasing one another.

Finally, Rimantas drove us in silence through the lovely woods of Ponar, place of terrible memory. A large memorial stands there for the many tens of thousands buried below in mass graves. Nearby a single stone indicates the burial place of HKP's last victims. Here I placed the token of my own remembrance, a pebble that must have been touched by the hands of many other visitors.